The Warrior, the Voyager, and the Artist

THE LEWIS WALPOLE SERIES IN
EIGHTEENTH-CENTURY CULTURE
AND HISTORY

The Lewis Walpole Series, published by Yale University
Press with the aid of the Annie Burr Lewis Fund, is dedicated to
the culture and history of the long eighteenth century (from
the Glorious Revolution to the accession of Queen Victoria).
It welcomes work in a variety of fields, including literature
and history, the visual arts, political philosophy, music,
legal history, and the history of science. In addition to
original scholarly work, the series publishes new editions and
translations of writing from the period, as well as reprints
of major books that are currently unavailable. Though the
majority of books in the series will probably concentrate
on Great Britain and the Continent, the range of our
geographical interests is as wide as Horace Walpole's.

The Warrior, the Voyager, and the Artist

THREE LIVES IN AN AGE OF EMPIRE

Kate Fullagar

Yale UNIVERSITY PRESS

New Haven and London

Published with assistance from the Annie Burr Lewis Fund. Illustrations published with the generous assistance of the Australian Academy of the Humanities.

Yale University Press books may be purchased in quantity for educational, business, or promotional use. For information, please e-mail sales.press@yale.edu (U.S. office) or sales@yaleup.co.uk (U.K. office).

Set in Adobe Garamond type by IDS Infotech, Ltd.
Printed in the United States of America.

Library of Congress Control Number: 2019937181
ISBN 978-0-300-24306-2 (hardcover : alk. paper)

A catalogue record for this book is available from the British Library.

This paper meets the requirements of ANSI/NISO Z39.48-1992 (Permanence of Paper).

10 9 8 7 6 5 4 3 2 1

To my father, Peter Fullagar,
and to the memory of my mother, Daphne Fullagar

He therefore who is acquainted with the works which have pleased different ages and different countries . . . has more materials, and more means of knowing what is analogous to the mind of man, than he who is conversant only with the works of his own age or country.

—JOSHUA REYNOLDS, Discourse VII (1776)

A rich documentary archive demonstrates the diverse strengths and nuanced strategies by which Indigenous individuals and nations have not only challenged colonialism, but also articulated other realities and distinctive ways of being.

—DANIEL HEATH JUSTICE, "To Look upon Thousands" (2010)

At one time they were flesh and blood; then, what was left were memories, portraits . . . and their art.

—NATALIE ZEMON DAVIS, *Women on the Margins: Three Seventeenth-Century Lives* (1995)

Contents

The Warrior, the Voyager, and the Artist

Prologue

ON LIVES AND EMPIRE

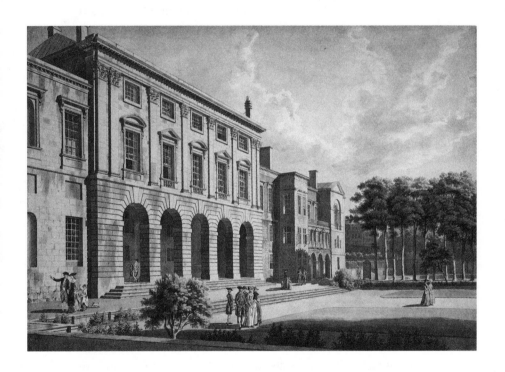

The evening of 10 December 1776 was exceptionally cold. It had been a trying winter for Londoners in more ways than one. News from across the Atlantic was getting worse every day, and no one seemed to agree on the best path forward. Some thought the American colonists were justified in their break for independence. Others believed that hanging was now not punishment enough. The weather didn't help. Yet, undeterred by it all, that night the members and students of the Royal Academy of the Arts scurried up the steps into Somerset House on The Strand for their annual prize-giving ceremony. Perhaps they were eager for some distraction from the splintering of their empire. Perhaps they wanted simply to find out who were the medal winners for that year and to listen to their president's seventh formal address.[1]

The president, Sir Joshua Reynolds, was fifty-three years old in 1776. He had held his position as inaugural head of the Royal Academy for seven years. The audience was by now used to his low-toned Devonshire accent and his ruddy if commanding appearance. They were also used to the message with which he opened his address. "The first idea of art," he declaimed, is to show the "general truths" of humanity, which are all indisputably "universal." The artist should never privilege those quirks that make a sitter distinct from everyone else because that would draw attention to what makes humans disagree with one another instead of to what unites them.[2]

About halfway into his speech, the president, unusually, changed tack. He brought up the tricky issue of what artists should do when faced, nonetheless, with sitters who bore such pronounced quirks that they challenged his core idea of human universality. To illustrate the problem, Reynolds offered the examples of an ochre-daubed Cherokee and a tattooed Tahitian.

Most listeners in the room that night knew that Reynolds spoke from experience in invoking such examples. Just a few months earlier Reynolds had exhibited his portrait of Mai, the first Pacific Islander to visit British shores (who was really from the island of Ra'iatea but was thought by most Londoners to be from nearby Tahiti). A dozen years before, Reynolds had painted the portrait of a Cherokee visitor, equally celebrated, called Ostenaco.

Today, these two Reynolds paintings are rarely connected. They have met with starkly opposing fates. At the start of the twenty-first century the portrait

Figure 1. *Somerset House*, watercolor over pencil by Thomas Sandby, 1770s. Reproduced with permission from the Royal Collection Trust / © Her Majesty Queen Elizabeth II 2018.

of Mai—grand, beautiful, idealized—caused a controversy when it sold to a
foreign buyer for a record £10.3 million. At the time, this was the second-
highest price ever paid for a British work of art. The controversy continued
when the British government placed an export bar on the piece to prevent it
from leaving the country, citing the portrait as a "national treasure," an "icon
of the eighteenth century," and a "vivid testament" to enlightened multicul-
turalism. The export bar still applies, making Reynolds's Mai the longest-
detained work of art in British legislative history. The portrait of Ostenaco, by
contrast, is seldom discussed. Smaller, quieter, more subdued, it has long been
housed in an American museum as an ethnographic artifact.[3]

Back in Somerset House, though, during the dying days of Britain's Atlantic-
based empire, few would have questioned the connections between either the
paintings or the sitters. Everyone remembered the visits by Ostenaco and Mai.
Both had been popular arrivals, tracked by a burgeoning press and by substantial
crowds who were just then learning the ropes of celebrity culture.

Ostenaco had arrived in London in the summer of 1762. He was in his late
forties by then, a seasoned diplomat for the Cherokees with an even longer
record as a distinguished warrior.[4] He had been a chief prosecutor of the
deadly Anglo-Cherokee War of 1760–61 but came now to secure the war's
termination with King George III of Britain. During his ten-week stay Oste-
naco took in tours of London's docks, cathedrals, jails, parklands, and tavern
scene. He returned home more confident of the Cherokees' relationship with
the British, but he was not to know that the British were soon to find their
status in America ripped to shreds from within. Ostenaco would become
caught up in the subsequent settler revolution in complicated ways.

The Ra'iatean man, Mai, had come to Britain under less official auspices.
He had made his way in 1774 by jumping on board the returning leg of James
Cook's second voyage to the Pacific. Cook, although reluctant, had conceded
to his joining because he assumed that Mai might serve one day, like Oste-
naco before him, as a kind of broker between Britain and a "New World"
Indigenous society. For his part, Mai had no interest in diplomacy. He wanted
simply to acquire the special firepower he had seen Europeans deploy spo-
radically in his home islands over the last six years. Mai was still a young man
when he arrived in Britain—around twenty-one or so—and he enjoyed a
longer stay than Ostenaco, returning after two years. He took in even more
sights than his Cherokee predecessor had, attending theaters and museums in
addition to the palaces and pubs. Mai too became embroiled in conflict upon

his return home, though in his case it was mostly internal to the various Indigenous peoples surrounding Ra'iatea.

Reynolds was younger than Ostenaco but older than Mai, middle-aged when he encountered the two men. He was already a famous painter in 1762. By the time he met Mai in 1774 he was the undisputed leader of Britain's art world. Reynolds's interest in representing people from other cultures was a constant, if unrecognized, undercurrent in his life. Though he was never wildly successful at its portrayal, the exotic attracted Reynolds as a testing ground for his beloved theories about human sameness. He was better known for representing the leading men and women of Britain's unfolding empire. He died in the 1790s amid British fears of a wholly new political order emerging just one narrow channel away.

Three vastly different lives, then, separated for the most part by many thousands of miles. My initial interest in these men focused on the key differences among them. They promised enticing ways to explore the variety of experiences and cultures of the eighteenth-century world. What were the respective distinctions—or "quirks," as Reynolds might have it—of the three characters? What were the distinctions of each man's society? What was most characteristic of the Cherokees during Ostenaco's lifetime? Of the Tahitian archipelago while Mai was alive? Of Britain from the 1720s to the 1790s? Were these men representative of those societies? What were their childhoods like? What defined the advent of maturity for each? What marked out the moment of his death?

The things that separate, though, soon lead to the things that bind. As I tracked down answers to questions about differences, it became obvious that what these three men shared was a connection to British imperialism. Ostenaco dealt with the traders and officials of colonial Britons in Cherokee country from his earliest days. Mai encountered his first British voyagers—sailing through the Tahitian archipelago on the lookout for new imperial fodder—during his midteens. Reynolds was born in the heartland of British global aspiration and remained always surrounded by the riches and opportunities as well as the anxieties and troubles that it brought home to its subjects. Braided into one narrative, these three diverse lives suggested then, as well as an insight into variety, a fresh way of looking at a phenomenon that went on to impose its will and influence over a quarter of the world's population. Together, they promised vivid, personalized insights into how people from unrelated corners of the globe coped with the burgeoning stages of one of history's largest empires. How did each man relate to this age of empire? Did he suffer from it? Resist it?

Welcome, accommodate, or shun it? Who were his coactors, challengers, and allies? And what effect did each have, even if in small ways, on its course?

These two sets of questions reflect two resurgent cultural concerns: the possibilities of life writing and the moral legacy of empire. Always a mainstay of history, life writing has found new audiences in the last decade or so among consumers of social and cultural history, of histories of objects and places, and of the exploding enthusiasm everywhere for family history. The so-called New Biography, with at least one eye out for the constructed nature of selves, has offered historians compelling ways to refute perennial accusations of dehumanized analysis and dullness.[5] This book is an experiment in New Biography. It emphasizes the historical nature of selves, such that Ostenaco, Mai, and Reynolds appear more different from than similar to present-day lives. It honors the diversity and dissonance of the past through three specific characters.

Unlike biography, empire has gone in and out of historical fashion over the generations. Currently it is very much in fashion, evoked nostalgically by many in the Western world's swing to the right. Despite concerted efforts by historians over the last few decades to expose the precise degree and kinds of oppression inherent in British imperialism, the present climate has regressed the level of debate back to asking whether empire was "good" or not.[6] A detailed narrative of three unlikely personalities touched by empire offers some return of nuance to the discussion. It prompts an advance to the *next* stage in understanding, which should not be to indulge nostalgists but instead to go further in excavating empire's culture. It should seek a reckoning with the British empire by looking more deeply into its rhetoric, critiques, regroupings, and redirections. Such a narrative should also attempt ways not merely to appreciate the presence of the Indigenous people who faced this empire but finally to see it through their eyes.[7]

This book combines, then, lives and empire. It offers a history of one nation's expansionist mission through the tale of three hitherto unconnected biographies. Approaching empire through the experiences of an Indigenous leader from one old colonial site, an Indigenous itinerant from one prospective colonial site, and an insider artist not normally associated with imperialism at all adds new faces to a history in need of a reboot. It also underscores how various and how complex were the faces *of* empire during the eighteenth century.

Over the course of writing *The Warrior, the Voyager, and the Artist* I often paused to wonder how each character might have remembered the other. Did

either Ostenaco or Mai think back on the calm, pinkish, and, to them, rather short man who worked to reproduce an image of his face? We know that Reynolds reflected on his meetings with Ostenaco and Mai in order to explain his art theories. But did he conjure Ostenaco's steady gaze when he heard in 1783 that Britain had finally surrendered its American colonies and with them all obligation to its native inhabitants? Did he see again Mai's proud stance when he learned in 1788 that Britain would now turn its colonizing sights onto the Pacific, sending settlers to its largest island?

For the Indigenous men, the answer is almost certainly no. Upon returning to their respective homelands, both became immediately involved in local dramas that had always claimed more of their attention than anything the British had ever done. In a sense this lack of attention exemplifies the first specific point in this book: Indigenous people were less impressed with Europeans than Europeans were with them—or at least less impressed than Europeans have ever since liked to believe.

The lives of Ostenaco and Mai reveal how the intrusion of empire into Indigenous societies was momentous but never total. It was important but not overdetermining. Ostenaco's Cherokee society was affected by the advancing influence of colonists from Charleston, Williamsburg, and other places. But it similarly affected those settlements in turn: Cherokee existence and actions influenced colonial strategies, capacities, ideals, and projections. Mai, for his part, witnessed firsthand the violence and disease that imperialists brought to his society, but he managed to use empire for his own ends more pointedly than empire ever managed to use him. Both Ostenaco and Mai took the even more notable liberty, on occasion, of ignoring empire altogether—to the great frustration if not complete disbelief of observing Britons. Though the immense scale of Indigenous dispossession through the modern era suggests an all-consuming history of degradation and control, individual stories insist on a bumpier and more negotiated process on the ground. These stories are harder to find than those of defeat, but they are crucial to any serious attempt to include more of the voices actually involved in the making of the contemporary world.

Did Reynolds think of his sitters more than they thought of him? Apparently, since he remembered them in his annual speech of 1776. But his memory was sporadic and unpredictable. He did not mention Ostenaco or Mai again in any written source. He did keep both portraits of them in his studio all his life but displayed one as an example of painterly prowess rather than imperial commentary and hid the other away from public view altogether.

Reynolds's patchy and curious remembrance of Ostenaco and Mai aligns with the second specific point made in this book: Britons had more conflicted attitudes toward empire in the eighteenth century than the record of later imperialism indicates.

Joshua Reynolds was not a radical in any sphere of life. He consorted with, painted portraits of, and benefited enormously from the leading imperialists of the age. At the same time, though, he showed signs of hesitation and worry about his nation's expansionist activities. Several of his key paintings include elements of doubt about imperial endeavor. Sometimes he revealed doubt by refraining from imperial representation altogether when the reverse was most expected.

Reynolds's mixed views on empire have not only gone unrecognized in most commentaries on the artist. The existence of this range has rarely been credited in any history of eighteenth-century Britain. Too often historians have read back into the eighteenth century the strident jingoism of later eras—if, that is, they acknowledge imperial sentiment prevailing then at all.[8] Reynolds's expressive work, though, points to the existence of various opinions on empire during his lifetime. Usually, views appeared singly in eighteenth-century British people. For example, Reynolds's friend Samuel Johnson held largely anti-imperialist views while his other boon companion, Edmund Burke, was mostly pro-imperialist.[9] Reynolds was unusual in how he combined oppositions in his one person.

None of this is to deny that British imperialism was pernicious or pervasive. The three lives here betray empire's brutality, insults, and everyday insinuations in ways that will surprise the most hardened doomsayer. But to see simply empire's destruction is to miss seeing also how individual Indigenous people absorbed, manipulated, adjusted, snubbed, or otherwise survived empire's force. Only the recognition of such survival can explain Indigenous lives in the present and, more important, offer usable histories for Indigenous futures. Likewise, to identify jingoism as the sole possible domestic attitude to empire is to overlook how empire permeated British life for some as a controversy. To see both pro- and anti-imperial views provides a powerful guide to the fault lines along which the British empire stumbled and floundered even while it continued to grow. It emphasizes the contingency, the potential fallibility, and, in the end—most important—the breakability of enterprises that appear in all other senses intractable.

The British empire did not rise like the sun, uncontested by either its perpetrators or victims. It was, and is, resistible. British imperialism deserves

no nostalgia today. On the contrary, it requires histories that reveal the detail of some of the actual lives involved, in order to absorb the problems inherent in its formation as well as the achievement of those who endured it.

There is precious little earlier literature on either Ostenaco or Mai, through any lens. But published work that does exist always situates these figures as examples of cross-cultural encounter. This means it focuses on the moments when they met or fought or befriended imperialists. "Encounter histories" have been vital in recovering the nuances of imperial-Indigenous contact, but they inevitably raise the role of imperialists to at least costar status.[10] Discovering the whole life of an eighteenth-century Indigenous person—upon which imperialists impinged as just one of many actors or for just a finite period—puts empire into more modest place. It also helps keep Indigenous people the main characters in their history.

So, too, the full biographic approach offers a way out of a persistent dilemma in any narrative about Indigenous people. As the anthropologist James Clifford has diagnosed, "Only a few basic stories are told, over and over, about . . . 'tribal' peoples." Their societies are always "assimilating or resisting."[11] Dying or fighting. Agents of either Tragedy or Romance. Telling instead the whole, messy, complicated, changing, and idiosyncratic tale of a life blurs such an either/or way of thinking. Lives are often tragic *and* romantic. As well as funny, tedious, awkward, and ordinary.

In Reynolds's case it's the imperial framing that proves, surprisingly, the novel and productive lens. Unlike Ostenaco or Mai, Reynolds is a canonical figure—one of the Great Dead White Males who has, since death, thrived on the historian's addiction to those who made a big impact on impactful societies and who left plenty of written sources for writing-obsessed posterity. Reynolds has prompted numerous studies, some of which are full-life biographies. Barely any, though, see Reynolds as an imperial subject.[12] This is strange enough given the huge proportion of his paintings devoted to the generals, merchants, princes, memsahibs, and scions of Britain's expansionist experiment. It is even more strange given how much empire was transforming, during Reynolds's adulthood, everything about his society, from its armed forces to its commercial outlook to its favorite breakfast beverage. The reluctance derives in part from Reynolds himself, a man who worked assiduously while alive to mold an apolitical reputation.

If seen as an imperial subject, however, this sense of Reynolds as apolitical starts to look less about being disengaged than about being conflicted when

it came to Britain's empire. Caught between an aesthetics that understood humanity as universal and a society that needed increasingly to justify exclusionary colonization, Reynolds often bounced between both positions. Sometimes he even combined them in one work. To uncover this specific ambivalence in one British life is to grasp the divisions at home regarding imperialism through empire's burgeoning years.

There are hazards in taking a biographic approach to the history of empire. Braiding three lives together, though, helps to address some of them. One hazard occasionally leveled at biography in any form is that of assuming a modern, individualized self in subjects who did not come from modern, individualized communities. This is especially pertinent for would-be biographers of Indigenous subjects. The Sioux scholar Elizabeth Cook-Lynn has explained with some vigor how inappropriate biography is for Native Americans, for example, since the genre's fetish for "selves" aligns more with colonial thinking than with native traditions. In consequence, she argues, such work usually degenerates into "pimping the stereotypes."[13] The point is well taken. Comparing the selves of Ostenaco, Mai, and Reynolds as a trio, though, underscores how little any one of them matched the modern ideal of the individual. If eighteenth-century Cherokees and Ra'iateans understood lives in more communal, interconnected ways than later Europeans did, then this was almost as true for Britons born in the early 1700s. Rather than abandon the genre for some or all of these figures, my comparisons occasion instead an effort to discover and then to integrate the ways that each man himself would have understood the concept of his life story.

Braiding three lives helps address, too, a hazard regarding evidence. One simple reason there have been so few biographies of eighteenth-century Indigenous personalities or indeed so few studies of Reynolds in an imperial context is that the sources do not readily suggest them. When it comes to Indigenous people, the sources seem so compromised—so scant or so filtered by colonial bias. And when it comes to canonical artists, they seem so unrelated to empire—most are, after all, about art theory, sitter appointments, or social occasions. But comparison encourages alternate ways of assessing what is good enough or plentiful enough in the texts that remain. For example, in comparison to the well-known slants of colonial records, the testimonies on or about Reynolds start to look equally mitigated. Or, to put it in a positive light, the records on Reynolds start to make those on Ostenaco and Mai seem more usable than first assumed. Evidence for eighteenth-century lives and empire is both more fragmentary and more

promising than it initially appears. This book acknowledges the limits and the possibilities of what can be known.

Jumping from the Appalachian mountains in revolution to a Ra'iatean refuge in Tahiti to newly wealthy London, this book is very much a history of the eighteenth century around the world. Its far-flung scope and simultaneously intimate details reflect exactly the concurrent enlarging and contracting of the globe that so many people saw and felt in this period.

Over twenty years ago Natalie Zemon Davis published her landmark history *Women on the Margins: Three Seventeenth-Century Lives* (1995).[14] Like Davis's book, mine illuminates a large topic via the relatively tiny stories of three people. Davis looked at the persistently yet productively marginal role of European women through the lives of a Jewish merchant in Germany, a Catholic missionary in Canada, and a Protestant naturalist in Suriname. None of her subjects met another. Unlike Davis's book, mine tracks people of three vastly removed ethnicities who nonetheless connected in real or indirect ways. Nothing could better summarize the most significant changes that the intervening century brought.

The eighteenth century was above all an era of globalization. Though more often credited as an Age of Enlightenment or of Revolution or of Commerce, none of these specific developments would have occurred without a new series of exchanges—both imperial and counterimperial—between peoples from now every corner of the world. One instance of eighteenth-century exchange transpired when a British artist met, within a dozen years, a Cherokee warrior and a Ra'iatean voyager. If Reynolds never did fully work out how to portray the quirks of human difference, this book digs out, pores over, and celebrates them in all their untidy, uneven, and unraveling ways.

The Warrior-Diplomat

OSTENACO OF THE APPALACHIANS

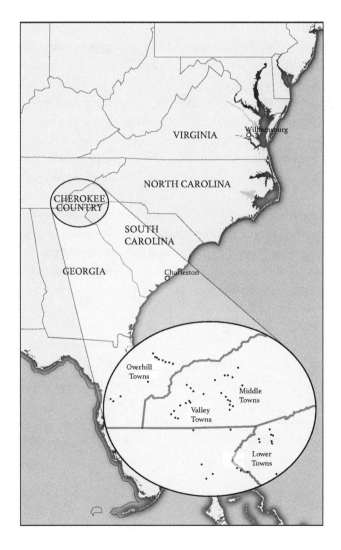

An aging Thomas Jefferson once mused in a letter to John Adams that "I knew much of the great Outassete, the warrior and orator of the Cherokee. He was always the guest of my father on his journeys to and from Williamsburg." Jefferson remembered that it was on a spring night in 1762, back when he was a freshman at the College of William and Mary, that he saw the Outassete (also known as Ostenaco) make "his great farewell oration to his people." This was on the eve of Ostenaco's departure for London. "His sounding voice, distinct articulation, animated action, and the solemn silence of his people at their several fires, filled me with awe and veneration," Jefferson went on, "altho' I did not understand a single word he uttered."[1]

Knowing much, yet not understanding. Claiming intimacy, yet confessing incomprehension. Jefferson's memory speaks poignantly to the experience of reconstructing the life of a long-dead Indigenous personality. In the case of Ostenaco the obstacles to understanding include the gaps and partiality of the sources left about him. For example, there is very little direct evidence about Ostenaco's early years and next to nothing on his domestic life. What sources do exist are compromised by thick layers of interference—they are either the observations of colonials, the translations of colonial interpreters, the memories of multiply removed descendants, or the generalizations of anthropologists (who have mostly forged their knowledge out of the former three kinds of sources).

On top of this lies the additional roadblock of genre. So often when aspects of Ostenaco do emerge through the mesh of overlain sources they show up the inadequacies of biography's conventions. In the absence of an assumption about an individualistic modern self at the core of Ostenaco's life, many following assumptions about a life's beginning, ending, or motivation start to come undone. Did Ostenaco even have a cradle? What exactly is meant by identifying his grave?

All, however, is not lost. Even Jefferson grasped Ostenaco's high status and commanding affect, after glimpsing him on only a few occasions and without the benefit of translation. Fleeting snippets can illuminate more than at first assumed, especially if they can be added to a line of sources tracking nearly seventy years. Proxies can also say a lot, if provisionally or speculatively. Just as, say, Jefferson's own mother is usually suggested through an understanding of the

Figure 2. Map of southeast North America, c. 1750 (but with modern state borders), with inset of Cherokee towns. © Mark Gunning.

general female immigrant experience of her time, Ostenaco solidifies in certain discoveries about his town or about eighteenth-century Cherokee men or, occasionally, in the actions of his closest peers. As well, the partiality of eighteenth-century sources seems less a problem when we see it shaping the past of all involved. If Ostenaco's words sometimes appear forced and stylized by colonial imagining, the same turns out to be true for British leaders. However much reality we can accept from the sources for a colonial history might also be the case for an Indigenous history. Likewise, biography's impositions are perhaps not an exclusively Indigenous issue. If Ostenaco reminds us that modern selves are not universal, so too does every type of newcomer he ever encountered in his lifetime—trader, explorer, bureaucrat, and rival Indian alike. Understanding an eighteenth-century life entails an attempt to discover that person's own notion of selfhood and then to use it to shape the unfolding narrative.

As incomplete as Ostenaco might still appear, his life is surely worth knowing—even if only in the Jeffersonian sense.[2] Stretching the near full span of the 1700s, it shines a torchlight onto the history of the Appalachian Cherokees from their earliest contacts with Europeans through to their involvement in the settlers' colonial revolution. It shows how Cherokees kept much of their own world alive in the face of incursion: their institutions of family and political life, their techniques of warfare, and their foodways and fashions. In those moments when incursion did spell change, Ostenaco's life shows how this always occurred through an Indigenous framing and, moreover, how Cherokees triggered adjustment quite as often in the transplanted Europeans. The story of Ostenaco is an Indigenous story of empire, where empire is sometimes fateful but rarely engulfing; frequently altering but never the sole plotline.

When and where was Ostenaco born? Probably in the 1710s (in the Christian calendar) and probably in the Overhills town of Tellico.[3] The Overhills towns, so named by Europeans, made up one of four key regions of the Cherokee people during the eighteenth century. They were situated on the most westerly stretches of the Cherokee's richly wooded Appalachian mountainous lands: *over the hills,* that is, from the other, more easterly Cherokee regions. The other regions were named the Valley, Middle, and Lower towns. At the beginning of the eighteenth century Tellico was one of about sixty Cherokee towns within a country around the size of today's Kentucky. The Cherokee people numbered then around twenty thousand, which meant towns of about three hundred persons each.[4]

The records will even suggest Ostenaco's birth order and manner. One source claims he was the youngest of four children. Various authorities imply that his mother would have stood, knelt, or sat to deliver him, allowing the baby to fall on leaves placed underneath her. Ostenaco's first experience was almost certainly a cleansing dunk in the nearest stream, an experience he probably repeated at the hands of his mother every day for the next two years.[5]

Dates and places, numbers and means. These are vital data, but to be meaningful they do assume certain things about the signal importance of a self's physical emergence into the world. It's not clear, in other words, how well they induct us into an understanding of how Ostenaco himself would have told the story of his beginnings. When Ostenaco was still a youth in the early eighteenth century, he may instead have begun his story with details about his mother's clan. To think that a self has an alternate starting point than that claimed by modern readers is to embark on a process of stripping away other assumptions about the key markers, and perhaps even the point, of a life in history.

Ostenaco's earliest years were dominated by the protocols and members of his mother's clan. The matrilineal clan system gave a Cherokee kin, and as such it was the first key component of his or her identity. Several observers have guessed Ostenaco's mother's clan to be that of Wolf, or Ani-waya, the largest clan and traditionally the source of most warriors (hence the guess). The other six were Ani-tsiskwa or Bird, Ani-wodi or Paint, Ani-sahoni or Blue, Ani-kawi or Deer, Ani-gatogewi or Wild Potato, and Ani-gilohi or Long Hair.[6]

Cherokees held that only those who could trace a connection through the mother were properly kin. That is, only maternal siblings, maternal uncles, maternal aunts, and so on counted as relatives. Connection didn't always have to be about blood, though. A bond could be made through adoption, but this too had to be created by the mother. Cherokees did not marry within a clan; some sources suggest that they were expected to marry instead into their grandfather's clan. The salient point is that cross-clan marriages produced children who belonged to their mother in ways that they never belonged to their father. Fathers were not kin, as neither, it followed, were husbands.[7]

This meant that in Ostenaco's early life his mother loomed largest. We know that she was still alive and living close by Ostenaco some fifty years after his birth. "His mother still continues her laborious tasks," noted the Virginian soldier Henry Timberlake when he met Ostenaco in the 1760s. She then had "strength enough to carry 200 weight of wood on her back near a couple of miles," Timberlake reckoned, but he believed she was not yet considered

by her own kin to be among the "super-annuated."[8] It may not be coinciden-tal that there is no mention of Ostenaco's father in any archive. Perhaps he died young. More likely, he just never figured as prominently in Ostenaco's world as his mother did.

From that first soft landing onto leaves, Ostenaco's life was in so many ways determined by his mother—not least in her decision to let him have one. Cherokee women had the power, and the responsibility, of controlling the health of a town's population. The historian Theda Perdue has noticed how many Europeans in this period observed the uniform vigor of Cherokee bodies: "I never met with an Indian who was born a cripple," wrote the British surveyor-general in 1772. "It is remarkable that there are no deformed Indians," wrote a trader a few years later.[9] While the soldier Timberlake put this down to the daily dipping of infants into cold creeks, Perdue thinks it may have had more to do with selective infanticide. Only mothers could make this decision, she adds; "for anyone else to kill a newborn constituted murder."[10]

Ostenaco received his name not from his mother but almost certainly from *her* mother. Cherokee scholars today explain that Ostenaco's name means "Big Head," which perhaps referred to an outstanding feature of his babyhood.[11] It was the women of a family, also, who administered discipline to small children. Many outsiders noted how "they do not practice beating . . . children as we do," but rather to correct them they scratched their skin with a stick or other sharpened object or they chastised verbally. As Ostenaco grew into his teens his behavior may have come more often under the view of male relatives such as maternal uncles and so on. Once again, though, such men derived their authority over him via their relationship with his mother.[12]

Finally, by the time he was a teenager Ostenaco would have realized that it was women who held greatest sway over local resources. While men and women contributed equally to the supply of food, men hunting for meat and women farming the staples (especially corn), it was women who crafted most of the household wares and who decided how wealth was to be distributed. Cherokee society in this era did not allow for the individual accumulation of resources. Rather, households held resources, always keeping some supplies in reserve for feasts, strangers, or the needy. As the only permanent members of a household, women therefore controlled the economy.[13]

The high status of women among the Cherokees was not lost on the earli-est Britons to encounter them. Most sneered at the idea of something that appeared so alien. The trader James Adair noted in 1775 that Cherokees "allow

their women full liberty to plant their brows with horns as oft as they please, without fear of punishment." This kind of license, he thought, meant that the Cherokee lived "under a petticoat government."[14] In fact, women's domination of clan life did not translate into women's domination of all political life. Cherokee society was matrilineal, but it was not matriarchal. Town councils were usually run by men, esteemed elders who had proven themselves in war or in wisdom or both. Critically, male leadership in government was not accorded the same weight it carried for the observing Britons. It was not a sign of male precedence in all other aspects of society. It was instead regarded simply as a balance to women's greater power elsewhere.

Balancing the spheres of men and women spoke to the central organizing principle of Cherokee life in the eighteenth century—that of harmony. As Perdue has also explained, the Cherokee "conceived of their world as a system of categories that opposed and balanced one another." Hunting was to farming as winter was to summer as men were to women. When it comes to gender roles, Perdue admits, this sense of balance "may not have permitted equality in the modern sense," but it did make any notion of "hierarchy, which often serves to oppress women, untenable."[15]

Men's power in town councils, then, balanced women's power in the households. Historians have argued over whether clan or town had greater influence over a Cherokee's sense of identity in the eighteenth century. Proponents of the town's influence point to the power of towns in defining a Cherokee's diplomatic, legal, and spiritual status. But such a view also favors the perspective of age over youth, if not also that of men over women. Imagining the progress of Ostenaco's earliest years helps one see how identity was always first clan and then town.[16] No doubt by the time Ostenaco was grown he felt matching obligations to both institutions. This was a layered match, however, with town affiliation cloaking a core formed by maternal relatives.

Ostenaco's town of Tellico was one of the oldest in the Overhills region. An early colonial visitor described it in the 1720s as "very compact and thick settled."[17] Like all Cherokee towns, the clan-based households clustered around the large council house, a round building with tiered seating that grouped clan members together and faced downward to a central fire. Later in life Ostenaco would exclaim that the huge rotunda in the Ranelagh Gardens in London reminded him of his hometown's council house. It was big enough to hold every person in the town.[18]

During the early decades of the 1700s a Cherokee council house would host discussions about local judicial and strategic matters. Its leaders guided

the townsfolk to unanimous resolutions on crime, punishment, and the group's collective relations with outsiders. No course of action could be decided without reaching a consensus, which needless to say could take some time. Adair noted, with his usual exasperation (and in some contradiction to his earlier statement about women), that Cherokee "voices, to a man, have due weight in every public affair."[19] The Cherokees themselves saw that this practice was unlike those of the British. "It is not our custom" noted a Lower towns leader in the 1750s, "like the white man to talk altogether, but when one is done another begins."[20] Importantly, the Tellico council did not answer to any central authority. There was no overarching federal or national locus of power among Cherokees in this era.

The Tellico council also supplied religious leadership. Sometimes called conjurors, priestly men oversaw "rituals of certainty" pertaining to the weather, illness, and other things generally felt to exist beyond clan or town control. Like most Europeans in North America at the same time, however, Cherokees by the eighteenth century were a secularizing people. Priestly men did not have more say in a town than the other elders. In fact, embedded in the Cherokees' historic concept of harmony was a story about how they had at some point overthrown a dictatorship of their own priests and now accorded them only a voice like any other, to be balanced with the rest.[21]

Spiritual but secular, then. Town-focused but clan-made. Equally masculine and feminine. Healthful, nurturing, and communally minded. This was roughly the world of a Cherokee boy in the first quarter of the eighteenth century, and it was perhaps the world that Ostenaco would choose to evoke if he was telling the origins of his life. That tale would not necessarily identify the beginnings of his self with the unique moment of his birth, nor indeed with any moment that set him apart from others as a distinct individual. It would more likely find beginnings in those practices that secured him among kin, community members, and shared resources. Cherokee selves were in and of their clannish, collectivist, mountainous world rather than against it.

No direct records exist concerning Ostenaco before 1751 (when he was around thirty-five years of age). The first written document bearing his name—rendered "Usteeneke"—is a translation of a message from him to the British governor of the colony of South Carolina. It accompanied one French prisoner of war captured by Ostenaco and the scalps of two others, proffered to the governor as evidence of Tellico's ongoing cooperation with South Carolina. The document is signed with Ostenaco's then formal title, the Tassitte of Great

Tellico. This title is today rendered utsidihi (Jefferson tried Outassete). It meant Mankiller—a well-recognized, distinguished warrior rank.[22]

The second surviving document about Ostenaco, dated one year later, was also a rendition of his own speech and was again addressed to the governor of South Carolina. This document referred to a recent meeting between the two in which they had discussed new terms for commerce and was titled by the colonial scribe as "a talk from Jud's Friend."[23] Ostenaco appears commonly in the archives as Judd's Friend or Judge's Friend. The nickname acknowledged a relationship forged earlier between Ostenaco and a white trader known now simply as Judd.

These initial sources not only set the scene for the turbulent decade of the 1750s but also encapsulate the two great external themes that had defined Ostenaco's world from boyhood till now: war and trade.

"Warlike" was probably the adjective most used by colonials to describe Cherokee people in the eighteenth century. "We cannot live without war," declared one warrior, supposedly, in the 1730s: it is our "beloved occupation."[24] Given how many town rituals centered around warriorhood, and given how both men and women could become warriors in their otherwise gender-differentiated society, this is in many ways a fair statement. War parties usually set off in large companies but attacked in small, coordinated ambush groups. Weapons included arrows, darts, tomahawks, and clubs as well as, later, traded muskets and knives.[25] Europeans sometimes recoiled in shock when observing Cherokee military tactics, which included torture and scalping. What these Europeans called "unmerciful," however, were more properly the effects of a strict juridical code.[26] Cherokees followed a carefully calibrated sense of restorative justice (a life for a life), which meant that they avenged rather than plundered. Their methods, in other words, could seem extreme, but they were rarely frenzied. Indeed, when Cherokees observed the British at war, they in turn were often taken aback by how colonists always seemed just to "kill everyone" instead of precisely the requisite number needed to "quell blood."[27]

The first major conflict of Ostenaco's life was the so-called Yamasee War. More like an intercultural war between many groups, it lasted for two years from 1715.[28] Whether it was really started by the Yamasee or some other Muskogean group in the vicinity, the war's original aim was to push back against encroachments newly made by British newcomers. The British colony of South Carolina, based in swampy Charleston on the coast, had existed since 1670, but it had only started seriously to bother mountain-based native peo-

ple from the new century. The colonists' unfamiliar attitudes toward land and exchange deals jarred with established demarcations and economic rituals.

The Cherokees at first seemed reluctant to enter the hostilities. This was hardly from squeamishness but rather because they felt the least connected to the other native groups. Cherokees were distinct in the southern Appalachian region for speaking an Iroquoian dialect. Almost everyone else spoke a Muskogean-based language. This not only suggested that the Cherokees had migrated from further north at some point in the past but also indicated that they had forged fewer links or agreements with their neighbors in the meantime.[29]

In fact, the Cherokee lack of connection with one particular set of neighbors, the Creeks, was so pointed by the 1700s that the two groups had become implacable enemies. Their enmity focused on respective territorial and hunting rights. It was this old hatred, rather than any positive relationship with Charleston, that eventually tipped some Cherokees into the war on the side of the colonists. Not all Cherokees followed suit, given the lack of a central power to force them to do so. But many towns did end up aiding colonial efforts through their strategic attacks on the colonists' foes.

One such attack by Cherokees on Creeks during the Yamasee War prompted, fatefully, the next major and much more severe war of Ostenaco's life. In early 1716 a Creek party had come to meet some Lower-town Cherokees to seek a peace. A touring party of Overhills Cherokee, however, possibly from Tellico, instead took the chance for a long-awaited revenge and killed the whole delegation. The event triggered a sustained guerrilla war between the two native groups that lasted nearly forty years. The historian Tyler Boulware points out that the ensuing Cherokee-Creek war amounted to the longest conflict for Cherokees for the whole eighteenth century.[30] The war is rarely recognized as such by other modern historians, though, because its intra-Indigenous nature defies ongoing expectations of European centrality to all early North American dramas.

Although too young to fight in the Yamasee War, Ostenaco certainly engaged in many battles of the epic Cherokee-Creek conflict. These battles forged the backdrop to his adult maturation. He would have partaken in one of them while still a teen; the experience would constitute his first step to recognized manhood. Only after several such experiences, however, would he be considered a "Young Man."[31] From this point Ostenaco would gradually acquire his many facial tattoos and his distinctive shaven hairstyle, with longish tuft left flowing from the crown.

We know Ostenaco became an exceptional warrior because out of around one hundred warriors in a town only a handful ever earned special titles. The head warrior of any town, a skiagusta, was usually the most senior person among the titled. Just below the skiagusta ranked the younger utsidihis, rarely more than two or three per town.[32] For Ostenaco to gain this rank, sometime during the 1740s, he must have shown consistent strength, acumen, courage, and leadership. By the time he was known to the South Carolina governor as the Tassitte of Great Tellico, Ostenaco had lived through, one way or another, over three decades of warfare. Notably, very few of those war years had seen Europeans dominate their politics or direction. In Ostenaco's vision at the age of thirty-five at least, Europeans were but bit players in the central business of Cherokee life.

Europeans did play a larger role in the next most absorbing external pre-occupation of the eighteenth-century Cherokee world, that of trade. But still they determined less of the ways and meanings of Appalachian-based ex-change than is often assumed. For one thing, after the bruising experience of the Yamasee War Carolinians realized they needed to ensure against trader abuses in the future: Indian retribution for breaching the codes of conduct had proved chasteningly severe. In response, Charleston instituted a factory system for trade with the Cherokees. Colonists were no longer permitted to set up shop in Indian towns but instead had to meet Indians in designated factories, neutral meeting places, where exchanges could take place with greater transparency. To the Cherokees this system had its flaws since factories sometimes instigated intense rivalries between Cherokee regions. But it was also a clear example of compromise on the part of colonists, a compromise forced by native pressure. Successive South Carolina officials remained sensitive to this fact until at least the 1750s. When one such official heard complaints endorsed by Ostenaco himself—complaints involving horse theft and being treated "as if . . . a Dog"—the official immediately offered generous gifts as well as a promise to jail the trader in compensation.[33]

Tellico in the Overhills region was one of the towns furthest from Charleston. It didn't have a factory nearby, but it did already have enough political and military influence to warrant a factory assistant from as early as the 1720s. Ostenaco would have grown up knowing, then, that his town was an important node in the burgeoning trade relations between Cherokees and South Carolina. How he understood the exact nature of that relationship, though, is less clear. Most historians have in retrospect seen Indigenous-white trade as a grossly imbalanced affair right from the beginning, with whites gaining

valuable commodities and eventually irreplaceable land in exchange for cheap
trinkets and debilitating alcohol. They have also assumed that South Carolin-
ians always knew this, chortling to themselves all the while at the magnitude
of their deception. In the early eighteenth century, however, it seems that
Charleston colonists were baffled by their native trading partners at least half
of the time. Another way, then, in which trade was never simply a European-
dominated enterprise for the Cherokees is in how Cherokees insisted on plac-
ing their own valuation on trade goods—a valuation which often remained
opaque to their counterparts.

For example, colonists were stumped at how Cherokee women clamored
for iron pots but never seemed to use them for cooking, preferring their own
earthenware. Instead, the women broke up the pots and used the fragments
for hoeing. Likewise, glass was used not for drinking or making windows but
for religious rituals. Some outsiders guessed at why red dye was so sought
after—the naturalist William Bartram saw how it was used as a critical signal
of men setting off to war—but others remained perplexed, even while they
scrambled to supply it.[34] And most never figured out the true meaning of
alcohol for Cherokees. Adair noted with incredulity that they "in general do
not chuse to drink any spirits, unless they can quite intoxicate themselves."[35]

For their part, on the other hand, the Cherokees seemed to understand
precisely what the colonists wanted in return for European manufactures. By
the 1730s the most profitable resource coming out of South Carolina was
deerskin, a commodity best procured by Cherokee hunters. Even in 1770,
after the establishment of huge slave plantations, deerskin still rated as the
colony's second most lucrative export after rice. "Now go up and carry [in]
plenty of Goods," Ostenaco once instructed colonists during yet another
trade renegotiation, "and we shall make good Hunts to purchase them."[36]

Along with the mystifying Cherokee understanding of goods, colonists
were also unsure about the Cherokee understanding of what trade obligated
of them. Unlike the British, Cherokees seemed to expect a personal tie to fol-
low a commercial transaction. They did not separate commerce from the so-
cial realm as cleanly as colonists did. Hence when one of Ostenaco's closest
associates, Attakullakulla, discovered that the governor was related to a rogue
trader called Mr. Elliot he could not contain his displeasure. Since Attakul-
lakulla believed he had a special relationship to the governor, he expected all
the governor's relatives consequently to treat him in a special way. The discov-
ery about Mr. Elliot had "surprized him very much." The governor was left
scurrying to make amends for indiscretions he had not known were his.[37]

Almost certainly Ostenaco's nickname of Judd's Friend by 1752 had come about from his own special relationship to a trader called Mr. Judd. Timberlake later elaborated that Ostenaco had saved "a man of that name from the fury of his countrymen."[38] Subsequent readers have taken this line to mean that Ostenaco saved him from the wrath of other Cherokee, but it may mean that Ostenaco delivered him from other European traders and perhaps in a commercial rather than violent sense. Either way, the name stuck to the utsidihi. He never disowned it. Perhaps he saw, too, that it served as a reminder to colonists of the distinctly Cherokee approach to business.

If war and trade were the two great external forces on Cherokee life in the early eighteenth century, neither was controlled by the recent European newcomers. In many cases Europeans were the ones stumbling to understand the rules of those forces and to get a foothold for themselves in the complex world of Appalachian America.

Despite the demands of war and trade a young man like Ostenaco also of course had a home life. Frustratingly, details of his domestic world are thin. Several sources mention a wife, but we never learn her name. In the mid-1750s a colonial officer reported that Ostenaco's wife had come "in a Canoe" to ask for extra supplies for her husband's hunt that winter. She relayed the message that the utsidihi had fallen ill while out hunting and demanded more time and thus more ammunition for the skins the colonists desired.[39] Later, Timberlake mentioned meeting Ostenaco's "consort." She was perhaps the soldier's exemplar when he noted that Cherokee women were "remarkably well featured . . . streight and well built," with hair so long it reached their legs.[40]

Probably Ostenaco's wife had also grown up in Tellico. The two would have married with the mutual consent of their respective households, after which Ostenaco would have gone to live with his wife's clan. Families lived in small timber and daub houses during winter months but in large, open rectangular structures during the summer. We know that Ostenaco had at least one child, a daughter called Sokinney, to whom he was in later life especially close. He probably had more. It was his wife, though, who would have made all the key decisions about their offspring, raising them as she raised the crops of vegetables that formed the basis of their diet. All family members, men, women, and children, would have taken part in the evening entertainment of dancing, ball games, and plays.[41]

Later pictures suggest that in adulthood Ostenaco had a tall, broad physique. He certainly was a sturdy walker, covering something like fifteen hun-

dred miles per year during the 1750s at least, not to mention his yearly hunting treks lasting several weeks each. It was probably Ostenaco whom Timberlake had in mind when he declared all Cherokee warriors to be "very hardy . . . of an olive color," with low voices and dramatically elongated earlobes. As his guest, Timberlake frequently commented on Ostenaco's hospitality and amicability. His host apparently had a "kind manner" and "gentle disposition." Whether these were unique characteristics, though, or merely correct protocol for someone in Ostenaco's role, is uncertain.[42]

What is evident is that by the time Timberlake bashed his way into the Overhills settlements in 1761 Ostenaco was well versed in long-stay visiting Europeans. Tellico had the odd distinction in the 1730s of hosting not one but two of the most eccentric characters of American eighteenth-century history. Both of these characters—the hare-brained Scot Alexander Cuming and the utopian, freethinking German Christian Priber—are often credited with introducing two significant adjustments to Cherokee society overall. Cuming has been said to help centralize power between the disparate Cherokee towns while Priber has been connected to the Cherokee adoption of more strategic attitudes toward British relations. To Ostenaco, however, who witnessed both of their arrivals and both of their departures, such accreditations were surely overblown.

Cuming arrived in Tellico in the spring of 1730, when Ostenaco was still a teenager. Cherokee headmen doubtless guessed straight away that the Scot carried no official British sanction, for he could not produce any identifying words from the governor. True enough, Cuming had arrived in Charleston under his own auspices, claiming to be answering a call from God, via a personal interpretation of the biblical book Isaiah 28, to bring all Cherokees under British subjection. (This interpretation was based on the verse's reference to cumin seed, which he took to be a correlate of his name).[43] Possibly, and a little more pragmatically, he had read about the growing threat of French colonists moving into the Cherokee trade and hoped by his actions to earn a royal award. Either way, most colonists reckoned him a lunatic and gave him a wide berth.

Most, that is, except one seasoned trader in the Tellico area called Ludovic Grant, who was apparently curious enough about this supposed visionary to see what might transpire. Grant agreed to lead Cuming into Cherokee country, whereupon Cuming quickly realized, as had multiple Europeans before him, that his chief impediment was the lack of a clear-cut, national authority among the Cherokee. He therefore set about inviting representatives of all the towns to come together to elect an "Emperor," with whom he could then

negotiate. Many towns did send delegates in April 1730, their elders evidently just as intrigued as old Grant by the grandiose proclamations of the manic Highlander.[44]

Cuming's understanding from this point is that all the delegates then agreed about the need for a central sovereign and that it should be embodied in the headman of Tellico at the time, an elder called Moytoy. Cuming believed that Moytoy, in turn, then submitted both himself and all his subjects to the British king. Needless to say, as Grant could have told him, no Cherokee present shared any such understanding. Moytoy was never recognized as an "Emblem of universal sovereignty over the whole Cherokee Nation."[45] Nonetheless, most present did see that Cuming's talks promised something else, namely, a chance for a few Cherokee negotiators to go to Britain's capital, far away across the seas, to solidify town by town their trade relations with Charleston. Could they secure a guarantee about supplies? Could they agree on some shared protocols? Among other things, the evident enthusiasm of many Cherokees for such a trip indicated that even if they did not work with a centralized form of government, each knew that the British people from Charleston did.

If he had been keeping up with local news, young Ostenaco would have heard how in the end seven Cherokees volunteered for the journey to Britain. Cuming considered them political underlings of Moytoy, but Ostenaco, like everyone from Tellico, would have known they were instead a disparate set of diplomats. When the seven returned six months later Ostenaco learned they had signed a paper agreement while in London that the British called a treaty of "Friendship and Commerce." The governor in Charleston was surprised but pleased to think that this now entailed a unified Cherokee alliance against the French and a commitment to trade only with them. Ostenaco would have seen, however, that among Cherokee leaders it meant, conversely, a unified British promise to keep the towns well stocked in their preferred goods so long as each prioritized the British and occasionally assisted them in their own complicated wars with other Europeans.[46]

Cuming never came back to Cherokee country to see the failure of his centralization plan. His bizarre mission, however, did have one important, if unintended, effect. It deepened the relationship between Charleston and the various Cherokee towns. As Boulware has commented, this relationship remained henceforth a difficult one—as each realized the mismatched expectations on each side—but it was much more entangled all the same.[47]

Christian Priber's arrival into Cherokee country a few years later turned out to reveal in fact one of the key abiding difficulties between Cherokees

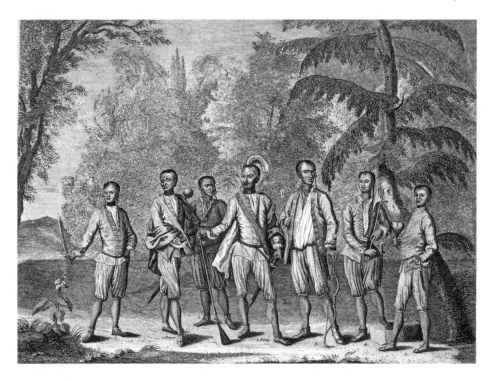

Figure 3. The seven Cherokees who visited London. Attakullakulla is at far right. Engraving by Isaac Basire after "Markham," 1730. © The Trustees of the British Museum.

and the British. Priber appears in some ways an even less likely figure than Cuming. An exile from his native Saxony for preaching radical ideas about "the natural rights of mankind," Priber was also a self-propelled agent, driven to find personal redemption among an unsuspecting Native American group.[48] He did not, though, seem to have any ulterior motive; he was simply seeking a society that more closely matched his ideals. Local Carolinians, including Grant, disparaged those ideals as atheistic and anarchic.[49] They bridled to hear him speak about a republic where "each should work according to his talents," where women could have sexual freedom, where childcare was a collectivist enterprise, or where titles might be conferred "according to . . . merit."[50] What Cherokees thought of Priber is unknown. Perhaps they took pity on him, seeing a lost soul rather than a malign propagandist. They were hospitable enough to allow him residence in Tellico for around six years, from the late 1730s, just as Ostenaco was formally becoming a Young Man.

Priber's residence ended in 1743 when British colonists arrested and jailed him for espionage. The rumors about Priber's philosophies had hardened into convictions that he was actually a spy for the French. Certainly Grant, for one, insisted he was an "inniquitous" trickster, whispering seditious notions to the Cherokee about trading with the French as much as with the British. Grant's fellow trader James Adair agreed that Priber was a plant of the French and that by his gross misrepresentations of the British as a "fraudulent, avaricious, and encroaching people" he had convinced the Cherokee to question their alliance with Charleston. Priber died in jail one year later. Decades on, Adair laid full responsibility for the Cherokees' constant slipperiness when it came to loyalty at the feet of Christian Priber.[51]

Whether or not Priber was working for the French—his anti-absolutist politics make it seem doubtful—he hardly invented the notion of external competition for the Cherokee. For a start, Tellico had known of French colonies to the west for over a generation before Priber's arrival. The town's elders had seen other Overhills men bring back mementos of French overtures for years.[52] In addition, when the first major wedge to the trading relationship with Charleston did appear, a decade later, it came not from Tellico but another Overhills town altogether. Like Cuming, Priber made less of an impression on Cherokee life than has been believed—especially by most colonists. In his case the presence of a European merely highlighted a problem for the British that was always there. Cherokees were never going to commit wholesale to one set of newcomers. The logistics of their unfederated political structure made this unlikely anyway. The masterly nature of their diplomatic skills, as we shall see, made it unnecessary.[53]

If he never managed to exert national influence, the old Tellico headman Moytoy did yet reign as chief leader of Ostenaco's town throughout Ostenaco's young adulthood. Moytoy had achieved this position well before Cuming's arrival. Perhaps part of his appeal to Cuming was his unusually strong charisma. It was magnetic enough among his own townspeople at least to demand that his son become chief leader upon his death—not a typical example of the progression of town power among the generally merit-based Cherokees. Thus when Moytoy died in 1741 his son, Amoskiacite, rose to take his place. Awkwardly, though, Amoskiacite was not even yet a Young Man at this time, let alone an esteemed warrior. Various guardians were appointed to represent the regent until he could lead on his own. Among these appointments was the emerging utsidihi, Ostenaco.[54]

The role of guardian would have entailed dealing mostly with issues internal to Tellico. In 1751, however, the town council was drawn into an affair with Charleston officials that went on to have significant consequences for the status of both Tellico and Ostenaco.

By 1751 the governor of South Carolina was the lean, ascetic James Glen. Eight years into his role, Glen had learned the hard way that the Cherokees had never understood themselves as unswerving allies of the British. He knew their cooperation was always conditional and strategic. As he once tried to explain to his own council, the Cherokees would only ever act as "bulwarks at our backs" for as long as the British held up their part of a complicated commercial friendship. They would not serve the British, in other words, simply out of obligation to a now-aging piece of paper.[55]

Glen also understood that the Cherokees were fundamentally decentralized; that Cuming's concoction of a single emperor had always been a ridiculous fantasy. Thus when news of a series of Cherokee-colonist altercations filtered down to Charleston in the spring of 1751 he tried to deal with them town by town. Glen's fellow legislators, however, increasingly anxious about the rumors of violence toward their traders, refused to be taught and demanded severe wholesale punishment. Reluctantly, around May the governor caved and announced a trade embargo against the entire "Cherokee Nation" until the guilty came forward to account for their "insolent and outdacious behavior."[56]

Tellico was not among the suspected towns and naturally took the colonial edict badly. Ostenaco was one of the leaders to remonstrate with Glen about the unfairness of the embargo against a town that currently displayed "great affection" toward the British. Not only would Tellico suffer from a lack of goods but their usual supply might go instead to their staunch foes the Creeks. The Tellico executive requested Glen meet them at a site halfway between their respective locales to discuss matters. Glen paled at the prospect of the trek involved, but he did want to engage in talks. Could any Tellico representatives come to Charleston instead? He knew his town was not attractive to Cherokees during its unhealthful summers, but if two leaders of the stature of "Eustinaca" would make the journey he promised to take great care of them.[57]

The situation was dire enough for Ostenaco at least to take up the invitation, instantiating fully his secondary role as diplomat alongside his primary role as warrior. The Cherokees' general aversion to the thick airs of Charleston in August, however, proved well justified when Ostenaco became ill

during the talks.[58] Still, the utsidihi listened to Glen and agreed to help persuade other Cherokee towns during his journey home to consider the colony's request for confessions. He concluded that such a resolution best suited Tellico's needs.

By November many Cherokee towns had heard Ostenaco's argument and sent representatives down to Charleston to see to new trade terms themselves. Everyone, it seemed, was going to be satisfied.

Critically, though, Ostenaco himself could not return since he was still convalescing from his illness back home. The final November agreement between Charleston and the several Cherokee towns, as a result, turned out to be only a partial success. The Cherokees managed to get most of their respective trades renewed on the mere promise of future delivery of Charleston's suspects and a pledge to prevent later altercations. The downside was that Glen refused to close off the new trades now established with the enemy Creeks.[59]

Tellico regent Amoskiacite, never a penetrating thinker, was pleased with the results of the November meeting, but Ostenaco remained nervous. The Creek infiltration threatened to be a big problem. As well, he must have heard by now the whisperings from those several towns that had refused to go to Charleston. Chief among them was the insurgent Overhills town of Chota, headed by famously powerful warriors. The smartest was Attakullakulla, who had been one of the delegates to travel to Britain back in 1730. All through 1751 Attakullakulla had held that Glen's embargo was an effective break to the treaty made in London twenty years before, exposing Cherokee towns to Creek attack. He argued that in consequence all bets were now off. In fact, at the exact time Ostenaco had been talking with Glen that summer, Attakullakulla had been on a scouting mission, traveling not to a French colony but to Virginia. He wanted to see if the Cherokees could start a new trade with a rival polity inside the British empire he knew. This demonstrated, among other things, an astute reading of the so-called nation with which he had originally treated. Attakullakulla had not needed a German interloper to teach him the art of the deal nor was he going to remain only reactive to British actions. The Virginia governor in Williamsburg had received Attakullakulla cautiously, had provided gifts, but had then decided to wait and see what Glen would do.[60]

Ostenaco's nerves were all too warranted that winter, when Creeks took advantage of a trade-depleted Tellico and bombarded his town for weeks. Ostenaco made concerted appeals to Glen into the new year, pleading not for

direct assistance but simply for him to stop supplying Tellico's foes. He reminded the governor that after spreading "your Excellency's talk" to many towns he hoped "the Government won't trouble themselves no more" with Creek trade.[61]

The rest of 1752 was tense. The surviving official documents suggest that Ostenaco mostly held on to the idea of reconciliation, but somewhere along the line he clearly had doubts. The first we hear of him for the year 1753, Ostenaco had moved, momentously, to a new Overhills town called Tomotley. Tomotley was adjacent to feisty Chota. Perhaps what finally finished Ostenaco's allegiance to Tellico was the mad dash made by Amoskiacite against his advice late in 1752—to Virginia in an ill-planned imitation of Attakullakulla's own venture to secure a new relationship. Unlike Attakullakulla, the headstrong regent Amoskiacite had received no attention from the Virginia governor and, what is more, he had faced disastrous ambush by enemy Indians on his way back.[62] Tellico's star was falling on all counts: attacked by native enemies, deprived of goods, and unable to lever a special connection with either Charleston or Williamsburg.

Some historians, in passing, have seen Ostenaco's subsequent shift to the rising vicinity of Chota as the act of a self-preserving turncoat. Canny Ostenaco, they imply, always on the make for his own personal prestige and importance.[63] His move, however, might be interpreted otherwise. First, Ostenaco never seemed to suffer ridicule or harassment from other Cherokees for the switch. Second, he never contested the Chota leadership, deflating somewhat the idea of him as a wily political opportunist. And, finally, it is noticeable from this point on that he never speaks again of town interests but instead only of those of larger entities, such as the Overhills *region*. It is possible that Ostenaco, rather than swapping out town interests for his self-interests, was instead putting something bigger again before all other considerations. It is possible that, by living through the embargo affair, he had come to see how regional blocs delivered better results than town negotiations, and how Chota was becoming unquestionably the preeminent center of his region.

By 1753 Attakullakulla had secured his trade line to Williamsburg. The Virginian governor, Robert Dinwiddie, was too beguiled by the potential riches and manpower of a Cherokee connection to worry any longer about upsetting South Carolina. Ostenaco saw that only when a town like Chota matched Charleston's two-pronged dealings with local native groups did stability return. Other historians have noted the gradual trend toward region over town in the Cherokee's sense of their identity during the eighteenth

century. Ostenaco's move to Tomotley not only exemplifies it but also newly helps to explain such a tendency as a strategic internal adjustment rather than as something forced by colonial interference.

For his part, Glen was not thrilled with the rise of Chota. It may have been easier for him to deal with regional blocs rather than multiple towns, but a regional bloc operated by a center that could negotiate in lockstep with his own machinations was hardly ideal. When Glen met with Overhills delegates in Charleston that summer to resolve finally the degree and nature of their mutual trade, he was consistently outsmarted. At first the governor tried to dilute the discussion by diverting them onto the question of a Cherokee peace with the Creeks. Small, wiry Attakullakulla, as the lead negotiator this time, reminded him that when he himself was in Britain meeting King George II there was never any instruction about intra-Indigenous relations—only trade. In reply, Glen, equally wiry, attempted to condescend to Attakullakulla by saying he was too young in 1730 to understand how the British chain of command worked. The Cherokee leader suggested he had other colonies now to send him back to London to verify that.[64]

Glen admitted a checkmate. He agreed to new concessions, backed away from Cherokee-Creek business, and accepted the new Virginian competition. Just before the close of the talks, Glen spied Ostenaco among the assembled Overhills delegates and made a last, desperate lunge for leverage. "Here is Oustneca," the governor cried. "If he has anything to say I shall be glad to hear him." He came down to see me two years ago, Glen added pointedly, *when it was needed:* "We allways have looked upon him as our good Friend." Ostenaco, though, understood his changed responsibilities to support the Chota leadership, which, in turn, was now in charge of a whole regional polity. He only bolstered Attakullakulla's fine tactical work. "Every Thing is now made streight," he declaimed, "now every Thing is done and ended. . . . Nor can the Rest [of our people] contradict what we say." After making a play for regional consensus, he added, "If any of the traders shall be rogues, I shall not hide it . . . if others are afraid to complain, I shall tell it."[65]

Ostenaco's move to Tomotley near Chota indicated more than a shift toward regionalization in Cherokee society. It may also have been a very early sign of changing understandings of eighteenth-century gender roles. Evidently both Ostenaco's mother and wife moved with him, involving the transplantation of two households that had until recently been ruled more by women's decisions than by men's. There is no direct evidence to explain how that

negotiation transpired—perhaps Ostenaco's wife saw the fate of Tellico as clearly as her husband did and suggested the move herself; perhaps Ostenaco overruled her otherwise final veto powers. If the latter, it was a foreshadowing of what Perdue has identified as the gradual masculinization of Cherokee society into the nineteenth century. The former scenario, though, is not unlikely since, in a society where divorce was simple for women, Ostenaco's marriage endured apparently till death.[66]

The town of Tomotley was still new in 1753, a recent satellite of Chota, which itself was only around two decades' old. Both centers were situated about twenty miles northwest of Tellico, further again away from Charleston, nearer again to the tantalizing French colonies.[67]

Tensions between British and French, always simmering, exploded in the American southeast in 1755. Eventually, this old rivalry shattered the hard-won détente made between Cherokees and Charleston. It shattered, however, not from direct French interference but indirectly, from the bungling nature of the Cherokees' new partners in Williamsburg. The colony of Virginia was among the first British sites to feel the pressure of what would become known as the Seven Years' War.[68] Virginia militia had helped ignite the hostility, over in the Ohio Valley, in 1754. One year later they were scrambling to aid general British army campaigns against French attack on all fronts. It was at this point that Virginian governor Dinwiddie turned to his new friends, the Cherokees. He had no nearer native groups to appeal to, and he was being pushed mercilessly by his young colonel George Washington to recruit some. "Five hundred Indians have it more in their power to annoy the Inhabitants than ten times their number of Regulars," Washington knew. "Without Indians . . . we may expect but small success."[69]

Dinwiddie sent messengers and gifts to the Cherokees. Chota showed interest, especially Ostenaco. The utsidihi knew that his military assistance would not only entrench his region's fresh trade ties but also encourage the Virginians to build a fort in the Overhills regions. Perhaps counterintuitively, the Overhills had been requesting a British fort in their region for some years. In fact, Glen's inability to build one had been another reason for Chota to turn against him. The Overhills argued that if colonists wanted them to leave their homes to hunt for deerskins or, later, to fight their battles, they needed a secure place "for the Protection of our Wives and Children."[70] The Overhills saw a fort more as a structure for their own ends and a sign of mutual cooperation than as any incursion by colonials or threat of infiltration.[71] Around December 1755 Ostenaco evidently worked out a deal with the latest

Virginian messenger. In exchange for attacking some French-allied Shawnee towns along the Ohio River, he would get continued "friendship" and a fort from Virginia.[72] Ostenaco set off for Williamsburg in January 1756 with 130 fellow fighters.

Dinwiddie was delighted with the recruitment, most notably with the lead warrior, Ostenaco, who he'd heard had "the Character of a brave officer." Dinwiddie's own pugnacious commander, Washington, was less convinced of the odds for this particular battle but was relieved nonetheless by the general prospect of Cherokee support.[73] Washington ordered Capt. Andrew Lewis to match Ostenaco's force and attack the Shawnee the following month.

Unfortunately, the ensuing engagement, the Battle of Sandy Creek, proved a disaster. Washington was right about the inability of his soldiers to keep up with "Indian methods" as well as their currently poor morale and provisioning. The campaign turned back within weeks, starved, depleted, and no nearer a resolution with the enemy side. Ostenaco was nonplussed though probably felt less bad about it than Dinwiddie. The utsidihi had wanted to see a more competent show from the British, but it had never been his ambition to oust an entire European nation from the continent. He had merely set out to prove Cherokee credibility to a second colonial center. This he had done. Ostenaco now looked forward to bringing Lewis home to the Overhills with him to build his promised fort.

Before sending both back south, Dinwiddie knew he had to thank Ostenaco publicly for his efforts. His need for Cherokee assistance was far from over. The governor organized for Ostenaco to lead a parade down the main street of Williamsburg, flanked on both sides by an honor guard of militia. He also billeted the utsidihi with the reputable Jefferson family during his layover, as the eldest Jefferson boy so fondly recalled in later years. Both provisions appeared to satisfy.[74]

Back home in the Overhills, Ostenaco watched expectantly as Lewis and his men constructed their long-awaited fort. He was quickly disappointed. The shoddy workmanship and gaping lack of a garrison to staff the new structure proved a second mark against these new colonial partners, after their poor military performance at Sandy Creek. At this point Ostenaco must have been glad that Chota had decided to keep more than one colonial site in play. All along, Governor Glen, down in Charleston, had smarted over the Overhills' turn to Virginia. Throughout the preceding year he had sent several letters to Dinwiddie decrying his "intermeddling with our Indians" even while he scrambled to find the funds to build his own fort for the Cherokees

to win back their favor. Just as Lewis packed up to go home in the fall of 1756, South Carolinian soldiers finally arrived in Chota to offer an alternate stronghold.[75]

This second fort was to be much bigger and better manned than the "mere bubble" thrown up by Lewis.[76] Both the architect, William de Brahm, and the garrison captain, Raymond Demere, resided at various times in Ostenaco's house during its completion, suggesting that Ostenaco's recent ventures with Williamsburg had not damaged his standing with Charleston.[77] The new stronghold, Fort Loudon, ended up being three times larger than the Virginian effort. Ostenaco was pleased to see it properly maintained. When Demere fell ill and left the following year, he was replaced by his younger brother, Capt. Paul Demere, who also struck up a personal connection with Ostenaco.[78]

Into 1757 the French threat to British settlements worsened, pushing even South Carolina and Virginia to start working together. This trend was aided by the replacement of Glen in Charleston with a much more empire-minded, rather than colony-minded, governor called William Lyttelton.[79] Governor Lyttelton refused to inherit Glen's grudges against Virginia. He also had far less understanding of the Cherokees as a distinct Indian group—to him, Indians were all the same: ferocious, savage, pliable. He heeded Washington's general British call for Cherokee recruits and now actively encouraged the Overhills to continue their assistance to Virginia in aid of what he called simply his "Great King's" cause.[80]

The Overhills Cherokees were mostly positive in response to Lyttelton's invitation, despite Virginia's lackluster fighting record. The promise of long-term trade benefits and at least one decent British fort (built by the other colony) made them overlook, for now, Williamsburg's recent failures. Ostenaco led numerous Cherokees north to join Virginian regiments over the next twelve months. None of the trips managed to improve his admiration of the colony.

During the summer, while leading a force into the Ohio Valley, Ostenaco had to stop to sort out a mess created by a leading British official in western Virginia. The superintendent for Indian affairs had wrongly held a party of Cherokees hostage as French spies. The utsidihi combined his warrior skills with diplomacy once again and secured a peaceful resolution. When Washington heard of the incident he saw at once how high the stakes had risen. "The Chief who . . . prevent[ed] an [avenging] massacre . . . was so incensed against what he imagined neglect and contempt that, had we not supplied

him with a few necessaries, without which he could not go to war, he threatened to return [home], fired with resentment."[81]

Ostenaco, along with nearly one thousand other Cherokees, also aided the major Virginian campaign against the French Fort Duquesne in 1758. The details of his sideline part are not recorded, but the utsidihi no doubt heard in person about the part played instead by his Overhills peer Attakullakulla. When this Cherokee leader realized the French had abandoned Fort Duquesne before the planned British ousting, Attakullakulla turned his several men homeward. This enraged the British general, John Forbes, who arrested the Cherokee leader for desertion and stripped him of arms and payment. Attakullakulla was deeply affronted by being treated "like a child."[82] Again, Washington shook his head with frustration and fear. The Virginian "train of mismanagement" with the Cherokee, which included straightforward denials of payment as well as the insults given Ostenaco and Attakullakulla, made these crucial partners "justly fired with the highest resentment." He foresaw that "our Interest with those Indians is at the brink of destruction."[83]

Cherokee disillusion crescendoed at the end of that year. In retaliation for the lack of promised war prizes, Cherokee warriors started taking colonists' coveted horses. In retaliation for the horse thefts, settlers amped up hostilities by wreaking murderous violence on random Cherokees. News of some Carolina soldiers raping Cherokee women while their husbands served Virginia was the penultimate straw. An English missionary passing by Chota in January 1759 summed up the mood of the town: "They talk bad [and] appear in general disaffected. . . . Now they won't go to war. . . . [Attakullakulla has] called us all Rogues and Thieves." The missionary was in no position to argue: "There is too much Truth in what he says."[84]

The dramatic breaking point occurred ten months later. Throughout the spring and summer of 1759 individual Cherokee warriors, especially from the Overhills, took revenge with increasing impunity on borderland British settlers for their recent killings of kin during Cherokee service to Virginia. In response, Charleston—ruled by both Lyttelton and the general hysteria of prolonged war with the French—tried to put all Cherokees on uncompromising notice. "All the King's children upon this Continent [are] Brothers," Lyttelton declared, and so the murder of any British person anywhere will face the extreme "resentment" of South Carolina. In August 1759, eight years after his predecessor had experimented with the same trick, Lyttelton decreed an embargo against every Cherokee.[85]

This time around, in a darker world, most Cherokees received the message with thoughts of violence rather than negotiation. "This News was no sooner heard," reported Captain Demere, stationed in the Overhills in Fort Loudon, "but all Indians were in an Uproar." Within weeks rumors had spread back to Charleston that some Cherokees were so enraged as to be determined even on "the extirpation of [all] white People from the Face of this Earth."[86]

At this point Ostenaco appeared to be in the minority who favored diplomacy. So was Attakullakulla, who had been working for months for a resolution with Lyttelton. In early October Ostenaco joined the skiagusta of Chota, a formidable warrior called Oconostota, on a multi-town mission to back up Attakullakulla's dogged diplomatic effort. The two Chota warriors assembled over fifty leaders from an assortment of towns from three regions (a notable phenomenon in itself) to march down to Charleston to argue for peace and a resumption of trade. Many brought their wives and children, which most older Charleston residents saw as a clear sign of their nonviolent purpose.[87]

For unclear reasons Ostenaco turned back after a few weeks of traveling. This was probably at the behest of Oconostota. Perhaps this skiagusta realized, as each worrying day went by, the ever-greater need for reassuring leadership at home. The rest of the delegation, however, pressed on, arriving in Charleston a week later. All fifty-five were admitted entrance into the Council Chambers, but the South Carolina response had already been decided in Lyttelton's head. The governor refused to accept the party's deerskin offerings or to let the skiagusta Oconostota speak. He then announced that South Carolina troops would march into Cherokee country and extract those responsible for the recent killings themselves. The worst part was when he added, with the threat of bayonets drawn within the government's own offices, that all the present peace seekers were to march with them—as hostages.[88]

Ostenaco heard of this almost inconceivable offense within days and no doubt plunged into deep anxiety about how it might all unfold. Was it here that he started to lose hope in a diplomatic solution? Or did he yet plug on, steeling himself for the intense work of negotiating further with both Lyttelton and his own ever more enraged countrymen? Ostenaco's voice goes quiet in the archives for the next couple of months. Attakullakulla's view, however, remains discernible. He rushed to meet the oncoming South Carolina procession as quickly as he could. He "shed tears" at the thought of delivering up the accused Cherokees and hatched a counteroffer of more Cherokee military service to the British crisis up north.[89]

Attakullakulla met Lyttelton's party at Fort Prince George, a British en-
campment in the Cherokees' Lower towns region. By December the governor
had released half of the hostages but was still holding about twenty-six inside.
Attakullakulla talked for days with the volatile leader and managed at least to
get Oconostota released, along with a few others. Twenty-two Cherokees,
however, remained under armed guard.[90]

Lyttelton went home to Charleston in January, though the impasse con-
tinued. Appallingly, smallpox ripped through Fort Prince George in February.
Attakullakulla redoubled his work, but by then he was pretty much alone in
his stand for peace. No less than the Chota skiagusta Oconostota himself
finally felt confident in the tail end of winter to override the South Carolinian
guards with force. On 16 February, several dozen Cherokees surrounded Fort
Prince George and, on Oconostota's signal, fired a volley of rounds into the
wooden walls. Tragically, Attakullakulla's abiding fear that such tactics would
hurt only the Cherokee hostages became reality almost at once. The com-
manding officer screamed to stop his soldiers from retaliating, "but before I
could get one to hear or answer me," he later recounted, "they laid them all
lifeless."[91]

The massacre of the Cherokee hostages at Fort Prince George shocked
even Charleston residents. Cold-blooded murder, is how one put it. A "shock-
ing" betrayal of "innocent and unfortunate prisoners," declared another. Even
the skeptical Adair condemned the "uniform misconduct" of his fellow colo-
nists involved in this "shameful" incident.[92] No one, however, was more hor-
rified than Ostenaco, still up in Chota. "If peace was made even 7 times," he
told the garrison at Fort Loudon upon hearing the news, "he would always
disregard and break it."[93] The utsidihi had evidently joined his skiagusta's
militant position against the British. Attakullakulla's diplomatic efforts lay in
tatters.

Whatever Lyttelton had thought would be achieved by his hostage taking,
he knew for certain that the executions now changed everything. Quickly
he sent word to the British army commander-in-chief, Jeffrey Amherst, for
armed assistance against the inevitable Cherokee retribution. Amherst, sta-
tioned in New York, was annoyed by the request, attending as he was to quite
a few other blazing fires over the continent at the time. But he also saw the
dangers presented by having such powerful warriors now turned against
the British. A notorious hater of Indians, Amherst duly sent Col. Archibald
Montgomery and thirteen hundred troops to help quash "those barbarian
savages," as he saw them, for their "infamous breach of the peace."[94]

Lyttelton accepted that it would take Montgomery's regiment two months to arrive in the south. The Cherokees also had their work cut out for them, assembling men and arms from their still largely uncentralized towns and a now broken trade network. In the meantime, therefore, only small, uncoordinated attacks between the foes took place. One of them was led by Ostenaco. In late March he ordered a four-day firing into Chota's Fort Loudon. It rattled the two hundred colonists garrisoned inside (soldiers and many of their wives), but no one died. It had been engineered solely to arouse the garrison's worst suspicions: that they would eventually pay the price for the hostage disaster.[95]

War escalated in April 1760, when Montgomery's troops finally arrived in South Carolina. They set to attacking the Lower towns, which Amherst, consistently lazy on the details of Indian history, believed were to blame for the attempt on Fort Prince George. With fresh provisions, they razed most of this lower region, slaughtering scores and displacing hundreds to the more westerly regions. Though Montgomery paused to regret that "some [women and children] could not be saved," he wrote to Amherst that his work had "sufficiently corrected" the Cherokees of these parts.[96]

It took a few weeks for Montgomery to realize that his correctional work, frustratingly, was not prompting the surrender he expected. No Cherokees offered peace terms. The hostage event had smashed all their confidence in colonial good faith. Montgomery marched next into the Middle towns, wreaking more damage. After a month of further killings, the colonel knew his remit could be stretched no more. He turned home, writing to Amherst, "We succeeded in everything we have attempted but 'tis impossible . . . to extirpate them . . . they will not treat with us for fear of being made prisoners."[97]

Chota warriors were not just fearful but furious. None, bar perhaps Attakullakulla, could forgive the hostage massacre. Their chance for revenge came that summer. In early June Oconostota and Ostenaco renewed firing into Fort Loudon. Together, ever since the March attack, they had controlled the supply of provisions to the garrison. The colonial soldiers inside had been surviving on minimal rations for months. Through July the Chota leaders drove the supplies down even further, such that Captain Demere started allocating horse meat. On 7 August, admitting everyone was now "miserable beyond description," Demere relented to a capitulation.[98]

The terms of surrender, signed by Demere, Oconostota, Ostenaco, and some other Overhills headmen, allowed for the garrison to return to Charleston so long as they relinquished the bulk of their weapons.[99] With long

experience of Cherokee notions of justice, Demere should have known better. Maybe he did. Either way, the soldiers were doomed. At dawn on the second day of their march south—just outside, in fact, the fading town of Tellico— hundreds of Cherokee warriors suddenly ambushed the party, shouting for blood and shooting arrows. Ostenaco, almost certainly a chief mastermind behind the scheme, was among them. He stood by as others dove especially for Demere, scalped him, quartered him, and filled his mouth with dirt. Only then did Ostenaco yell for the warriors to stop, for "they had got the man they wanted."[100]

Most of the surviving garrison were taken prisoner. About twenty-two regulars had died.[101]

It was Ostenaco who notified Charleston. "This is to acquaint you with . . . bad news," his missive began. Speaking in the third person, like so many Cherokee dictations in this era, it went on: "Judd's Friend says they are deter- mined to take Fort Prince George, since they have already taken a much more defensible fort . . . there is no peace belt in the world strong enough to hold them . . . they are coming down with all the cannon from Fort Loudon." Ostenaco switched back into a first-person voice for the triumphal sign-off: "Don't think I am a fellow telling you lies."[102]

The governor in Charleston was now William Bull. Lyttelton had fled the scene in April when offered the colonial governorship of Jamaica. Bull hastily wrote to General Amherst, realizing that events had once again made it neces- sary to beg for the full arsenal of the empire. He implored the commander- in-chief to send him troops to finish off Montgomery's earlier job.[103]

Even if Ostenaco guessed at such a response, he knew that nothing would happen quickly. In the meantime he and Oconostota would offer peace terms on a more equitable basis. In September the utsidihi gathered two thousand Cherokee warriors in a Middle town to debate a peace treaty and sent gestures of truce making to Charleston.

Bull's council, however, would not consider a word. Most of the town had now turned fully against the Cherokees, feeling that the siege on Demere and his garrison had swung the pendulum of justice well back into their realm. The council determined to crush their former friends into a total "state of subjection."[104] Amherst agreed. He sent not Montgomery this time but the lieutenant colonel of the earlier campaign, James Grant (unrelated to Ludovic). The new leader's orders were to secure a complete and unbreakable peace from "those perfidious savages."[105] Into the new year Grant duly

launched systematic assaults on the remaining Middle towns. Aided by enormous numbers—up to three thousand fresh troops against the original, tiring defense—his men laid waste to the region.

Away from Charleston's convulsive mood swings, Grant's soldiers started to feel uncomfortable about their task. One of them, the later revolutionary Francis Marion, spoke pityingly of the damage they inflicted: "We proceeded . . . to burn the Indian cabins [which was] a shocking sight. . . . But when we came . . . to cut down the fields of corn, I could scarcely refrain from tears. Who, without grief, could see the stately stalks . . . the staff of life, sink under our swords . . . in their mourning fields?" When another, John Moultrie, saw a Cherokee woman cry at the sight of her home on fire he confessed that it "melted me and made me sorry."[106]

Grant, too, appeared heavy-hearted. "If both parties were heard," he brooded early on, "I fancy the Indians have been the worst used." By July 1761, though, it was a moot point. "Nothing [is] left to be done on this side," he reported to Amherst. Over fifteen hundred acres of fields had been ruined. Fifteen towns obliterated. Thousands of Cherokees killed.[107]

Most warriors conceded that fall to the idea of surrender. Where Ostenaco stood then on the matter is unclear. Governor Bull explicitly invited him to join the treaty talks in Charleston, but he declined.[108] Perhaps he needed more time to get used to its implications. In the space of one decade Ostenaco had gone from being a supporter of good relations between one town and one colony, to being a leader of an alliance between one region and two colonies, to being a deadly foe of all British interlopers. Uniform peace would be yet another wrench in political orientation, and it was not obvious which Cherokee identity would emerge next for him.

Alternatively, perhaps Ostenaco was already hatching plans to defuse the power of the resultant South Carolina victory? At exactly the same time Bull was hosting Attakullakulla and other Cherokee peace negotiators down south in Charleston, a separate delegation of Overhills leaders was marching northeast to meet with a troop of Virginian soldiers. Ostenaco was not among the delegation. He was firmly lodged in Chota for the duration. But almost certainly he had planned the encounter: he was later to become the most implicated in its repercussions. If Charleston was, during that very month, ensuring peace with each of the various Cherokee regions (it had learned its lesson after Montgomery's campaign), why shouldn't the Cherokees now negotiate similarly with all the different "regions" of the British empire? Such a tactic would not only keep South Carolina on its toes when assuming undivided loyalty in

the future. It would also send a powerful message to all British officials that the Cherokees understood precisely the imperial nature of the British presence in America: sometimes it was splintered into colonies, sometimes it was coalesced into an unwieldy behemoth. Moreover, the move would show that the Cherokees did not forget Virginia's part in provoking the war in the first place.

The governor of Virginia was now Francis Fauquier. Colonial governorships turned over nearly as often as Cherokee corn seasons. Fauquier had mixed motives in backing the separate Cherokee peace negotiation. Partly, he recognized Virginian culpability in starting the hostilities. The colony's disreputable treatment of Cherokee warriors back in the mid to late 1750s "may have done mischief," he admitted, and he wanted to draw a line underneath those times. Partly, though, Fauquier knew, as Dinwiddie and Washington had before him, that Cherokee warriors yet promised to hold the key to ultimate glory in the larger French war still ongoing elsewhere on the continent.[109]

With due support from their respective leaders, then, the Overhills and Virginian parties signed a treaty of cessation midway between their hometowns. At this point the Overhills leaders requested that an ambassador of the Virginian party come back to Cherokee country as a sign of its sincerity. This is where Ensign Henry Timberlake finally entered Ostenaco's life story. Anyone familiar with Appalachia's recent history of hostage taking and revenge killing might have thought twice about this request. And indeed Timberlake was not unaware of the dangers. He knew that his colonel feared him becoming a guarantor for the Cherokees against any British breach of the peace. But Timberlake believed himself estimable enough in Cherokee eyes and a canny enough judge of Cherokee character not to worry that such a practice would apply to him.[110]

The self-regard implicit in such a decision characterized most of the rest of Timberlake's involvement with the Cherokee and indeed his own life story. It was also at play in his refusal to join the Overhills on their march back to the Appalachian mountains. He decided instead to journey separately, believing the Cherokees would be too slow and also poor company. He took with him only a sergeant (and later famous revolutionary, Thomas Sumter), an interpreter, and a black slave.[111]

Three weeks later his party crawled into Tomotley, having suffered bear chases, mislaid canoes, lost guns, and overwhelming cold, only to find the Cherokees had returned in half the time. Ostenaco welcomed them "in a very kind manner," confessing he had feared the group lost some time ago.[112]

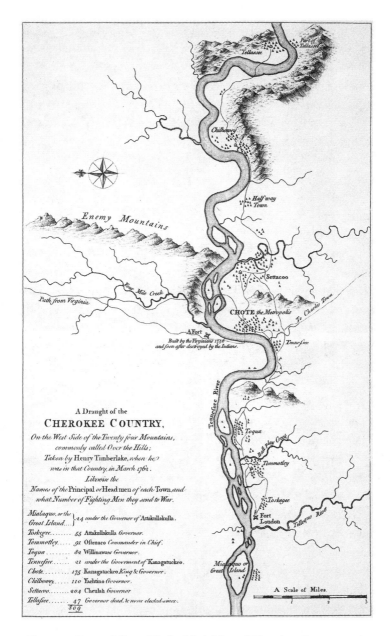

Figure 4. Copy of Henry Timberlake's Map of Cherokee Country, 1765.
Reproduced courtesy of Old Salem Museums & Gardens.

There was never any question that Ostenaco was the leader of negotiations from this point on, though plainly always in the interests of a greater goal. The Virginian party stayed in his house, and he led every ritual of truce making. The first order of business was a regionwide congress in the Chota council house. "The bloody tommahawke," Ostenaco intoned in front of headmen from across the Overhills, "so long lifted against our brethren the English, must now be buried deep, deep in the ground, never to be raised again." The speech was followed by pipe smoking, feasting, and dancing.[113]

If Timberlake thought he might be home again by Christmas, he was sorely mistaken. The Chota reception turned out to be only the first of Ostenaco's planned events. Next came trips to all the major towns in the Overhills, for Timberlake to enact again and again the agreement of peace. Eventually Timberlake realized these rituals were not simply about entrenching the deal but were also delaying tactics. The Virginian Four were absolutely being held as guarantors. Ostenaco had still not heard from Attakullakulla down in Charleston about his negotiations with South Carolina, and it became clear after two months that no Virginian was going anywhere until he did.

Timberlake's memoirs for February 1762 trace a rising anxiety. "I now began to be very pressing with Ostenaco," he wrote, "threatening if he would not set out immediately [for Williamsburg], to return without him."[114] Evidently Timberlake had also realized by now that he needed a Cherokee escort for the trip home; he had barely survived his trek inland. It was similarly evident that Ostenaco had resolved to lead that part of the encounter too.

Attakullakulla finally arrived in Chota at the end of the month, confirming his confidence that the British really were going to put down all arms. Ostenaco gave the signal for a departure, and in mid-March 1762 the Virginians and about twenty Cherokees set off for Williamsburg. Joined variously by extra clutches of Cherokees during their journey, as was typical among many Indian groups at the time, the party numbered around seventy by the time it knocked on Governor Fauquier's door. Fauquier "seemed somewhat displeased with the number of Indians" now requiring hospitality, but it was nothing he had not seen before. The governor knew that present giving and further ceremonies of good will should now proceed.[115]

Probably Ostenaco did not go back to the Jefferson home during this stay in Williamsburg, despite his happy billeting there six years earlier. The paterfamilias, Peter, had died in 1757. But he may have caught sight of the eldest son,

Thomas, around town. Thomas Jefferson was now an undergraduate at the college, just down the road from the governor's house.

Ostenaco attended a dinner at the college near the end of April. He had been invited by a professor, along with Timberlake. The professor showed him several "curiosities" during the meal, including a portrait of the new British king, George III. Ostenaco was said to have stared long and hard at the picture. He then announced, "Long have I wished to see the king my father; this is his resemblance, but I am determined to see himself; I am now near the sea, and never will depart from it till I have obtained my desires."[116] Had a single image prompted these desires? Perhaps they had been inflamed by the professor's own musings of a Britain he'd just that year departed? More likely Ostenaco had planned this next move months beforehand.

Whatever the catalyst, events moved swiftly thereafter. Ostenaco informed Governor Fauquier, who in turn started writing to officials in Whitehall. "I am conscious my Lords that such guests are troublesome to his Majestys ministers," he began, but he was convinced that a trip to London would be of "great utility" to Britain and the Cherokee alike. "The chief is a man of great influence . . . being reputed the boldest warrior of the Nation, and a Man of Integrity." He never talks, Fauquier noted, employing a Cherokee saying, "in a double tongue."[117]

CHAPTER II

The Artist-Philosopher

REYNOLDS IN BRITAIN

The artist who would one day paint the most compelling likeness of Ostenaco was about ten years younger than his Cherokee sitter. Joshua Reynolds was born in 1723, in the village of Plympton, five miles from Plymouth in the rolling west-country hills of Devon in the British Isles. Unlike Ostenaco, Reynolds probably did, later, consider his birth the moment of his true beginning. By the time Reynolds was old, many Britons recognized "selves" as highly distinct individuals, measuring them by how they stood apart from others rather than by how they existed in relation to them. It is not certain, though, that back in the 1720s Britons were as individualistic as they would become. The eighteenth century was the key era of transition in Britain regarding selfhood, shifting from an idea defined by how one related to others—chiefly, family members and then social peers—to a notion considered much more the creation of a private independent soul.[1]

The family and social order that Reynolds first knew was, respectively, patrilineal and intensely stratified. That is, his kin were determined by male lines, not female, and together they clustered in the thin strip of "middling" folk located below the even thinner wedge of aristocrats but well above the various slabs of laboring classes. Reynolds's father, Samuel, was a schoolmaster, descended from clergymen and scholars. Reynolds's mother, Theophila, did not have a public occupation. Before her marriage to Samuel her rank had been determined by her father, who was a vicar (who had himself descended from a mathematician).[2]

For all that, Reynolds's society was not a simple inverse of Ostenaco's. Where Ostenaco's childhood world was matrilineal, it was not also matriarchal—women's power in the Cherokee family was balanced by men's power in Cherokee towns. Reynolds's childhood world was both patrilineal and patriarchal: men's power was consolidated in every sphere of life. Similarly, where Ostenaco's early society was relatively flat, it was not precisely a meritocracy. Cherokee social roles were more uniform (most people did the same thing) than variegated according to talent. Reynolds's early society was rigorously ranked, determined in the main by inheritance, which was signified by landownership, with a central dynastic monarch at its head. It entertained a greater range of occupations but little chance of upward mobility.

If harmony was the overarching principle for Cherokees around 1700, then hierarchy was the name of the game in Britain. The most distinctive feature of

Figure 5. Map of southern Britain, c. 1750, with inset of Covent Garden. © Mark Gunning.

British society into the eighteenth century was the way its various hierarchies inspired unprecedented expansion. In 1700 the population of Britain was roughly five million. By 1800 it had doubled to ten million, not including the additional ten million claimed by the British government through its coloni-zation of lands near and far.[3] Over the course of the eighteenth century Brit-ain's imperial reach spread over the entirety of its own archipelago and sent tentacles deep into Asia, across large if shifting swathes of North America, around a couple of strategic slaving stations in Africa, and through great blobs of Oceania. From a rainy section of a modest-sized, west-lying European is-land, Britain became within one hundred years the biggest empire on Earth.

Reynolds's life spanned much of this explosion. His development as an artist-philosopher illuminates its effects and reception within Britain in un-usual ways. Reynolds's sparkling success in his chosen field represents less the opportunities created by a newly imperial nation and more the way that old, landed aristocratic values came to jostle awkwardly with a novel, unfamiliar commercial ethos. Likewise, while there was no clear erosion of men's privi-lege from imperial demands, there was some important tweaking of the idea of manliness. Most of all, Reynolds's own gradual political evolution indicates how empire provoked conflicting views in its local constituents. Some Brit-ons were undoubtedly jingoistic and celebratory. Others became disturbed by imperial rise. Joshua Reynolds was a rare individual in seeming to embody both impulses.

If Ostenaco's life tells an Indigenous story of empire, exposing the compli-cated ways that Indigenous people maintained some autonomy in the face of incursion, Reynolds's life uncovers a little-known insider's story. It shows that empire neither followed an even path toward global supremacy nor enjoyed uniform support from within. Never a radical in any sphere of life, Reynolds yet teases open some of the bumps, fissures, and problems that featured in empire's progress through the century.

Though Britain's empire was already expanding by the 1720s, not every Briton at home yet thought too much about it. If questioned outright, many Britons would have demurred from the very word "empire." At best, empire con-noted the ancient Romans. An impressive civilization to be sure, but look what happened to them in the end. At worst, it conjured rapacious Spaniards or ferocious Portuguese. In 1719 Daniel Defoe's fictional character Robinson Crusoe shuddered to contemplate the "bloody and unnatural cruelty" of the Iberian conquistadores.[4]

Tucked away in sleepy Plympton, Reynolds's parents, Samuel and Theophila, probably thought about empire even less than most. They, too, had each been born in Devon, a chunk of the peninsula that jutted southwest out of the main British Isle and was situated nearly two hundred miles away from the center of politics in London. Although both had come from academic and clerical strains of the slim middling class, neither had found this background to be much of a means for social betterment. They lived out most of their years in that rather more baggy and stolid middling category of "village worthy." Like the majority of Britons living in the remote provinces at the time, they never ventured beyond the county of their births and eventual deaths.

Samuel Reynolds had become master of Plympton Grammar School in 1715. He lodged his fledgling family in the schoolhouse, where he also gave most of the lessons (chiefly in the study of Latin) to the fee-paying, all-boy student body. He led the family every Sunday to the next-door church, St. Maurice's, though, like most of their rank, the Reynoldses kept their Christianity a relatively private affair for the other six days of the week. It was probably Samuel's earlier stint as a student at Oxford that created his son's unusually extensive connections to the local grandees of the region. Samuel would later, for example, introduce Joshua to the member of parliament for Plympton, Lord Edgcumbe. The few remaining sources on Samuel suggest that he was charitable, thoughtful, a faithful husband, and a doting father.[5]

For all that, however, he was also unquestionably the head of his household. Theophila Reynolds, nicknamed Offy, was in all areas subordinate to her husband. One of Joshua's older sisters once reported that Samuel used often to chirp fondly to his wife, "When I say 'Thee,' You must make Tea. / When I say Offy, You must make Coffee."[6] Fond or not, the ditty tells us much about the roles of father and mother during Joshua's early years. The glaring lack of sources on Theophila's life compared to Samuel's communicates the most significant thing about her. Probably she taught her daughters sewing, cooking, and dancing while her sons took formal classes from their father. Probably she supervised the drawing tutor who came to instruct her children in the rudiments of art. And probably she helped her husband maintain and run the family's livelihood in the schoolhouse. But we can't be certain. The clear descending order of gender in British society rendered deep silences in the records of nonelite women.[7]

Samuel and Theophila had eleven children all told, though three died before reaching their teens and two more died as youths. In the early eighteenth century the rate of infant mortality was as bad in Britain as anywhere

else in the world. Disease was usually the culprit, especially diphtheria, influenza, measles, and smallpox as well as, in Devon, a mysterious condition called Devonshire colic. Joshua, the seventh-born Reynolds child, was apparently quite hardy, for he survived the noted smallpox epidemic that swept through Devon when he was three years old.[8]

Later in life Joshua compiled an account of his siblings' life dates. Here, he reported the grievous facts of two of the infant deaths: "*1720, April 7,* Saturday, a quarter before 9 in the morning, my sister Ann [aged 2] died. . . . *1726, Nov. 8,* Tuesday morning, about 7 o'clock, Offy [aged 1] fell out the window, and died between 6 and 7 at night."[9] In modern times these kinds of sad roll calls have prompted some to assume that the deaths of children in earlier ages could not have registered with parents as profoundly as they do today. Surely, if they had, they would have gone mad with grief? Some historians, however, disagree. They show that parents in the eighteenth century suffered just as much "unutterable and hopeless agony" when losing a child as those who lived later on. Samuel Reynolds seemed to fit this profile when he confessed once to a correspondent, "I cannot yet write about . . . the death of my youngest son Martin . . . without hurting myself. I cannot write this little without great agitation of mind."[10]

Joshua grew up, then, amid the bustle of lots of fellow children but also with the darkness of loss never too far away. Ahead of him by ten years was Humphrey, followed by Robert, Mary, Jane, and Elizabeth. The only sibling after him to survive was Frances, who turned out to be his nearest rival in artistic talent.

All the Reynoldses sported the same apple-cheeked, fair complexion. Each may have enjoyed games popular at the time, including, as one player remembered it, "shuttlecock, quoits, bowls, tops, knucklebones, dice, cards, hide and peep, and blind man's buff."[11] Certainly all had access to plenty of books. Visitors noted the unusually large number of books within the Reynolds home, though none were written particularly for children. One of Joshua's first portraits after leaving home was of an unnamed boy reading a book, his face aglow as if lit from the page. He kept it his whole life. Perhaps it reminded him of his favorite pastime while living under his parents' roof.[12]

Little evidence exists about Joshua's initial artistic prowess. His later friend James Boswell recorded that his "two eldest sisters [Mary and Jane] did little things & he copied them. He used to copy [as well] the frontispieces and plates in books." His nearest sister in age, though, Elizabeth, remembered things differently: "As pencils and paper could not be afforded to the young [children], they were allowed to draw on the whitewashed walls of a long pas-

sage, with burnt sticks." She added that "Joshua's productions were the least promising of the set, and he was nicknamed *the clown*."[13]

If the Reynoldses were not paying much attention to their nation's growing empire in the early decades of the eighteenth century, signs of expansion were nonetheless appearing everywhere around them. At the most intimate level, the empire was evident in the foods, drugs, and clothes found in their home. The tea that "Thee" made for Samuel was the most obvious item. Imported from British colonies in Asia and sweetened by sugar grown in the British Caribbean by slaves traded from British ports in Africa, the so-called quintessential British beverage was a perfect distillation of eighteenth-century imperialism. Sweet tea proved so addictive to Britons through this period that despite its significant expense at the time even the poorest of the poor drank it—in some cases spending as much as 10 percent of the household budget on the drink.[14]

Other common items indebted to empire in the Reynolds household included the Virginian snuff that Joshua's father enjoyed inhaling (much as Joshua himself did later on in life), the Bengali cottons that his sisters sewed upon each evening, and the coffee, chocolate, and porcelain that arrived via protected trade routes through Arabia and China. Ostenaco's South Carolina figured in their lives by way of the leather hats and gloves everyone wore as outer garments (all those deerskins hunted by the Cherokees) and via the rice served not as a separate foodstuff but as a thickener for soups and puddings.[15]

The Reynoldses acquired most of these imperial consumables in Plympton's local market, set up every week along the street above their home. Shopkeepers would have earlier bought the products just five miles down the road in the dockyards of Plymouth. Although a very old port town, Plymouth did not receive the majority of imperial merchant ships in the early 1700s, since the cost of transporting goods all the way to London by ground was still prohibitive. Shipped goods arrived in Plymouth having docked first in a London port.

The more direct connection Plymouth had with empire at this time was as a key hub for the Royal Navy. The town had witnessed massive dockyard construction from the 1690s. These docks soon became one of the two most important naval sites in Britain outside London (along with those in Portsmouth). Britain's naval supremacy emerged around the same time, itself an effect of a recent revolution in British governance.

In 1688 the British parliament had arranged for an unlikely member of the royal family, Prince William from Holland, to take the crown from the sitting

monarch, James II. Parliamentarians had begun fearing that James II was overstepping his conventional powers as king (which should have, in their view, always acted in concert with them). In the Faustian pact of the so-called Glorious Revolution, King William got a new country to rule and British politicians got a more manageable sovereign. What the British also gained, unexpectedly, was a commitment to continue William's current wars against the French and Spanish empires on the European continent. Until then, Britain had for some centuries managed to avoid major warfare in Europe. Now, more wars spelled more ships. They also spelled more costs, which only new commercial ventures overseas could meet in a traditionally land-based economy. This demand spelled even more ships.[16]

In very concrete ways, then, the British empire burgeoned because of the development of the British navy, notwithstanding the empire's proclaimed roots in private enterprise. Soon the navy and imperial trade were growing in lockstep. The navy needed fresh capital to flow in from elsewhere to fund its wars; new overseas commercial enterprises needed the navy to protect and in some cases force their way into new markets. Plymouth in those initial decades saw more the naval end of this dual boom. Without doubt, this was the more palatable end of expansion, considering the still-cautious contemporary views on expansionist Roman precedents for empire.

In 1734, when Joshua was eleven years old, Plymouth was enjoying the longest stretch of peace it would know all century. After that first continental war of the 1690s, which had spread quickly to the adversaries' respective colonies in America, Britain had engaged in another Atlantic-wide war through the first decade of the 1700s. This second war, once more against Spain and France, had ended in 1713. Once more, too, no side gained meaningful spoils. Unlike after previous peace treaties, though, the navy was not then significantly disbanded. Two decades on, the dockyards in Plymouth still hummed with naval business—building, training, and readying. Young Joshua would have learned that the government now assumed a recommencement of hostilities at some point in the near future. King William was dead by this stage, but his legacies of ever-escalating arms, debts, and greed lived on. In Joshua's eleventh year, the first lord of the Admiralty boasted, "We are at present stronger than any nation at sea, perhaps than any two."[17]

Five years later still, just as Reynolds graduated from Plympton Grammar School, Plymouth saw its long-readying work put into place. In 1739 Britain and Spain quarreled over their respective rights in the colonial slave trade. Within twelve months the squabble had ballooned into a multifronted war

among all the European imperial powers. This war, sometimes called the War of Jenkins' Ear, lasted nine years. It was the conflagration that tipped Plymouth from booming naval port into one of the ten largest and most prosperous towns in all Britain.[18]

Upon matriculation, Reynolds could not have missed the heightened focus on the naval service in his home region or the increased expectation that the new war would require fresh recruits. His eldest brother, Humphrey, was by this stage already a naval lieutenant. Young Joshua, though, turned out to have different ideas about how to make the most of flourishing Plymouth.

If he "could be bound to an eminent master," he opined to his father in this year, then he would most like to try becoming a portrait painter.[19] "Phiz mongers," as sellers of face paintings were then known colloquially, were not unconnected to patriotism. They were understood to perform the critical function of recording, and in most cases of glorifying, the achievements of the nation's leaders. Chief among these, in 1739 Plymouth at least, were naval leaders. Perhaps Reynolds sensed new opportunities afoot in this field as his hometown grew ever more militarized, organized, and rich.

Certainly Reynolds knew that to become a phiz monger he would need a multiyear apprenticeship. As for most occupations at the time, apprenticeships were the most efficient path to gaining the knowledge and credibility required to succeed, especially for beginners who had not shown particularly notable previous ability. Reynolds was lucky to have a family loving enough to arrange one for him. From 1740 he would live with the artist Thomas Hudson in London for four years (at the substantial premium of £120). He hoped to learn as much as he could before setting up in the trade himself.[20]

Most biographers of Reynolds have suggested, or at least implied, that Reynolds chose Hudson to be his master because of his connections to an important art theorist of the times, Jonathan Richardson. Hudson was married to Richardson's daughter. Perhaps Reynolds assumed a Richardsonian philosophy in Hudson, or maybe he hoped for an insider's connection to the great man. This assumption, though, may also be an instance of later observers suiting their own theses. Certainly by the 1750s, ten years later, Reynolds had come to a version of Richardsonian ideals. And forty years after his apprenticeship Reynolds liked to remember that his teenage years had been fired up by reading Richardson.[21] But by that stage Reynolds also thought of himself as the chief successor of Richardson in the country and tended to imagine that everything in his past had led up to that point. Later biographers have

been happy to accept his view because it fits with modern notions of how the basic building blocks of selves are formed in youth. However, there is little solid evidence to confirm that Reynolds was a mini-Richardson ready to unfold before he turned twenty. He had read his father's copy of Richardson's *Theory of Painting* (1715) as a teen, but then, as a bookish boy, he had read almost everything on Samuel's shelves. The more likely reason Reynolds wound up with Hudson was regional rather than philosophical. Hudson also hailed from Devon. It was Samuel Reynolds who set up the contact for his son, not some precocious version of Joshua with clairvoyant insight. Samuel used his local connections to establish the apprenticeship and expressed immense relief to one of them about fulfilling his paternal duties when Joshua finally set off to begin it.[22]

The life of a phiz monger apprentice was not glamorous. Joshua lived in the master's home, copied set pieces of antique or contemporary work (drawings, paintings, and sculptures), and performed various chores, including canvas preparation and inspecting new lots of artworks at auction houses. Hudson, like many painters before him and like Reynolds later, had his apprentices finish off some of his commissions, especially the drapery. The master does not appear to have introduced this particular apprentice to his father-in-law, Jonathan Richardson, before the lauded theorist died in 1745.

Drudgery notwithstanding, Reynolds loved his time with Hudson. In numerous letters to friends, Samuel related the successes of his seventh child. He boasted that Joshua "goes on very well," that he is "pleased with this employment, with his master, with everything," and that all his works now "deserved frames and glasses." Indeed, in one letter Samuel records Joshua's very words: that "while I am doing this I am the happiest creature alive."[23]

Some of Reynolds's later acolytes wondered if his split with Hudson soon after writing that statement meant a nasty rupture then occurred between them.[24] One full year before the apprenticeship was up, Reynolds quit London and moved back to Devon to start up his own practice. The split, though, may not have been acrimonious: Reynolds continued to be friendly with Hudson in later life. Instead, it may have been due to Reynolds's impatience to get started on his own career. If so, Reynolds had begun to absorb at least one of Richardson's key ideas. Richardson wanted phiz mongers to reconsider their station in society. He wanted them to stop identifying as tradesmen-like artisans and start thinking of themselves as something nobler.[25] Richardson was in many ways inventing in Britain the category of artist as modern readers understand it today: independent, inspired, driven by loftier ideals than

money alone. If Reynolds came to share this view while under Hudson's tute-
lage, he would also have started to wonder why he was continuing to go
through the motions of a tradesman-like apprenticeship.

In 1743 Reynolds set up rooms for himself in Dock, the town adjacent to
Plymouth (known today as Devonport). More than half a century later one
of his friends claimed that Reynolds regretted the move, feeling stuck back in
provincial Devon, removed from any improving company.[26] This, though,
could be another case of the later Reynolds, or even of a surviving friend, re-
writing earlier events to match a current image of the self. Plymouth in war-
time was no longer a backwater, and, just as key, London in the 1740s was not
yet the home of a high-minded art scene. Most of the nation's leading naval
officers passed through Plymouth in this decade. And naval officers, as the
best regarded military level of the best regarded service in the empire, ensured
that plenty of prestige flowed with them. Besides, while living in Dock, Reyn-
olds made regular excursions to London to spend time with artistic friends
made during his apprentice years.

Over the next five or six years Reynolds painted predominantly Plymouth-
based patrons, but with as much confidence as any young, London-based por-
traitist. Chief among his regional sitters were two aristocrats who would become
crucial to the next stage in his career, his father's friend Lord Edgcumbe and a
young naval captain called Augustus Keppel.

Edgcumbe went on to be Reynolds's most supportive early patron, invest-
ing in his initial establishment and introducing him to important clients. His
best introduction was to Keppel, a dashing young aristocrat whose friendship
with Reynolds would last for the next near-forty years till his death. Keppel
had sailed with George Anson on his historic circumnavigating mission to
capture Spanish colonies during the early stages of the 1740s war. Keppel was
engaged continuously in other British quests till war's end. His youth and
high breeding (and remarkable luck, considering the 90 percent death rate on
the Anson voyage) overshadowed the grubbier aspects of his imperial adven-
turing. Now a naval luminary, Keppel stopped in Plymouth in early 1749.
This was just after the peace treaty concluded the War of Jenkins' Ear, with,
again, indiscernible victories for any power.[27]

Reynolds painted Keppel's portrait that spring. The picture showed that if
Reynolds had started thinking about Richardson's views on the status of phiz
mongers, he still had some way to go in realizing fully the theorist's funda-
mental ideas on style. Richardson had advocated a neoclassical approach
to art. He believed that art had the capacity not merely to entertain but

Figure 6. Joshua Reynolds, *Augustus Keppel*, 1749. © The National
Maritime Museum, Greenwich, London.

also—supposedly like the best art of the best ancients—to raise the virtue of
the viewer. Richardson had argued that this was achieved through the depic-
tion of instructive, epic, and universalized subjects. Reynolds's 1749 Keppel is
upstanding and admirable, but he is hardly a transcendent hero. In line with
then typical practices (in fact, very much like Hudson's work), the picture
conveys the subject's position, occupation, and command through its atten-
tion, respectively, to his dress, background, and calm pose. The end result was
a fairly representational, particularistic, and static portrait.

Neither Reynolds nor Keppel left any indication of what they thought of the painting. But both were evidently friendly enough with each other by this stage for Keppel to invite Reynolds to be a guest on his next commission. While the war had ended, Britain's empire forging had most certainly not. The navy was still busy guarding British commercial interests in the Mediterranean. Keppel's new orders were to confront the ruler of Algiers in order to forestall any incipient Algerian advance into the region. Recently promoted to the rank of commodore, Keppel had the discretionary power to add whom he liked to his fleet. Reynolds accepted the offer gratefully. He knew he'd have few chances to afford such a trip otherwise.[28]

At the start of the eighteenth century it was a commonplace ritual for young, aristocratic Britons to spend a few years on the Continent—completing, as it were, their initiation into the highest rank in the nation. Several decades on, sons of lesser social levels sometimes participated in this ritual, too, if they had the means. Reynolds almost certainly would not have found those means without Keppel.

Reynolds's objectives in going were different from those of his social superiors. Despite Richardson's desire for portraitists to lift themselves above the station of artisans, there was still a big practical obstacle to doing so. Reynolds knew he would need a mostly aristocratic paying clientele in the future to secure his name, even while he tried to carve out an artistic persona that was above the tawdry conceits of cash. At the same time, and in some tension with this rationale, Reynolds knew that Richardson had located the origin of virtuous, "nontawdry" art in the ancient Roman world. Richardson, for one, had never entertained any qualms about the portents of Roman imperial history—he had always focused exclusively on its rising arc rather than the declining arc, situating it generously across southern Europe. In consequence, Joshua saw a Grand Tour as offering two things at once: it would help him make necessary connections for his future trade, and, ironically, it would cultivate his artistic sensibility to transcend, one day, the need for connections in trade at all.

Reynolds set sail with Keppel in May 1749, arriving at Lisbon first and then Cádiz, Gibraltar, Algiers, and finally Minorca. The last port was a British colony in 1749, captured during one of the earlier European wars for imperial supremacy. It was Reynolds's first taste of British territorial colonization. Here, the colonized were predominantly Spanish-speaking Catholics and Jews, many of whom faced suppression or expulsion with the advent of

British rule. On this initial experience, though, we do not have any evidence of Reynolds's personal view—only that he found such strong favor with the governor of Minorca that he was invited to dine and lodge with him and to attend "English Ladies Balls" for the whole four months of his stay. Whenever back on board Keppel's vessel, Reynolds was given the "use of the [commodore's] cabin and his study of books." The agreeable young prodigy clearly had a knack for endearing himself to his betters.[29]

In early 1750 Reynolds bid farewell to his Minorcan hosts, including Keppel, and set off on his own to the core site of the eighteenth-century Grand Tour: Italy. The first and most significant stop was Rome, where Reynolds stayed for two years. He lived off patronage awarded by Lord Edgcumbe back in Plymouth as well as an allowance from his family (including from eldest sister, Mary) and some monies he earned himself from painting. Unlike his aristocratic counterparts, Reynolds could not afford to be idle. He spent most of his time observing, studying, copying, and taking notes on the splendors around him, especially Renaissance paintings and architecture. "I am now at the height of my wishes," he wrote in a letter back to Edgcumbe, "in the midst of the greatest works of art that the world has produced."[30]

It was only now, during his two years in Rome, that Reynolds immersed himself fully in Richardson's neoclassical teachings about art. Or, at least, it was from this period that he claimed an unstinting devotion to the great Renaissance masters who had, as neoclassicists believed, best captured the essence of ancient Rome. Their "grand manner" demonstrated the true point of art. Many years later Reynolds would explain this point as the presentation of ideal human qualities in generalized subjects. Such work had the ability to "raise the thoughts . . . of the spectator," which may in turn lead to a "refinement of taste," which may itself lead to an overall improvement in civic "rectitude."[31]

What stands out most boldly in this aesthetic theory are its big moral claims and its loyalty to a specific historical sensibility. Here was no simple cheer for the delights of pleasing design. Or for the utility of accurate representation. Or even for Art for Art's Sake. Instead, neoclassical theory insisted that art was important because it could elevate the values of an entire society. It was in this way deeply political. Moreover, the theory held, unabashedly, that the best guide to proper values was ancient Rome—the Rome of independence, fortitude, modesty, civic engagement, and so on. In redeeming ancient Rome, the neoclassicists of course sidelined all the other things possibly associated with the phenomenon—luxuriance, overreach, factionalism, or defeat, for instance.

Reynolds's encounter with Raphael's Renaissance frescoes in the Vatican Palace illustrates well his early take on neoclassicism. Before seeing the frescoes, he noted in his diary that he knew Raphael was "praised to the skies for being natural." But, he came to realize, all "pretenders to painting" think the purpose of art "lies in making things natural." Raphael, in contrast, Reynolds saw, portrayed not the real at all but the ideal. His portrayal of the human form did not aim for accuracy in the least but instead distilled what was essential in every human. In consequence, all viewers should be able to recognize themselves in this form. From such recognition, viewers "grasp what we each have in common with others." To Reynolds, this was the critical start of any worthwhile civic action. Moreover, the essences he found in Raphael's forms were "great nobleness" and "much dignity."[32]

Reynolds later admitted that he didn't figure all this out straight away. When he first laid eyes on Raphael's frescoes he was underwhelmed. What was all the fuss about? It was only after he had viewed them "again and again" that "a new taste and new perceptions began to dawn upon me." Though Reynolds was quick to blame his lack of appreciation on his own ignorance rather than on Raphael, he also noted that this ignorance came from having dwelt only in Britain thus far. In 1740s Britain, he reflected, "art was at the lowest ebb—it could not, indeed, be lower." There, artists only produced work "superficial and alluring" rather than profound and educative. Until now, he realized, his views had been too much the product of his time and place. He would endeavor from here on to cultivate better senses through "great labor and attention."[33]

At the end of two years Reynolds started to wind up his tour. Before crossing the channel again, though, he briefly took in Florence, Bologna, Venice, and Paris. Of painters in the last city, Reynolds was scathing. No doubt tinged by a now-pervasive British hostility to all things French, he thought that Parisian artists "seem to have taken their ideas of grandeur from romances, instead of the Romans." He perceived that "their heroes are decked out so nice and fine, that they look like knights-errant . . . loaded most unmercifully with silk, satin, velvet, gold, jewels, &c." This was a fundamental misinterpretation of the call for a grand style, Reynolds thought. It swung the pendulum from naturalism too far in the opposite direction. This fake grandness "corrupt[ed] true taste [with its] mock majesty and false magnificence."[34]

Reynolds had certainly acquired plenty of opinions during his time away. From an apprentice phiz monger at seventeen and a respectable practitioner by twenty-six, he was now, as he edged into his thirties, a self-declared

instrument of a "liberal art." That is, he styled himself no longer an artisan but an artist-philosopher.[35]

Later in life, as we shall see, his enemies derided Reynolds for parading a flimsy connoisseurship or for spouting pretentious waffle. Many modern readers today would agree with them, assuming—just as these enemies intended—that Reynolds's utterances stood for an old-fashioned view that had always held sway. The historian Vic Gatrell, for example, has scoffed that when Reynolds elaborated his "windy appeals to universal truths . . . he trod, as was his wont, on the very safest ground."[36] On the contrary, Reynolds in 1752 felt himself to be the young blood. His views may have been windy, but they were not yet dominant in the country of his return.

Reynolds's challenge upon resettling, then, was manifold. How was he going to convince the British art world—peers and patrons—to share his new ideas about lofty, virtuous practices? What if no one cared to buy noble homilies about common humanity or civic dignity? And even if they did, what did payment mean or represent if the artist was no longer a mere tradesman but now an intellectual?

Many of these queries boiled down to how well Reynolds could control the Richardsonian resurrection of ancient Roman imperialism. It was becoming increasingly impossible to ignore the fact that Britain was currently on its own expansionist streak. Would the image of Rome necessarily conjure the specter of its downfall? Worse, would too rosy a picture of the Roman empire reveal a rather shabbier version under way in Britain? Joshua Reynolds was poised to find out answers to all these questions and more as he scouted out premises in the city he was to call home for the rest of his life.

If not the center of a vibrant art scene, London at midcentury was nonetheless pulsating with political, economic, and social energy. The king and government were located here. Merchant shipping resided here. And around seven hundred thousand people, or roughly 10 percent of all subjects in the British Isles, called it home. Already famed for its smog, its density, and, compared to the rest of Britain, its ethnic mixture, London society also stood out for its notably large middling class. Between a top 2 percent or 3 percent of aristocrats and many underlayers of plebeians, the middle rank amounted to perhaps 20 percent, far more than in the somewhat equivalent city of Paris.[37]

Reynolds decided to rent a house in St. Martin's Lane, which was situated in the west end vicinity of Covent Garden, an area termed "the world's first creative bohemia."[38] Once an enclave of aristocrats, this snug quarter of a

square mile witnessed, from the decade of the 1750s, the infiltration of more middling- and even lower-class types. From soldiers to taverners, printers to prostitutes, shopkeepers to pornographers, a diverse crowd was edging into the neighborhood, attracted by the well-built houses, just the right distance from the serious end of the city, and centered around a piazza that still bore traces of its original market function. Most of all, Covent Garden attracted artists—engravers, poets, musicians, actors, painters—many of whom still identified as artisans or craftsfolk. Here was a case of gentrification in reverse: the area became more modish the more that the poor pushed out the rich, rather than the other way around.

Except, these new residents were not exactly poor—or they were not poor in the old ways. Their infiltration into the former homes of the aristocracy was one of the clearest domestic effects of Britain's advancing empire. If in Plymouth the most overt sign of increasing imperialism was the buildup of the navy, in London it was the increasing power of middling types due to new disposable forms of wealth now circulating in the country. As global imperial commerce gradually made inroads on local inherited land as the core of Britain's economy, so too did the demands of cashed-up merchants and colonial entrepreneurs based in the empire's capital. These demands were not only for greater influence for themselves. They also entailed generating more avenues in which to conduct imperial commercial business—more physical spaces like coffee shops and pubs and more printed spaces like newspapers and journals. Such avenues in turn proved a boon to all those who could serve these businesses, like waiters, newsagents, retailers, sex workers, and creatives.[39]

Reynolds's decision to reside in Covent Garden may seem an obvious choice, then, for an aspiring eighteenth-century British artist, but it did involve some risk. Social and economic change had not exactly revolutionized the cultural sector. Aristocrats still led patronage of the arts. Nothing was really different in that regard since Reynolds had accepted Keppel's invitation to meet his many aristocratic fellow travelers. Reynolds had been right to assume a need for aristocratic commissions in the foreseeable future. He would need, in other words, commissions from the very rank threatened by all that Covent Garden now symbolized. Negotiating a balance between aristocratic or old-world preferences and the trends of a newly cash-based society encapsulated Reynolds's core professional test for the next several decades.

His first major artwork upon his return from Europe illustrates how well Reynolds would, on the whole, meet that test. Within months of moving into

St. Martin's Lane he hung up in his studio, as a kind of advertisement of a fresh talent in town, a second portrait of his friend Augustus Keppel. This work proved very different to his earlier attempt. Where the first portrait was static, the second was dynamic. Where the first strove for likeness and admiration, Reynolds now depicted a big idea with a vital message. That message concerned exceptional leadership in the face of otherwise overwhelming

Figure 7. Joshua Reynolds, *Augustus Keppel,* 1752.
© The National Maritime Museum, Greenwich, London.

adversity. Posed like the best-known statues of the Roman god Apollo, this Keppel strides clear of a storm that would have surely destroyed lesser mortals. In the middle distance are the remaining shards of a shipwreck, hinting at what such weather does to mere wood and iron.[40]

The influence of Richardson's neoclassicism is evident everywhere in this painting, in the epic sense of movement as well as in the driving deliverance of an uplifting lesson. But crucially, as the scholar David Solkin has noted, neoclassicism is not all there is. The gesture to Apollo is precisely that—gestural. The grandeur of the figure is not so universalized as to negate all sense of time: the gilt uniform, sword, and accoutrements tie the subject to the contemporary British navy in subtle ways. Moreover, most viewers would realize that the depicted shipwreck was not generic but the very one Keppel had survived five years earlier.[41]

Here was neoclassicism but with some critical modifiers. These modifiers lent just enough particularity to the piece to satisfy the vanities of the present and to distract from the more troublesome aspects of the ancient precedent. These troublesome aspects involved *either* Britain failing to meet Roman standards *or* any portent of Britain one day declining too. At the same time, the modifiers were not so distinct that they interrupted the viewer's chief experience of civic uplift. None were so particular, in other words, as to remind anyone that the contemporary British navy was mostly now driven by commercial rather than ideal motives or that the shipwreck had actually involved Keppel in a controversial court martial for loss of ship. The portrait presented the best of the old, smoothed over with touches of the new.

Responses to Reynolds's second Keppel were resounding. His old patron Lord Edgcumbe immediately identified it as something new in British art, with all its parts "so perfectly in union." The landscapist Joseph Farington later recalled that "the public, accustomed to see only the formal tame representations which reduced all persons to the same standard of unmeaning insipidity, were captivated with the display of animated character." The writer Edmond Malone agreed, pointing to the work as the one that catapulted Reynolds straight to "the head of his profession."[42] Quickly, a cheap printed reproduction of the portrait circulated about London, both fulfilling and fueling further interest.

Reynolds had pulled off his first test to a tee. He had successfully balanced his beloved theories with the contrary whims of a changing age. He had brought about a unique convergence of Richardsonian precept with a few canny observations of incipiently imperial Britain—those first gathered in

naval Plymouth but now clarifying in mercantile London. It was a winning recipe, one he was to apply to multiple situations into the 1750s.

To Reynolds's studio now flocked the most fashionable and flamboyant people of the land, all wanting images of themselves as if they too had just stepped down from Mount Olympus into a palatable vision of imperial Britain. From his daily pocketbooks we learn that after the success of the second Keppel painting, Reynolds was confident enough to charge the same prices as his one-time master, Thomas Hudson. Over the next five years Reynolds would more than double those prices.[43]

Through this decade Reynolds worked fiendishly, often seven days a week in eight-hour blocks at a time. Sitters usually stayed for one hour. Each required several separate appointments. Other portraitists at the time complained of a lack of commissions, but Reynolds by 1753 was humblebragging to a friend that he scarcely had time to write a letter.[44] His clients included dukes and duchesses, lords and ladies, MPs, and the ever-steady supply of naval officers as well as, increasingly, merchants, lawyers, actresses, courtesans, and colonial administrators. Reynolds's charismatic style was seductive enough to brush over social discrepancies.

Within a year Reynolds had moved to the better address of Great Newport Street, two blocks north of St. Martin's Lane. To cope with his quick establishment, his unusually heavy workload, and the studio move, Reynolds employed an Italian teenager called Giuseppe Marchi. Reynolds had met Marchi in Rome, bringing him home, along with several trunks of notes and sketches, to work as his assistant. Whatever Marchi's own painterly aspirations, he ended up staying with Reynolds for the rest of his master's life, serving as studio technician, secretary, model, copyist, and main finisher of works.

Some modern historians have speculated about Reynolds's relationship to the young Marchi, as indeed they have about his earlier connection to the handsome Keppel. Reynolds's lifelong bachelor status has only added to their musings about his intimate preferences. If those musings had circulated in Reynolds's own lifetime, it would have entailed a far greater risk than choosing to live in Covent Garden. Sodomy had been a capital offense in Britain since the sixteenth century. Even the rumor of homosexuality would have killed Reynolds's career. In the private realm, though, Reynolds seems, as in public, to have engineered an appropriate balance for his shifting era. He lived an intensely homosocial life but avoided any overt association with

homosexual culture. That is, all his close friends were men, but he never generated malign gossip about his relations with them. He dined, clubbed, and holidayed almost exclusively with men but was never linked to any known homosexual venues. He did paint some suggestive works in later life, such as *Cupid as a Link Boy,* which depicted a young male street cherub holding a phallus-like torch. But these were produced to gratify clients—in this case, Lord Sackville—before his own erotic inclinations.[45]

One of the reasons Reynolds escaped censure for his preferences was that the figure of the committed bachelor was itself undergoing transformation. Where an earlier age might have raised eyebrows at such a man, chiefly for his suspected unproductivity, the British eighteenth century found new value in him. Bachelors in this era generated conviviality. With their male privilege and fewer familial obligations, they had the power and time to set up social clubs, frequent the burgeoning coffee shops, host dinner parties, and support the latest periodical. This kind of conviviality was proving crucial to a commercializing society. The domestic end of imperial commerce needed not only fresh spaces in which to make transactions but also fresh ways of meeting, judging, and forging future prospects. Where the old model of landed wealth needed only to know pedigrees, a fledgling trading society required access to individual characters, connections, and appearances. Those who provided the means for these new imperatives gained proportional kudos.[46]

All the same, as Reynolds was coming to know very well, no society changes overnight, and the transition from landed wealth to a commercial economy was jagged, loopy, and, even by the end of the eighteenth century, far from complete. What was really needed in the 1750s were convivial bachelors who were never so overt in their identity that they reminded anyone of why London was now more sociable—or, for that matter, of why Britons had for so long distrusted all-male worlds. Reynolds was not simply the beneficiary of historical change. He was also active in carving out a peculiar niche for himself that was almost exclusively male and yet simultaneously inoffensive. Just as he managed to live in a confronting neighborhood without confronting anyone, and just as he was pulling off neoclassical portraits while dodging neoclassical problems, Reynolds pursued a homosocial lifestyle free of otherwise likely disapproval.

A later friend once pondered Reynolds's uncanny ability to strike such happy balances in his life and work: "Every thing turned out fortunately for [Reynolds] from the moment of his Birth to the hour I saw him laid in the Earth."[47] This observer ascribed such outcomes to luck, but the scholar

Richard Wendorf has wondered if it was not due to something more consciously fashioned. Wendorf has offered Reynolds's famous affability as the key to his personal success. He notes this was a quality crafted with deliberation in adulthood. Certainly it was the feature that Reynolds's contemporaries most often noted in him from this period.

"He was blessed with such complacency and equality of temper," declared Malone, adding that Reynolds was "so easy, so uniformly cheerful, so willing to please and be pleased." To Malone, in fact, "Not to have loved as well as admired him would have shown great want of taste and sensibility." The memoirist James Boswell agreed. He dedicated his landmark *Life of Samuel Johnson* to Reynolds because he thought him the "most ingenious and amiable man."[48]

Reynolds's students remarked similarly upon this feature. Farington thought that "placidity of temper may be said to have been his characteristic." James Northcote felt his teacher was most distinguished by a "great equanimity"—an attribute he also felt, nonetheless, was nurtured rather than innate: "He had studied himself thoroughly."[49]

From within Reynolds's innermost circle, the novelist Oliver Goldsmith put it more cheekily. When he and Reynolds were drunk together one evening, Goldsmith penned a mock epitaph for his friend:

> Here Reynolds is laid; and to tell you my mind,
> He has not left a better or wiser behind;
> His pencil was striking, resistless, and grand,
> His manners were gentle, complying, and bland.[50]

Immersed in a mainly male social set and yet free of homosexual innuendo. Resident in one of the most upstart areas of Britain but still lauded by the establishment. Perfecting an art practice that pleased both patrons and principles. Reynolds's shrewd affability, a decidedly adult-aged acquisition, was taking him far in an intricately transforming society.

Reynolds's social set was not just principally male. It was also dominated by literary and performing artists. Together with Goldsmith, Reynolds counted among his closest London associates the musician Charles Burney, the actor David Garrick, and, always, many writers, including Laurence Sterne, Horace Walpole, and John Hawkesworth. The absence of fellow painters from this list of bosom comrades reflected less a sense of jealous competition and more Reynolds's conviction that few British painters yet engaged much with ideas. His commitment to a philosophical approach to art never wavered

after he came home from the Continent. In midcentury London he felt this was shared only by those who dealt in words, notes, or performance rather than in canvas, metal, or stone.

Without doubt the two most influential male philosophical friends in Reynolds's life were the famous writer-lexicographer Samuel Johnson and the famous writer-statesman Edmund Burke. Usually Reynolds's biographers present one or the other of these formidable men as his primary personal anchor. This is because Johnson and Burke were so different from one another in political renown that it has been hard to reconcile equal attractions to them. Johnson was haphazardly Tory, which meant he favored the older ways of British society, that is, landed royalist hierarchy but also peace and stability. Burke was one of the best-known Whigs of the age, which meant that, while he respected the principles of the British past, he supported parliamentary checks on royal power and the promotion of British liberties at almost any military cost. Despite their differences and despite their own strained relationship with each other, Johnson and Burke shared top billing in Reynolds's heart from the mid-1750s. As Burney once observed, "He had a true veneration for these 2 great men."[51]

Taken together, Reynolds's parallel friendships with Johnson and Burke offer a telling glimpse into the artist's developing political profile. That Reynolds even held political views might have surprised his earlier chroniclers. Few art historians, too, mention his politics, following implicitly the trail that Reynolds himself laid down, which was to appear far too congenial and conciliatory to get involved in the muck of partisanship.[52] Some emphasize either his Johnsonian or Burkean friendships to imply that he was either latently Tory or circumstantially Whig.[53] Instead, though, it's possible to read Reynolds's politics as a telling and continuing, if also jarring and rare, combination of views. All the same, where combination (or at times fluctuation) might trip up other people, Reynolds, as ever, turned it to his advantage. At the least he prevented his mixed politics from harming his reputation.

Reynolds met Johnson sometime in 1755, after which they communed almost daily until Johnson's death twenty-nine years later. The two recognized a shared middling and regional background, even while their connection was based more on oppositions than on similarities. In place of Reynolds's famed serenity, Johnson was fiery, manic, randomly abstemious, and prone to fits (he was posthumously thought to have had Tourette's syndrome).

To Reynolds, Johnson was simply the man who "qualified my mind to think justly."[54] Johnson's attachment to aspects of old, landed British ideals fit

well with Reynolds's neoclassical leanings. If not wholly on board with the Tory defense of monarchical and inherited powers, Reynolds did sympathize with Johnson's ideological wariness of overextension, commercial vulgarity, and the lust for luxury. These were, after all, archetypal ancient Roman fears as well.[55]

To Johnson, the attraction probably had more to do with Reynolds's everyday patience. Johnson was well known to suffer from what he called "mad melancholy," but only Reynolds seemed to understand that "solitude to him was a horror."[56] Most evenings after they had dined together at Reynolds's house, Reynolds would accompany him home in his own coach to assuage Johnson's fears. An observer once noted that Reynolds "never lost his temper" with Johnson even though he could be "sometimes so violent as to treat him harshly or unworthily."[57] Johnson rarely expressed his feelings about Reynolds, but one time when he learned that Reynolds had been ill he wrote to him, "If I should lose you, I should lose almost the only man whom I call a Friend."[58]

Reynolds met Burke about a year after he met Johnson, probably through their shared connection to the staunchly Whig Augustus Keppel. While Reynolds didn't dine with Burke as frequently as with Johnson, he was a regular guest at Burke's country estate in Beaconsfield. After Johnson's death in 1784, Reynolds made Burke his executor, and in his will, of all his many bequests to friends, he left Burke the largest.[59]

Burke, too, was from a middling background, though unlike Reynolds and Johnson he was born across the Irish Sea, in Dublin, of mixed-faith parentage. In temperament Burke was a lot like Johnson, strident, forceful, loud, though not as mutable. Reynolds's respect for him, as for Johnson, was primarily intellectual. As one observer noted, Reynolds "was never weary of expressing his admiration of [Burke's] profound sagacity."[60] Most of that regard centered on Burke's Whiggish commitment to checking monarchical and ruling-class ambition, especially when it entrenched privilege so severely as to curtail the progress of middling types like himself. Johnson believed it went further than admiration, at one point complaining that Reynolds was "too much under . . . Burke"; that he was indeed "too much under the *Irish constellation.*" Then again, Johnson sniffed, Reynolds "was always under some planet," attacking the very attribute of devotion that glued Reynolds to himself in other ways.[61]

Burke's fondness for Reynolds, like Johnson's, centered on his steady character. In his later published eulogy, Burke extolled the "even tenor" of Reynolds's demeanor. Interestingly, Johnson's gentle sense of rivalry with Burke

over Reynolds seems to have been returned. Burke once noted that Reynolds always attended "to the writings and conversation of Johnson . . . when Johnson neither understood nor desired to understand anything of painting."[62]

Where the two titans Johnson and Burke really clashed was over empire. It is here that any easy mapping of Toryism and Whiggism onto modern notions of conservatism or progressivism falls apart. Johnson defended British monarchy against Whig suspiciousness and thus mistrusted the Whig government's relentless push into fresh imperial trades and wars. He thought territorial colonists were mostly thieves and slavers, which is why he particularly spurned the American settlers who would later cry their "yelps for liberty."[63] Burke believed that parliament should moderate monarchy and so found in the current Whiggish parliament's expansionist vision a means of consolidating its power against the threat of royal tyranny. Precisely because the future American revolutionaries spoke his language of liberty, Burke would come to side with their cause as a credible defiance of arbitrary rule.[64]

If Reynolds had a tricky time handling the contrary temperaments of his two closest friends, he was much more pressed to steer a path between their different takes on imperial propriety. By 1756 this had become an unavoidable challenge. Till now, some had been able to downplay the rise of British imperialism, but the latest outbreak of war put it squarely under everyone's noses. Two years earlier Britain and France had renewed their old hostility, starting in North America (where it would touch Ostenaco and many other Cherokees). Now, it had spread to Europe. Soon, it would infect colonies in Asia and Africa. It later became known as the Seven Years' War. The scale of this conflict broke every national record: it grew Britain's military by nearly 50 percent and raised its overall debt by over 70 percent.[65] Most of all, its global nature forced Britons, whether they liked it or not, to recognize the huge extent of their claims. Some now sounded ancient alarms about overextension, overweening aggression, and overstretched resources. Others, conversely, tried to rationalize the war's mission as something new rather than something returned, as the necessary price for the consolidation of cosmopolitan wealth unique to the eighteenth century. Either way, public discourse zeroed in during the mid-1750s on the nation's overseas activities.

Johnson voiced his disgust with the imperial connotations of the war early on. In 1756 he published an article denouncing France and Britain equally. "Neither can shew any other right than that of power" to their colonies, he argued. And neither can occupy them "but by usurpation, and the

dispossession of the natural lords and original inhabitants." Usurpation and dispossession had involved, Johnson was quite clear, either violence or fraud. He found that "no honest man can heartily wish success to either party."[66]

Burke shared the more prevalent view that the war should be fought gamely in order to secure British expansion. Perhaps more subtly than other supporters, he also thought that the point of British expansion was to spread peaceful constitutional government rather than merely add notches to belts. But his 1757 history *European Settlements in America* was adamant that British victory was crucial: it was imperative to strengthen British opportunities, to curb "intestine" violence between Indigenous peoples, and most of all to rid the world of despotic French oppression.[67]

In keeping with his conciliatory persona, Reynolds did not presume to enter the fray with the tools of his famous writer friends. However, a painting he undertook in 1756 suggests something of how he did approach the new war for empire. His portrait of the British army officer Capt. Robert Orme revealed a curiously dual attitude to the resumption of fighting. As was now becoming his trademark, Reynolds executed this two-way position with more flair than flailing.

Orme had been an aide-de-camp to Gen. Edward Braddock during the notorious Battle of Monongahela in Pennsylvania one year earlier. Then commander in chief of British armed forces, Braddock had tried to take a French fort with a loose conglomeration of regulars and colonial militia. Unable to attract native recruits, he found that his force was quickly outmaneuvered by French soldiers and French-allied Indians. Under ambush, most of Braddock's men deserted. More than one quarter of the two-thousand-strong British contingent died on a single day. Braddock himself died—possibly shot by one of his own.[68] Orme survived to deliver the news in person to the London public. His message told a grim tale of Indian brutality, though many readers glimpsed as well in his story an even grimmer suggestion of British incompetence and cowardice.

Orme was not, then, an obvious choice for a portrait in the mid-1750s. One year later, Braddock's Defeat, as it became known, still reverberated for Londoners as a hot mess of shame, anger, humiliation, and nagging questions. Twelve months on, Britain's prospects for overall victory had not noticeably improved either. Yet Reynolds's portrait seemed to appease all pundits: he addressed in apparently acceptable measures both the jingoistic and the anxious responses to the battle current among his contemporaries.

Figure 8. Joshua Reynolds, *Captain Robert Orme*, 1756.
© The National Gallery, London.

The dominant mood in the work is heroic glorification. The captain's long, youthful figure proudly displays the red coat of his regiment and easily dominates his accompanying beast and surrounding environment. All the same, as the scholar Mark Hallett has implied, in the background swirls the undeniable smoke of bitter conflict, rising upward to darken the sky. The "grotesqueries" of the battle are muted, but they make their mark. Hallett has

pointed out how this mixed attitude of "inviting a visual shuttle" between moods is repeated in Orme's facial expression. The illuminated right half is all "resolute and reassuring." But the shadowed left half is distracted, unnerved, strained.[69]

While Hallett goes on to argue that Reynolds's dualism here was between pride and worry, between a celebration of military prowess and a concern that it might not deliver, it's also possible to interpret the viewers' "shuttle" more broadly. The heroic elements accorded with Burkean ideas about the certain, if solemn, duty to win imperial wars. The anxious elements echoed more Johnson's critique of the whole business of fighting for unceded lands, of allowing riches to justify bloodshed, and of setting oneself up for a fall. The difference between the political positions in Reynolds's Orme was wide, reflecting the extent of dissent about imperial matters in 1750s Britain.

The work also reflected Reynolds's uncanny ability to span radical oppositions. Unlike Johnson or Burke, who perhaps had more charisma or resources to protect themselves or didn't care, Reynolds managed to enflame none and placate all. No viewer at the time read the piece as partisan in either direction. Instead, viewers saw it confirming either one of their already preconceived prejudices. A journalist for Lloyd's Evening Post, for example, thought it showed "all that fire [that] love of his country can give: in the background, a view of a skirmish." On the other hand, Reynolds's student and neoclassical devotee Northcote found it a "very sombre picture." Once again Reynolds had appealed across the political spectrum against unlikely odds.[70]

War raged on through the rest of the 1750s. Only in 1759, though, did British forces start to gain noticeable traction. That year the British secured decisive wins inland in Prussia and at sea off Portugal and France. They captured the strategic colony of French Guadeloupe in the Caribbean. They averted a planned French invasion of their own shores as well as a French siege of their key hold in Madras in India. They welcomed home strategic booty won by seizing French holdings in Senegal and Goree in Africa. Most spectacular of all, they received news of Gen. James Wolfe's victory in Quebec City, striking a huge blow to France's center in North America.

So great were the victories of 1759, indeed, that Prime Minister William Pitt ventured to call it an "annus mirabilis." Those Whigs and others who had always supported the war's imperial goals now raised their jingoism to the next level. Even some Tories and fellow doubters softened in the face of such

triumph. "Our bells are worn threadbare with ringing for victories," declared the writer and Whig politician Horace Walpole. The essayist Catherine Talbot, usually aligned to Johnson's set, penned a letter to a friend applauding the "series of successes and mercies! . . . Nothing could be cheerfuller."[71]

Against this tide of self-congratulation a few holdouts stood their ground. One, in fact, was the recipient of Talbot's letter, the poet Elizabeth Carter, another of Johnson's associates. She chided Talbot in reply, writing that, still, "One must and ought to shudder at the calamities of war."[72] No one, however, was less impressed than Johnson himself. That year he published his first piece of fiction, a novella called *The Prince of Abissinia,* which took explicit aim at the legitimacy of European occupation in "the Orient." He also wrote a vehement article in *The Idler* in the supposed voice of a Native American. The narrator here, after describing the staggering violence, enslaving callousness, and deceitful treaties of the Europeans in America, casts a cool eye over the current war between the colonial rivals: "The time, perhaps, is now approaching, when the pride of usurpation shall be crushed." This was because "the sons of rapacity" have turned on each other. "Let us look unconcerned upon the slaughter," the Native American narrator advised. "Let them then continue to dispute their title to regions which they cannot people [and] to purchase by danger and blood the empty dignity of dominion over mountains which they will never climb."[73]

Reynolds could not have been in any doubt about his friend's angry views on the year's outcomes. They were some of the most extreme of the age. Still, he would also have known that most of his circle was delighted in 1759. Burke articulated the general gladness when he noted that Wolfe's victory especially was "joyful news," even while it occasioned some gloom to think of the general's own death in the venture.[74] Most of the intelligentsia of London were so delighted, in fact, that they started to ponder the kind of arts scene that Britain might or should have if it ended up truly master of the world. Did a superpower not warrant, perhaps even require, a national arts scene comparable to that of the best ancient empires? The stronger Britain's own position, it seemed, the proportionately less concerned Britons were with the problems of the ancient Roman example.

Even Reynolds's supposedly plodding fellow painters started thinking this way. In November 1759 a group of them met at an annual artists' dinner to discuss a proposal to lift the profile of British visual arts to match the nation's impending glory. Given the mixed chatter about glory among his particular intimates, however, Reynolds must have gone along to this dinner with some hesitation.

The initial artists' proposal sought the establishment of a "public recep-
tacle to contain the works of artists for the general advantage . . . of the Na-
tion." One of the attendees had already composed a poem to accompany
their discussion, which apparently all sang at the dinner's conclusion:

Tho' long, too long, had grandeur seen
The blooming arts uncherished die;
Yet now aspiring, their aspect's more serene,
For affluence looks with wisdom's eye
Soon shall the globe confer Britannia's charms
All glorious in her arts as arms.[75]

It was not quite the aspiration to civic virtue Reynolds had been working
toward. But it was at least an idea. And who knew what later, grander, more
powerful schemes might come of it? Cautiously, he put his name forward as
one of several endorsers.

A week later Reynolds joined thirty other painters at the Turk's Head tav-
ern a few blocks from his house. The group decided, for now, that the desired
"public receptacle" ought to be an open exhibition, held every spring and
funded independently by the participants.[76] As surprising as it may seem to-
day, such an event would constitute Britain's first ever public contemporary
art show. The organizers were not to know that it was the genesis of a perma-
nent national institution for art.

The independent nature of the planned exhibition was crucial. The ma-
jority of the Turk's Head artists saw that for their works to align with the na-
tion's looming superpower status, they needed to avoid any overt connection
to royal patronage. Britain's aggressive, future-oriented empire was always
more associated with its Whiggish parliament than its Tory-defended monar-
chy. Moreover, Whiggish artists had long linked royal patronage to the French
whiff of tyranny: they knew that public art spaces existed in France but felt
these were always compromised by their obligations to an absolutist king.

Reynolds helped the group secure good premises for the exhibition near
The Strand, just east of Covent Garden. He arranged them via his connection
to an already existing civic organization. This organization was generous with
its loan, though insisted on one proviso. The exhibition must allow visitors in
for free. The condition rankled most of the artists, who had hoped to charge a
small sum for running costs and, as they claimed at the time, for alms to col-
leagues of "Age and Infirmity." They could still make some money through sale

of a catalogue but nothing else to generate funds. In the end the deal was too sweet to ignore; the group accepted the rooms and consented to free entrance.[77]

The show opened on 21 April 1760 and proved to be a decent success. Contemporaries estimated an attendance of around one thousand people per day over its three-week existence. All levels of London society turned up, from aristocrats to middling types to "menial servants and their acquaintance."[78] The press, never having covered a contemporary art show before, produced only a few reviews. One, though, was especially taken with the contributions of Mr. Joshua Reynolds. "This gentleman," it began, "whose merit is beyond anything that can be said in his commendation, has obliged the public with four pieces of his hand." Together they testified, so thought the reviewer, to the presence of "a perfect painter . . . one living proof that . . . Englishmen need not travel abroad to see fine things, would they but always study to cultivate and encourage genius at home."[79]

Reynolds was certainly riding high by 1760. That year he moved once again. The new house was his fanciest yet, a four-story mansion in what was then named Leicester Fields (today's Leicester Square). Though still within the Covent Garden region, the superior address signaled Reynolds's true arrival: not just of his artistic self to the top echelons of painters but also, in a way, of his artistic approach to the center of British culture. His brand of neoclassicism was winning the hearts and minds of the city's growing viewing public.

The following spring the Turk's Head artists sought to stage a second exhibition. At this point, though, a split emerged among them. The dividing issue was the entrance fee. A majority were still smarting over the open-door proviso of the previous year and insisted in the future on being able to charge for admission. They were prepared to find a different venue if necessary. A minority disagreed, for various reasons, and wanted to stay with the Strand location.

The passion with which the majority argued their case suggested that running costs and collegial charity had not been the only objectives for fundraising earlier. Now they claimed that the first exhibition had suffered from being too "crowded and incommoded by the intrusion of great numbers whose stations and education made them no proper judges of statuary or painting."[80] A modest entrance fee, they suggested, would help keep out the lowest rungs of society. It would serve as a blunt tool, in other words, for engineering an audience that was broader than royalty and aristocrats but not so broad as to offend royal or aristocratic tastes.

The dissenting minority contained a range of responses: a few proto-radicals disliked the idea of a fee because they disliked any form of social exclusion; the rest, having rather different sensibilities, shunned it because they feared being associated too closely with the baseness of commercialism.[81]

Unsurprisingly, Reynolds sided with the conciliatory majority. He threw himself into helping this faction secure new premises in Charing Cross. Finding a place that would allow the right price for admission chimed perfectly with his two-way attitude in so many things. In this instance the fee needed to be just high enough to generate sufficient funds for independence and to cut out those lowly types who reminded Britons too much of the leveling effects of commerce. At the same time, the fee needed to be just low enough to welcome some enlargement of art's traditional clientele and, in some nod to the naysayers, to avoid seeming too money-focused themselves. Reynolds's majority faction at this point formally split off from the remainers and named itself the Society of Artists of Great Britain. It opened its second annual show on 9 May 1761. The price of admission was one shilling, around half a laborer's daily wage.[82]

The story of the remaining rump illustrates neatly not only Reynolds's knack for backing the right horse but also something of what was at stake for artists who did not. The motley bunch of painters who refused to move to Charing Cross now named themselves, in pointed defiance, the Free Society of Artists. In the same week, they opened a rival show in the old Strand venue, with no charge for admission.[83] Reviewers were less impressed with this rival group. Where they raved about the ticketed Charing Cross exhibition, which "filled the heads of the artists and lovers of art" and helped raise the reputation "of the English school," the free Strand show appeared overrun by "the most baneful, idle, insolent banditti." One visitor complained vividly of the sweaty rooms at the latter exhibition, the choking "clouds of dust," and the elbows everywhere, "as if in Bartholomew's Fair."[84] The Free Society of Artists lost its Strand venue a few years later and never emerged as a leading voice for British art.

Reynolds's Society of Artists, conversely, went from strength to strength. By 1762 its exhibition catalogue was confident enough to state plainly its rationale for the entrance fee. Art suffers, it explained, when "spectators assemble in such numbers as to obstruct one another." Besides, as "every one knows . . . all cannot be judges or purchasers of works of art." The experience of 1760 and the Free Society's later gamble had shown that when there are huge crowds at a show, it not only makes access dangerous but it also frightens away "those whose approbation [is] most desired." To the lingering

skeptics, both those who rolled their eyes at such pretensions and those who sniffed at the optics of high-minded artists scrounging for money, the catalogue delivered its final word: "The purpose of this exhibition is not to enrich the artists but to advance the art." Advancement, the society was equally clear, required an audience that could recognize merit. This was a quality unlikely to emerge, regretfully, from the uneducated masses.[85]

Rumors at the time fingered Reynolds as the actual author of this catalogue or at the least whispered that he'd got his wordsmith friend Samuel Johnson to pen it for him.[86] Reynolds never confirmed the speculation either way, but the catalogue's sentiments do fit him precisely. His Whiggish sensibilities rejoiced in the society's efforts to carve out a nonroyalist public space for art. But his Toryism was loath to see art reduced to the same level of commodification that Whiggish imperial commerce foretold. And, while he fervently believed that art had the capacity to raise viewers to the consideration of greatness, he never said that *all* viewers were capable of being thus raised.[87] Like Reynolds's take on neoclassicism, the Society of Artists' exhibitions promised to cater to older prejudices even as they stretched to accommodate some new conditions of the age.

Reynolds had sent in five works to the 1761 Society of Artist's second show. He submitted four to the third exhibition of 1762. This show was adjudged the most successful yet. All spectators were "highly respectable," a reviewer noted, and each was "also perfectly gratified with the display of art which, for the first time, they beheld with ease and pleasure to themselves."[88]

During the three years of these earliest contemporary art shows in London, British forces had continued their campaign for global imperial supremacy, though it had not all been smooth sailing since the Year of Wonders. Granted, there were additional victories in Montréal, Pondicherry, and Havana, but there had also been fresh setbacks in Martinique, Prussia, and Spanish mainland America, not to mention in Cherokee country in the southern Appalachians. Unexpectedly disconcerting had been the coronation in late 1760 of a new British king, a young George III ascending after the death of his grandfather, George II. The new king seemed decidedly less pleased with the endeavor of world war than his parliamentarians wished. He annoyed them with talk of pulling out of the European theater and with his grumbling over the cost of it all. The effect of these highs and lows, after now several years of warfare, was to harden the apologists' position and to return dread to the original doubters. Division about empire was back in Britain's public sphere.[89]

Against such a backdrop Reynolds's contributions to the exhibitions of the early 1760s are intriguing. Whereas most others, in either artists' society, now submitted sweeping images of Greco-Roman landscape or the goddess Britannia in victory pose, Reynolds sent in notably circumspect works.[90] He may have become an enthusiastic proponent of British visual culture, but he still could not, it seemed, shake his fundamental political ambivalence about Britain's imperial direction. Of the thirteen portraits he presented over three years, only four addressed directly the ongoing war for empire: in 1760 he had offered pictures of two high-ranking officers from the European theater, and in 1761 he had sent his Orme portrait as well as a depiction of a field marshal. In 1762, even more notable, Reynolds gave no works related to imperial warfare at all.

All four of the submitted imperial portraits harbored reservations. The 1760 works were of Lt. Col. Charles Vernon and Lt. Gen. William Kingsley, respectively. Both men had just served on the Continent. Both appear with some undoubted aspects of grandeur, indicating successful missions. Vernon is in anachronistic armor, chin uptilted, with right hand resting on his gleaming helmet after a job well done. Kingsley, older, is in contemporary clothing though richly decorated in fine golden embroidery and large, shining buttons. But each man is also decidedly somber in countenance and coloring. Vernon glances over his shoulder to the viewer, turned momentarily away from a smoldering gray scene of battle to which he may be forever tied. Kingsley's expression is even graver, his left side almost completely shadowed in darkness.[91]

The two 1761 offerings were similar. Orme's portrayal, as noted, contained mixed messages on the North American theater. Its pair, that of Fd. Mar. John Ligonier, was nearly as conflicted. Although eye-catching in pose, with the officer bedecked in glinting brocade astride a bucking horse, the picture contained some counternotes. Ligonier was nearly eighty years old when depicted. Both his weighty stomach plate and the clear scenes of chaos in the background offset the otherwise obvious show of leadership. While Reynolds's colleagues might have been looking forward to ultimate triumph, the painter's recently displayed work did not convey resolute confidence that such a result would be either assured or righteous.

That Reynolds sent in no war-related portrait in 1762 was especially telling. Instead, he included works of his actor friend Garrick; one of Keppel's sister Elizabeth (a recent bridesmaid to the new queen (see fig. 10); and one of Walpole's niece, the Countess Waldegrave. His fourth was unacknowledged,

though most saw it as coming from Reynolds. It was a portrait of the courtesan Nelly O'Brien, the well-known mistress of a viscount long associated with Tory principles.[92] Pro- and anti-imperial inclinations abounded in such choices, even while all seemed on the surface scrupulously apolitical.

No one at the time mentioned how Reynolds's offerings over the last three years added up to any mixed messages on the question of empire. Nothing, in fact, interrupted the tides of praise now being heaped upon the man. This does not mean, though, that a conflict didn't exist in the combined proffered faces. It was the same dualism that underlay Reynolds's own charming and ever-lauded persona. The opposing views of Johnson and Burke continued vying within Reynolds during the war's later years.

As Britain headed into its seventh year of warfare (or ninth, depending on how one measured it), did Reynolds start to feel the burden of his confused sentiments? Northcote noted that he suffered from poor health through the spring of 1762, reckoning it owed to "incessant application to his profession."[93] We might wonder, instead, if there was a more general current of malaise at the time for anyone touched by caution about the state of the nation. Johnson certainly seemed to be battling writer's block that season.[94] Perhaps this is why Reynolds decided now to scout out an entirely different type of sitter. Perhaps he sought through such a subject a way to clarify his perspectives or to explore them freshly. After all, there were only so many military officers one could portray in a modified neoclassical mode to evoke both triumph and doubt simultaneously. A new kind of figure might push Reynolds to a wholly other viewpoint.

A Cherokee Envoy and the Portrait That Failed

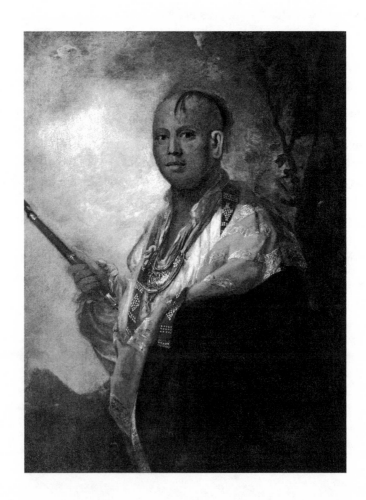

Back in Williamsburg, Virginia, Governor Fauquier was writing his letters of introduction for Ostenaco's trip to Britain. To the Board of Trade in Whitehall he explained that the warrior's journey would do more than secure peace in the southeastern colonies. It would surely keep the Cherokee people "in order" if one of their most esteemed leaders was "personally informed of the number of our people, the grandeur of our king, and the great warlike power we had at our command."[1]

As for Ostenaco's motives, the governor assumed he was simply jealous of his peer, Attakullakulla, who had journeyed to Britain thirty-two years earlier. He thought the utsidihi wanted to match his rival's status by making his own trip. Historians have often repeated this assumption that Ostenaco rivalled Attakullakulla, but little proof exists for the claim. While colonial officials were busy plotting complex acts of diplomatic theater, they rarely considered that Cherokees were doing the same.

To the secretary of state for American affairs, Lord Egremont, the governor wrote separate letters. In one, he introduced Ostenaco as the "skiagusta," or head warrior, of the town of Tomotley and mentioned that he would be accompanied by "two of his followers."[2] The records are never clear about the identities of these two additional Cherokee travelers. The first was called both Stalking Turkey and Cunne Shote. His name almost certainly referred to some iteration of turkey (*guna; kala*) and his hometown of Chota. The second follower was known as Pouting Pigeon, or Woyi (the Cherokee word for pigeon), though little else remains to distinguish him.[3] Whether Ostenaco chose these two men or they chose themselves is also unclear. Whatever the circumstances, all three seemed to work well as a team throughout the journey, with the utsidihi always the unquestioned leader.

In the other letter to Egremont, Governor Fauquier explained the presence of Henry Timberlake. He clarified that the soldier would be traveling with the Cherokees at his own expense. Timberlake apparently wished to serve the empire by giving these Indians the best impression of British "wealth and power," though naturally he hoped he "might meet with some recompense." Fauquier left the escort's financial fate at that, "recommending him to your Lordship's Favour."[4]

Figure 9. Joshua Reynolds, *Scyacust Ukah*, 1762. Reproduced with permission from the Gilcrease Museum, Tulsa, Oklahoma, acc. no. 0176.1017.

Timberlake's decision to accompany the Cherokees was a gamble. He made much of it in his subsequent memoirs, claiming that he'd given up a promising business deal to "please the Indians" and to "preserve" them from going over to the still-problematic French. No doubt he thought he'd garner something better from the secretary of state if Ostenaco proved a welcome visitor.[5]

Just as two fellow Cherokees accompanied Ostenaco on the journey, two fellow colonists traveled with Timberlake. These were Thomas Sumter, who had been with Timberlake as his military junior during the trek into the Cherokee Overhills (both soldiers were around twenty-eight years old); and William Shorey, an older man and also harder to place in the colonial landscape due to his twenty-year marriage to a Cherokee woman. Like Timberlake, Sumter was a volunteer for the trip, adjudging that its success would boost his army career. Shorey, though, was an official appointment—his fluency in the Cherokee language made him an essential component of the mission.[6]

The six adventurers sailed together from Virginia on 15 May 1762. Governor Fauquier had arranged their berths aboard a sixteen-gun sloop called *L'Epreuve*. Each man harbored diverse hopes and fears in his breast for the journey ahead. Sumter dreamed of professional promotion while Timberlake sought more material and political gains. Shorey's motivations are a bit hazy. Possibly his long-standing connection to the Cherokees made him more interested in ensuring Ostenaco's position in London than the colony's. Similarly, Cunne Shote and Woyi remain opaque. They may have seen themselves as the latest versions of Attakullakulla back in 1730, young men rounding out the entourage of a more senior body.

The more senior body in this case was Ostenaco. His dreams were of a diplomatic nature. On the face of it, he was traveling to nail down a peace after an especially terrible war. Many observers, then and later, assumed an ulterior ambition to turn the experience into personal leverage. Ostenaco's actions over the long term, however, suggest instead a wish to remake the Cherokees' defeat into something usable for a larger collective. At the heart of Britain's empire, this Indigenous envoy would remind his former foes just how immersed in native machinations they yet remained. For his own people, he would learn as much as possible about the British in Britain so as to protect Cherokees further in future relations.

The three Cherokees were seasick for the whole four weeks of the voyage. A much worse calamity, though, was the death of the interpreter, Shorey, midway across the Atlantic. Timberlake diagnosed Shorey's fatal condition as

consumption, contracted earlier by following the Cherokee practice of cold-water dunking. More likely, Shorey was just a victim of the 80 percent greater chance that British men bore in the eighteenth century of dying at sea than on land. Certainly contemporary Cherokees thought their river bathing helped to bolster health rather than endanger it.[7]

Either way, Shorey's demise had far-reaching implications for the overall mission. The party suffered notable communication mishaps during the next five months—politically and socially. Whatever these mishaps meant for the success or contours of the trip, they show indirectly just how much the British empire depended on interpreters. Most of what we know about Ostenaco's utterances comes from records informed and often even written by transla-tors. Understanding this process defeats any sense of pure access to the past. But then most of what we know about colonial utterances also passed through scribes or other filters of officialdom. Viewed another way, the existence of interpreters throughout colonial America reveals how extensively Indigenous people forced imperialists to adapt to their presence rather than ignore or run roughshod over it. No colonist could afford to neglect Indigenous linguistic imperatives. None was able to insist on using English only.

On board *L'Epreuve*, Ostenaco perhaps foresaw the potential problems of losing Shorey, or maybe he was just sad to lose an ally. He bore a notably solemn demeanor by journey's end. When the vessel pulled up to harbor in mid-June, the utsidihi broke into a low and loud dirge. His face dramatically darkened with ochre, his mournful sounds and upright stature made a deep impression on the locals. "A vast crowd of boats" drew up alongside theirs, Timberlake reported, and the dock was so "thronged" with pedestrians that they barely managed to disembark at all.[8]

The dock in question was none other than Plymouth harbor, the port town of Reynolds's youth. Joshua Reynolds was not among the crowds that day. He was in his London studio picking up his routine of appointments after the festivities of the third annual artists' exhibition. His later encounter with Ostenaco, however, suggests that he shared much of the popular sense of wonder about the Cherokee arrivals.

Despite the bustling crowds surrounding the three Cherokees, Timber-lake did eventually manage to break open a path to an inn. There, he secured two carriages and set everyone off to London at once. The journey took a full night and day, pausing only briefly at Exeter and Salisbury. The Cherokees seemed unimpressed with the famous cathedrals in either town, though on-lookers in Salisbury were clearly impressed with them. "On Thursday last,"

reported one journalist there, "arrived in this city on his way to London, the King of the Cherokee Indians in North America, attended by two of his chiefs. . . . They are tall well-made men, near six feet high, dressed with only a shirt, trowsers, and mantle about them; their faces are painted a copper colour; and their heads are adorned with shells, feathers, ear-rings, and other trifling ornaments." The journalist was a bit mystified about their purpose in Britain: "Their only business over, as far as we can learn, is to pay their respects to the King of Great Britain."[9]

This kind of puzzlement was precisely what Timberlake most feared: what if no one at Whitehall recognized the significance of a Cherokee deputation so soon after their traumatic war in South Carolina? What if Lord Egremont refused even to see them, let alone commend Timberlake for his efforts with a handsome payment? Fauquier's letters of introduction had not been sent ahead. Timberlake carried them on his person, so he knew that no one in London was expecting the party. These worries may have been what prompted Timberlake to invite the captain of *L'Epreuve,* Peter Blake, to accompany their group of five and help arrange the meeting with the secretary of state. As a member of the more respected armed force in the nation, the navy, and having a longer record of colonial service than either Timberlake or Sumter put together, Blake was the most commanding figure in the cohort. Blake, fearful maybe of accusations of neglectful duty if the envoy was not dispatched correctly, agreed to join them. He duly knocked on Egremont's door on the Saturday morning of their arrival.[10]

Lord Egremont had been in the job only since Christmas. Professional merit was never a leading criterion for British ministerial positions in the eighteenth century. Egremont had acquired his through a combination of immense aristocratic wealth and a decade's worth of pandering to influential Whig politicians. His gigantic belly and blustering demeanor often made contemporaries think him a fool but later events indicated a somewhat thoughtful disposition when it came to colonial affairs.[11] Certainly Egremont seemed aware enough of the damage wrought by the recent Anglo-Cherokee War to receive Blake graciously. The secretary ordered lodgings for the whole party that weekend and told them to come back for a proper meeting on Monday.[12]

The lodgings were in Suffolk Street, Covent Garden, three blocks south of Reynolds's new residence in Leicester Fields. The landlord was probably Nathan Carrington, a civil servant to Egremont, though Timberlake referred to him only as "Mr. N——Caccanthropos," a mash-up of the Greek *xaxos* (evil)

and *anthropos* (man).[13] Feuds between escort and landlord would feature in the future. What Ostenaco, Cunne Shote, and Woyi made of their London residence is unknown. Perhaps they missed the openness of their own summer housing during warm weather. Perhaps they were simply happy to sleep again on solid ground instead of a rocking boat or carriage.

By Monday all were rested enough to take up their appointment with Egremont. They walked the short distance to his handsome mansion on Piccadilly Circus. Timberlake handed over Fauquier's letters of introduction and was relieved to find Egremont respond appropriately. The secretary assured the party that he would notify the king that day and start arrangements for a royal encounter as soon as possible.[14] For his part Ostenaco probably expected nothing less. He knew the recent war with the Cherokees had made a sure dent on British resources in North America. The British, assuming that the French and French-friendly Indians were their biggest problems from the late 1750s, had been frustrated to find themselves spending additional energy on fighting supposed allies. The larger war for empire in North America was still not over. Keeping the Cherokees on Britain's side, especially in the wake of their defeat, was paramount to achieving overall victory. Fauquier had seen this. Egremont recognized this now. Ostenaco had banked on it all along.

To Timberlake, Egremont insisted that the group make themselves comfortable and "want for nothing." He assigned a tab to the landlord for expenses. In his return missive to Fauquier, the secretary confirmed that the Cherokees would be "treated with all possible civility and attention."[15]

In that letter to Fauquier, Egremont also addressed a comment made earlier by the Virginian governor. "You rightly observe," he wrote, "that such visitors are always troublesome, and these Chiefs are become more so after from the Death of their interpreter." The trouble here was that of ensuring Native American satisfaction with British officials. Far from trivial emissaries from a marginal part of the empire, such diplomats were, as Ostenaco long realized, yet critical to Whiggish Britain's ambitions overseas. Egremont not only shared this opinion but also evidently understood its lineage: his use of the word "always" indicated knowledge of a long tradition of Indigenous traveling envoys.[16] He would have no doubt heard of the last Cherokee mission to London, back in 1730, and certainly in his new position he had learned how its resultant treaty had aided southern colonial trade for twenty-five years. Egremont had perhaps even met subsequent Indigenous envoys to London, such as the Creek delegation of 1734 that had secured decades of good business for Britain in Georgia. These visitors may cause work for officials, but those with a clear

enough view of imperial politics saw their worth. Ostenaco and his two companions were set to have as fine a time in the city as Whitehall could muster.

The official tour of London's "wealth and power" started with a visit to Kensington Gardens, a toney park just to the west of Covent Garden. A newspaper reported that the three Cherokees "walked for some time, and seemed highly delighted with the Place." Next were more overt representations of national clout. The Tower of London showed off glittering jewels, sourced from British plunders around the world, as well as many rooms full of intricately wrought armor, attesting to a warrior culture of several centuries. This was closely followed by the massive dome of St. Paul's Cathedral, the intricate pile of Parliament, and the imposing solidity of Westminster Abbey. Later in the trip the Cherokees floated on an Admiralty barge down the Thames River to witness the ostentatious naval hospital at Greenwich and the extensive arsenal at Woolwich docks.[17]

Riches, weaponry, organization. A focused will, a selective worldliness, and an overwhelmingly martial appetite. There was little doubting the intended message behind the presentation of these sites to the Cherokees. Here was a nation worth siding with, and definitely not worth messing with. The person most taken in by this message was probably Henry Timberlake. Raised in Virginia, the solider was on his first ever trip to the center of an empire he'd always been told was his own. In his memoirs Timberlake breathed that everyone was quite bowled over by the tour, the party's impression of Britain's potency "greatly increased by the number of ships in the river" and by the industry and variety of the docks and arsenals it viewed.[18]

Ostenaco had already experienced firsthand the very worst that British potency could throw at him, at five thousand miles' remove from its heartland. He was not in any frame of mind to be awed into imagining further threats. He also knew that all this power was designed to push multiple efforts at imperial expansion—not just one against the Cherokees. More likely the utsidihi was happy to bear witness to the chest beatings of a fellow warrior culture, understanding them to be rituals just as important to the British leadership as Cherokee town council performances were to his elders. He was here to remind the British government that no amount of brute force yet made up for having friends in the right places. What the British chose to lay on for him in the meantime was their business.

On only two sightseeing occasions do the sources indicate anything other than a mild response from the Cherokees. The first of these was when they were

shown a large statue of the Greek god Hercules set in the sweeping grounds of an aristocrat's estate. Timberlake reported that Ostenaco and his companions thought the uplifted club so dreadful that they "begged immediately to be gone." The second moment occurred when watching a review of British soldiers fixing their bayonets. The drill threw the Cherokees into "an agitation."[19]

An observer in the *Public Register* interpreted these acts as signs of Cherokee fear of British violence.[20] This was not an unreasonable conclusion: only one year earlier, after all, the British had been the Cherokees' most mortal enemy. But it's hard to say definitively what these reactions were about. Did they jar with Indigenous customs little known today? Giant statuary was rare in eighteenth-century native Appalachia. Likewise, drilling bayonet usage in a manicured park would have been an odd sight, even for people well versed in the practices of red-jacketed soldiers. More pragmatically, were the Cherokees' reactions instead mini-eruptions of impatience with ceremony altogether? They wanted to meet with King George III. There were only so many diplomatic functions they could endure till they did.

In the end the person who best recognized the limits of interpreting the Cherokees' thoughts was, strangely enough, Reynolds's close Whiggish friend Edmund Burke. As then editor of an annual political affairs roundup—not yet a statesman—Burke saw that the three Cherokees had been paraded about London venues that "could serve to inspire them with proper ideas of the power and grandeur of the nation." But, Burke went on, it is hard to say exactly "what impressions these seights made on them, as they had no other way of communicating their sentiments but by gestures."[21] In all sorts of ways the loss of Shorey made Ostenaco harder to read while in Britain than when in North America, despite, ironically, the more plentiful sources on him through this period.

Interpreter or no, the London press soon realized they had a story on their hands. Once they saw how each stop in the Cherokees' tour attracted masses of onlookers, journalists jumped on the bandwagon of extrapolation. "There seems to be a mixture of majesty and moroseness in their countenances," opined the *Royal Magazine*. The Cherokees were actually from Canada, declared a widespread broadside. Cunne Shote and Woyi were Creek and Catawba, respectively, according to the *St James' Chronicle,* brought over by Ostenaco to stage a coup for Cherokee leadership through the help of multiple foreigners.[22]

What did the popular fascination with the Cherokees mean? Plainly, it was different in tone—and accuracy—to Whitehall's interest. Few locals understood the particulars of British-Cherokee relations, even if everyone was

now quite conscious of Britain's activities overseas. In consequence, few cared about Egremont's mission to impress and pacify Ostenaco. This is not to say, however, that the public's fascination was all about ogling exotic bodies (and, by extension, celebrating Britain's colonization of them). Or, rather, it was not just about that. As Reynolds could have attested, for every pro-imperial declamation about the Cherokee visitors, there were roughly as many comments that used the envoy to question imperial behavior. That is, for every observer who believed the Cherokees were "utterly astonished" at the "magnificence" of Britain's navy or monarchy, there was someone like the letter writer in the *London Chronicle* who felt that the frenzy around Ostenaco was similar to the frenzy the British state always now showed for "running after fights." This latter was a "folly," the letter writer went on, that other nations "reproach us with but too justly and which undoubtedly is pernicious as well as ridiculous."[23]

Popular fascination with the Cherokees contained within it both positive and negative views on Britain's contemporary empire. It was, as one might expect, British-centric—too few expressed any serious engagement with Cherokee society—but it was markedly mixed in its opinions about Britain.

The crush of people surrounding the Cherokees was most intense at their place of residence. Crowds swarmed every day around the Suffolk Street house, hoping to catch a glimpse of Ostenaco, Cunne Shote, or Woyi. While the travelers seemed mostly to cope with the gawping when out in public, they were less happy about intrusions in their residence. "Home became irksome to them," reported Timberlake. Others also saw by "their looks or behaviour" that the Cherokees hated all the staring. People pressed against the windows even to watch them dress or eat.[24]

Eventually Egremont had to issue an official edict against anyone gaining access to the Cherokees "without an order from himself." This may have been in response to the ruckus the crowds produced more than a concern for privacy, as Egremont reserved the right, after all, to offer access to his own appointments. The worst catalysts for ruckus turned out to be the accompanying Virginians. At one point Thomas Sumter tried to introduce a friend of his to Ostenaco but was stopped by the landlord's servant asking for financial compensation. The colonial soldier promptly knocked the servant to the ground for his insolence. The next day the landlord came round to yell "in scurrilous language" at Sumter and Timberlake, who both apparently gave back equal fire.[25]

For these humiliations, the landlord wrecked revenge on Timberlake—so Timberlake thought—by spreading a rumor that it was rather he, the escort,

who was profiteering off the spectacle of the Cherokees. Timberlake likened the experience to a sheep being accused by the "wolf of rapine." He went on: "The sheep, a raw Virginian, who, ignorant of little arts, innocently believed others as honest as himself, and could never believe such impudence existed."[26] Timberlake's bluster notwithstanding, Egremont's confidence in him was never fully regained. The secretary would later entrust others with Ostenaco's return arrangements.

Among those who assembled at the Suffolk Street address to gape at the Cherokees was another of Reynolds's close friends, the writer Oliver Goldsmith. One day in late June, before Egremont's edict, Goldsmith queued for over three hours to gain an audience with Ostenaco. When the two finally met, Goldsmith presented a gift to the utsidihi, who duly thanked him with kisses on both cheeks. The kisses transferred ochre all over Goldsmith's face, which in turn prompted peals of laughter from the surrounding crowd. Goldsmith, a restless soul constantly in search of both edification and personal validation, found the encounter discomforting. He didn't like being laughed at. And the heavy makeup of the Cherokee went against his preconceived notion of Native Americans. To him, indigenes of the New World were meant to be simple, humble folks. Ostenaco's facial decor made him look as vain and superficial as the British.[27]

Despite his reservations, it was probably Goldsmith who first alerted Reynolds to the possibilities in a meeting with Ostenaco. The novelist and the artist dined together frequently. To Goldsmith, Reynolds was like a brother, and rather too soon Reynolds was to serve as Goldsmith's executor. To Reynolds, Goldsmith was more complicated. He appreciated Goldsmith's own close association with Johnson and their similar Toryish views, but he sometimes grew tired of Goldsmith's relentless insecurity and competitiveness.[28]

No doubt Reynolds saw that Goldsmith was interested in Ostenaco for what he promised his current literary project. For the last two years Goldsmith had been publishing faux letters in the *Public Ledger* periodical in the voice of a pretended Chinese traveler called Lien Chi Altangi. Each letter took a British building or industry or custom and, through Altangi's foreign eyes, mocked its more absurd characteristics. This was a common technique in eighteenth-century writing, employed most famously in Montesquieu's *Persian Letters* of 1721. Johnson had used it, in rather more cutting fashion, in his recent *Idler* piece when he posed as a Native American to decry the Seven Years' War. On imperial politics Goldsmith was not as sharp as Johnson,

though in Letter XVII he had posed Altangi as being perplexed by both the British and the French for waging war over who could have "greater quantities of fur than the other."[29] In meeting Ostenaco, Goldsmith perhaps sought a real-life Altangi to further his modest critique of Britain's quest for empire.

Though close to some of the wittiest men of his era, Reynolds himself rarely indulged in satire. He was nonetheless clearly taken, like Goldsmith, with the chance to encounter a visiting Native American. No records explain how Reynolds secured Ostenaco's sittings: his pocketbooks merely state that the "King of the Cherokees" came to his studio on 1 July.[30] In the grinding summer of 1762, with the war showing few signs of resolution, Reynolds may have been after a fresh but still serious way to reconfigure this seemingly endless campaign.

Ostenaco was not Reynolds's first nonwhite sitter. Twice Reynolds had portrayed people of African heritage as additional figures in his paintings of whites. Back when he was twenty-five, before traveling to Rome, Reynolds had painted a white naval lieutenant in Plymouth posed with a black attendant. More recently his 1761 portrait of Keppel's sister Elizabeth had also included a black servant.[31] In both depictions the Afro-descended subjects appear beautiful, attractive, and certainly as human as their masters, but, notably, they also take up less space than the whites, they are positioned off to the side, and each has a face upturned in supplication. As neoclassical theory dictated, Reynolds was committed to the idea of universal humanity, but his two initial attempts at portraying nonwhites suggested that universality did not quite mean equality.

With Ostenaco, did Reynolds intend to convey a similarly delicate message? Give a human face to the injustice of imperial incursion but do so in such a way that ruffled no war-mongering feathers? If that was the hope, this time, for some reason, he could not quite pull it off. To the historian what is most remarkable about Reynolds's portrait of Ostenaco is how its creator ever afterward hid it from view. Reynolds almost always worked to commission or on pieces designed to further his career. The Ostenaco portrait, though, he sold to no one and hung nowhere. For Reynolds to conceal it pointed to a judgment of failure on his part, even while, also intriguing, he did take care to store it.

Knowing the artist's view on his portrait shapes our reading of it today. We can spot his usual combination of opinions (see fig. 9). We note the sure signs to ideal military allyship in the confident bearing of Ostenaco's stance, in the glinting gorget around his neck, and in the red and gold fabrics gathered about his body. At the same time, we note the subtle countersigns. The subject stares directly at the viewer in an unnerving manner. He holds an ambiguous-

Figure 10. Joshua Reynolds's portrait of Lady Elizabeth Keppel, 1761.
Reproduced with permission from the Woburn Abbey Collection.

looking implement. And his supposed robes of friendship are undeniably
crumpled and ill-fitting. But Reynolds's rejection of his work intimates that
here combination faltered. Did the artist think that the countersigns worked
too powerfully? Were they, to him, too critical of the imperial position?

Possibly the portrait would have still passed muster with Reynolds's audience. His similarly ambivalent Orme, after all, had won over viewers of all stripes. We will never know since Reynolds prevented its reception either way.

It is conceivable that Reynolds put aside the portrait for aesthetic reasons rather than political ones. Like his famous second Keppel portrait, the Ostenaco painting mixes various attempts at what Reynolds called "general nature" with touches of "particular nature." Reynolds decided to omit Ostenaco's attested tattoos and ochre markings in an effort to make his face more universal, and much of the background is rendered as muted clouds in order to suggest any number of interchangeable places. These aspects, though, work alongside a nod to Ostenaco's specific hairstyle, an inclusion of uniquely Native American wampum, and at least some gestures to a mountain range and mountain foliage. Perhaps, then, Reynolds's indictment came instead from judging it too unstable in its balance of neoclassical principle and contemporary grounding? Was it too particular, too realist? Was it a rare glimpse into how Ostenaco actually appeared to some of his imperialist hosts, calmly staring down the British contortion to believe that empire was about Burkean liberty rather than Johnsonian theft? Again, a definitive answer is lost.

All we know for certain is that the painting was kept but not shown. Reynolds did credit it sufficiently to give it a title: *Scyacust Ukah,* a muddled, aurally impaired rendition of "skiagusta Ostenaca."[32] But no one else was granted access enough to offer an opinion on its meaning. Storing the work indicated that Reynolds sought to remember only his own opinion, at some future date, when he might use it to ensure a later, more palatable depiction of how Indigenous people faced the British empire.

What Ostenaco made of sitting for a phiz monger is likewise hard to nail. No direct evidence survives. He could not draw on Indigenous practices of portrait painting since none existed in Cherokee culture. Paint was important for eighteenth-century Cherokees, but as a substance to put onto faces rather than as one to represent them. In fact, an entire clan within the seven-clan kinship system in the era was devoted to paint. The Ani-Wodi, or Paint Clan, was responsible for creating the red ointment used by warriors when they set off for battle. Ostenaco would have commonly worn the Ani-Wodi's ochre-based paint across his forehead to signify his transition into warrior mode. To keep the markings refreshed, he carried small, hollow clay balls with him during battle, which he could break open to find dried ochre paint inside ready for mixing with water.[33]

That said, Ostenaco had seen plenty of European-style portraits before. It had been King George III's portrait, after all, painted by Reynolds's rival Allan Ramsey, that had catalyzed his trip to Britain. He had also seen portraits adorning the walls of colonial government chambers in both Charleston and Williamsburg. He knew they were always of the most significant leaders in a society, intended also to remind future viewers of those leaders and their values after death. It would have seemed only fitting to Ostenaco that he would also garner a three-quarter length, two-dimensional representation. He was not to know that it never gained an audience.

Ostenaco may have been less thrilled about the rough, multiply reproduced images of him circulating around London during his stay. One of the roughest and most widespread depictions was a triptych of his full figure, heading a cheap broadside called *New Humorous Song on the Cherokee Chiefs*. This squib retailed for just sixpence and included titillating verses on how smitten all British maidens were with the Cherokee visitors. The masthead claimed to portray the three Cherokee delegates, but they were all variations on other recent newsprint etchings of Ostenaco.

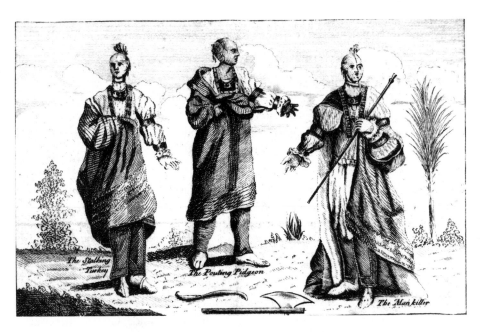

Figure 11. Masthead of engraving of H. Howard's *A New humorous song . . .* , 1762.
Retrieved from The Library of Congress.

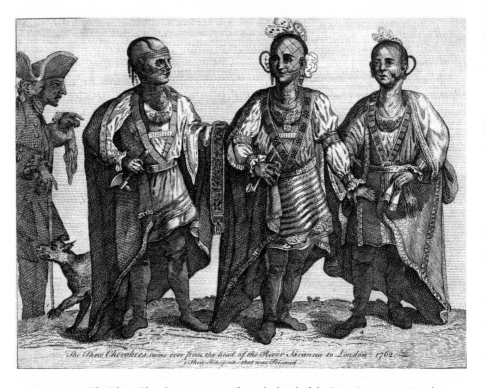

Figure 12. *The Three Cherokees, came over from the head of the River Savanna to London,*
1762, engraving, London, 1762. © The Trustees of the British Museum.

Another popular image boasted "The Three Cherokees" as well as, lurking
in the left margin, "their Interpreter who was poisoned." This printed engrav-
ing included two different plagiarisms of Ostenaco as well as a sketch of "Ye
Great Hunter, or Scalpper" (probably Cunne Shote) and a wild approxima-
tion of the deceased Shorey.

Not only were these scrappier representations clumsy, they didn't seem to
Ostenaco very reverent about leadership or great values. They didn't hang in
frames on governors' walls but were glued up on print shop windows or clutched
in the hands of ordinary people on the street. Their only effect, in Ostenaco's
eyes, was to goad the crowds further in their passion to follow his party wherever
it went. The Cherokees were growing tired of the impositions of celebrity.

Fortunately one other portrait from the envoy rose to meet official stan-
dards. Around the same time as Ostenaco sat for Reynolds, Cunne Shote sat
for a much younger, aspiring artist, Francis Parsons. Parsons was a relative
unknown in London art circles in 1762. He ran a studio further out from

Covent Garden. How he came to meet Cunne Shote remains, as in the case of Reynolds meeting Ostenaco, obscure. But his rendition did gain an elite viewership. He would show his Cherokee portrayal at the Society of Artists' exhibition of 1763, even while Reynolds continued to hide *Scyacust Ukah*.

In contrast to Reynolds's complex work, Parsons's portrait was a fairly straightforward take on noble savagery. Cunne Shote, rumored to be a sharp scalper, stands front-facing and bears a sizable knife. The blade's dramatically pointy tip, together with the shine of the British gorget, armband, and medallions, attracts the most attention. This is just as well since the facial expression on the subject is fiercely bland, conveying martial focus but little else. Here, simply, was a weapon in human form, safely swathed in the colors

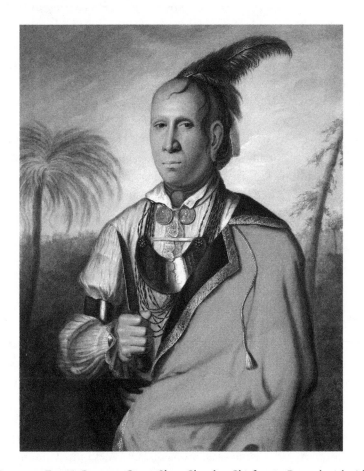

Figure 13. Francis Parsons, *Cunne Shote Cherokee Chief,* 1762. Reproduced with permission from the Gilcrease Museum, Tulsa, Oklahoma, acc. no. 0176.1015.

and adornments of British alliance. No wonder Parsons felt confident to display it to London's Whig elite ten months later.[34]

Notably, even Parsons's attempt to idealize the delegation brushed against the ragged, popular elements around Ostenaco. A local newspaper reported that once Cunne Shote departed Parsons's rooms, a "throng of ladies" pressed in to goggle at the artist's rendition. One of the women then "had the misfortune to fall down the Stairs and dislocate her knee." Two doctors were sent for amid ever-gathering crowds, "and she was carried home in a Chair."[35]

After nearly three weeks of distraction Ostenaco still awaited his audience with George III. "What is the reason," he questioned Timberlake, "that we are not admitted to see the Great King our Father, after coming so far for that purpose?"[36] Timberlake had no idea. He, too, wondered why the appointment was taking so long to arrange. Only Egremont knew that the young monarch had taken ill, an early bout of the porphyria that would later send him completely mad.[37] All official engagements were halted for a while as George III got back on his feet.

If Timberlake was starting to lose his nerve about the envoy's chances of success, Ostenaco remained confident that the fault at least did not lie with him. When he was finally summoned to St. James's Palace on 8 July, the utsidihi prepared himself as if nothing had been delayed. He dressed carefully, went over his speech one last time, and made sure to bring along a peace pipe to smoke with the British monarch afterward.[38]

Various organs described Ostenaco's attire that day. He wore "a very rich blue mantle covered with lace." The twenty-four-year-old George III, only two years into his reign, hosted all three Cherokees for over an hour, despite the lack of an interpreter. Timberlake babbled in his memoirs that he had stepped in during the meeting to convey a translation of Ostenaco's speech "word for word," since Shorey had told it to him before his demise. The Virginian escort added that he had been compelled to suppress the last part of the oration because it was just too flattering to his own role in Ostenaco's story. Palace media, all the same, disagreed that Timberlake's save was as satisfactory as the soldier imagined: "The man who assisted as Interpreter," stated the royal *Gazetteer*, "was so much confused that [the king] could ask but few questions."[39]

To be fair, one person in London had been trying to come up with a solution to the government's linguistic problems. Old Alexander Cuming, now in his seventies, was wasting away in debtors' prison, where he had been on and off ever since returning with the first Cherokee envoy to Britain in 1730. A

local newspaper speculated that Cuming was brushing up on his "Cherokee language" in order to serve His Majesty in any way needed. The offer was never taken up.[40]

In the end Ostenaco seemed little troubled by the lack of transparency between the king and himself. He took his time to stand and deliver the full version of his speech, in Cherokee, anyway. He'd been around colonists long enough to know that his words would later be translated and, more important, filed with both Egremont's ministry and several governors back home. He'd acquired a good sense of the British distinction between regal ceremony and workaday diplomacy and how necessary both were to these hierarchy-focused Europeans.

"Some time ago my nation was in darkness but that darkness is now cleared up," Ostenaco began, referring to the Cherokees' last bitter war. "My people were in great distress, but that is now ended." He went on: "There will be no more bad talks in my nation, but all will be good talks. . . . Our women are bearing children to increase our nation, and I will order those who are growing up to avoid making war with the English." Ostenaco closed his speech not with humility and meekness, as the newspapers had it, but with a vow to address any Cherokee transgressors of this order on his own terms. Rather than accept British laws on the matter, he would "deal with them as I see cause."[41]

Egremont's presence in the room doubtless bolstered Ostenaco that day. The secretary of state seemed to understand best the wider context of the meeting and took assiduous notes of all that unfolded. His paperwork afterward included a formal certification to the Virginian governor Fauquier that the king had indeed met with his envoy: "His Majesty was graciously pleased to receive the Assurances of Attachment which the said skiagusta . . . gave." The king in turn was pleased to offer Ostenaco "regard," "proper attention," and all "other marks of royal favour."

Egremont also wrote to the South Carolina governor, since that colony's entanglement with the Cherokees was even greater than Virginia's. To Charleston, Egremont was more directive. You will assure the returned Cherokees, he said, "that it was the King's particular Order that the utmost attention should be paid to them." Whether the minister felt more pressed to avoid another bloody Cherokee war or to enlist the Cherokees as committed allies against the French, or both, he certainly did not take for granted this delegation from a key Indigenous group.[42]

Oddly, the colonial soldier Timberlake seemed less perceptive about the need to keep Ostenaco onside than did the Whitehall minister. All Timberlake

saw at the meeting was an Indian rightly submitting to the "youth, person, and grandeur" of a British king. The escort was delighted to record later how he single-handedly protected George III from enduring Ostenaco's planned pipe-smoking ritual. "Finding Ostenaco preparing his pipe to smoak with his Majesty," Timberlake wrote, he leapt to prevent a disastrous breach of protocol.[43] Possibly George III would have enjoyed a puff—his spouse at least, known widely as Snuffy Charlotte, was famed for enjoying her tobacco.

Just hours after the royal encounter in St. James's Palace, Ostenaco, Cunne Shote, and Woyi were to be found unwinding at the distinctly lowbrow Star and Garter tavern a few miles further west in Chelsea. The Star and Garter was a landmark on London's popular nightscape at the time. Every evening it hosted spectacles of human acrobatics, deformity, and ingenuity, with no particular distinction between them, to well-watered, often rambunctious customers. Equestrian tricks, dwarfs on display, sound-and-light shows: here, the Cherokees perhaps felt their own apparent novelty disappear amid even more extraordinary sights. They returned to the Star and Garter no fewer than four times.

Taverns were not their only preference for entertainment. The Cherokees were also partial to the booming watering spas about town. Spas in London mostly appeared from the late seventeenth century; they centered around spring water discoveries and boasted healthful cures for those who drank (not bathed in) their waters. By the mid-eighteenth century, though, urban spas had also become alternate venues for popular showmanship. Ostenaco's favorite spa, Sadler's Wells in Clerkenwell, offered tightrope dancers, glass-harp playing, and monkeys who turned lit Catherine wheels for the enjoyment of its patrons. The Cherokees visited it as well as several other spas frequently.[44]

Their number-one popular site, though, was the pleasure garden. Like spas, pleasure gardens had sprouted through the city during the late seventeenth century. Mostly situated on what was then London's outer suburban ring, they provided teahouses, music rooms, bandstands, occasional plays, and often their own spas and taverns, amid several acres each of cultivated greenery. Also like spas, pleasure gardens were originally intended as wholesome daytime places for respectable Londoners, but, a couple of generations on, they had become more diverse in their entertainment offerings, more mixed in their clientele, and, in consequence, altogether more risqué.[45]

To the Cherokees the crowds attending the pleasure gardens were probably their chief attraction. Amid them, the visitors did not have to worry about the constant gawking mobs because masses of people were already there

gawking at other things. They visited Ranelagh Gardens and Marybone Gardens a couple of times each, and Vauxhall Gardens at least six times. No doubt these popular venues reminded the Cherokees fondly of home, their carnivalesque amusements being similar to those performed in the Overhills. Complicated dances, raucous feasts, pantomime charades: Timberlake noted that when in London the Cherokees connected especially to the athleticism and technicality of British entertainment. Even the architecture in these fun-spaces had a resonance. It was here that Ostenaco observed how similar the famous rotunda at Ranelagh, with its tiered seating and central fire, was to the council house at Chota.[46] Such echoes added to his enjoyment of London's popular culture, soothing perhaps an incipient homesickness as well as affording relief from the continual staring.

Pleasure gardens offered the Cherokees a chance to escape until, that is, they didn't. One evening late in July the trick of hiding among the crowds backfired, and the Cherokees became instead the biggest sensation at Vauxhall that night. It's not clear what turned the tide. Whether it was the female singer who decided to attach herself to Ostenaco or the greater volume of alcohol drunk that night by everyone or perhaps a lack of anything else more exotic, the crowds suddenly latched onto the utsidihi like limpets. Some papers reported close to ten thousand people following him. At length Ostenaco hit his limit. He jumped into the outdoor orchestra pit with his female companion to dodge the press of bodies. A few other women joined them, and together the group spent a time making unorthodox music with the abandoned instruments. This only attracted more onlookers. After a while Ostenaco simply wanted to get home. Approaching his coach, "a sort of scuffle" then broke out. A gentleman's sword was drawn. Ostenaco remonstrated. The sword broke. Ostenaco's hands were bloodied. He shouted in fury and "threw himself . . . on the ground." The night had turned into a disaster.[47]

Although afterward the *St James's Chronicle* felt the "wretched scene" owed equally to "British curiosity" and "Savage debauchery," most outlets recognized that the British crowds were chiefly to blame. "The Reason" for the debacle, declared the *Public Advertiser,* was the "ungovernable curiosity of the people." The *London Chronicle* cried, "What can apologise for the people running in such shoals to all public places, at the hazard of health, life, or disappointment, to see the savage chiefs that are come among us?" These guests, it went on, "must look upon the English People as a Pack of Idiots, Beasts and Barbarians."[48] Just like the overall media coverage of the Cherokees' doings, the popular press in this instance was not all of one ideological

voice, even while it did focus primarily on what these exotic visitors reflected about Britons rather than the other way around.

What the Cherokees' tour of popular venues most revealed about Britain was how much these sites had changed through the eighteenth century. Few commentators made the connection overtly, but when journalists wrung their hands about British idiocy in places like Vauxhall what they were really agonizing about was the social uncertainty produced by Britain's booming economy. Spas and pleasure gardens had taken off in London through this era because of the massive influx of disposable wealth now flooding the city. They were no longer places for the privileged few but increasingly open to the merchants, builders, artists, courtesans, and other businessfolk profiteering from imperial commerce. The same people moving into Joshua Reynolds's Covent Garden were also demanding access to and changing unpredictably the leisure world of London. Wealth was exciting, liberating, boosting, but it was also confusing. British understandings of social status and cultural norms were racing to catch up with the consequences of rapacious colonization.

Who better placed, however inadvertently, to highlight the confrontation of imperial success than those who had been confronting it otherwise for decades? Ostenaco's envoy was a lightning rod for observers already split over the effects of empire at home. The Cherokees' own disconcerting closeness to a phenomenon that was dividing Britons in London helped fuel the general interest in these visitors. They conjured both the controversial empire and its far-reaching effects.[49]

By the beginning of August Ostenaco was looking forward to going home. He'd achieved his main goal of meeting George III. More important, he'd made productive contact with the chief minister for British affairs in America. The tour of official London was wearing thin. The solace of London's popular scene was also fairly exhausted.

Ever on his toes with the Cherokee delegation, Egremont had by now started planning for its return voyage. He was pleased to find Peter Blake and his *L'Epreuve* still in the country and gave this old naval hand the commission of safe repatriation. Egremont did not, however, endorse Timberlake for the job of returning escort. Already suspicious of his ability to control events, blaming him perhaps for the Vauxhall incident as well as the scenes at Suffolk Street, the secretary lost all patience when the Virginian asked for fresh fees. Money was not the actual issue: Egremont went on to pay Sumter several times the amount Timberlake requested to chaperone the Cherokees back.

He was simply sick of the man's pretensions. Timberlake would have to find his own way home.[50]

Before the Cherokees departed London, Egremont arranged a second, final meeting between Ostenaco and George III to bid each other farewell. It took place on 6 August. No record of the meeting survives, other than a newspaper account of Queen Charlotte watching the delegates leave the palace from her window. She was now in her "confinement" in anticipation of the birth of her first child.[51]

Ostenaco, Cunne Shote, and Woyi were still in London a few days later when they heard that "the Queen was happily delivered of a Prince"—the future George IV. That night all three Cherokees joined the thousands dancing in the streets. Fireworks and bonfires lit up the city. One reporter commented that Ostenaco "was no stranger to the cause of illuminations . . . and testified a great approbation at their appearance." It was a nice reminder to them of the best of British showmanship, when it did not tip over into a frenzy about their own presence or meanings. Ostenaco was seen with everyone else cheering "huzzas!" for the new prince.[52]

On 20 August the Cherokees, with Sumter, left Covent Garden for good. They headed south, not toward their incoming port, Plymouth, but instead to the other major British naval base on the south coast, Portsmouth. On the way, the party stopped off at Winchester. Most tourists to this town gravitated to the famous cathedral, but Ostenaco had already shown his lack of interest in such buildings. He was, however, struck by the sights of British soldiers training at Winchester Castle and the many French prisoners of war locked up in Winchester Gaol. If his mind was not already refocused on international relations, the sight of red coats and fleurs-de-lis surely did the trick.[53] The Cherokees spent their last afternoon viewing the elite students at Winchester College before setting off on the final leg to port.

By an odd twist of fate Ostenaco's chief portraitist, Joshua Reynolds, was also heading south that week. Reynolds was traveling to Plymouth, but he too had to pass through Winchester. He stopped there with his friend Johnson just four days before Ostenaco did. Reynolds and Johnson also skipped the cathedral but stayed longer than the Cherokees at the college. The pair lodged with their mutual acquaintance and teacher at the school, the critic Joseph Warton.[54]

This trip south was to be a respite for both Londoners. Reynolds, as James Northcote had intimated, had been suffering indifferent health since the spring. The experiment with Ostenaco had evidently not revived him. A trip

home to Devon after ten years away might do a better job. Johnson, usually the one more vulnerable to low spirits, was seeking a break from notoriety more than illness that year. He'd just heard he was to receive an annual pension from the king in recognition of his literary achievements. Although a great honor, one that thrilled Reynolds, the award was undeniably controversial, too. Whiggish skepticism of royal patronage was getting worse with the new king, and even Johnson himself had defined in his famous *Dictionary* that a pension was "pay given to a state hireling for treason to his country." Some time away from London to escape any braying blowback was attractive, even for a man well disposed to a little political jostling.[55]

After Winchester, Reynolds and Johnson detoured to Torrington in northern Devon, where two of Reynolds's sisters resided and where his London-based sister, Frances, joined them. Sibling relations were not Reynolds's forte, especially with sisters. Frances would later accuse her brother of being a gloomy character, while Elizabeth once informed him that his soul was "a shocking spectacle of poverty."[56] Mary seemed an easier item, though how much she reminded him of her earlier financial backing for his Italian Grand Tour is uncertain. The days spent with family were probably the least relaxing of the holiday for Reynolds.

The trip improved when they reached Plymouth. It improved especially for Johnson, who decided to suspend his usual abstemiousness and drink his way through the rest of the vacation.[57] The consequent high jinks were amusing to Reynolds but may also have been trying since it was Reynolds who had to conduct the social mop-up afterward.

An example occurred when the pair visited the neighboring town of Dock. Johnson pretended to be a Plymouth bigot and entered into a recent debate over water supply from Plymouth to Dock. "I am against dockers!" Johnson is said to have bellowed to the townsfolk. "I am a Plymouth man. Rogues! Let them die of thirst. They shall not have a drop!" Later, at a nearby estate, Johnson broke with gender conventions and challenged a woman to a running race. Surprisingly, she agreed, and, even more surprising given Johnson's immense bulk, he won. Another woman at the same residence inquired why Johnson had in his *Dictionary* defined the "pastern of a horse as the knee of a horse." Johnson replied, possibly intoxicated, "Ignorance, madam, ignorance."[58] Reynolds was always at hand to smooth over the social irregularities.

Just before heading back to London the duo spent some time down among the town's shipyards. The bustle of the scene must have conjured the ongoing war for both men. Here, shipwrights built and refitted the navy's

huge vessels, sailors bunked down in giant floating barracks, officers convened in newly constructed mess houses, doctors tended to the wounded in the Royal Naval Hospital, and stonemasons continued raising ever-stronger crenulated fortifications. The business and scale of forging empire's critical infrastructure were unmissable.

Johnson's first biographer, James Boswell, later wrote that his mentor was bowled over by Plymouth's maritime activity: "The magnificence of the navy, the ship-building and all its circumstances, afforded him a grand subject of contemplation." But Boswell was a Whig, constitutionally inclined to see his nation's military endeavors in 1762 in a favorable light. While Johnson may have been inspired to contemplate Britain's war anew during his stay in Plymouth, he probably did not yield so readily his earlier skepticism about the war's end-goal.[59]

Reynolds, too, probably beheld with some reservation the increased activity in this once-familiar place. Johnson was by now a profound influence on his thinking. Reynolds's recent empire-related portraits, as noted, evinced a deep ambivalence. We can only imagine the painter's ponderings about it all when he accepted an invitation from the shipyard's commissioner for Johnson and him to visit the most recently lauded monument in the area, the new Eddystone Lighthouse. This structure, erected amid the triumphs of 1759, was a marvel of bombastic confidence. Made from jointed granite blocks, it rose in near defiance of physical laws from a small rock in the middle of Plymouth Sound. The commissioner sailed the friends out to it on a naval yacht. Unfortunately, though, the waves were so wild on the day that the party had to turn around before actually touching the lighthouse.[60]

Here, then, stands Joshua Reynolds, gripping the yacht's railings, listing with the chop, and taking in the retreating prospect with his artist's eyes. He surveys this solid-stone representation of British achievement. Apparently undisturbed by the forces of nature, the lighthouse is yet strangely disappointing in its inaccessibility. The boy from Plymouth well knew, too, that it was the third such structure to rise from the rocky outcrop. The earlier two had each succumbed after a time to internal fractures and damage.

By the day of the lighthouse excursion, Ostenaco, Cunne Shote, and Woyi were well on their way home. They had departed Portsmouth harbor on 24 August 1762. Due to Atlantic sea currents, the voyage back took twice as long as the voyage out. Despite Sumter's presence as escort, Egremont entrusted Captain Blake with the most important tasks of the mission. Chief among

them was to deliver by hand the secretary of state's instructions to the receiving colonial governor. These instructions asked the governor to ascertain exactly Ostenaco's feelings about his trip. The governor was to "conciliate" him most particularly, it went on, "in case you shall perceive, that they have been offended or disgusted with anything that may have happened."[61]

CHAPTER IV

Home to a New World

OSTENACO'S AMERICAN REVOLUTION

O stenaco's journey back to America proved eventful. Off the coast of Rhode Island the *Epreuve* intercepted a schooner running French goods into British colonies. The three Cherokees, armed with muskets and cartridges, helped the crew chase down the vessel and seize its cargo.[1]

Eventually, though, the returning party docked at Charleston, and the latest in a quick-moving line of South Carolina governors, Thomas Boone, received them. On reading the group's missives, Governor Boone realized that Egremont was serious about ascertaining Ostenaco's satisfaction with his recent trip to London. Accordingly, he set up a meeting with the Cherokee leader in the South Carolina council chambers for 3 November 1762.

Boone opened the meeting with a warm welcome, using Ostenaco's trading name: "I am extremely glad to see you, Judd's Friend, and your two warriors who accompanied you to London." The governor brought up the unfortunate issue of Shorey's death, which had so marred the formal part of the visit: "I am ordered to mention to you that the King was sorry that your interpreter died on the Passage to England; whereby your words, and your intention by going thither, could not be so well understood." Boone tried to prompt Ostenaco's reaction by suggesting that, nonetheless, perhaps it hadn't mattered too much? "If however," he added, "you had anything more particular to say, I am commanded by His Majesty to hear and faithfully report it; Speak out therefore, freely open your mind."

It turned out Ostenaco had quite a lot to say. The surviving transcript suggests he talked for at least two hours. Although sad about Shorey, Ostenaco agreed now that his absence had not hindered things too badly. He saw by then that the true import of his trip lay with ministerial recognition and perhaps with colonial recognition rather than with what a young foreign king had managed to absorb. Much of his talk with Boone covered the same points raised with George III, but here he expanded and elaborated. Two particular additions or revisions were telling. The first was the way Ostenaco noted Boone's keen reliance on him for a happy report. "His Excellency might take it amiss," he observed, "if I did not make a Talk to you on my return . . . especially as you desire to hear from my own mouth how I liked England." The trip to London had given the utsidihi a noteworthy increment in negotiating

Figure 14. Engraving of Ostenaco. Anon., *Outacite, Chief of the Cherokees*, 1762. Reproduced courtesy of the National Portrait Gallery, Smithsonian Institution.

power: now colonial governors not only arranged for him to travel to their capital but also needed to know that he remained friendly afterward.

The second consequential aspect of the speech was the way Ostenaco expressed his earlier remark about the Cherokee population. The formal address to George III had stated, "Our women are bearing children to increase our Nation." To Boone, perhaps less elegantly, he went on, "Our women are breeding Children Day and Night to increase our People." The second version drew out what had been only implicit before: the Cherokees were not annihilated despite their recent military surrender, and they promised to rebuild their numbers, strength, and autonomy.

Boone instructed a scribe to write everything down and then returned to the as-yet-unanswered original question. So what were the utsidihi's overall impressions of his journey? Ostenaco replied affirmatively if briefly. Yes, the "head warrior of the canoe [Captain Blake] that brought us over used us exceeding well." Yes, Timberlake "treated me exceeding well" too. And, yes, London was very impressive, especially "the number of warriors and the people being all of one colour." Further than this, though, he would not be drawn. Boone was nonplussed. He wrote back to Egremont that Ostenaco "whether from policy or constitution appears to me astonishingly reserved and silent upon everything he has seen."[2]

Ostenaco's quiet confidence may have dissipated a little upon his return to the Overhills. He had been away for nine months, missing the immediate aftermath of the Anglo-Cherokee War. He'd known all too well the fundamental problems. The loss of towns and crops and lives had been the issues that pushed him to accept peace in the first place, nearly a year ago. But now, as winter approached once more, he could see the effects of loss etched into the very bodies of his kin. During his absence, the South Carolina officer (and later revolutionary) Henry Laurens had visited the Overhills and reported a "calamitous" scene. A "pinching" hunger everywhere reduced many to live off old acorns and "the offals of mangled horses." A "state of despair" prevailed too, Laurens thought, in their temperaments. At Chota Laurens encountered Attakullakulla, who admonished him for the war's legacies in no uncertain terms: "I hope I shall not live to see such days again," spat the aging Cherokee leader.[3]

On top of the hunger, and perhaps abetted by it, the Overhills Cherokees were afflicted with another rash of smallpox and a crippling stomach flux. Physical problems were exacerbated by the ongoing effort to assimilate the many Cherokee refugees from the still more devastated Lower and Middle

towns.[4] As a former relocator himself, Ostenaco knew intimately how such moves could be difficult for everyone under even the best of circumstances.

While Laurens took all this misfortune as evidence that the Cherokees were too beaten down ever to bother South Carolina again, a couple of historians have read it otherwise. For sure, few Cherokees were thinking about further conflict with the British at this time. But they were not without hope for their recovery. Amid the wreckage, they showed a dogged determination to rebuild. As Ostenaco would have been able to see for himself upon his return, the clearest sign of this determination was in the women's production of a different kind of harvest. Overhills women now not only planted the usual corn and other vegetables but also took on fowl and hog farming for themselves, practices adopted from the British. Ironically, Cherokee women fought back against damage inflicted by British warfare by appropriating British ways. Colonists living near the Cherokees recognized and complained about this appropriation: once upon a time Cherokee women had raised hogs for *them,* they noted; now they raised farm animals only to feed their own.[5]

The historian Tom Hatley has argued, perhaps counterintuitively, that the indifference of the relaunch of trade relations between South Carolinians and Cherokees was another sign of recovery. He finds that the indifference was less from South Carolinians losing interest in deerskins than from Cherokees losing interest, at least temporarily, in European manufactures. In war's immediate aftermath Cherokee men like Ostenaco spent more time helping women cultivate food nearby than going off to hunt for outsiders. They decided that directly supplying parts of their own economy would restore harmony more effectively than demanding more guns from the victor's economy. Cherokee dependence on British goods was not as constant or as desperate as many early scholars surmised.[6]

Even Attakullakulla, despite his anger toward Laurens, expressed a largely sanguine view of the future. After his cutting words to the officer regarding the war, he stated simply that he wished the British would "do no more to destroy us." They "should live like Brothers & I pray that our Brothers will now spare the rest of my people."[7] Another Cherokee leader, Sauly of the Lower towns, later remembered feeling a similar sense of muted optimism. He recalled how at this time he was offered asylum by another native group, but he refused because "I loved my country" and felt that "perhaps times would mend."[8]

Together, the cautious sense of hope and the steady work to rebuild did much to complete the emergence of a pan-Cherokee political identity. To be

sure, a formal national council was still some way off, but the 1760s witnessed "a new epoch in Cherokee history," as Tyler Boulware has put it. The Cherokees felt more and more like one polity rather than a series of kin-linked, decentralized regions. Even Boulware, one of the leading historians on the importance of regional identity among eighteenth-century Cherokees, sees that the Anglo-Cherokee War had done much to forge this more singular identity. He writes that the conflict pushed all involved to "find common ground among a common enemy."[9] The collective *post*war effort, performed amid the turmoil of whole regions resettling, cemented further what the war began.

The evolution of Cherokee political identity was no more apparent than in the mindset of the utsidihi, Ostenaco. In retrospect, it is clear that ever since he entered, late, the peace talks to end the war, Ostenaco stood for mostly pan-Cherokee objectives. Certainly his words and actions while in Britain appeared to be in aid of all Cherokees rather than just the Overhills. This cast of allegiance rarely changed over the next two decades.

Whatever the larger vistas of Cherokee damage and then recovery Ostenaco surveyed in the early 1760s, his arrival back in Tomotley also prompted a turn toward the more personal. In December 1762 the middle-aged world traveler came home to find he'd become a grandfather. His daughter Sokinney had just given birth to a boy. She'd named the baby Richard Timberlake.

While most later descendants claim otherwise, it's not certain that Richard was the blood progeny of Henry Timberlake. Just as Ostenaco often went by the name Judd's Friend in honor of an earlier connection he'd forged with a white trader, Richard may have been named merely to celebrate a connection that promised, in the difficult days of 1762, a fresh chance at stability. Whoever the father, the boy was always going to claim Cherokee identity through his maternal lineage. His paternity was never going to be the key feature about him. Like Ostenaco nearly fifty years before, Richard would grow up in his mother's household, which included in this case a now-famous warrior-diplomat as the maternal grandfather.

Ostenaco became particularly fond of Richard—he would leave him a key legacy upon death. If indeed there was no father on the scene, it may well have been Ostenaco who fashioned the baby's first cradleboard. An earlier European observer had once noted that "as soon as the Child is born . . . the Husband takes care to provide a Cradle, . . . consisting of a Piece of flat Wood, which they hew with their Hatchets to the Likeness of a Board." The observer went on to provide rare details of this Cherokee custom: "It is about two Foot long, and a Foot broad; to this they brace and tie the Child down very

close. . . . the Mother slings her Child [on the board] on her Back; so the
Infant's Back is towards hers, and its Face looks up towards the Sky."[10]

Babies, new farming practices, less trade, more home time. A widely se-
cured peace treaty. Despite the pain of war's aftermath Ostenaco had many
reasons to believe that his newly expanded concept of the Cherokees as a
whole people faced a tolerable future. They had suffered setbacks before.
They had always found ways to let newness into their world. They had ad-
justed, they had re-formed, and they had carried on.

Preoccupied with internal matters Ostenaco, like most people in North
America, would take a while to catch up with the importance of the year that
followed his return to the Appalachians. In early 1763 Britain and France fi-
nally concluded their long-running war with each other—the war that had
started officially in North America in 1754 but that had been alive sporadically
for nearly seven decades. The Paris peace treaty declared Britain the victor
over France and awarded the nation almost all prior French and French-allied
claims in North America. On European paper this meant that all land east of
the Mississippi River and most of today's Canada was now British. As the
nineteenth-century historian Francis Parkman once famously declared, on 10
February 1763, half the continent "changed hands at the scratch of a pen."[11]

Contemporary Cherokees could not have laughed harder at the notion
of Britain claiming ownership to anything that escaped formal Indian
agreements—which in 1763 still amounted to at least 80 percent of the lands
in question. But they may have shared Parkman's stupefaction at the magni-
tude of the gesture. Some three thousand miles away from North America,
four European politicians believed they were rearranging the sovereignty of a
couple of million square miles of territory upon which lived up to two mil-
lion native people. To the Cherokees the magnitude was of pure arrogance.
And it was this hubris, not the legitimacy of the move, that would go on to
transform the history of North America.[12]

As many historians have narrated, when the British government took
stock of their new presumed booty they finally realized how expensive it had
been to acquire and how much more it would cost to maintain. Their conse-
quent shifts in imperial policy set them on an unwitting path to revolution
with their kin who lived there. Fewer historians have tracked how the Paris
peace treaty also instigated a revolution for Indigenous Americans. This was
less a revolution by warfare, although for many it included that. And it was
less a revolution in governance, although for most it ended thus. For a Cher-

okee man like Ostenaco, the hubristic treaty of 1763 set in train a revolution in *how* Indigenous people related to newcomers and *on what* relations would now focus.[13] Such a revolution colored the rest of Ostenaco's life.

The first signs of transformation for Native Americans occurred far to the northwest of the Overhills, in the former French fort of Detroit. In the late spring days of May, an Annishinaabe Odawa warrior called Pontiac led a siege on the fort—now held by swaggering British soldiers—as his personal response to news of the peace. Like wildfire, similar attacks flared all over the interior, hundreds of miles apart and by dozens of native groups. The violence persisted for two years, later to be called Pontiac's Rebellion even though Pontiac was only the spark and it wreaked much more havoc than a mere protest. As Michael McDonnell has observed, this was in many ways "the first war for American Independence," waged some twelve years before the better-known colonial version.[14]

Formal independence was not always the initial goal for these Indigenous attacks. Most were provoked by the earliest consequence of Britain's changed position in North America—a new dictate against arms supply to native peoples, passed down from the continuing commander-in-chief of British forces, Gen. Jeffrey Amherst. General Amherst had not grown any fonder of Native Americans since he had ordered the two sequential campaigns against the Cherokees in 1760 and 1761. If anything, he loathed them more. Now, with French competition for Indian hearts and minds out of the way, Amherst felt even less need to engage with them. He declared that the former Indian practice of negotiating for diplomatic gifts and war prizes (usually arms) stemmed from mere greed on the Indians' part. In fact, he now saw it as a sign of Indian ingratitude for the many benefits they already received, such as, presumably, civility, metallurgy, and Christ. Amherst noted that "the Indians continue their *old* way of reasoning" by demanding material recognition of their presence and goodly compensation for their assistance. He for one, however, knew there was "nothing so impolitick as to furnish them with the means of accomplishing . . . Evil."[15]

The captain of Fort Detroit could have told Amherst precisely what would be more impolitic. Just before Pontiac's War erupted the captain mused, "If the Indians knew General Amherst's sentiments about keeping them short of Powder, it would be impossible to keep them in temper."[16]

Although aware of events inland, the Cherokees declined for the most part to join the attacks, at least during that first, intense year. Other native people asked them constantly for assistance against the mounting counterattacks,

but they had suffered more brutally and more recently from total war than anyone else and needed to keep their heads down for a bit. Moreover, as a warrior like Ostenaco no doubt reminded all, most of the peoples involved in the current uprisings had lately been a Cherokee enemy. Pan-Cherokee sentiments against British imperialism were one thing, but pan-Indian feelings were still quite another for this particular Indigenous group.[17]

All the same, the Cherokees did become immediately implicated in the next key sign of North American transformation. In response to the violence of Pontiac's War, the British government in London issued a royal proclamation in October 1763. This decree tried to articulate more precisely the contours of Britain's imperial policy in North America post-victory, superseding the mere implications of the Paris peace treaty. Chief among the royal proclamation's points was an injunction for colonists to stop molesting, disturbing, and defrauding the natives.[18] Most significant, it sought to achieve this by drawing a boundary line down the continent to protect natives from colonial settlement. The distance between Whitehall and those on the ground like Amherst was growing ever wider.

While the royal proclamation was indeed a reaction to Pontiac's War, some of its ideas had been percolating in Whitehall since even before the Paris peace treaty. Its main architect was none other than Ostenaco's new acquaintance, Lord Egremont. As far back as December 1761 Egremont had voiced his concerns about the potential for poor British behavior in America if the French ceased to be competitors. Most historians contend that Egremont was following the sentiments here of a former governor of Georgia, Henry Ellis. Certainly Ellis had the minister's ear by late 1761, and both already feared the Indian violence that might flow after Britain's colonial ambition reigned unchecked.[19] But how much did Egremont's meeting with an actual Indian eight months later confirm these fledgling worries? Had Ostenaco's story of war's devastation given him pause? More to the point, had Ostenaco's insinuation of the Cherokees' sure rebirth made him calculate the costs of endless further conflicts? Historians have not considered the utsidihi's role in furthering Egremont's push for the royal proclamation, but the timing is too compelling to ignore.[20]

If Ostenaco did nudge Egremont onward to improve Indigenous-imperial relations, it's unlikely, all the same, that he prompted the specific solution of a land-based boundary line. Trade and military alliance had been Ostenaco's usual fixes till now. Both were activities that required a porous border between natives and newcomers rather than a dividing one. But to bureaucrats far removed from the scene a clear geographical barrier seemed the most logical or

at least the easiest way to stop the violence. By May 1763 Egremont was sketch-
ing out plans for "a Western Boundary . . . beyond which our People should
not at present be permitted to settle."[21] The final royal proclamation of Octo-
ber forbade any surveying or granting of lands over a set limit and, further,
ordered all settlers currently "seated" there "forthwith to remove themselves."[22]

To the Cherokees the most pertinent part of the royal proclamation was
where it imagined a line to run in the southern Appalachians. In 1763 the
rough assumption was the ridge of the Cherokees' own mountain range, leav-
ing most of their customary hunting grounds as well as the Overhills towns
region clear of settler intrusion. The exact definitions of the line and its many
adjustments would occupy Cherokee leaders for the next ten years.

The year 1763 inaugurated, then, two fundamental alterations to the po-
litical landscape of North America. The removal of French competition led to
a new tone in relations between Indigenous and British people, one far
harsher and balder than had existed before. The Pontiac-led attacks and the
counterattacks that started that summer were only the most immediate ef-
fects of this change.

Comprehensive British victory over France, amid other reasons, also re-
sulted in a shift in the focus of those relations. Gradually, unevenly, but ever
so surely the topic of land came to dominate over all others. The royal
proclamation of October was the first solid inkling of that shift. For Native
Americans everywhere, more was to come.

After nearly a year of living quietly Ostenaco once again assumed his role as a
warrior-diplomat. In late 1763 he set off with around three hundred other
Cherokees to Augusta in the colony of Georgia to attend a massive conference
of Indigenous and colonial leaders from across the southeast. He was moti-
vated to attend on two counts: he wanted to reiterate to the British for the last
time the Cherokees' desire for peace, and he wanted to spread to his fellow
native neighbors the need for a similar aspiration. Ostenaco was sick of colo-
nial war in every guise.

To the British the conference was meant to address three crucial points of
information. In addition to news of Egremont's boundary line, it was de-
signed to convey British plans to demolish every old French fort in the vicin-
ity and their equally determined intention to reestablish trade with all Indians
thereafter.[23] Possibly not even the conference convenors realized, though, how
much French erasure was bound to change the nature of trade in the future.
That is, none grasped how the removal of French competition meant that

economic relations between Indigenous and British peoples were never going to be the same.

By 3 November all four key southern governors, representing Virginia, Georgia, North Carolina, and South Carolina, had arrived for the conference. They met with around seven hundred headmen and two hundred observing women from the Cherokees, Creeks, Choctaws, Chickasaws, and Catawbas. Some had traveled more than four hundred miles, all keen to put forward their opinions as much as to listen to others.[24] After the governors' opening speech about their king's intentions—renewed commerce, no more French, native protection—the Indians had a day to take the stage. The Cherokees were the fourth group to speak. Ostenaco led their orations. "Judd's Friend desires he may be listened to," he began. He went on to explain his understanding that the conference was as much about securing good relations among his "Red Brothers" as with "the White People." He concluded by driving home the key theme of his earlier meeting with the white people's sovereign: peace for the Cherokee.[25]

The second speaker was Kittagusta, a senior Chota leader and Ostenaco's elder by at least a decade. He provided the central piece of theater for the delegation. Proffering a string of beads with three knots, Kittagusta explained that the first knot was Chota and the last knot was Charleston. The middle knot signified Fort Prince George among the former Lower towns, through which all trade between Cherokees and colonists had, since the war, narrowed. This headman's goal was to underscore the Cherokees' wish to refocus now on trade. He believed it was the best way forward for mutual stability.

The third and final speaker was Attakullakulla, undeniably these days the most respected spokesman for the Cherokees. Though lengthier and with more dramatic flourishes, his speech reiterated the two points already made. The Cherokees had an intimate promise of peace from King George III himself. They wished only to reforge good relations with the British through the tried and true method of trade. Of course, the previous war had been distressing—Attakullakulla was never one to let a sore point go unremarked—but here at Augusta he hoped simply for a "clean . . . path" ahead.

The meetings went on for two more days. They concluded agreeably enough, but during the talks the Cherokees had glimpsed a vision of how the future might be less "clean" than desired. In their allocated slot, the Creek delegation—those Indians most familiar with colonial Georgians and least friendly to Cherokees—had offered not merely a commitment to peace and a wish for more trade. They had offered *more* of their hunting grounds to the

British than had been proposed. The governors were perplexed. What was the catch? No catch—for the British at least. The colonists looked to be the beneficiaries and so quickly accepted the changes.

The true beneficiaries, though, turned out not to be the British governors but the rogue British traders of Georgia who were present at the conference. These traders had been back-channeling with the Creek delegation before the officials had turned up. The traders and Creeks had struck a deal that allowed whites far more land to settle on than planned in exchange for preferential treatment in any upcoming native trade negotiations. In this brave new world of a single European player in American affairs, the onus to bargain for preference was suddenly now on natives rather than newcomers. Unlike the British governors, the Creeks, it seems, had figured this out.[26]

Even so, the Creeks had perhaps not given much thought as to *why* the traders would want land now instead of goods. If trade was to be the mutual ticket to ride, why focus on a finite commodity like real estate? The historian Ed Cashin wonders whether the traders were not completely on top of this question either. "Why did the traders use their influence to obtain a land cession?" he asks. "After all, it was in their interest to maintain an Indian preserve which would have sustained the trade."[27] It's not clear that any group at Augusta in 1763 recognized the full extent to which a trading model in North America was giving way, bit by bit, to a land-based economy. The change was as subtle, ironically, as that moving the other way within the British Isles.

For now, anyway, the Georgian traders looked to be winning, at least so long as they were reconciled, eventually, to become frontier farmers. The governors hoped, wistfully perhaps, that the deal spelled a permanent end to squabbles around Georgia at least. The Creeks, for their part, were triumphant, if momentarily. There was little love lost between them and the other four native groups at Augusta. For a certain sacrifice, they had secured priority over their now clear competitors.

What did the Cherokees think? None would have claimed surprise at the Creeks' underhand behavior or malign objectives. They had always nursed, as the British observed, "an inveterate hatred" of the group, believing them "haughty and insolent" with "bad intentions."[28] But why were these least-liked of "Red Brothers" helping to create such a disturbing new precedent, giving land for trade? Was the postwar world to revolve around totally new issues?

Such questions may have turned over in Ostenaco's mind during his multiday march back to Chota. Certainly later events would remind him of the unusual moment when Creeks demonstrated a changed mode of engagement

between Indigenous and colonial folks. All the same, more pressing queries grabbed Ostenaco's attention into the new year. Other sets of "Red Brothers"—northern-based Indians still fighting Pontiac's cause in the interior—came to the Overhills to ask if the Cherokees still declined to join their pan-Indian endeavor. Did they not want to see the British banished from the continent for good? Some fighters were in fact tired of asking politely. Through the coming months the Shawnees, longtime Cherokee foes, launched several raids on Cherokee towns as punishment for their presumed foot-dragging in support of Pontiac's War.[29]

To the requests and the threats, though, the Cherokee response continued largely unchanged. They had too much to lose. They were too committed to local work. They had never really liked northern Indians anyway. For many, as well, it was undeniable that the Cherokees wanted to honor the core agreement of the recent Augusta Conference, namely, "a perfect and perpetual peace and sincere friendship," free of "any kind of hostilities, injury, or damage."[30]

Some British officials in the area sensed a loyalty to this principle, particularly among the Cherokee leadership and especially, it turned out, in Ostenaco. They lobbied him and some other headmen to break their neutrality and help them actively fight back against Pontiac-inspired uprisings. It would be just like old times! In late 1764 the utsidihi agreed. He told the British that he would go north into Shawnee country to help push back this enemy in the name of peace. His lifelong distaste for the once French-aligned native people was no doubt a key motivation. The still-formidable Oconostota, skiagusta of Chota, joined him, along with a small party of junior warriors.[31]

For nearly two months the Cherokee group scouted around the Ohio River. The British hoped they would attack Shawnee rebels directly. They knew that just a few years ago Ostenaco would have made short work of this task. He'd have relished the chance to exercise his warrior skills in exact proportion to the favors he could then expect or to the debts he could then delete. In 1764, however, some things were tellingly different. Upon their return to the Overhills, Ostenaco's party revealed to the newly placed British agent that they had not touched the Shawnees themselves. Instead, they had captured four straggling French traders in boats on the Ohio. They had performed one of their lightning ambushes, got the men, and confiscated both their boatloads of goods. This is all they brought back to the Appalachians. Ostenaco then demanded from the agent rich compensation for their efforts. Since they had "lost their hunting season by this expedition," he pointed out,

they wanted "as many necessities as those that brought in skins or furs instead of prisoners."[32]

In some respects the incident showed how canny Ostenaco still was when it came to promoting Cherokee interests. He knew that involving his people too directly in a Pontiac-inspired battle was out of the question: the Cherokees could simply not afford to deal with another front of difficulties, either from infuriated Britons or from hostile Indians. In making a show of alliance with the British by agreeing to trek up to the Ohio, Ostenaco placated them enough to ease suspicions. But by refraining from overt combat with the Shawnees he avoided fresh antagonism from natives elsewhere.

At the same time, though, the operation pointed to a couple of ways in which Ostenaco was, like everyone, still figuring out the postwar scene. To bring home two French captives assumed that the French continued as a tenable threat in the southeast. The radical implications of the erasure of European rivalry had not yet fully hit home. As well, to demand prizes in exchange for military service meant that he had also not absorbed Amherst's decree against "gift-giving" to Indians. As wary as Cherokees may have become about manufactures, they did not comprehend a world in which Indians were expected to serve for nothing. In his report back to Charleston, the British agent interpreted Ostenaco's behavior as worryingly out of touch. He feared that it spelled "very unstable" times ahead.[33]

The ensuing decade did prove exceptionally tough for the Cherokees. Instability came not through the horror of outright conflict but through the claustrophobic stress of ever-impinging land pressures. Ostenaco remained in the front line of leadership during most of it.

In 1765 Pontiac's War mostly subsided. Indians no longer wielded the element of surprise and, more important, they were indeed mollified by Egremont's promise of a boundary line.[34] As soon as peace broke out, however, colonists of Amherst's ilk betrayed Indian trust and started moving across the line. These colonists embodied more the hubris of the earlier Paris peace treaty than the attempted amelioration of the later royal proclamation.

Down south the first colonial effort to renegotiate a section of the line occurred between South Carolina officials and Cherokees. It was held at Fort Prince George, poignant reminder of Lyttelton's cataclysmic hostage crisis of four years ago. Ostenaco headed the Cherokee delegation. Most later historians have generalized that all Cherokee land cessions from this grim era were made to acquire, in a deepening paradox, a better trade for themselves. They

were reenacting the dubious Creek deal from Augusta, with or without self-consciousness: giving away permanent land for impermanent goods. In October 1765, though, at this first major Cherokee cession, Ostenaco was clearly trying to secure more than just a path to stuff.

First, Ostenaco wanted to entrench further peaceful relations. "This cession," he began, "is an instance of [respect and] love." It was respectful to British officials higher up the imperial command, who should in turn, he declared, award the Cherokees continued protection. And it was loving to those he called variously the "country people" or their "poorer brothers"—those ordinary settlers already encroaching on hitherto Cherokee lands. Ostenaco had it noted that his cession now saved such settlers the "inconveniency" of moving. They could stay put legitimately, he said, if they also in turn treated the Cherokees "with confidence and civility."

Second, Ostenaco wanted to articulate in an open forum exactly what he thought confidence and civility—or love—entailed. "God is the maker of both white and red people, and we are all his children," he said. These sentiments ought to have rung loudly to his Christian listeners. "There is no difference between . . . us, we are both alike, the blood flows in their veins as in ours and we have essentially the same passions and desires." To this stand for joint humanity, Ostenaco added a firm admonishment to any who would gainsay a deal made from such love. "[Don't say] hereafter you know not where the Line is," he scolded. "Don't shame your warriors any more with being told you went below it. . . . Will you not then be honest? . . . for we are tired of traveling backwards and forwards to make up matters for you."

Only as a third point did Ostenaco admit that the land cession was also in aid of some better trade. "We had promises of a good trade," he noted, "I do now request . . . our Brothers below [in Charleston] to settle rates upon the goods lower than what they are sold at present." As much as he was learning that trade discussions with colonists were changing hue, Ostenaco—again, like most everyone—was not yet clear on the exact nature of that change. He still thought that the poorer settlers wanted Cherokee hunting grounds so they instead might hunt on them. He had mentioned earlier that the land given included "the game that is upon it." Ostenaco's vision of the colonists' economy was still that of a trading polity, powered by deer hunting. He was yet to grasp how much it was shifting to a landed society, with less and less need for skins, and especially for the Indians who had once obtained them.[35]

Twenty months later Ostenaco headed another delegation to make another cession. By this time he seemed more aware of the colonists' growing

land obsession. This meeting was with North Carolina officials, little involved with Cherokee matters till now, and entailed shaving off a northeastern segment of Cherokee country. He spent less time on noble rhetoric about a shared humanity now. Perhaps it seemed already pointless. The only mention of the "Maker" in 1767 was not to God's common paternity of all peoples, but to God's original designation of the lands in question to the Cherokees. "The man above is head of all, he made the land and none other, and He told me the land I stand on is mine," Ostenaco asserted. Nonetheless, the utsidihi was here this day to "make a division" of Cherokee land and "give it to the white people."

In return, Ostenaco no longer demanded respect, love, or even the chance to shame his listeners into listening. He knew it was for goods alone. The Cherokees were pushed to cede to North Carolina in order to pay off goods already given on credit. If there was anything left to wonder about the colonists' lust for land, there was certainly no more confusion about the inequity of the deal it led to. "The price the white people give for land when they buy is very small, they give a shirt, a match coat and the like which soon wears out," Ostenaco stated with devastating clarity. "But land lasts always."[36]

Cherokee headmen were involved in several more cessions into the 1770s. Some were formal acts with crown authorities; some were informal acts with settler cowboys. All were permanent losses of centuries-held country to white encroachment. Ostenaco was present at many of them. He was a signatory to the formal Treaty of Hard Labor with Virginia in 1768, which gouged more chunks out of the Cherokees' northeastern lands.[37] He also sanctioned an informal agreement three years later with Georgia, which did the same to southeastern parts. Both these acts were pushed by the Cherokee need for goods—goods that were ever more undersupplied and overpriced by British colonists who simply cared less to sell things to Indians than they cared to expand their agricultural estates.

Notably, as much as Ostenaco recognized the power of this Cherokee need, he also saw that violence played a role as a stick to cession. In the 1771 cession to Georgian settlers, for instance, his rationale included not merely paying off debts but also avoiding "the danger of our enemies, who are surrounding us everywhere."[38] His missive to the British superintendent for Indian affairs gave vivid expression to this pervasive physical threat. "The white people pay no regard to all our talks," the utsidihi stated. But "they are in Bodies, in the middle of our Hunting Grounds [with their] Guns Rattling every way."[39]

Ostenaco was not present at the formal Treaty of Lochaber in October 1770, which added about ten times the acreage of the Hard Labor cession to Virginia's assets. It is not clear where he was at the time. Maybe he was ill; he was now over fifty-five and had taken the lead on much of the diplomatic work for his people over the past five years, traveling hundreds of miles for each heart-wrenching deal. Maybe he was taking time out to be with his adored grandson: Richard was turning eight and would soon be needing induction into masculine duties from his maternal male kin. Wherever he was, he presumably agreed with those who did preside. He never later contradicted them. The leaders at Lochaber were his longtime peers Oconostota and Attakullakulla. Both these warriors admitted the pressure of material needs as a cause of the cession, though Oconostota also brought up violence. Certain settlers, he noted, come "into our Grounds" with packs of men. When we tell them off, they "threaten to shoot us down."[40]

Attakullakulla's speech at Lochaber was particularly eloquent. Among his ruminations on the Maker's intentions, the current flat state of trade relations, and the irritating way that "now all our talks are about land," he raised a topic that, in retrospect, was prescient. "There are young [Cherokee] people," he said, "grown up" on their side of the now six-year-old line. "Yet the white people want to come into their doors." It was one thing for the elderly to see lands disappear. What must it be like for those coming up to see their inheritance sold off?

In 1770 Attakullakulla voiced a confidence that the "great being above" would call out any overly gross injustice. His fellow negotiator Oconostota was not so sure. "We are old men who come over the Mountains," he said, "[but our] young fellows are gone out to Hunt, & know nothing of this, and will say why should these old men give away the land without our knowledge?"[41]

Tensions between young and old were, in the end, what broke the bleak trend of the post-proclamation decade. For good or ill the rebellion of Cherokee youth eventually disrupted the elders' constant cessions in the name of goods, safety, and peace. Theirs was both a catastrophic and cleansing break. As a key elder statesmen now, Ostenaco was caught up in the consequent maelstrom in complex ways.

The rebellion of youth brewed for a couple more years after the Lochaber cession. Young Cherokee warriors first had to watch their elders sign over ever more parts to Virginia in 1772 and then Georgia in 1773.[42] Revolt finally burst

forth in 1775, at a meeting on the wooded riverbanks of Sycamore Shoals in North Carolina.

By this stage, tensions between various segments of the British in North America were also near boiling point. Some colonists, mostly the office bearers, were keen to uphold the spirit of the 1763 royal proclamation. Others, chiefly the entrepreneurial "country people," were starting to chafe at what they saw as draconian restrictions on their right to extend settlement. One of these entrepreneurial types was Richard Henderson, judge and, more recently, land speculator from North Carolina.

In 1774 Henderson had formed the Transylvania Company, designed to acquire and sell land well to the west of both Carolinas, in today's Kentucky. This land was deeply contested. It was not only recognized by most colonial officials to include the northern swathes of the Cherokees' hunting grounds but also considered "protected" by both Virginia and North Carolina. Henderson's move to buy the land off the Cherokees through a private transaction was set to provoke an array of groups.[43]

Henderson began his venture by traveling to Chota, where he laid out his plans to the Cherokee leadership. Probably he did not indicate quite how extensive his ambitions were at this point. Later, some Cherokee headmen would protest the expanded coordinates of the proposed cession.[44] All that the Cherokees heard at Chota was the promised payment: up to four thousand pounds' worth of goods, including several wagonloads of crucial guns, clothing, alcohol, and livestock. That most Cherokees were ready to enter into this exchange suggests how hard times had become in the Overhills. In addition to the constant need to repay debts for now seemingly essential goods and the ever-threatening menace of bloodshed, the Cherokees were facing a reduced annual hunt and therefore starvation. The last decade's cessions had been mostly of hunting grounds. As Ostenaco himself had recently complained, the deer were "growing scarcer every year."[45]

Small, resilient, gray-haired, Attakullakulla led the delegation to Sycamore Shoals to formalize the agreement. Oconostota and several hundred other Cherokee supporters accompanied him. Attakullakulla seemed to have the support of the full phalanx of the leading elders. In fact, as one observer noted, only "one principal man" did not attend. This was Ostenaco, presumably at home due to illness or to keep watch over the towns. He sent word, however, that "what the other chiefs agreed to he would abide by."[46]

The formalities opened in mid-March 1775. Carolina Dick, as the Cherokees liked to call Henderson, outlined the acreage he desired. Instead of

consenting immediately, the Cherokee leaders huddled to confer, declaring a need to delay matters for a day. In the morning, Attakullakulla offered an alternate swathe of land, but Carolina Dick shot this down, saying he would have his proposed cession or none at all.

Suddenly cries of fury broke up the talks. Attakullakulla's son, a skiagusta in his own right named Dragging Canoe, got up and stomped out of the meeting. The Cherokees knew they needed to confer in private once again.[47]

Dragging Canoe was not operating on instructions from his father. It was in fact toward Attakullakulla that the son directed most of his rage. Through the rest of that day Dragging Canoe harangued his elders about the deal being struck. For one thing, the fiery younger man pointed out, the proposed land was not all the Cherokees' to give. He called it a dark and bloody ground, meaning some was already contested by other native peoples and would surely prompt carnage for whoever settled there (or sold it). Second, he was disgusted at the greed shown by the whites; could his elders not see how those rogues always asked for too much? Finally, he had just had enough of his own "Old Men" making so many cessions, year after year. They gave and they gave and they gave. But the gains were never sufficient, he believed, to secure the Cherokees' future. The elders, he later accused, were too old to hunt for themselves and so out of poverty sold everyone's land.[48]

The younger generation's revolt had begun. Dragging Canoe refused to partake in any further dealings at Sycamore Shoals. Many fellow disgruntled Cherokees joined him in abstaining. None, though, could prevent Attakullakulla from going ahead with his political work. On the third day the Cherokee old guard accepted Carolina Dick's proposal. Whether from pique against his son's criticism or from a profound, perhaps now habitual, fatigue, Attakullakulla signed away what would amount to more land than all the previous decade's cessions put together. He must have felt overwhelmed at that moment by the stench of defeat. Some estimated that the goods the Cherokees wheeled home were worth quite a bit less than four thousand pounds.[49] Certainly, as Ostenaco had once observed, they soon wore out.

It was not just the younger Cherokees who protested the Henderson purchase. Officials from both Virginia and North Carolina quickly pounced on the illegality of the transaction. The royal proclamation had stated that all negotiations for land had to be made through the crown, not through cowboy speculators. Even those now leaning toward rebellion against the crown were aggrieved at such renegade behavior. The newly formed Continental Congress refused to sanction the landgrab on grounds that it violated earlier

claims—not of the Cherokees but of Virginians and North Carolinians. Eventually Carolina Dick was able to claim around one quarter of the land he'd purchased off the Cherokees, over ten square miles of today's Kentucky, in reward for his subsequent revolutionary activities.[50]

How did Ostenaco react to the Sycamore Shoals affair once he heard directly from its returned participants? Not with surprise, surely, at Dragging Canoe's defiance. He'd known the firebrand all his life, perhaps even witnessed the time when as a boy Dragging Canoe had pleaded with his statesman father to join a war party. Attakullakulla had apparently allowed it so long as his son carried his own canoe. The young stripling could only drag it behind him but did so for the whole campaign, earning his name thereafter of Tsiyu Gansini: *he is dragging his canoe*. Probably Ostenaco was not even shocked by the support Dragging Canoe had gained among other younger men. Attakullakulla and Oconostota had not been the only ones to worry about youthful retaliation over the years. As far back as 1769 the utsidihi had observed that "our young warriors are very angry to see their Hunting Grounds taken from them."[51]

For the present Ostenaco seemed to support the elder majority and to accept the Sycamore Shoals cession. He had sent word he would do this, and nothing in his behavior over the next year at least spoke of backpedaling. However, some whisperings of doubt may have started swirling in his mind around this time. Where would the cessions end if something did not change? What would his now twelve-year-old grandson do if the Cherokees' country continued to shrink at this rate? The year 1775 in North America was a turning point for more than one set of people.

The Cherokee delegation to Sycamore Shoals had returned to the Overhills just as the revolutionaries' first shots rang out in Lexington, Massachusetts, far away to the north. The settlers' War of Independence from the crown reached the southern colonies by the end of the year. Most Cherokees treated the news about the white-on-white conflict with studied indifference. A few, however, glimpsed an opportunity.

By the spring of 1776 Britons loyal to the crown were feeling pressed. Scrabbling to come up with a plan for a counterattack, many started to look to their former occasional-allies-and-sometime-foes, the Cherokees. It was a delicate situation: loyalists knew that an injection of Cherokee force could help turn the tide for them, but they also knew that Indian attacks in general could unite the currently divided settler population against them. The main

British agent for Indian matters, John Stuart, sent his deputy and brother, Henry Stuart, to Chota to achieve a delicate feat. He was to galvanize the Cherokees sufficiently against the revolutionaries with loads of ammunition and reminders of settler rapaciousness but not so sufficiently that they would charge before the loyalists were ready.

Needless to say, Henry Stuart did not manage his task. He arrived in the Overhills in April 1776 to find a Cherokee population now perceptibly split between the raging and the reticent; the young and the old. He found Dragging Canoe leading a faction of Cherokees, men and women, in a state of fury about the encroachments of the western-pushing settlers. The Cherokees are "almost surrounded by the White People," stormed Dragging Canoe to Stuart, "they had but a small spot of ground left for them to stand upon." In fact, the youthful had come even to suspect that the whites intended "to destroy them from being a people."[52] Dragging Canoe was not interested in propagating British tenure in North America—they were still white, after all—but for now those whites under crown rule were a better bet for the Cherokees than those overturning all royal regulation. He could not wait to start using Stuart's fresh ammunition for his defense.

By contrast Stuart found the "Old Sensible People," including Ostenaco, remarkably subdued. He interpreted their "dejected and silent" composure as a rebuke to the Cherokees' rebellious young, though it must in part have been in reply to Britain's cheek in asking for their cooperation one more time. Elders like the big three, Attakullakulla, Oconostota, and Ostenaco, remembered all too vividly how they had helped the British fight wars previously, only to find British cannons turned against them whenever the wind blew otherwise. These same British authorities had also been fairly useless over the last decade, condoning time and again violations of their own promised protective boundary. The elders wished only for Stuart to go away—or come up with a better plan.

The following month Stuart had to watch helplessly when a deputation of fourteen northern Indians arrived in Chota. Each had a face dramatically blackened with the paint of war. In some reprisal of a Pontiac War alliance these northerner Indians had come to ask the Cherokees to join them in a large pan-Indian attack on whites. Unlike the 1760s attacks this one would target revolutionaries specifically. Where such an alliance stood on loyalist whites in the long term was left tantalizingly vague. The point here was to gather a force to break the thinnest edge of the wedge. In some repetition of Dragging Canoe's earlier stance, the deputation's leader declaimed, "All red people who were

once masters of the whole country [now] hardly possessed ground enough to stand on." He also thought the white people wished "to extirpate them." An attack on these worst kinds of whites would be worthwhile since it was surely "better to die like men than to diminish away by inches."

Dragging Canoe leaped to the challenge. Within days he too had painted his face black and recruited hundreds of fellow young Cherokees to join him. Ostenaco was not among them. In fact, Stuart particularly noted that the utsidihi went unblackened and that he agreed with his peer Attakullakulla that the young peoples' behavior was "precipitate." At the same time, though, no elder prevented the force from departing. Attakullakulla even went out of his way to reassure Stuart of his confidence that the youngbloods would not fight beyond the supposed proclamation line.

Dragging Canoe's force struck on 1 July 1776. Pointedly, the first settlers to feel the wrath of the rebel Cherokees were those newly planted around Sycamore Shoals. The settlers were taken by surprise. The revolutionary Henry Laurens, who had once written off the Cherokees as being broken for good, fumed that "suddenly, without any pretence to provocation, these treacherous devils . . . made inroads upon our settlements burned several houses and murdered about sixty persons."[53] The rebel Cherokees continued to have the upper hand through July. Although they may have contained themselves within the original proclamation line, as Attakullakulla had guaranteed, they did not always discriminate between types of white folk. Another revolutionary spluttered that the Cherokees killed "without distinction of party."[54] He suggested this was owing to their innate savagery. Dragging Canoe might have argued that such distinctions were not very meaningful to his particular rebels.

The revolutionary backlash came together by August. And it was, to give the Stuarts credit for their earlier fears, extreme. United troops from Virginia, Georgia, and both Carolinas surged into Cherokee country by the thousands. Most estimated around six revolutionaries for every one Cherokee warrior in the consequent battle.[55] Ostenaco was surely caught up in it. Together with their numbers, the revolutionaries were aided by a newly burning sense of conviction in an unfettered scorched-earth policy. "For my part," claimed one South Carolina revolutionary, "I shall never give my voice for a peace with the Cherokee Nation upon any other terms than their removal beyond the mountains." Ostenaco's old admirer Thomas Jefferson agreed: "I hope the Cherokee will now be driven beyond the Mississippi [as the] consequences of their beginning a war." By October scores of Cherokee towns had been smashed. Up to two thousand Cherokees were dead.[56]

The Cherokees' negotiation for surrender through the winter of 1776 revealed a people pushed to the edge of a precipice. They were battered, angry, terrified, and in some cases desperate. But they were not, for all that, slinging quite as much mud at each other as many colonists assumed. True, it was those elders who had opposed the war in the first place who had to submit to the humiliation of another truce. But notably these elders drew the line at handing over Dragging Canoe and the other rebels to the punitive southern revolutionaries. Likewise, Dragging Canoe and his fighters, who in turn refused to concede defeat, made the awful decision that winter to pack up in their hundreds and leave the Overhills for good. In leaving, they cleared the elders of any responsibility for them and allowed each to reexert authority among those remaining.[57] The damage was enormous, but the Cherokees pulled back at this worst of moments from the lure of self-immolation.

To Ostenaco, the ordeal turned out to be as provocative as it was painful. At some level the departure of Dragging Canoe's rebels to Chickamauga Creek, one hundred miles to the west, represented the nadir of his life. Watching a key section of his people decamp forever—men, women, and children—seemed like the end of everything he had ever fought for. All his own relocations, battles, haggling, and travels had been dedicated solely to strengthening his greater community, even while the definition of that community broadened over the decades from town to region to a whole kin-crossed polity. Now, here was a vital section breaking his community apart.

At another level, though, it soon became evident that Ostenaco also saw an alternate interpretation. He knew that Dragging Canoe called his group the Ani-Yunwiya, the "Real People." They disagreed with the arms-supplying British loyalists that they were secessionists.[58] The utsidihi saw that these Chickamauga Creek pilgrims truly believed themselves to be the most steadfast examples of Cherokee principles—the torchbearers and the preservers rather than their least respectful offspring.[59] As the snow fell once more on the remnants of the Overhills towns, the two competing interpretations churned in Ostenaco's mind.

Attakullakulla and Oconostota organized most of the details of the elders' formal surrender to the revolution. There would be two separate treaties, one in May 1777 with South Carolina and Georgia, the other in July 1777 with North Carolina and Virginia. Despite his mixed sympathies, Ostenaco trudged along to the first signing at Dewitt's Corner, just south of old Fort Prince George.[60] His is the lead signature on the treaty, which not only

sanctioned peace but also ceded another large chunk of Cherokee land in reparation, this time to people calling themselves citizens rather than subjects.

The second signing was conducted by the Holston River, near Sycamore Shoals. Officials from North Carolina and Virginia arrived by late June. Attakullakulla, Oconostota, and scores of other reputable Cherokee leaders joined them soon after. Ostenaco, however, was absent. If his peers knew he was not going to appear, they kept it to themselves. The white officials delayed the serious end of the talks for his attendance, but he continued to frustrate. After ten days the leading Virginian official announced that, while he understood the Cherokees had a long journey to make to get to the Holston, he had been waiting "some time." He thought it best now to press on. "We are very sorry that Judge Friend [Ostenaco] is not come to the Treaty as we expected," he remarked; he understood, all the same, that enough warriors were present to "authorise" this next promise of peace.[61]

The articles of the second treaty were finalized without Ostenaco. In fact, his mark never again appears on any colonial record. The revolutionaries' parting words to the Cherokees asked them to "find out the temper of the Dragging Canoe and how far he and his people approve of the present peace [and] whether there is any danger of one or more chiefs renewing hostilities." Foremost among Dragging Canoe's "people," the revolutionaries now understood, was "Judge Friend."[62]

Perhaps it had been a sudden snap, a jolt of realization that he had gone this far with accommodation but could go no further. Or perhaps it had dawned slowly, a gradual arrival after a long struggle with obligation, fear, and history itself. Ostenaco's mental journey to his decision about joining the Ani-Yunwiya remains obscure. All that later events indicate is that by June 1777 Ostenaco had foresworn his old home and moved his various households permanently to the new establishments along Chickamauga Creek—daughter Sokinney; teenaged Richard; the lot. There, he could finally put an end to his questions about the most recent negotiations for peace; about the ruthless machinations of Carolina Dick; about the unforgiving grind of the last decade's constant cessions. He could, in short, draw a line under the whole sorry story of engagement with white people ever since his return from Britain in 1762. In place of questions the Ani-Yunwiya were crystal clear on their twinned objectives: carry on the fight against the revolutionaries; preserve heritage through practice if no longer through territory.

At well over sixty years of age, Ostenaco was not about to take up arms literally with his fellow Ani-Yunwiya. However, he clearly supported their

continued aggressive defiance. It would be impossible to reside among these outliers, not to mention face down the dismay of his old friends left in Chota, without holding a solid commitment to the principle of no-surrender. More important, the retired utsidihi supported the social effort to reestablish Cherokee order along the Chickamauga. He watched over the building of eleven Ani-Yunwiya towns, each complete with seven clans and a town council. He saw the effort to grow population through the old matrilineal adoption of other kin, in this case, lost loyalists, freed blacks, and throwback traders. Above all, he helped promote the ancient quest for harmony in all things among this new, unexpected, but eventually cherished blooming of Cherokee life.[63]

At a personal level Ostenaco's last adjustment of allegiance can be seen as a way, finally, of sidestepping the exhausting vacillation between resistance and accommodation that had characterized most of his adult life and indeed the majority of all Native Americans' lives throughout the eighteenth century. For many, such a sidestep was impossible. For the bulk of Ani-Yunwiya warriors, for instance, it was impossible, as they had committed themselves completely to the side of violent resistance. But for a renowned warrior with a rich record of diplomacy with Europeans, the act of encouraging resistance without lifting arms and of refusing to talk despite exceptional negotiating capacity stood as a unique rebuke to the pressures of empire. Loyalists could no longer name him an ally. Revolutionaries could not precisely target him a foe. He wouldn't fight. He wouldn't wrangle. He had slipped their nets, and all their waiting labels (dying native, ignoble savage), by moving to Chickamauga on his own terms. Much as he had done at other key moments in his life, Ostenaco turned what appeared to be a sad tale of Indigenous reaction to foreign forces into an Indigenous tale of deliberate, local creativity for a group's survival.

Ostenaco spent the rest of his days living on the flatlands of an unfamiliar waterway, far out of sight of the mountainsides of his youth. He was not, though, without the stimulus of the young. They dominated his life along the Chickamauga. Youth shone in the warriors picking up after Dragging Canoe before the year was out. It drove the wives and sisters who stayed behind in the towns to till fresh fields of corn and vegetable sustenance. And, of course, it radiated out of the children of these younger Cherokees—children like Richard Timberlake, who kept Ostenaco company through old age, assuring the fading warrior-diplomat by his mere existence of an abiding future for the lifeways, values, and hopes of a beloved people.

Interlude

ON ORNAMENTS

Let us return to that chilly night in London in December 1776. Members and students of the Royal Academy of Arts are clustered inside Somerset House, sheltering not just from the cold outside but also from the grim news coming out of America. Their president is delivering his seventh annual address.

"The first idea in art," Joshua Reynolds intones, "is that presiding principle of which I have so frequently spoken in former discourses—the general idea of nature." The audience that evening certainly has heard him on this topic before. In earlier lectures Reynolds propounded at length his views on how artists should primarily depict the universals of human life—those values and ideas that are general to every person regardless of their place in history. As a good neoclassicist, he implored artists not to fixate on "likeness" over "taking the general air." Likeness captures the "particularities" of people, which may flatter and thrill momentarily, but it also panders to the superficial and cannot survive the tests of time or space. Likeness cannot speak forward or backward to "different ages and different countries." As a good neoclassicist, too, of course, Reynolds holds that ancient Roman statuary—always his artistic ground zero—does pass these tests.[1]

In later lectures Reynolds will go on to elaborate what such generalized, universalist art can do for human societies, namely, elevate viewers' thoughts to the contemplation of the best values and ideas the world has known, which in turn can help develop "virtue" among nations.[2]

In this lecture, though, Reynolds focuses on a problem that faces all practitioners on the road to such art. What should an artist do when presented, nonetheless, with a demand for particularity? This question arises especially when dealing with sitters from foreign cultures. Everything about such subjects seems, at first glance, different rather than common, particular rather than general. Hair, dress, manners—all those things that Reynolds snubs as "meretricious ornaments" but which also define foreigners as, well, foreign.[3]

Figure 15. Engraving of a Māori man called "Otegoongoon . . . curiously tataow'd," from Sydney Parkinson, *A journal of a voyage to the South Seas, in His Majesty's ship, the Endeavour* (London: Stanfield Parkinson, 1773), plate XXI, between 108 and 109. Reynolds would have been familiar with Parkinson's published images, if not also his original sketches. Retrieved from TROVE via the National Library of Australia.

Before answering, Reynolds notes that the demand for particularity can come also from rich British customers who are more interested in looking attractive and fashionable in their portraits than they are in helping to moralize or to educate viewers. Reynolds knows this second type all too well and concedes that "art is not yet in so high estimation with us, as to obtain so great a sacrifice as the antients made." No Briton he's ever met has allowed him to paint his or her portrait in the truly universal costume of the naked body, unlike the more generous Romans.[4]

The solution to the problem, Reynolds finally explains, is to allow for *some* particularities. As he himself figured out long ago, this additionally solves another difficulty with the universalist approach. His famous Keppel portrait of 1752 had entertained touches of particularity in order to hook in a reasonably superficial starting audience. Noticing Keppel's uniform and position had distracted from pondering too deeply the meaning of Britain's version of empire. How, though, do we decide which "meretricious ornaments" to include and which to exclude? Or, in Reynolds's own very particular, eighteenth-century phrasing: how do we determine "which of the different customs of different ages or countries we ought to give the preference"?[5]

It is at this point that Reynolds reaches for the examples of a Cherokee and a Tahitian. The Cherokee provides him with an ornament that is worthy, the "yellow and red oker" covering his "forehead or cheeks." This kind of cultural quirk to Reynolds, no less than the European's powdered wig, is "very innocent." It is minor in every sense; in fact, to remove it would draw more attention to human difference than would showing it. The Tahitian, on the other hand, offers a custom that requires suppression—that of tattooing. Reynolds explains obliquely that he objects to tattoos because they are "painful and destructive of health." What he means is that tattoos cut too far into the supposedly common body; they flaunt difference too indelibly for an artist to condone them.[6]

Audience members may well be wondering where the president is going with this line. Most know that he exhibited only seven months earlier in this very room his portrait of a Tahitian man (so-called) *with* tattoos on his hands and feet. They would be even more surprised to learn that fourteen years earlier still Reynolds had painted the well-known Cherokee Ostenaco *without* his characteristic ochre markings.

Consistency between theory and practice, though, has never been a strong suit of the president of the Royal Academy. Reynolds has, after all, made an art form out of blurring contrary positions over the last twenty-five years. At any rate, the contradiction does not seem to bother anyone too visibly

tonight. Perhaps listeners are more occupied with the idea that they live in an era that can draw from such examples; that some among them have even met a Cherokee or a (supposed) Tahitian. Only in their lifetimes has this become anything other than fantasy. Such wonderment might in turn lead to the topic of empire, that octopus-like creature of Britain's own national making, currently flailing in North America but finding some potential purchase in the Pacific. It is this creature that brings exotic people home to Britons, even while it provokes every kind of headache, from concern over empire's oppressions to worry about losing the lot now to rebellious settlers.

What is plain is how much Reynolds associates his experience of painting a Native American with his later artistic encounter with a Pacific Islander. To him, both are epitomes of the exotic. They are the most relatable and teachable instances of the utterly foreign. These two men will also prove to be among the most challenging subjects of his career. Reynolds has already declared his portrait of Ostenaco a failure, consigning it to storage—probably for ending up "too like," despite his best intentions. He is happier with his painting of Mai, the Ra'iatean who met Capt. James Cook in the Tahitian Isles and traveled with him to London in 1774. Reynolds had displayed this portrait prominently in the Royal Academy exhibition the previous May. It showed far more a general man: intrepid, worldly, symbolic of the possibility of a well-knit globe. But this work has also cost Reynolds. He labored harder on it than on most, and his final version suggests that some niggling doubts remain. Indigenous people from the contact zones of empire push Reynolds's aesthetic and political principles to their limits.

Reynolds spoke longer than usual that night. Fortunately, Somerset House was only half a mile from home. Perhaps he walked it, despite the inclement weather. Almost certainly, once settled back in his Leicester Fields house, he had a servant bring him some wine. Fortified, sweet, red—wine always put him "in very good spirits." No doubt he also took some Virginia-grown snuff, to which he was famously partial, pinching it out of one of his two snuffboxes—the first, elegantly made from gold, the second, "shabby" and cast from tin. His choice depended on whether he was feeling as refined as his ambition for art or, instead, in the mood for "a little blackguard."[7] Such were the ornaments of Reynolds's own life.

Five thousand miles to the west, in even worse weather, Ostenaco was contemplating different customs. Negotiations for a Cherokee surrender to the

American revolutionaries were under way in December 1776, but the aging utsidihi wondered if this was truly the best option. Huddled next to the central fire of his winter home, he considered the white cloth of peace that his senior peers were turning over in their hands. He noted the black paint of war still smeared across the faces of the angry younger men. And he eyed the diminishing baskets of dried vegetables stacked against the walls by his wife or daughter.[8] What was the most precious ornament of all, and which decision would best protect it?

Also at the same time, smack in the middle of the Indian Ocean, a one-hundred-foot sloop of Britain's Royal Navy was voyaging east. Here, the weather was meant to be summery, but in fact, this close to Antarctica and with "strong gales" prevailing, it was the coldest and roughest of all three scenes.[9] Gripped to the topside, rolling in sync with the pitching waves, a square-shouldered, dark-locked man stood with eyes fixed on the horizon. Far ahead lay the familiar peaks and warmer waters of his youth. Red feathers, black stones, turquoise shallows. Breadfruit, plantains, taro. All beckoned. After two years away, the Ra'iatean Mai was heading home.

Man on a Mission

MAI FROM RA'IATEA

Like most Pacific Islands, Ra'iatea appears on the horizon as a jagged green mountain clump rising out of a dark blue sea. Less common, it is completely surrounded by coral reef, which gives the island an almost iridescent turquoise frame. On its southeast coast, just opposite a tiny passage in the reef, there lies a large, square platform made out of black volcanic rock. Today, the platform is fairly exposed, surrounded by flat, dry earth and a sprinkling of modest banyan trees. In the eighteenth century there was more foliage. Taller trees hung over the platform to shade the men who prayed there.[1]

Mai was born in the middle of the eighteenth century, somewhere on Ra'iatea's 105-square-mile landmass.[2] We don't know if his birthplace was at or near the sacred platform of Taputapuātea, but it is certain that he later ground his primary sense of identity in this key *marae*, or temple. Like every Ra'iatean, he knew that Taputapuātea had been founded by his ancestors to commemorate the place where the god Ta'aroa entered the world and created all the other gods, people, and islands. He also knew it had served as the launching pad for his adventurous forebears, who had from this place become the first human discoverers of Hawai'i, Aotearoa, and Rapa Nui.[3] The temple of Taputapuātea made Ra'iatea the most important isle in Tōtaiete mā, or what Europeans later called the Society Islands. Being Ra'iatean granted Mai a special respect among all Islanders of the eastern Pacific, and it turned out to be the most defining attribute of his life.

Rather more like Reynolds than Ostenaco, Mai grew up in a society both hierarchical and patrilineal. Status was determined by birth more than by merit, and families descended mainly through men. Ra'iatean women, like British women, were generally subordinate to men in local and regional governance. Yet it was not impossible for Ra'iatean women to achieve eminence. Several did so in Mai's lifetime, suggesting that the rules of patriarchy were less rigid on his island than on Reynolds's. As well, there were many female gods to revere among the male gods in Ra'iatea's polytheistic culture, unlike in Britain.[4]

What was least like the society of either Reynolds or Ostenaco was the way in which eighteenth-century Ra'iatea blurred the line between religion and politics. While the British and the Cherokees of this time were distinctly more secular than their respective forebears, Ra'iateans understood power as they had for some centuries, in terms equally spiritual and worldly. That is, leaders

Figure 16. Map of the central islands of Tōtaiete mā (the Society Islands) in the eighteenth century. © Mark Gunning.

on Earth exerted power to the degree that they possessed *mana* (efficacy or force), which was granted directly by the gods. Mana, indeed, was the means by which the spirit (and ancestor) world linked to people in the present.[5]

The combined cosmological-material worldview also helps to explain Ra'iatean ideas of the self in the eighteenth century. All beings were connected to the gods and past relatives through mana. At the same time, all beings were animated by the masculinist, intricate hierarchy of Ra'iatean life on Earth. In very shorthand, then, we might say that, like Ostenaco, Mai would possibly start his own self-narrative with a description of his predecessors instead of his actual birth, though rather more like Reynolds those predecessors were understood to descend through his father instead of his mother. To a far greater extent than either Ostenaco or Reynolds, however, all predecessors lived every day with Mai through mana.

Mai's father was of the *ra'atira* rank of Ra'iatean society. Above him were the *ari'i* chiefs—jointly religious and political leaders and intensely variegated within themselves—and below him were the *manahune* commoners—also variegated but generally landless laborers. The ra'atira, in between, often held land but served predominately as the administrators of the will of the ari'i.[6]

All three major ranks of Ra'iatean society were replicated within district groupings on the island. Where scholars have tended to use the terms "town and region" to describe Cherokee social organization and "village and town" to describe Britain's basic eighteenth-century units, they often employ the more anthropological words "ramage" and "chiefdom" when referring to Pacific societies. In an effort to break down the disciplinary ways of seeing the eighteenth-century past, it may be as useful to understand Ra'iatea in Mai's lifetime as consisting of large, extended families living in land-based districts. Distinctively, on Pacific islands districts were usually shaped like pie slices, so that each could enjoy the various environmental niches on offer. For example, each could have some highland forest, some agricultural land, and some access to coastal resources. A bit like a Cherokee region or a British town, eastern Pacific districts usually contained five thousand to ten thousand people. There is no established estimate for the total population of Ra'iatea in the eighteenth century, though if Tahiti at the same time was around one hundred thousand, then at a quarter of the size, and considerably more arid, nearby Ra'iatea may have come to fifteen to twenty thousand. This would indicate three to four major districts.[7]

One way into the world of Mai's father is to imagine the day he celebrated the arrival of his second son, sometime during 1753. That day was not when

Mai's mother labored and bore him, surrounded by female relatives in her house or nearby location. It was instead the day Mai's father himself presided over the welcome ceremony in the local marae. Following speeches and offerings to the god 'Oro at their temple, the nearby community was invited back to the parents' open-sided thatched house for a special meal. Guests enjoyed the treat of eating pork, accompanied by the more usual plantain, taro, and breadfruit dishes of everyday life. Not quite the elaborate, district-wide merrymaking that would signal the birth of an ari'i child, the party was nonetheless joyful and bonding.

Distilled in this moment are many of the key elements that would go on to define Mai's early childhood. Dominant among them is the pervasive presence of 'Oro worship. 'Oro was the god of war and fertility and had emerged as a ruling force in Ra'iatea only around fifty years earlier.[8] Born, like all the other gods, at Taputapuātea, 'Oro was denoted by the color red. His image, fashioned from a three-foot upright stone, now stood at the head of Ra'iatea's most sacred marae, wearing a red-feathered girdle. The few paramount chiefs of the 'Oro-dedicated districts wore similar belts. Signal 'Oro rituals entailed human sacrifices, deferring to 'Oro's warring role, and erotic dances and dramas, deferring to the god's command over fertility.

The most notable quality of the 'Oro sect in Mai's youth was its missionizing zeal. More than other sects, 'Oro followers set out to convert all neighboring island district leaders. They had succeeded first in Bora Bora to the northwest around 1710 and in Tahiti to the southeast around 1720. Missions were led by a special class of ari'i uniquely associated with the 'Oro sect, known as the Arioi. These leaders were said to travel in flotillas of canoes, with red feathers streaming, drums and flutes sounding, and crews performing, bedecked in flowers and scented bark cloths. In almost all surviving testimonies the Arioi are described as particularly vigorous and charismatic— both men and women, each martial and alluring. No wonder they attained such thorough conversions. Stone images and place names of the eighteenth-century 'Oro sect are today found in places as far apart as Hawai'i and Aotearoa, though its impact was always deepest in Tōtaiete mā.[9]

One of the first things Mai learned to recognize growing up was the single Arioi lodge in his district, headed by a "Black Leg"—either a man or a woman but distinguished by extensive tattoos from hip to toes. Mai witnessed many times the periodic dances and dramas performed by Arioi members in the districts, all apparently highly erotic, involving as well public displays of sexual intercourse. He understood, however, that any progeny resulting from

Arioi performances faced infanticide, according to the group's strict care to keep itself exclusive. An Arioi parent might decide to save a baby, but he or she would then have to forsake privileged membership.

Perhaps less consciously, Mai's childhood was overlain with the militarizing effects of 'Oro's eminence. Although Ra'iatea was assuredly the heartland of both the east Pacific cosmos and 'Oro worship in particular, this did not secure it against internal attack from its newly converted recruits. As often happens, the furthest-flung adherents became the strictest devotees, and the return pilgrimages to Taputapuātea by surrounding Islanders increasingly resulted in armed contests over the purest or best form of worship.

Eroticized and militarized, then. But at the same time, highly rule-bound regarding sex and increasingly and bitterly factional. This was the particular, or "historical," Ra'iatea of Mai's youth, and the aspects which most distinguished it from the Ra'iatea of, say, his grandfather.[10]

Of course, some features of everyday life prevailed the same as they had for generations. Mai's house was doubtless similar to the neat, cubelike structures, built on stone platforms and lined up in rows around communal fruit-tree stands, that his ancestors had known. He ate similar food, preserved in similar storage pits, and cooked in similar earth ovens.[11] Most of all, he engaged in childhood activities reminiscent of those of his forebears, especially the preeminent Pacific arts of fishing, clothmaking, and voyaging. One early European observer, Johann Forster, once observed that "every child is instructed in the . . . most expeditious ways for catching fish, the proper season and bait for each kind, and the places which they haunt and resort to." Forster went on to note that while every youth was also well instructed in the cultivation of the mulberry tree for bark cloth, only girls were taught how to make the bark into cloth and how to dye it and produce dresses or furnishings. Instead of finishing cloths, boys were directed toward learning about the best woods for "making the various parts of a boat, and for navigating it by paddles or sails." In fact, Forster asserted, boatbuilding and boat sailing were male skills that cut across the otherwise observable class borders. They were "understood by every person, from the last *toutou* [servant] to the first chief of the land."[12]

All the same, even the most enduring of Ra'iatean customs probably bore some specific eighteenth-century inflection. If Mai's family house was comparable to his immediate ancestors' house, it now had a heightened *tabu* against using the color red within it since that was a color reserved for 'Oro chiefs. If Mai stored and ate foods similarly to his forebears, he may have experienced periods of food shortage which they had not. Several early Europeans noted

that the feasts demanded by Arioi during 'Oro's ascendency—including some-
times all the pigs, vegetables, and seafood available in a community—could
lead to a "prodigality extremely oppressive to the people who had to furnish
the provisions."[13] Further, we may speculate that even the bark cloths made by
the women in Mai's family bore the mark of their particular time: with so
much more interaction between the islands of Tōtaiete mā on account of 'Oro
missionaries, a greater variety of designs and methods now circulated among
the makers. Certainly the canoes Mai was taught to craft and handle from an
early age were in his lifetime newly imperialist vehicles, venturing out of the
'Oro heartland, as well as everyday vehicles for transport and recreation.

Mai's reasonably steady life by and in the sea, surrounded by family mem-
bers and his purposeful if sometimes fearsome leaders, promised a similarly
steady future. All this started to change, however, when Mai was about seven.

Around 1760 'Oro-dedicated Ra'iateans came face to face with the worst con-
sequences of their missionizing zeal: the returning imperialism of the freshly
converted. In this year fleets of canoes from neighboring Bora Bora landed in
the name of 'Oro and tried to take control of the island. Ra'iateans and Bora
Borans engaged in sporadic guerrilla warfare for the next three years. The
fighting was deeply destructive and often lethal. At different stages in the
ensuing three-year war key district leaders and Arioi counselors either died or
were forced to flee to sympathetic Tahiti, stripping the heart out of Ra'iatea's
hitherto finely grained polity.

Needless to say, Bora Borans became the most hated figures in Ra'iatean
culture. Later European explorers translated Ra'iatean epithets about Bora
Borans as "incorrigible blockheads," "terrorists," and "pirates."[14] Ra'iateans
explained to these explorers that many generations ago other Islanders had
banished their worst criminals to Bora Bora, an island too "rocky and barren"
for anything else. But, they thought, the poor environment had in turn
pushed the inhabitants to submit to despotic government and to the pillaging
of resources from elsewhere. Their weird lack of the custom of infanticide,
Mai himself later added, could also have had something to do with their push
to colonize other lands due to overpopulation.[15] By the end of the 1760s Bora
Borans, under their absolutist sovereign Puni, controlled most of the Leeward
Islands (west-lying) in the Tōtaiete mā archipelago.

Much of what we know about the Bora Boran invasion comes not from
Mai but from another Ra'iatean who connected with the earliest-arriving Eu-
ropeans, a man called Tupaia. Both Mai and Tupaia would go on to have their

lives equally affected by the Bora Boran invasion and its aftermath, but in most respects Tupaia was as different from Mai as it was possible for a fellow Islander to be. Tupaia was at least a generation older than Mai, born into the chiefly ariʻi class and through his exceptional talents one of the most eminent Arioi Black Legs of the midcentury era. His later European friends from James Cook's *Endeavour* expedition described him variously as "an extraordinary genius," "a most proper man," and "infinitely superior in every respect to any other Indian we have met." Even the dour Cook himself admitted that Tupaia was "a Shrewd, Sensible, Ingenious Man."[16]

Tupaia appeared to European observers to hold the equal offices of high priest and leading political counselor. He was also a prodigious artist, navigator, and warrior. During the initial 1760 attack by Bora Borans, Tupaia took charge of one of the principal chiefs and smuggled him over to the Paparā district in Tahiti. This mission took with it some sacred stones from Taputapuātea and established Paparā, in the south of Tahiti, as a center for Raʻiatean refugees. Tupaia made it back safely to Raʻiatea that time, though his days living on his homeland were numbered.[17]

Mai was only a small boy when the invasion began. He could hardly have led heroic escapades off the island or even fought with guerrillas who ventured into his district. But equally he could not have missed the heightened danger everywhere in his native Raʻiatea. Even in a bellicose era, the Bora Bora invasion was something unprecedented.

Nonetheless, as in so many war zones in so many eras, the lives of children carry on in at least a piecemeal semblance of ordinariness. At the age of eight, Mai, despite the new threats, would have kept up when possible some typical boyish activities, refining in particular the skills in cooking and hunting that many Europeans later associated with him.

The centerpiece of Raʻiatean cooking was the earth oven, or *umu,* which was a deep pit lined with heated rocks that slow-cooked meat and root vegetables wrapped in banana leaves.[18] Most historians today suggest that women prepared the everyday foods in Tōtaiete mā while men helped out only for special feasts. But it is undeniable that Mai eventually knew a lot about all kinds of cooking—at least more than the average Englishman. His later British peers shared similar views about his uncommonly tasty dinners: "an excellent cook," raved James Burney; "he succeeds prodigiously," added Joseph Banks. On several occasions as an adult Mai would feed huge parties single-handedly, providing "a very good dinner," everyone agreed, "of fish, fowles, pork and puddings."[19]

Mai's later hunting prowess was also always noted by others. While travel-ing, British friends benefited from his "keen sportsmanship" and his ability not only to catch more fish than they but also to net, strike, and noose birds and fruit bats in ways they couldn't even guess at. His hunting "did him great credit," commented a rather more begrudging European acquaintance, who nonetheless admitted eating better after one of Mai's hauls than he had for some time.[20]

As Mai edged into puberty, he would have faced at least two key rituals of male initiation: tattooing and supercision. Around the age of ten he gained the first of his many tattoos on his hands, feet, buttocks, and legs, continuing an ancient—though not, it turns out, exclusive—Pacific custom. Almost ev-eryone in Tōtaiete mā, men and women, acquired tattoos gradually over many years and from designated experts. Tattoo artists copied and adapted a huge array of complex designs that included both naturalistic figures and geometric patterns. After an apprenticeship as formal as any undertaken by phiz mongers in Britain, tattooists inscribed skin with bone and shell needles, using an ink mixed from burned nut oil and water. When the British natural-ist Joseph Banks observed Pacific tattooing up close he shuddered to think what could possibly be "sufficient inducement to suffer so much pain." The answer probably combined the sacred and the material in ways Banks was disinclined to see: Pacific markings seem to have been both a form of spiritual cleansing and a signal of approaching sexual maturity.[21]

Around ten years of age Mai also undertook the ritual longitudinal scar-ring of his penis, carried out by a male friend a bit older than himself. Super-cision was a communal rite of passage, to be enacted before sexual initiation as proof not only of virility but also bravery in all aspects of life.[22]

Whether Mai started his sexual engagement with others at this age is de-batable. One of the most abiding associations with Pacific history today, other than a highly anthropological way of describing it, is the concept of a pervasive and rapacious sexuality. Observers from the eighteenth century to at least the end of the twentieth century noted and reiterated the sexual open-ness of Tōtaiete mā Islanders. "These people," wrote the French explorer Louis Antoine de Bougainville, seemed almost to "breathe . . . sexual plea-sures." "Just copulation, copulation to climax, one after another," reproved the mid-nineteenth-century missionary John Osmond. An established cus-tom "everywhere"; always "uncomplicated"; an act started "very early" by people "very active . . . until their physical prowess waned"—such are the insistences of countless modern ethnographers.[23]

Some scholars, however, have started to wonder if this long-standing assumption says more about outside observers over the centuries than it does the Pacific past. Almost all the early European commentaries on public sexual relations in Tōtaiete mā turned out to be of Arioi youth, performing highly choreographed acts designed both to worship 'Oro and to underscore the authority of 'Oro's leading representatives on Earth. These displays were therefore the opposite of sexual permissiveness. They were regulated, disciplined, and socially exclusive. Sexual relations between ordinary people in everyday life were no doubt quite visible to all family members owing to the unpartitioned houses, as many commentators note. But then they were probably no more so than in tiny London apartments or the roundhouses of Chota.[24]

Mai's sexual education, then, can be dated from his supercision and tattoos, though it is not clear if he engaged in sexual intercourse at this point. It's also not clear if, later, Mai participated in a culture that was particularly more sexualized than any other in the eighteenth century.

Mai's childhood ended spectacularly when he was around ten years of age, not through any intimate encounter but by the further onslaught of war. In 1763, that signal military year for another island people half a world away, a battalion of Bora Boran canoes fought with a Ra'iatean fleet out at sea. Bora Boran victory in this battle secured finally their total ascendancy over Ra'iatea. Mai's superior Tupaia was among the combatants in Ra'iatea's last defensive stand. He managed to survive, but only just. He was seriously wounded by a stingray barb crafted as a weapon. He fled to the Ra'iatean mountains to recuperate, though he knew the battle was lost. Once well enough healed, Tupaia smuggled himself off the island to find refuge in allied Tahiti. It was at this point that he adopted the name Tupaia, meaning "beaten," to remind himself of the dishonor he would strive to avenge for the rest of his life.[25]

Mai's father was even less lucky. Though there are no details as to the manner of his death, numerous reports confirm that he died as a direct result of Bora Boran violence when Mai was about ten. Even before Tupaia arrived in Tahiti, then, Mai's remaining relatives had made the dash to safety, leaving behind not only the island of their ancestors but also the landholding tied to their family.

While Tupaia settled in the expanding Ra'iatean refugee villages of Paparā in Tahiti's south, Mai's family went north instead, to the district around Matavai Bay. Probably they already had relatives there. Probably, also, Mai felt in

this region a strong sense of familiarity. The black beaches and blue lagoons sweeping up to high green mountains looked similar to the landscapes of Ra'iatea. The district worshiped at a marae called Fararoi, replete with its own red-feathered 'Oro statue. Mai's family, touched by the eminence of their Ra'iatean background, were welcomed at this marae, so long as they submitted, as they had back home, to the directives of the presiding Arioi. Here, they would see the same rituals of human sacrifice to 'Oro in the temple and witness the same types of dramatic entertainments performed outside of it. And, even as a child, Mai would have easily recognized the expectations around social status in this new land and known that his relatives fitted into the middling ra'atira rank just as they had before.

But in a very profound sense, too, nothing was quite right. Mai's relatives were landholders with no land. Their family tree now had several important branches lopped off it. They were from the special island of Ra'iatea but for the foreseeable future could not live there. Was it here that Mai's dreams of

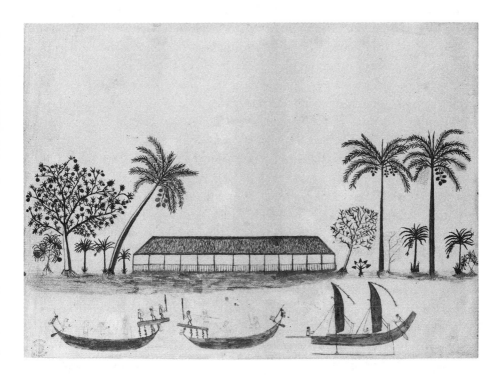

Figure 17. Tupaia's drawing of a Tahitian house, 1769. © The British Library Board
Add. 15508, f.14, no. 12

revenge against the Bora Borans began? All later British friends report how dogged Mai was in his self-appointed mission to punish the Bora Boran "usurpers [of] his property" and regain his "Native Island."[26] This mission certainly kindled at some point during his displaced adolescence. Whether it was on the volcanic sands of Matavai Bay in 1763 or later, Mai's aspiration came to dictate most of his subsequent behavior.

The story of the first British encounter with Tahitians has been told many times, mostly from the view of the British ship, the *Dolphin,* commanded by Capt. Samuel Wallis. Sometimes it's been from the view of the many Tahitians on the beach. Mai later informed his British friends that he had been in Matavai Bay during the *Dolphin's* stay in 1767. His view, that of the teenaged refugee standing to the side, watching proceedings with awe, has not been told.[27]

What Mai saw was in many ways the establishment of a template of behavior between European and Pacific peoples that would repeat several times over in the ensuing few decades. This involved violence, counterviolence, and then a strangely intimate but wary—or oddly affective but bruising—series of exchanges, produced by both parties. Always Europeans left with more questions than answers about the world and themselves. None in the eighteenth century succeeded in setting up permanent sites of colonization. Pacific Islanders, for their part, were mostly eager to discover fresh opportunities in newcomers, though frequently felt let down or annoyed by what actually transpired. Mai was only a fringe observer of events at first. In later encounters he would play a larger role.

On the day of the Tahitian winter solstice, 21 June 1767, Mai saw a tall, three-masted ship lurch westward into the bay. It was bigger than most seacraft he'd seen, and the sails were cut in an unfamiliar fashion, but it was not, for all that, too remarkable. Nor was its arrival a surprise. Everyone at the bay was expecting it. News had traveled up from the south that a large sailing vessel had recently tried to find harbor. Its sailors had not appeared very astute about the correct protocol for entrance. The southern Tahitians themselves had been forewarned of the *Dolphin's* approach by faster-moving canoes from the eastern-lying island of Me'etia. These southern Tahitians had gone out to meet the newcomers in small boats, offering the usual speeches and plantain branches of recognition. They were unimpressed to find little in return, other than some extremely fast-flying tiny missiles. Those who had got near enough, however, confirmed that the ship contained iron nails, which Islanders remembered had come from another tall-masted ship nearly two generations

ago. That ship had been the Dutch *Afrikaansche Galei,* wrecked back in 1722 in a far eastern part of Tōtaiete mā. Though Tahitians had not witnessed this Dutch visitor, they had eventually seen how useful (and durable) a tall ship's implements could be.

Word, then, of strangers and iron had reached northern Tahiti quickly. In the morning light of 21 June Mai witnessed scores of Tahitian canoes paddle out to meet the bulky vessel. He knew these canoes were packed with hogs, chickens, and fruit: the locals were already in a bartering frame of mind. The atmosphere, though, quickly became tense. The bartering did not go as hoped. The newcomers didn't seem to understand the behavior expected of them. In addition, several priestly men back on the beach didn't want the bartering to happen at all—the winter solstice was meant to be a time of quietude and godly contemplation. By nightfall, events had started to go deeply awry. Some Tahitians in canoes tried to shoo away the *Dolphin.* One was killed as a result, by a sizable missile shot from a black pipe.

Perhaps Mai went to sleep that night wondering about the weaponry of these newcomers and about what would happen next. In the morning the great ship was still out in deep waters. Its smaller boats had come into shore, though, asking for fresh water (as all vessels returning from deep-sea sailing do). Mai might have seen the newcomers' containers replenished for them and assumed things were getting better. But the newcomers kept waving their black pipes. The locals were now plainly more annoyed than frightened and waved paddles and other objects back at them. Mai knew that the situation had become outright adversarial when he saw several Arioi girls summoned to perform a hostile dance to the newcomers. Curiously, when the girls lifted their dresses to expose their genitals to the strangers—a blatant act of aggression—the strangers seemed simply stupefied in response. How could things possibly move forward from here?

The next day the strangers' ship moved about the bay confusingly. At first it looked like it was going to leave altogether. Then it turned back and rammed promptly into Te Toʻa o Hiro reef. Mai perhaps watched dumbfounded as the hulk spun on its bottom, desperately trying to get free. The day ended with the ship finally safe from danger but now set near to the shore, grounded by a giant anchor.

If Mai slept in on the twenty-fourth, he would have woken to see the *Dolphin* surrounded by hundreds of canoes. Evidently the local Arioi had decided overnight that these mysterious people were not worthy of welcome after all. The Arioi themselves launched out in their decorated canoes by

midmorning, the women displaying their naked bodies in warning to the intruders once more. All the signs, nevertheless, seemed to be failing. If standing on the hilly edge of the bay, Mai could well have gasped when he saw the first hammerstones fly from the canoes into the ship's deck.[28]

All at once the air was filled with a thunderous crack. Water and wood leaped into the sky as canoes split apart. Bodies seemed to catapult in every direction. The noise and the screaming were terrifying. Worse, it seemed to be spreading to the beach. At this point Mai's world contracted, at lightning pace, from the bay at large to simply the body he stood in. His torso had been hit—a stone? a nail? The wound was deep. Blood poured everywhere. It would leave a mark forever.

Perhaps friends now helped him to safety. Whatever happened, Mai was lucky to survive. The other survivors also retreated. By the time the sun was directly overhead that day Matavai Bay and its surrounding beaches were deserted. The main chronicler of the event from the British perspective,

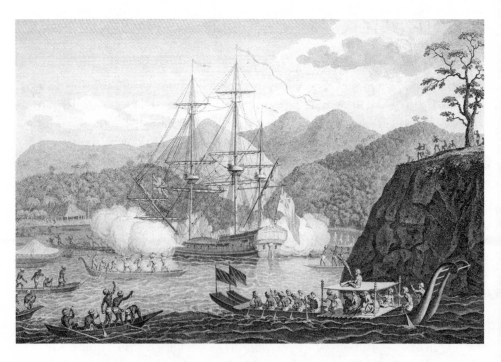

Figure 18. "A Representation of the Attack of Captain Wallis in the Dolphin by the Natives of Otaheite [1767]." From John Hawkesworth's *An Account of the Voyages* . . . (London: Strahan & Cadell, 1773), vol. 1, plate no. 21. Courtesy of Princeton University Library

George Robertson, wrote that night amid the eerie silence, "How terrible must they be shocked, to see their nearest and dearest of friends Dead and toar to peces in such a manner." To describe the full extent of the scene, Robertson rued, "would take the pen of Milton." Later historians guess that the dead numbered in the hundreds.[29]

Seven years later a British observer noted that Mai's wound was still "very visible."[30] Probably, then, he lay recuperating for some time afterward, certainly during the next few days. As much as he might have been feeling sorry for himself, though, he was also starting to turn over in his mind the possibilities of tall ship mana.

While convalescing Mai missed seeing a young, dark-haired, white-skinned man paddle out from the *Dolphin* during the stillness of the following afternoon, jump ashore, turn over a sod of earth, and make a solemn declamation to his pale assistants. Many moons hence, on a different island, Mai would become friendly with this man, Tobias Furneaux, and learn that his declamation had meant to be an act of possession for his king, George III. By then Mai would know that the pole with the red flag that Furneaux's men then planted was the insignia of this George III and not, as some Tahitians had wondered, an ominous sign from 'Oro.

While Mai remained out of sight, another, older Ra'iatean now emerged on the scene. Tupaia, living as a priestly political counselor to leading chiefs down in Paparā, had hastened to Matavai Bay when he heard news of the attack. With him came one of his bosses, the chieftainess Purea. Though a leader of a southern district, Purea had family ties up north. Whether her influence at Matavai Bay was a given or created by Tupaia's machinations, Purea tried in this suspenseful aftermath to neutralize the strangers' power. On the twenty-sixth she lifted the British red flag out of the ground and walked it over to the *Dolphin*. Captain Wallis, himself still tense from the recent showdown, ordered a warning cannon to be fired. Tupaia and Purea stepped back, but Tupaia kept with him the red flag for future purposes.[31]

The strangers' power was more successfully countered one day after that, when the local Arioi decided to trade goods and sex with the incoming British sailors. Though the British might have assumed that their new access to Tahitian foods and flesh underscored their triumph, those on the beach saw something different. To the Tahitians, British feasting was a kind of admission of British needs. Their delight in local bodies was a kind of submission to local command. As the historian Anne Salmond has commented, these exchanges from 27 June proved to be "a turning point."[32]

For the next four weeks Wallis and his men stayed at Matavai Bay. Wallis eventually met Purea and incorrectly assumed from her considerable influence that she was the "Queen" of the whole island. Her advisor Tupaia was more than happy with this assumption: it was his task throughout Wallis's stay to try to leverage a connection with the pugnacious British that would secure Purea as more than just a marginal ari'i chieftainess at Matavai Bay. He had also noted the potential of the *Dolphin*'s weapons.

How much Mai saw in the following four weeks is hard to know. He may have been too sore to move. Doubtless, though, he heard of the capers that followed: the specially performed Arioi dances, the great feasts shared by both parties, and the staggering accumulation of iron nails that the Tahitian girls obtained—so great a number in fact that some sailors worried the *Dolphin* would not now keep fitted together.[33] He learned, too, that the violence had eventually lessened. Wallis had even forged a formal bond, or *taio*, with Purea.

If Mai had managed to come down to the bay in late July, he would have seen hundreds of locals stationed to bid farewell to their somewhat mystifying guests. He would have seen Purea board the *Dolphin* to say goodbye to her taio, weeping profusely—perhaps from personal sorrow or perhaps from fear of what effect Wallis's departure would have on her future. Eventually, though, even Purea had to come back to shore and wave like everyone else to the departing hulk. Would they ever experience such an encounter again?

As it turned out Tahitians had only to wait nine months before another set of pale-skinned sailors arrived on their island. These sailors came in two triple-masted ships, but they did not speak the same language as Wallis's crew or seem very interested to hear about their predecessors. Mai, anyway, never saw them. He only heard about them up in northern Tahiti because Bougainville's French expedition didn't come that far. His two vessels stopped for just ten days in April 1768 on the eastern coast of Tahiti.

This landing did not cause quite the level of violence as had occurred with the *Dolphin,* but it was not without incident. An initial altercation saw one Tahitian shot dead by a French sailor, and then a few days later a worse event resulted in three Tahitians dead. Both tragedies were triggered by French ignorance of Tahitian behavior. Though the French were mostly delighted by Tahitian hospitality, they could not come to grips with what they thought was a relentless culture of thieving. They saw that it had little to do with material greed, but they didn't guess that it was really about performing and proving godlike bravery. For all that, Bougainville was cross about the French

shootings and sought to punish the offenders. He did not, however, quite gauge the extent of the betrayal felt by the Tahitian leaders. "You are our taio, taio," one Islander remonstrated to Bougainville, "and yet you kill us." The Islanders' earlier offerings of foods and entertainments had not been the inevitable inclinations of Edenic creatures, as the captain assumed, but instead the calculated attempts to forestall precisely this kind of outcome.[34]

Bougainville went on to do more than any other European to propagate the myth of Tahiti as an idyll of noble savages. He never wondered if their generosity had been produced by their earlier experience of tall ships, or indeed if his personal revelation of Eden on Earth had been effectively managed by a community determined to take what mana they could from the situation without giving quite so much as they had before. Certainly Mai would have been surprised to hear that his host country was a Utopia of innocence. More than betrayal at the killings, however, this fifteen-year-old, far away in Matavai Bay when he heard of them, probably felt intrigue instead. European black pipes, which he later learned to call muskets, continued to inspire possibilities in his mind.[35]

Along a fast-moving Islander grapevine Mai probably also heard that the two French tall ships departed with an Islander named Ahutoru on board. A teen like himself but of the ari'i chiefly rank, Ahutoru had volunteered to travel onward with the French. Such news may have seeded or perhaps by now just consolidated Mai's own ideas for exactly this kind of venture. Mai would wonder about the fate of Ahutoru for the rest of his life, since the youth never returned.

When the cool season came round again Tahitians saw their third tall ship arrival in as many years. James Cook's *Endeavour* expedition was the first of three that the Englishman would lead to the Pacific. It had been commissioned by the British government to further the explorations made by Wallis's *Dolphin*, which were themselves part of the British government's relentless quest to expand its economic reach one day into fresh new worlds. Cook was a seasoned naval man but also a solid student of the tradition he knew he was helping to further. He had absorbed as much information about the Wallis expedition as possible before setting out on his own mission to find great southern lands for Britain. One thing he remembered particularly from Wallis was that Matavai Bay was a good harbor for accessing the best of bountiful Tahiti.

Cook's *Endeavour* carried four men from the *Dolphin* expedition. It was these four men who revved up the sailors with great expectations about what

awaited them on Tahiti, but it was also these four who noted immediately upon disembarking that some things had changed. There seemed to be fewer houses, fewer canoes, fewer statues—it was altogether a place that felt more "shy," even "abandoned."[36] Cook may rightly have suspected that the Tahitians' diffidence toward them was linked to their memory of Wallis's encounter, but the changes indicated more than this. As Cook soon learned, there had been some intense internal battles in the region over the last two years. Purea's gamble for power in Matavai Bay had not gone well, and in a ferocious clash with rival families her influence had been significantly reduced, both in the north and in her own original southern district.[37]

Mai, by now a stocky sixteen-year-old, had seen the turmoil of the recent past play out in his adopted home. As a refugee, though, he might have felt a bit removed from the intricacies of the situation. His political cause, if it had developed by this stage, was always on the larger conflict between Ra'iateans and Bora Borans, over the seas on the northwestern horizon.

Later reports indicate that by the time of Cook's arrival Mai had acquired an adult occupation for himself. He was an assistant to a chiefly priest. His British friends sometimes described him as an "under priest" or a priestly "apprentice," but Mai never learned or even pretended to know the "priest talk" that Cook would later quiz him about (which was intentionally mystifying, just as Latin still was for many European priests). Mai was not in training to become a priest, he simply worked with and for one.[38] This was probably not the path Mai would have gone down if the Bora Borans had never come to Ra'iatea.

The *Endeavour* crew's suspicions about Matavai Bay were confirmed when they caught sight of Purea herself nearly two weeks after arriving. She appeared large and distinguished, but Cook noted she now carried "no authority."[39] The more body-minded Banks observed that "she might have been handsome when young but now few or no traces of it were left."[40] By this stage the *Endeavour* was firmly ensconced in the bay. If the old hands felt the Tahitian experience was less luxuriant than before, all those new to the island were yet in rhapsodies over the goods and the girls. Despite a few early violent moments—now seemingly inevitable when tall ships visited—Cook's men had been accepted, or neutralized, via various exchanges on the beach. Tahitian elders knew these encounters were best handled sociably, so long as there was an implicit understanding that the newcomers would leave eventually.

None of the *Endeavour* journals mention a youth called Mai, but we know he mixed among Cook's men during their three-month stay. When the other

naturalist on board, Daniel Solander, met Mai in London five years later he did not remember him, but he saw that Mai "perfectly well remembered all of us." Mai's memory was not simply of generic white men (though there were also black men on the *Endeavour*). He recalled Banks's name on sight and recognized Solander by his voice.[41] This suggests that of all the eighty-odd newcomers now staying around Matavai Bay Mai followed especially the movements of the expedition's naturalists. Perhaps he sensed the separate clout these men had—distinct but not necessarily subordinate to the more obvious leader, Cook. Indeed, Banks and Solander were different. Their berths had been secured by the scientific Royal Society and were considered more adjunct to the naval command than cogs within it.

If Mai was tagging along on the naturalists' extensive rambles into the interior and down the coasts of Tahiti, he would have seen that his fellow countryman, Tupaia, was also always present. Tupaia, downgraded along with Purea in the recent civil skirmish, was up to his usual strategizing. He saw—maybe as Mai did—that Banks in particular wielded influence among the British. Tupaia resolved to form a taio bond with him, in another gamble to gain British mana to help lift his political charge back up to her rightful position. Banks started to notice the exceptional talents of the ubiquitous Tupaia around May 1769. Not only did the Arioi man appear a tactician with his own people and a key communicator with the British, he now showed aptitude in astronomy, geography, and even art. After observing the techniques of Banks's artists, Sydney Parkinson and Herman Spöring, Tupaia tried his hand at the European style of pictorial representation. As the scholar Nicholas Thomas has noted, this was a significant experiment since Pacific art "was never descriptive . . . it was about presence and power. The idea that a place or activity might be represented, just because it was typical, [would have been] wholly novel."[42] Today, ten works by Tupaia survive, judged "not quite unintelligible" by Banks but considered hugely valuable for modern insights into eighteenth-century Pacific life (see figs. 17 and 33).[43]

In the end Tupaia, not Mai, was the first Ra'iatean to persuade a British crew to include him in their voyage. Cook was at first wary of the obligations entailed, but once Banks promised to take full financial responsibility, the captain agreed. Tupaia, after all, appeared "to know more of the Geography of the Islands . . . than any one we had met with."[44]

Whether Mai stood on the same hilly edge to see the *Endeavour* off as he had done to see in the arrival of the *Dolphin* two years before is unknown. Likewise, we cannot guess if he witnessed the emotional parting of Tupaia

from Purea on the deck of the ocean-bound ship.[45] If he had, Mai might have wondered at Tupaia's purpose. Was it mainly to boost the position of Purea at Matavai Bay? Was it also, or even instead, to save his own skin by getting out of a deteriorating situation? Or did he have larger plans in mind, plans that concerned the status of their shared homeland Ra'iatea? Whatever was going on with Tupaia, his British hosts did not question it. None of the voyage records speculate about Tupaia having any personal motive for the journey at all. So guided by these records in their histories, later scholars have generally followed suit and assumed he didn't have one. The little-known Pacific background to Tupaia's story, though, insists that something rather complicated was afoot.[46]

Mai himself never found out the details because Tupaia, like Ahutoru before him, died before making a return. In the five months he traveled with the British, Tupaia helped open up whole worlds of navigational nuance to Cook. He also helped smooth over several difficult moments with leaders in New Zealand and Australia. But unlike Ahutoru, Tupaia never even made it to the crew's homeport. He died, most likely from malaria, while the *Endeavour* was stationed in the sewerage-riven Dutch colonial canals of present-day Jakarta.[47]

Soon after Tupaia's departure Mai's priest-assistant duties started to take him on extensive local voyagings. One of his most assiduous later chroniclers, James Burney, recounted that Mai around about this time became a "great traveller." He toured all of Tōtaiete mā (presumably skirting Bora Bora and Ra'iatea). He may also have gone as far west as the Cook Islands and as far east as the Marquesas.[48]

In the early 1770s he ended up in Huahine, an 'Oro-worshiping island situated between Ra'iatea and Tahiti. Whether this was due to his occupation or his family ties is unclear. By the time Burney met him in 1773 he was working for one of the highest priests of Huahine. Burney also discovered, though, that Mai had by then many relatives living in Huahine, who all descended from a native-born Huahine grandfather.[49]

What Burney described as Mai's most exciting adventure was more likely his first major attempt at ancestral restitution. Mai told Burney that in about 1772 he had become caught up in a Bora Boran attack on Huahine. This was not the first time Bora Borans had sought to conquer Huahine. So far, though, the ari'i of the island had withstood the fate of Ra'iatea. The clash took place mostly out to sea, between large war canoes. Now a young adult, Mai was a

self-enlisted combatant in this battle for Huahine. As usual, Bora Boran vio-
lence was severe and exacting. Several leaders died, as did four of Mai's rela-
tives. Mai himself suffered a spear wounding in his arm, another mark that
remained visible for years. But unlike at Matavai Bay he was unable this time
to retreat to safety. The injured Mai was captured by the enemy, along with
six other warriors, and taken to Bora Bora.

Bora Borans usually killed or enslaved their prisoners of war. The seven
captives on this occasion were unexpectedly granted clemency because one of
them turned out to be the taio of an influential woman on the island, who
pleaded for their lives. Such an outcome underscores the seriousness of taio
bonding in the Pacific. Even so, the fate of the seven men was far from clear,
so the next night they resolved together to attempt an escape. "As soon as all
was quiet," writes Burney, setting down Mai's account as he later heard it,
"they stole out & found a canoe which they carried in their arms down to the
water." More daringly, they filched some paddles "from under a Bolabola
man's head, one softly lifting his head up while the another drew out the
paddles." The escapees had the forethought to carry off as well a hog for sus-
tenance on the long journey ahead. To stop the hog from making a noise, one
"held him hard by the snout till he came to the water side, then plunged him
in and kept him under till he was drowned." Just as the party was clearing the
surrounding reefs, they came upon an incoming canoe of Bora Borans, "who
asked them several questions." It was Mai who got them free. So keen a stu-
dent of his enemy's ways, he knew their accent by heart and in the dark re-
plied in what appeared the local voice. The interceptors let them pass, and the
captives fled to Huahine.[50]

In all, the ordeal must have been more terrifying than exciting for Mai.
Together with the new scar on his arm, it only fueled his already burning re-
solve to obtain vengeance one day against the hated Bora Borans. Back on
Huahine, Mai saw that even with heavy losses the local ari'i had managed to
prevail against conquest. For how much longer they could stave off the ag-
gressive colonizers to the west, though, was anyone's guess. Such was the at-
mosphere that Cook's second expedition sailed into in 1773.

This second expedition came in two ships, the *Resolution* and the *Adven-
ture*. Its mission was to further yet again explorations undertaken by earlier
British ventures—specifically, to ascertain if a great southern continent ex-
isted in counterbalance to Eurasia. Again, by the time Mai saw Cook's crew
edge into harbor he would have known that the British captain was back in
the region. For two weeks Cook had been staying in Tahiti—plenty of time

for the news to come over to Huahine. Probably Mai even knew that while some of the sailors were familiar, others were not. Neither Banks nor Solander were on this expedition, and the news of Tupaia was grim.[51]

Despite the lack of the more familiar characters Mai was evidently already determined to make this British visit the one that would fulfill his dreams. Within just one hour of the ships coming into harbor Mai was on board the *Adventure*, smiling, engaging, swapping, and generally endearing himself to as many of the crew as possible.[52] The captain of this sister ship (accompanying Cook's *Resolution*) was none other than Tobias Furneaux, earlier seen in Tahiti in 1767. Furneaux had no problem with hosting the likeable young Islander. It turned out to be a smart move on Mai's part, to make friends with the *Adventure*'s company first, before tackling the sterner audience of Cook aboard the *Resolution*. Whether this was intentional is unclear. Mai simply wanted to put the first stage of his grand mission into action as soon as possible.

Cook had visited Huahine back in 1769 on the *Endeavour* and was heartened to see and be greeted by one of his earlier taios, the eminent ari'i called Ori. He was moved to see how carefully Ori had kept the gifts Cook had given him last time and was concerned to hear about the island's recent troubles with Bora Borans.[53] While he and his crew feasted on the fresh meat and fruit the Islanders offered, Cook heard mixed views about the best course to take with these marauders. Several of "the common people" wanted him to go over to Bora Bora and fight its sovereign Puni for them.[54] Ori himself, though, counseled Cook against it. Cook understood Ori to say that Puni was his friend. More likely Ori feared catastrophic retribution if Cook interfered on their behalf but then sailed off, as he was bound to do, leaving Huahine to stand alone. On this count Mai's ambition to use the British to help build resources for an Indigenous-led attack was the wisest approach.

Constantly on board the *Adventure*, Mai would have had a peculiarly British view of the expedition's four-day layover. He would have seen the altercation that occurred on day three between an angry Islander warrior and Cook himself. During a trading session on the beach, Cook had found the warrior's presence threatening, so he intervened to wrangle the man's clubs off him and break them into pieces.[55] Mai might have guessed, though, that the Islander warrior had been simply trying to stop the flow of scarce breadfruit out to the British ship in exchange for nails, which keep no man satisfied in times of hunger.[56]

Mai might also have seen the rather more amusing spectacle of the naturalist Anders Sparrman returning to the expedition after a botanizing excursion

with nothing but a piece of bark cloth over his buttocks. Sparrman's clothes had been stripped off him by furious Islanders, possibly in retribution for the earlier clubs incident. Did Mai then see the ensuing standoff between Cook and Sparrman's fellow naturalists? The scientists demanded retrieval and punishment for the theft. But Cook was both annoyed at Sparrman's foolhardiness and loath to promote further violence. An uneasy half-measure resulted: Cook enlisted Ori's help to get back some of the stolen items. No one on this occasion was beaten.[57] Mai was learning the intricacies of British forms of justice. There were principles at stake, but apparently much depended on the personal whims of leaders.

On the fourth day Mai helped prepare the *Adventure* for its onward travels. This was the moment of truth. He was really going to go through with it. He was leaving his remaining relatives and taking the great risk of never seeing them again. His mother was dead by this time, but he had many siblings, cousins, and other relatives still living. He later recounted that some were adamant against him going.[58] Did he bring along any personal possessions? Later pictures show him in Islander cloths, carrying an Islander stool and Islander feathers. Whether these belonged to Mai, though, or were loaned by his souveniring friends is in question. Maybe he took nothing with him, fearing the attention such things might attract from either Cook or Ori. He had gained permission from neither to stay with the expedition.

As the *Adventure* hit the rougher waves out of harbor Mai probably felt he'd gotten away with the beginning of his big plan. If so, his heart would have plummeted to see a small boat from the *Resolution* now hurtling toward them. The sailor on it explained that he'd been ordered to bring back the "several Islanders" aboard the *Adventure*. Ori had requested it himself, just this hour, while on board Cook's *Resolution* still moored at Huahine. Cook wanted to oblige Ori, not just for the chief's sake but because he was always wary of adding men to his expeditions. With deep reluctance, Mai stepped into the small boat and rowed over to Cook's vessel.

At this point Mai's earlier fraternizing with the *Adventure*'s crew, and especially with its captain, paid off. Furneaux sent word with the small boat that there were not "several Islanders." Just one. Mai had been with the crew since first mooring, Furneaux reported. He was useful on deck, and his presence cheered his men immensely. Could he stay?[59]

Uncharacteristically, upon receiving Furneaux's request Cook dithered. He was keen to be away himself, and Ori had already departed. At length the captain decided not to send Mai on to shore. The Islander could stay with the

Resolution for now, though later he was to join Furneaux's *Adventure* formally as an able seaman. Mai breathed a sigh of relief. He could now feel confident of this initial leg at least. And its first layover was bound to entrench his ambition further. Both ships were headed toward Ra'iatea.

Mai was playing a long game. He had no plans to fight the Bora Borans in Ra'iatea at this point. The aim was to voyage all the way to Britain itself, gather up arms, maybe some manpower too. So this first stopover was merely poignant. Possibly dangerous.

The view from the ship provided the usual scenes between Islanders and Europeans of initial misunderstanding, troubling violence, and then a cautious, piecemeal, temporary coming together. Mai may have been bored with this dance by now. He was probably more captivated by some actual dances going on ashore. The Arioi of Ra'iatea were performing one of their famous erotic dramas. Ra'iateans, even ones colonized by Bora Borans, really knew how to put on a show. Mai's closest friend on board, James Burney, was particularly taken with the display. He found the Arioi dancers utterly absorbing, full of "action," "passion," and "entertainment."[60]

Once he decided that Ra'iatea was safe enough for a layover, Mai took the risk of spending a night sleeping on his precious native soil. It didn't go well. Burney recorded that around midnight Mai came pitching back on deck completely naked. He hadn't been mugged like Sparrman on Huahine but rather had left his attire in a mad hurry to escape. An Islander friend had woken him to warn of an impending attack by colonist Bora Borans. Word had evidently got around that Mai was no friendly returning native: apparently he had plans to use these British visitors in a grand-scale offensive against them one day. The conquistadors were taking no chances.[61]

Mai spent the rest of the nine-day layover on deck, observing the green mountains of his childhood from behind the barrier of a foreign ship's railing. He was relieved when both ships set sail again on 17 September 1773.

The vessels did not moor together again for another two weeks. When the crews linked up once more on land, this time in Tonga, Mai saw with some horror that the *Resolution* had brought with it from Ra'iatea a Bora Boran called Hitihiti. A direct relative of the sovereign overlord Puni himself, Hitihiti represented everything about the Bora Boran colonization of Ra'iatea that Mai opposed. Relations were awkward, to say the least. Mai could have wondered, as have several historians since, about Hitihiti's motives. The

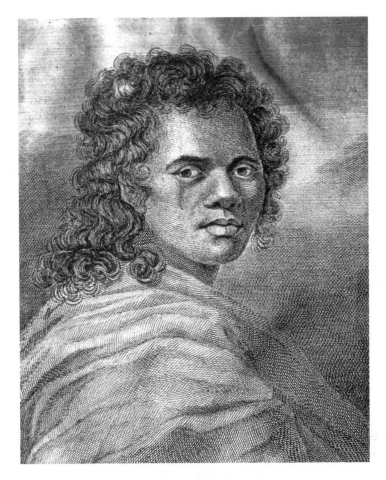

Figure 19. Mai, engraving after William Hodges, 1773. This copy owned by K. Fullagar.

young Bora Boran heir had no land to recapture as Mai did. His aspirations may have been more philosophical. Or was he on a mission to stymie Mai's plainly suspected operation? Mai would have to wait to find out.[62]

Mai had never traveled as far as Tonga. It was the start of a personal discovery of islands and people somewhat like him but somewhat different, too. The few records on his responses to it suggest that he always sought to find out an island's language and basic customs. At Tonga he was frustrated to find a linguistic barrier but delighted to see the color red revered just as much as at home.[63] The food preparation and housing felt familiar, but the patterning on the cloths and the freer mixing of the sexes seemed strange.[64]

The British stopped at Tonga for only four days. After that, the two ships set off due south for an altogether different island experience.

Cook had visited New Zealand before, as had a Dutchman in the 1640s. Cook remembered it with mixed feelings: the locals seemed tougher there to him than in other Pacific Islands, but at the same time they were also more familiar. They were fierce and protective and godly and had a strict honor code—a bit like eighteenth-century British people, in other words.[65] Most notably, though, they seemed to practice cannibalism, which from the start Cook understood in terms of ritual and custom but which some of his crew always believed was a sign of the New Zealanders' depravity.

The two great southern islands of New Zealand were necessary fueling stops if the expedition was to take the plunge of going even further south in search of a missing continent. Many days of hard sailing lay ahead of them. They caught their first sighting of the place—possibly identified to Mai later as Aotearoa—after two weeks. Since many Māori canoes launched out to barter food with them when off the eastern cape of the North Island, Cook saw no need to make an actual landing. After victualing, he pushed his ships on southward.[66]

At the end of October fierce gales started to knock the voyagers about. Mai hadn't experienced this kind of swell before, but once he saw how much the *Adventure* could roll in the seas without harm, he didn't fret. Some crew thought he even enjoyed it.[67] On 30 October a true storm hit them. Cook, in his rather staid manner, called it a "fresh gale" that nonetheless ripped apart a new topsail. Furneaux, not especially more colorful, admitted there were "heavy squalls and rain, which split many of our sails and blew us off course for three days."[68] In the ensuing quest for shelter the *Adventure* lost sight of the *Resolution*.

The two captains had earlier agreed that, if parted in this region of the world, they were to reconvene in the channel between the North and South Islands of New Zealand—a place named Queen Charlotte Sound by Britons but known to Māori as Totara-nui. Cook made it to the channel four days later, but Furneaux's *Adventure* hit more bad luck and had to stop for some time for repairs. Furneaux's crew did not reach the agreed destination till the end of November. When the *Adventure* finally limped into the designated shore they were dismayed not to see Cook's *Resolution* waiting for them. Burney describes in detail his "great disappointment" in his journal, telling of how they scrambled to the beach to find a log carved with a directive to

"LOOK UNDERNEATH." Under the log was a message in a bottle, dated nearly a week earlier: "Captain Cook . . . saild on the date hereof. [He] has not the least hope [now] of meeting with Captn Furneaux." The crew knew then that the two ships would never connect again. And since it was Cook's job to chart the Pacific for Britain rather than Furneaux's, the *Adventure* had no choice but to start the long and now solitary journey back home.[69]

There was a lot for Furneaux to do to the *Adventure* at Totara-nui before departure—and no particular need anymore to do it quickly. The ship stayed anchored in the channel for the next two weeks, fixing a damaged hull, torn sails, and ruined stocks. Burney reported that Mai had been present at the discovery of Cook's message in a bottle and was so struck by its method of communication that he resolved at the time to learn how to write. Burney sighed ruefully, however, that Mai stuck at it for only a week.[70] Burney didn't seem to notice that there was a lot going on otherwise to distract Mai in this new land.

First of all, there was the weather. Though November in Aotearoa was a summer month, the lashing winds and freezing rains felt nothing like tropical Ra'iatean monsoons. On top of this, there were the locals. In some ways the Māori looked more familiar than Tongans, but their behavior was, to Mai, off-putting. Mai didn't know that only two weeks earlier Cook's *Resolution* crew had caused a lot of trouble with their "experiments" to see if the Māori would eat human flesh. The relatives of a victim cooked by the *Resolution*'s crew and eaten by some rival locals were now acting in a very hostile manner to this next visiting British ship. Unfriendly encounters and aggressive thefts followed. Mai found it all very unsettling.[71]

Mai was probably glad, therefore, to hear that Furneaux had determined to leave Totara-nui around 17 December. He stayed with the *Adventure* while the ship's smaller boat was sent off with a party of ten to gather up the crucial last-minute provisions of fresh vegetables. The small boat was to return that night, for the company's full disembarkation the following morning. However, the party of ten had not reappeared by dawn the next day. Even Furneaux noted at this point a sense of "great uneasiness." The captain instructed Burney, Mai, and a few others to go off and look for the vegetable-picking party.[72]

Everywhere that Burney and Mai searched over the next few hours seemed foreboding. At one stop the locals waved them away in anger. At another the Māori looked downright "frightend." Finally, at a place Burney called Grass Cove, they saw some Māori beckon them in. There, the searchers found an item from the lost small boat and a few shoes of its party. Looking up the

beach, they then saw the spectacle of about twenty baskets trussed up with string. Inside the baskets they discovered roasted flesh. Beside them lay more shoes and the undeniably hacked-off hand of one of their own. It was at this point that Burney knew his fellow sailors had all been killed, and he inferred that their roasting was intended for the show at least of cannibalism.[73]

Mai's reactions are not recorded. The British accounts do, however, report that both Tupaia and Hitihiti had in earlier situations shown full-bodied disgust at the discovery of Māori cannibalism—more than ever relayed of the British, in fact.[74] No one from Tōtaiete mā was sheltered from the horrors of human conflict. Death had been a constant for those who lived through the warring eighteenth century. But Mai's Pacific culture had no custom of eating the dead; cannibalism was as *tabu* for Ra'iateans as it was for Europeans. Probably, then, Mai shared Burney's stupefaction: "such a shocking scene of carnage and barbarity as can never be mentioned or thought of, but with horror." Quietly Mai helped the British gather up what remains they could, including entrails, feet, and the head of Furneaux's African servant.

As the Burney party retreated back to the *Adventure,* Mai might have wondered at the loud taunts from the Māori watching proceedings from afar. While he shared the British revulsion at what he'd just seen, he also knew enough of Islander-European encounters by now to suspect that the locals here were making a point. More than once he'd seen his British friends misread or simply disregard Islander points in fraught situations. The Māori on this occasion were evidently saying something. Historians have debated what it was ever since.[75]

"The birds were the only companions we had in this vast ocean," wrote Furneaux some weeks later. The *Adventure* had stolen out of Aotearoa as soon as possible after the return of the scouts. Furneaux's bleak description of the relentless southeastern traverse to the Cape of southern Africa suggests eons of time spent in freezing, grimly contemplative silence. There was the occasional whale, sometimes a seal, Furneaux reported, but mostly nothing but icebergs and what Mai called white rain. For the first time Mai was reduced to the rations of British sailors in transit: retchingly salted pork; rock-hard stale bread. The lack of his usual fruits would have wreaked havoc on his guts. He was perhaps one of the men Furneaux feared had become desperate with "colds and pains." Three months of mostly sunless sailing was a severe test of his resolve. Together with the dramatic events at Grass Cove that still played on the minds of all the crew, it was conceivably the lowest point in his mission.[76]

No evidence really reveals how the *Adventure*'s men spent their layover at the African Cape, which the ship finally reached in mid-March 1774. But after such a long journey Mai was probably grateful just to be on solid earth again and to eat something fresh. It was his first experience of continental land. It was also his first experience of a European settlement, though he was no doubt forewarned by others that it did not resemble anything he'd later see in Britain. Cape Town in the eighteenth century was no more populous than a Tahitian district, but its range of people was astounding. There appeared no clearly dominant cultural code. Though ostensibly a Dutch colony at the time, there were also black slaves, Chinese merchants, and Arab traders doing their own things among the burghers in charge.

What interested his British sailor friends was not the cultural mix but the ability of the town to provide all that the crew had been deprived of for so long: fruit, company, repairs, a bed. Cape Town was famous for its obliging hospitality to visiting European ships. Cook later wrote that there was "no place where refreshments of all kinds are to be got in such abundance." These came at a high cost. Cook grumbled about the "exorbitant prices" charged for such balms, though this was hardly surprising. Cape Town had a captive market in the eighteenth century in supplying the ever-increasing forays of ever more expansionist-minded European empires. French, Spanish, Swedish, and Danish ships all jostled for anchorage with the British vessels in Table Bay in the 1770s.[77]

After Cape Town the *Adventure* meandered up the African western coast to home. At least Mai would have found warmth along the way and better food than the Antarctic Circle had allowed. What he made of the African peoples and the huge array of European ships they saw as they neared Britain is lost to us. Later accounts suggest he might not have been very bothered in any regard. He was focused instead on the final destination. More than ten months after leaving Huahine Mai got his first glimpse of the land of firepower. The *Adventure* docked at Portsmouth on 14 July 1774.

The Master Ascendant

REYNOLDS BECOMES PRESIDENT

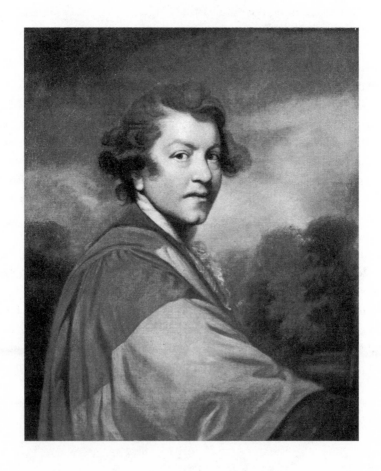

The last we saw Joshua Reynolds in action, he was leaning against the railings of a British naval yacht in the other major English port of the era, Plymouth harbor. In many ways the intervening fourteen years had been the most critical of his career. In 1762 Reynolds had been an eminent London portraitist. By the summer of 1774 he was the inaugural president of a Royal Academy for all arts, the elected mayor of his native Plympton, a doctorate-holder from the University of Oxford, and a knight of the realm. How had this mild-mannered man—so appeasing in person and in paint—managed such a rise? While determined in many respects, he never seemed the ruthless type. His successes had never depended on others' losses. Well connected, he yet appeared far from the levers of true power.

What, too, had become of Reynolds's efforts to promote a modernized neoclassical approach to art? And how had the fledgling Society of Artists progressed—that organization which Reynolds supported for its promise to his aesthetic ambitions but which others joined in order to bolster an appropriately imperial culture? For that matter, how had Reynolds's own conflicted views on Britain's imperial status survived over the years? The nation had reached its imperial high point in 1763 but was now sliding into a new kind of imperial morass. Did this decline make Reynolds more inclined toward his empire-skeptic friend Samuel Johnson or more sympathetic toward his now-elected parliamentarian friend Edmund Burke?

No doubt Reynolds himself would have liked knowing the answers to these queries back in late 1762 as he wound his way home from Plymouth to London. The winter of 1762 proved a difficult period for anyone keeping abreast of current affairs. King George III had recently helped secure one of his favorites, Lord Bute, to the highest ministry in the still-Whig-dominated British government. Bute was deeply unpopular with his fellow parliamentarians, not only for his supposed alignment to monarchy, suggesting undue royal power, but also because he disapproved of the ongoing war for empire. Whereas most ministers exalted in every fresh victory, counting up each conquest as a new prospect for trade and power, Bute saw only rising debts and more provocations to reprisal from France. By November 1762 Bute was campaigning hard to end the war, whatever further British victories might yet glimmer on the horizon. All those who had long opposed the aggressions, for

Figure 20. Joshua Reynolds, self-portrait in Oxford robes, c. 1773. Reproduced with permission from Althorp Estates.

whatever reason, cheered him on, while those who still gasped for more—or simply disliked the idea of politicians as puppets of monarchy—voiced their extreme displeasure. Printed propaganda from both camps started flooding the streets of Reynolds's adopted hometown.[1]

As prime minister, Bute secured the war's conclusion by engineering the Paris peace treaty of February 1763. Popular fury in Britain over the issue, though, continued unabated. Bute's enemies insisted that he'd squandered the nation's wins, handing back "valuable conquests . . . made at an immense expense of blood and treasure."[2] In fact, as Ostenaco could have told them, Britain kept most of its spoils—at least enough to make France step back from British claims to the most lucrative zones of the world. But such details did not deter the jingoists.

Strangely enough, peace didn't turn out to impress the war-haters either. Though glad to see the costly and advancing hostilities ended, most now turned their attention to the empire that had emerged in any case. Certain Toryish newspapers pointed out that British claims now stretched the nation's finances "so fine as to threaten cracking at the very next stretch." Some commentators, taking a different angle, feared the British had become as cruel as the Spanish of yore, simply "to gratify the avaricious merchants, landholders, and venal commissioners." Still others wondered about the effects at home after engaging with so many unfamiliar foreigners: "The riches of Asia have been poured in upon us," claimed one observer, "and have brought with them not only Asiatic luxury, but I fear Asiatic principles of government."[3] From every side, then, Bute was being battered as the head of a fraught government.

In the middle of all this Reynolds received an awkward commission. None other than the king himself asked him to paint the portrait of Prime Minister Bute. Both the subject and the customer threatened trouble for his reputation among his mostly Whig circle and clientele: too flattering a submission might make him look as creaturely as Bute himself. But refusing the task was hardly an option either. To do so, or to execute it in a critical way, would kill off a crucial corner of the market—for himself, and perhaps for his associated artistic organization.[4]

Reynolds accepted the commission sometime in the early spring of 1763. Difficulties, however, only mounted in April when Bute, never up to the pressure of unpopularity, resigned. The king still wanted his portrait, though. Worse, most of Bute's Whig detractors continued their attack on him, accusing him of carrying out the king's will now outside official corridors rather than from within. Things truly exploded two weeks after that when the noto-

rious libertine and Whig MP John Wilkes published a scurrilous lampoon of both the king and his former "insolent, incapable, despotic minister."[5] George III reacted hotly, charging Wilkes with seditious libel, a serious criminal offense. Whigs both in and out of parliament hit back, in their turn, that such a charge reeked of tyranny. London boiled over in a rage about the position, obligations, and very principles of the nation's state. Reynolds was left holding his paintbrush through the maelstrom.

In the end, he plowed on. And, no surprise to those who had followed Reynolds's career from the start, he managed to win over everyone with the final work. The portrait depicted Bute full-length, in fine clothing and confident stance. The prime minister confers with his secretary over official papers in a room resplendent with signs of governmental ascendancy. The king liked the painting and paid Reynolds two hundred guineas for his efforts—one of his highest earnings thus far.[6] The work also contained, though, significant countersigns for those who wished to see them. As the scholar Douglas Fordham intimates, viewers *could* interpret the secretary's greater height as a slight on the authority of Bute. They *could* say that Bute's hand on a coin pouch represented his nefarious grasp on public monies. And they *could* believe the rich red curtain behind Bute was in fact cloaking his actions rather than framing them. The bullish Whiggish press seemed determined to understand Reynolds's portrait of Bute this way. Even before anyone had seen it, one pro-Wilkes periodical reported that "we heard the Dictator sits to Mr Reynolds," but for what was sure to turn out "an emblematical picture," a satire on its subject destined only for "the king's kitchen."[7]

Reynolds had become so good at pleasing everyone in his world that most now simply expected to be pleased. In 1763, at least, no one was disappointed. His relentless equanimity was proving his greatest asset and the key component of his meteoric professional elevation. Was this the result of canny maneuvering? Or rather a deep personal unease about the most urgent issues of the day? The jury remains undecided, though a few in Reynolds's own world did begin to offer their judgments on this question from around the time of his Bute portrayal.

The first voices to question Reynolds's all-pleasing affability came from within his own family. Both his parents were dead by this time, but four sisters and one brother were still alive. His sisters were the tricky siblings, especially the youngest, Frances, who had come to live with Joshua as his housekeeper back in 1753. An aspiring artist-philosopher herself, she was welcomed into the

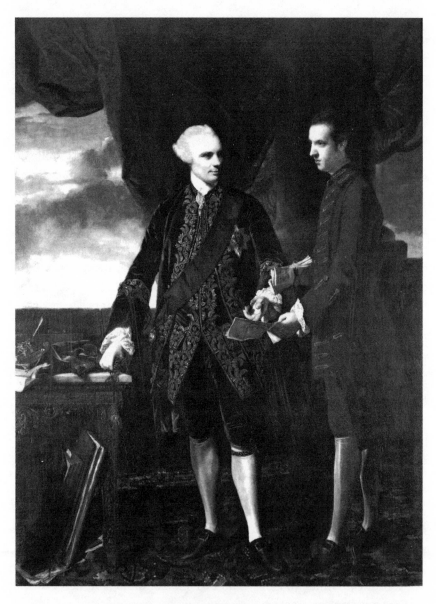

Figure 21. Joshua Reynolds, *John Stuart, 3rd Earl of Bute, with his Secretary Charles Jenkinson*, 1763. © Mount Stuart, Isle of Bute.

intellectual circles around Samuel Johnson, with whom she struck up a special friendship. When members of the same circle came to Reynolds's house, however, she had to revert to being a humble hostess. After a decade of subordination—though she would live with him for another fifteen years—Frances began making plain her unhappiness with her brother. She accused him of meanness and cruelty and let it be known how poorly she thought of his ability either to paint or to understand anything about painting.[8] She was certain that his so-called ambivalences were more strategic than genuine.

Reynolds's older sister Elizabeth criticized Joshua more for his irreligiosity than for his bullishness or fake talent. She did agree though with Frances about his financial tightness. When Joshua refused to support her son up at Oxford but suggested he become instead his pupil in London, she was outraged and forbade the boy to live with "the greatest villain on earth." After Joshua's death Elizabeth would write a letter to Frances about the gushing eulogies then appearing about their brother: they suggested "such an immaculate character," she observed, which "will be held up no doubt for humanity to copy after! such perversions in life are melancholy, particularly to his nearest Relations."[9]

The person who most despised Reynolds, though, was surely the memoirist and salonist Hester Thrale. It was Thrale who had drawn out Frances's objections to Joshua, criticisms she felt were delivered "with justice and judgement—mingled now and then with a bitterness that diverts one." Thrale never tired of puncturing Reynolds's reputation. At various times she accused him of being "puffed up." She thought his pretensions to philosophy ludicrous, his proclamations of friendship groundless, and his galloping success "odd." In the style of Goldsmith, she too once penned a satiric ode about him. Hers began,

> Of Reynolds what Good shall be said?—or what harm?
> His Temper too frigid, his Pencil too warm;
> A Rage for Sublimity ill understood,
> To seek still for the Great, by forsaking the Good.

Nothing "chills like his kindness," the ode went on. She for one was not for a moment taken in by his "pleasing" guise. It was all a front: "He seems to have no affections."

Thrale's set against Reynolds bothered their common confidante Johnson. Once when Thrale was complaining about how much people "overrated that man's mental qualities," Johnson pointed out, "Everybody loves Reynolds except *you*." The comment gave her pause. "The truth is," she reflected later in her diary, "I felt that he hated *me*."[10]

Thrale's rejoinder suggests a couple of reasons Reynolds should have irritated people like her and his sisters, even while most remained fond. Frances, Elizabeth, and Hester Thrale were all women. Reynolds's pronounced preference for male social company may have been the flip side of an outright dislike of women. More complexly, and more sympathetically, it may have had something to do with his compromised hearing. Reynolds suffered advancing deafness, which became so bad by the 1770s he started carrying a silver ear trumpet.[11] Among loud, confident, garrulous people—usually men in eighteenth-century Britain—such an affliction in others, if endured gracefully, could be an appealing quality. It could turn sufferers into an ideal audience. Among more marginal types, however—people who struggled to gain any limelight or social mileage, a fate which characterized most women at the time—a smiling, nodding, but mostly affectless man could seem instead aloof or unsupportive.

Some women did appreciate Reynolds. The precociously talented novelist Frances Burney, the sister of the Pacific voyager James and the daughter of Reynolds's great musician friend Charles, believed he had a "suavity that dissolved . . . angry passions in others." Upon publication of her first novel at the age of twenty-six Frances Burney became the recipient of that very rare phenomenon: intense celebration of a female author. At times the applause felt overwhelming, but she found the perfect respite in Reynolds's placid company. "He never once even alluded to my Book," she recorded, "nor paid any sort of compliments to me . . . but conversed rationally, gayly, & *serenely*." It made her feel "more comfortable than I have been." Even so, when another woman teased her about a possible romance with Reynolds, Burney instantly quashed the notion: "I would not run voluntarily into such a state . . . for the wealth of the East."[12]

The only woman who both liked and perhaps loved Reynolds went no further than Burney, either, in the end. The Swiss-born Angelika Kauffmann arrived in London in 1766 as a twenty-five-year-old, already-accomplished painter. She and Reynolds hit it off initially because of their shared passion for neoclassical art. Kauffmann turned out to be even more of a purist about ancient Roman aesthetics than he. Within months she was writing home to her father that Reynolds had become one of her "kindest friends" and that he "is never done praising me to everyone." Reynolds's own archive is more circumspect: he referred to her as "Miss Angel" in his pocketbook but gave little else away. He did, though, allow her to paint his portrait, a favor he granted to few.[13]

Hints at romance between the two come more from rumor than self-testimony. Their fellow artist Nathaniel Dance, himself apparently in unre-

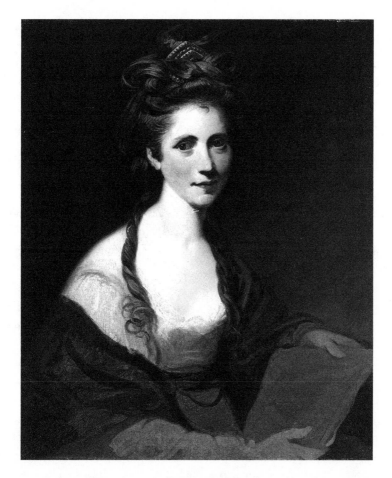

Figure 22. Reynolds's portrayal of his friend Angelika Kauffmann, 1766. Private Collection. Photo © Christie's Images / Bridgeman Images. Kauffmann's corresponding portrait of Reynolds hangs in Saltram House in Reynolds's native Devon.

quited love with Kauffmann, once circulated a compromising sketch of the pair, and several later commentators always swore that Reynolds had proposed marriage to her.[14] If there was a connection, though, it was not to be. Kauffmann married someone else within a year of their meeting.

Reynolds's close friends obviously wondered at his perpetual single state. Though most of them lived day to day, like him, in a homosocial bubble, each was also actually married or widowed. Only Reynolds remained a bachelor. "He said the reason why he would never marry," Boswell reported years on, "was that every woman whom he had liked had grown indifferent to

him." Thrale and Reynolds's sisters could have offered their own explanations for this indifference. None might have objected, all the same, to the alternate idea that it was rather Reynolds who was the indifferent one, repelling even Burney and Kauffmann when confronted with the reality of intimacy with such a serene man.[15]

Within Britain's burgeoning art world Reynolds still enjoyed an almost completely favorable reputation. His efforts at setting up the successful Society of Artists were noted and appreciated. By now, too, the society's own efforts at raising the nation's quality of art and at carving out a suitable space for art were making headway. Each year brought a still more successful exhibition, where success was measured by the quality of the pictures, the patrons, and (though few wished to dwell on it) the prices. From 1763 the annual exhibitions subtly indicated that all works were available for purchase.[16]

In 1765 the Society of Artists gained a royal charter of incorporation. This did not mean royal patronage as such but instead legal recognition and, most important, a sense of official sanction that its rival, the Free Society of Artists, lacked. That year the society's annual show was reckoned "the best exhibition that had been yet," and *Lloyd's Evening Post* declared that the society's "superior excellence" over the Free Society of Artists must now be "universally allowed."[17]

Chartered incorporation naturally meant a formal executive and, naturally too, Reynolds was invited to join it. Against contemporary expectation, however, he declined. Later biographers have speculated about a recent illness or an abiding reticence to explain this move, but it's likely to have stemmed from more complex reasons.[18] All along Reynolds had stood askew from the starker jingoism at the core of the society's foundation. Although Britain was no longer engaged in a formal war for empire, the Bute-Wilkes affair had shown that passions over Britain's imperial destiny were far from resolved. Maybe Reynolds still harbored doubts about aligning with an organization so determined to crow about imperial triumph. Alternatively, Reynolds might have been wary of the royal aspect of the charter. He knew incorporation didn't really mean royal control, but he was always very attuned to the power of perception over fact. His Whiggish friends might raise eyebrows at the idea of Reynolds serving a royalist institution. He didn't want to be aligned to a Whiggish jingoistic sect but neither was he keen to be seen as a kowtowing Tory sycophant. Abstinence from overt leadership seemed the best solution.

In place of formal executive duties Reynolds over the next few years concentrated instead on other associations. In 1764 he founded what he called the Literary Club but was soon known simply as The Club—it was to last as an exclusive male dining group for more than two hundred years. Among the nine original members were Reynolds's close friends Johnson, Burke, and Goldsmith. Reynolds was the only painter. Everyone else was a writer, philosopher, musician, or orator—still evidently the occupations Reynolds considered the most intellectual. Club members met every Monday in a tavern for dinner and scholarly conversation. Sometimes the debates became nasty: at least one member was expelled for attacking Burke, and Burke himself sailed close to the wind with Johnson and Goldsmith more than once. Reynolds, of course, never provoked. He understood his role to be auditor rather than combatant, even while he set up and encouraged the spirited disputes.[19]

Reynolds was, in fact, extremely clubbable, to use an eighteenth-century word. Informal, male, urban, genteel associations—so defining today of eighteenth-century London—suited and amplified his long-standing homosocial inclinations. In addition to The Club and the Society of Artists, Reynolds was a member of the London-based Devonshire Club, a local Sons of Clergy Club, the notably aristocratic-heavy Society of Dilettanti, and, interestingly, a gambling organization called the Thursday-night Club, which met in the same Star and Garter tavern so beloved of Ostenaco.[20] The night Ostenaco visited the Star and Garter after meeting with George III happened to be a Thursday and also one week after he'd sat for Reynolds. Whether sitter and artist spied each other there again that evening is now lost to history.

By 1767 Reynolds's measured engagement with the Society of Artists had grown so tenuous that he neglected to send in any works to the annual show at all. This absence would have marked his final farewell to the organization if it hadn't been for the exceptionally positive reviews then forthcoming about another painter. Thomas Gainsborough had been sending in pictures to the society from his base in Bath for several years. From the beginning he had won admirers for his light, lyrical works, both portraits and landscapes. In 1765 a pamphlet ode to that year's society exhibition had placed Gainsborough and Reynolds on an equal footing: "There Gainsborough shines, much honoured name, / There veteran Reynolds, worthy of his fame."[21] Reynolds may have been resigned to share praise with this newcomer, but he was not, it turned out, prepared to be outstripped. The reviews in 1767, two years later, implied that Gainsborough's portraits were the most successful, and expensive, of any

shown. Reynolds made sure to send in five works the following year. In coming decades their rivalry would become the stuff of legends.

Both Gainsborough and Reynolds shone in the 1768 exhibition. It was, though, to be the last engagement with the Society of Artists for each. Both by this time also felt a common dislike of other aspects of their involvement in the organization. Gainsborough thought the exhibitions brought out the showy and the immodest in his fellow painters in ways that did not best serve art. Reynolds, closer to the society's internal machinations, was more concerned about the backbiting and rancor that seemed to be corroding the fabric of the group.[22]

However else commentators have explained the events of that year, it can be no coincidence that Reynolds chose to depart for a short tour of the Continent during the autumn of 1768. It had been more than fifteen years since he'd discovered the delights of Europe. No doubt he enjoyed reencountering the superior collections of Old Masters and the more established neoclassical tradition among contemporary painters. But most of all he was happy to escape the sparks now catching fire within the Society of Artists. The archive is scant on the particulars, but it seems that when a groundswell of younger artists challenged the incumbent directors in October 1768 few were taken by surprise. Discontent had clearly been brewing for a while. The younger artists were angry about the entrenchment of privilege among the directors of the society. Although under the charter the executive was open to election, little ever seemed to change at the top. That autumn the advantages given to some directors in terms of hanging space at the exhibitions, access to the best patrons, and the ability to set the terms and tone of the organization finally pushed the rank and file into rebellion. These younger artists inspected the bylaws of the charter and arranged for their majority force to vote out sixteen of the presiding directors.

Reynolds was not a director, but at the same time no one ever identified him with the rebellious putsch. As usual his reputation floated free above all factions. His timely sojourn to Paris in 1768 made sure it stayed that way.

Upon their ousting, the former directors and several other members left the Society of Artists completely. They set about forming an alternative group right away. That their provisional leader, the architect William Chambers, thought to go straight to the king with their plans also speaks of a much longer period of institutional fraying than the archive allows.[23] It seems many members had for some time been plotting a move to outright royal patronage. Chambers was at this point the unofficial Architect to the King, a position

that awarded him a sumptuous residence at Hampton Court and connections to endless wealthy offshoots of the royal family. Like Reynolds, Chambers was a dedicated neoclassicist but due to his secure relationship to the monarchy he was always less committed to creating an independent public scene for art, and he was significantly more comfortable with his Tory convictions. Though cordial with one another, he and Reynolds never hit it off.

Chambers had no difficulty swallowing the more awkward elements of the idea of a Royal Academy and probably wondered why his fellow artists had pussyfooted around the issue for so long. Not for him any handwringing about the specter of the French example of a Royal Academy, which was so widely believed to be an unctuous pawn of despotism. To Chambers, the victory against France in the Seven Years' War made those comparisons irrelevant. And anyway the end of the war also made—or should have made—the old tussle in Britain between opposing political positions defunct. The time was ripe, so Chambers believed, for a proper British Royal Academy for the arts to emerge—one with a dedicated building, assured finances, and a school for the raising up of a new and larger generation of proud British artists. Leaders like him, and Reynolds, had done the necessary groundwork of introducing an elevated style into British art and of creating an appropriate viewing public to appreciate it. They had made an honest start on the original aspiration of the Turk's Head crowd to forge an arts scene adequate to the glory of the most powerful nation in the world. Chambers refused to be dragged down to the old tradesman-like level of art that the current rebels in the Society of Artists were recalling. Now was the time to step up to the next level and ask the king for consolidation, expansion, and money.

If Reynolds guessed at Chambers's plan, it made even more sense to absent himself so he could buy some time before confronting the next obvious question. Should he also leave the Society of Artists and work toward a Royal Academy? Or should he stay true to the organization he had labored hard to found and remain free of potential political restrictions? Later history has made it almost impossible to see that this was a genuine dilemma for Reynolds. His fame as the inaugural president of the Royal Academy obscures any sense that things could have gone another way. Even those scholars who note Reynolds's well-timed departure to Europe in the autumn mostly assume it was calculated for him to appear the least sullied and thus most suited to take up a headship he had always wanted.[24] Reynolds's old political ambivalence, however, may yet have been stalking him in 1768. For one thing, his friend Edmund Burke was still vocalizing a great dislike of all things royal.

Having watched Reynolds's efforts with the society over the years, Burke felt that "without an academy the English were making great strides after perfection, whilst others, with one, were every day more and more losing sight of it."[25] Second, Reynolds well remembered—even if fellow neoclassicists like Chambers chose to forget—that their mutual theorist hero, Jonathan Richardson, had always held a horror of "the slavery of court dependence." Lofty, grand, virtuous art could not afford the risk of contamination by the tedious whims of monarchical arrogance.[26]

On the other hand, Reynolds's other great friend, Samuel Johnson, thrilled to any suggestion of advancement for the arts.[27] With his own royal pension for literary achievement, he was hardly going to indulge Burke's wariness about the ties of kingly sanction. He may also have pointed out to Reynolds that things were different now from in Richardson's day. Patently, George III was no tyrant. He had managed to endure the Wilkes scandal without hanging anyone. In fact, it was Johnson's view that the Whig oligarchy which yet ruled parliament seemed likelier perpetrators of tyranny than the king, enforcing an acceptance of their commercial and brutal imperialistic order among all Britons whether they liked it or not.

The most eloquent testament to Reynolds's mixed emotions at this time was his silence. He was back home in London by November, while machinations were still ongoing, but he refused to signal his intentions for several more weeks.

On 28 November, after some to-and-fro, Chambers submitted his formal petition to the king, along with the signatures of twenty-one other artists. Reynolds was almost certainly asked to join, but his name does not appear among them.[28] In the same week the remaining Society of Artists members requested Reynolds take up one of their now-vacant directorships. But this, too, with elaborate regret, he declined. On 9 December the king agreed to Chambers's request: "I approve of this plan," he wrote on the detailed proposal, "let it be put into execution."[29] The Society of Artists' rump heard the news while convening in their old stomping ground of the Turk's Head tavern. They admitted horror, knowing that the clout of a Royal Academy could kill off their own efforts forever. One attendee swore that Reynolds was present in the tavern that night and heard him declaim that he was now done with exhibiting altogether.[30] Within a day or two a deputation from the successful Royal Academy petitioners brought Reynolds to a meeting and formally invited him to become their first president. (Chambers probably wanted the role, but the signatories agreed it should go to a painter.) Reynolds was "very

much affected by the compliment" but stalled, saying only that he needed to "consult His friends Dr Johnson and Mr Burke upon it."[31]

The next five days have no record for Reynolds. We can presume he sought out Johnson and Burke separately. He would have already known Johnson's views. It was probably Burke, then, who came around. Burke was, after all, no republican; he had only ever advised caution rather than outright defiance of Britain's legitimate head of state. Later, Burke was the friend who studied and praised more of Reynolds's works at the Royal Academy and attended more of Reynolds's lectures there than Johnson ever did. Perhaps he felt that if anyone could insist on a measure of independence for the new institution, which was emerging regardless, it was his dear friend, the ever-beguiling Joshua Reynolds.

The next piece of evidence we have is the minutes of the first Royal Academy assembly on 14 December. It is signed at the bottom, "J. Reynolds, President."[32]

Chambers had drawn up an exacting set of rules for the new institution. The most significant concerned the criteria for membership. First of all, the total body was restricted to forty. By this time the Society of Artists' membership had grown to over two hundred, which was evidently more than the older elite liked. The new Royal Academy now deliberately excluded amateurs, connoisseurs, and, controversially, engravers because they were considered nearer to craftsfolk than to artists. In a subtle swipe at the rebels of the Society of Artists, it also took a stand against youth, forbidding anyone under twenty-five years old. Finally and most pointedly it required renunciation "of any other Society of Artists established in London." At the opening ceremony the king accepted thirty-six founding members into the forty possible positions. These included Reynolds and Chambers, of course, as well as Reynolds's nearest artistic rival, Gainsborough, and his nearest romantic rival, Nathaniel Dance. All but two of the thirty-six were former members of the Society of Artists.[33]

In addition, all but two of them were men. The two female founding members were Reynolds's great friend Angelika Kauffmann, who by now had been exhibiting in London nearly as often as Reynolds, and the famed botanical painter (and also sometime portraitist) Mary Moser. Two out of thirty-six is a fair reflection of the poor status of women in eighteenth-century Britain. That it took another 150 years for the next woman to find election into the Royal Academy, however, speaks of an even worse time for British women through the nineteenth century.[34]

Chambers had secured handsome funding from the king until the Royal Academy could pay for itself through its shows (which did not occur until the 1780s). The money was spent on staging annual exhibitions, building up a library, paying for a "porter" and a "sweeper," renting an apartment for a manager from within the membership, and providing for over seventy scholarships. After a couple of years the funds also came with rooms in the old Renaissance royal palace of Somerset House on the Strand.[35]

The rules stipulated four formal professorships from within the membership, one each for anatomy, architecture, painting, and perspective. As president, Reynolds never served as a professor, though he did exercise typical eighteenth-century tolerances for nepotism and sinecures by handing out additional, informal professorships to his mates. Johnson became unofficial professor of ancient literature while Goldsmith became unofficial professor of ancient history.[36]

In a nod to the past, and with some desperate hope for the future, Chambers added as rule number 24 that "if any member . . . shall by any means become obnoxious it may be put to the Ballot . . . whether he shall be expelled."

There was no rule in the Royal Academy's founding document that the president should receive a knighthood from the monarch, and indeed later presidents did not assume this honor. Reynolds, though, became Sir Joshua soon after his ascension. This must have been in recognition of the work of being a *founding* president and perhaps of Reynolds's general achievements as an artist over the last twenty years. Because it certainly wasn't awarded out of any special relationship with George III. Despite the near total consensus held among London men about Reynolds's affability, one local man who remained immune was the young king. George III's personal dislike of Reynolds was first made apparent in 1761, when he passed him over for the lucrative position of Painter to the King. Even back then many observers were shocked at the slight and came up with a variety of reasons to explain it. Reynolds's loyal student James Northcote implied that it was due to George III feeling overawed by the older man: he was, after all, "only King of a great nation" while Reynolds was "the greatest painter in the world."[37] Reynolds's fellow painters may have smirked a little at this explanation. The pseudonymous critic Peter Pindar quipped instead that

"REYNOLDS is no favourite, that's the matter;
He has not learnt the noble art—to flatter."[38]

Against the tides of praise for his agreeable persona that virtually drown the sources on Reynolds's life, this rationale seems even more ridiculous than the idea of kingly cowering.

The real reason was probably political. George III was unlikely to read Reynolds's staunch neoclassicism and his close personal friendship with Johnson as signs of sympathy for Tory monarchy—those things were far too abstract for someone removed from urban public culture to understand. The king knew precisely, however, what Reynolds's connections to so many of the nation's leading Whigs implied and especially to the voluble Whig MP Edmund Burke. Later, George III would learn that Reynolds maintained a bond with his mortal enemy John Wilkes, a Whig troll whom not even Burke could stomach. The painter would numerous times meet the alleged libelist in hiding, enjoying Wilkes's rakish company just as he enjoyed the boisterous behavior of so many other sociable men.[39]

That George III caved in the end and awarded Reynolds a knighthood was the result of Chambers's tireless campaigning for the Royal Academy. It would make the institution look good, and Chambers would do anything to launch his pet project in the best possible way. It is conceivable that George III was also, privately, motivated by the image of Reynolds squirming under a royalist title. He knew Whigs like Burke had reservations about royal patronage. Though not known as a sadist, the king may have been tickled to make his critics stew in the difficulty of both wanting advancement and boasting independence. A rumor later that year told a story of Reynolds deciding to resign the presidency after only a few months but then having to face a patron who could now simply insist he continue.[40]

Reynolds did not resign and in fact embarked on the venture that would occupy the rest of his life with unflagging resolve. He began his first year as president with an address to the new academicians, a practice he kept up annually until the end. "An Academy, in which the Polite Arts may be regularly cultivated, is at last opened among us by Royal Munificence," his inaugural speech began. "This must appear an event in the highest degree interesting, not only to the Artists, but to the whole nation." With this direct linking to the British state, Reynolds went on: "It is indeed difficult to give any other reason, why an empire like that of Britain, should so long have wanted an ornament so suitable to its greatness, than that slow progression of things, which naturally makes elegance and refinement the last effect of opulence and power."[41]

This is a truly fascinating opening gambit. Today, readers may assume that an institution like the Royal Academy of Arts would of course be intermeshed with Britain's burgeoning empire—if they think of art and empire together at all, that is. But tracing the Royal Academy's origins through Reynolds's life shows that it was rather the Society of Artists, the institution's

earlier, jealous rival, which began in Whiggish jingoism. The Royal Academy was set up chiefly by Tories, which in the complicated politics of the 1760s should have meant it was *less* gung ho about empire, not more. Did Reynolds forge this link with Whiggish empire, then, purposively, as a subtle nod to his Burkean friends? Was it meant as a sign that he would take the leadership of a royal organization but he would not become any king's slave? If so, it was some price to pay. Reynolds had always been uncomfortable with the Society of Artists' more imperialistic rhetoric. But now here he was embracing an imperial basis for the Royal Academy. As ever, Reynolds was shifting to maintain his double position on the volatile political spectrum of his age.

One way of smoothing over the awkwardness of Reynolds's move was to make all of it seem inevitable rather than deliberate. His evocation of "the slow progression of things" worked to suggest a long, organic process, bound to happen eventually. The Royal Academy in this vision was the natural denouement of Britain's preordained rise to power rather than a minutely engineered by-product of conflicting positions. Such a vision had the effect of stripping the spiky politics out of the Royal Academy's history. This in turn made it seem to hover above both imperial and monarchical issues. It was a dissociation that would continue, for some, to the present day.[42]

Openings and bestowals are all very grand, but even knights must attend at times to the quotidian. Moving into the new decade of the 1770s, Reynolds's everyday life was set to expand. In 1770 he started drawing up plans for another house. This second home was to be ten miles away in Richmond, near the residences of friends like Horace Walpole in Twickenham but not so far out into the countryside as Burke's estate in Beaconsfield. Aptly and perhaps diplomatically he asked Chambers to design it for him. It turned out to be a rather plain, neoclassical brown-brick cube—four windows by four windows—set awkwardly atop a small hill. Reynolds never ended up using it much—he had become too much of an urban creature—but the second home's existence spoke of a domestic sphere catching up with Reynolds's public elevations.[43]

In 1770, too, Reynolds solved the problem of living with an increasingly resentful housekeeper-sister. Although Frances stayed on at the Leicester Fields terrace for a few more years, her duties transferred now to their niece, Theophila Palmer, the daughter of their elder sister, Mary. Like her grandmother this Theophila was also nicknamed Offy. Free of the bind of sibling rivalry and more headstrong a woman anyway, Offy enjoyed a better relation-

ship with Reynolds than did any of her aunts. When he died Reynolds left her four times as much wealth as he did to poor Frances, who had served him for over two decades. A letter he once wrote to Offy conveys something of his daily delight in her company, even if also something of his unfamiliarity with expressing fond feelings to women. "I never was . . . a great professor of love and affection," he admitted, "and therefore never told you how much I loved you, for fear you should grow saucy upon it."[44]

As housekeeper, Offy worked more as a manager of staff than the actual cleaner, cook, or maid. By the 1770s a handful of servants helped maintain Reynolds's private world. At least one of these was a man of African descent, a former slave from a British sugar plantation in Antigua. It was probably Johnson who had urged Reynolds to employ this man. Johnson had been a vocal critic of slavery long before it became the subject of an abolitionist movement. As a young man he had written against the "tyranny" of slavery and was by old age known frankly as a zealot for the cause. In the early 1750s Johnson had taken in a ten-year-old former slave called Francis Barber. He educated Barber, retained him as his servant for thirty years, and would upon death leave him the bulk of his by-then considerable estate. He believed that employing freed slaves was the best solution to their predicament in an empire that relied on slavery until well into the nineteenth century.[45]

Reynolds's black servant, whose name does not survive, had been brought to Britain by an acquaintance of both Johnson and Reynolds.[46] Reynolds probably started employing him around the time he moved into his Leicester Fields house. The man would not, however, go on to enjoy quite the degree of affection and reward that Barber gained from Johnson. In fact, his treatment reflects something of the conflicted feelings Reynolds harbored for all representatives, or reminders, of the empire. On the one hand, Reynolds flouted the worst attitudes of imperialism by housing and paying a man from a people that many were coming then to think were more naturally suited to bondage. On the other hand, he was hardly the kindest of masters. One time, also around 1770, Reynolds learned that his black servant had been the cause of a white man's imprisonment. Upon interrogation Reynolds discovered that the servant had been robbed in the street while running an errand for Reynolds. By the time he pieced together the full story, the thief had been caught, convicted, and was wasting away in prison. Reynolds demanded to know why his servant had not told him earlier, to which the man replied, tellingly, that he had feared being blamed for the whole event. Reynolds punished the servant's secrecy and possibly indeed his part in the original affair by sending

him round to visit the jailed thief every day with fresh food. While Northcote later offered this anecdote as an example of his teacher's charity toward unfortunate criminals, it also told of a harsh attitude toward black underlings.[47]

The same mixture of sympathy and contempt is evident in Reynolds's painterly portrayal of the ex-slave. Northcote explained in his memoirs that Reynolds used this man as a model in several portraits.[48] They included no doubt the impressive full-length portraits of the Marquess of Granby (1765) and the Count of Schaumburg-Lippe (1767), both military heroes in Britain of the Seven Years' War and both depicted with a black attendant. Just like Reynolds's portrait of Elizabeth Keppel from a few years before, these pictures figured the black attendant as beautiful, well-dressed, and youthful (see fig. 10 in chapter 3). But also just like the earlier picture, they showed the black individuals as smaller, humbler, and more marginally placed than the white subjects. All told, by the end of his life Reynolds had painted thirteen images of nonwhite people. Every single one of them—bar his portrait of Ostenaco—featured the subject turned away from the viewer, often looking up instead to a master or else off to one side. Other than his ill-fated Cherokee portrait, none had the black or brown person gazing out directly. Each was self-effacing. Each was more owned than an owner.[49]

The difficulty of empire still dogged Reynolds, even in the aftermath of Britain's supposed global ascendancy and even after he became the head of its artistic institutional "ornament." The only respite from his nagging ambivalence came, briefly, in the early 1770s. It was occasioned, as it was for so many Britons, by the arrival home of Cook's first expedition to the Pacific. Unlike most other Britons, though, Reynolds accessed this celebrated moment through his private networks. The true celebrity of the first voyage was not Cook himself—the retiring, gruff naval officer—but the young, flamboyant accompanying naturalist, Joseph Banks. Reynolds met Banks through his friendship with Charles Burney (later, the senior Burney would put pressure on Banks to get his son, James, admitted to Cook's second Pacific expedition). It was probably in the Burney drawing room that the painter first heard tales, from the naturalist's own mouth, of Oceania's wondrous isles. He heard of its fascinating natives and its vast arcs of space unclaimed by any rival European power.[50]

Throughout 1771 the British public shared Reynolds's evident relief at finding an overseas enterprise that did not seem compromised by the specter of imperial overextension, vicious warfare, Indigenous dispossession, or bonded labor. The initial year of London's "Pacific Craze" was dominated instead by a

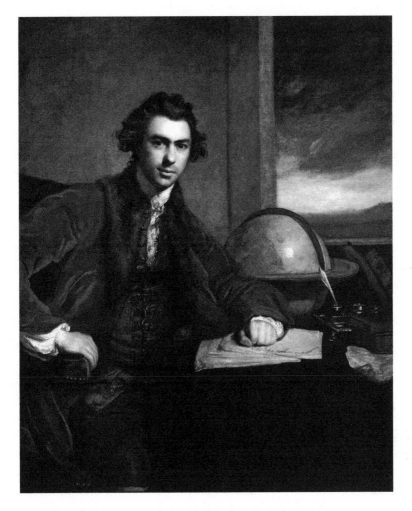

Figure 23. Joshua Reynolds, *Sir Joseph Banks, Bt,* 1772.
© National Portrait Gallery, London.

belief that the British were merely exploring, not conquering—encountering, not oppressing—in Oceania's new "New World." The portrait Reynolds undertook of Banks in December captured well this positive and wholesome, if all too fleeting, impression.[51]

Reynolds's portrait figures Banks as halfway between scholar and adventurer. Seated in his study, surrounded by papers, he is yet just about to rise out of his chair. Taking in the glimpse of a calm sea out the window and the globe placed near its sill, the viewer safely assumes that the action about to occur

is maritime in nature. The writing below Banks's left hand confirms it: *cras ingens iterabimus aequor,* a Latin line from Horace easily recognizable to Reynolds's audience: "tomorrow tempt again the boundless sea." Banks's lively, intelligent, half-smiling face completes the overall sense of an innocent, ideas-led mission. In place of the complexities of imperial action, this portrait suggested simple worldly curiosity. Instead of the awkward implications of colonization, it emphasized just scientific inquiry.

Even the imperial skeptic Johnson was taken in at first by the good news of Pacific exploration. He met Banks, in turn, in Reynolds's drawing room. In early 1772 he sent a note via Reynolds to the naturalist and fellow Pacific sojourner Daniel Solander thanking them "for the pleasure received in the conversation of the day before."[52] Although later exasperated by the affectation and sentimentalism used by his contemporaries to describe Oceania, Johnson seemed initially just as prepared to forget his more searing critiques of British intrusion when it came to the Pacific as the rest of his countrymen.[53] Burke, of course, was even more inclined to ignore the darker implications of Cook's voyage. In fact, he held on to the idea of Pacific exploration as primarily a service to knowledge for longer than most.[54] It was a strand of thought that would continue for some observers for centuries.

For others, though, the original shine of Britain's supposed discovery of the Pacific wore off within a couple of years. Doubts about the British venture into fresh new worlds arose amid a more general increase once again of worries about the empire. During the latter part of 1772 British imperialists in India, serving through the East India Company, came under heavy fire for both their management of Indian dependencies and their financial handlings. News of a horrendous famine in Bengal trickled through just as the share price of East India Company stocks plummeted. It was enough to alarm bleeding hearts and fiscal conservatives alike. British expansion had always troubled these types, but now they were reminded anew of the problems entailed in aggressive incursion.

One year later, in part triggered by the East India Company crisis, American settler rebels in Boston staged a powerful act of defiance to British metropolitan government. By dumping over forty tons of newly regulated East India Company tea into Boston harbor, they gave expression to years of pent-up anger over what they saw as the creeping tyranny of London (in this case, king and parliament together).[55] Britons back home saw immediately, if differently, the implications of such an act. For a critic like Johnson it was grim

vindication: sanction the colonists' sense of entitlement to dispossess others and don't be surprised to see it spread to a sense of entitlement to govern themselves. To supporters of American settlement like Burke it was more delicate. They had long defended the rights of colonists to spread British liberties far and wide; they could hardly complain now that the rebels had turned the Whigs' own fear of tyranny against them. Burke said as much in his later speech to parliament. Commentators ever since have read his words as a noble defense of the settlers, but it was more a melancholy acknowledgment that their actions had exposed a paradox at the heart of Britain's imperialism. The rebels' specific accusations, Burke admitted, have "shaken . . . this empire to its deepest foundations."[56]

In the middle of these gathering clouds came the long-awaited formal publication of all the major journals of British Pacific explorers over the last ten years. This three-volume collected work, *An Account of the Voyages,* had been commissioned by the Admiralty back in the 1771 heyday of Pacific celebration. The compiler was the journalist and librettist John Hawkesworth, friendly associate of all current members of Reynolds's Literary Club. The Admiralty paid Hawkesworth an astonishing six thousand pounds to edit not only the journals of Cook and Banks but also those from Samuel Wallis's 1767–68 voyage and an earlier voyage by Captain John Byron in 1764–66.[57] The advance was equivalent to around one million pounds today.[58] It was also, incidentally, around the same value of all the tea thrown into Boston harbor two years later. Hawkesworth evidently judged the sum a sign that he could take whatever license, and time, he wanted. It was to prove a fatal decision.

By the time Hawkesworth produced his edition in the summer of 1773 attitudes around empire had reintensified. Worse, he had let his literary sensibilities run amok by experimenting with Cook's and Banks's voices, blending them together into one first-person narrator and highlighting the more risqué revelations of their voyage. These latter discoveries focused especially on the sexual and infanticide practices of the Tahitian Arioi.

Readers of all stripes were outraged. They complained about the inability to distinguish Cook from Banks. Boswell later described the text as a brew of the journals, much like tavern wine. They were furious about the attention given to "vicious indulgences" as well as Hawkesworth's apparent lack of censure against them. Scientific inquiry was to be lauded, it seemed, except when it turned up behaviors unspeakable. Most of all, they were offended by Hawkesworth's insinuation that Pacific peoples, even despite their behaviors, didn't

seem noticeably more savage than Europeans. Not only was this downright "irreligious" but it also implied that Britain had no business making claims on the region, and "*what possible Good can your establishing [this] produce?*"[59]

The hyperbole of the disgust heaped upon Hawkesworth was extreme even by eighteenth-century standards: criminal, blasphemous, shameful, deceitful, fraudulent, oppressive—as one observer noted, the publication occasioned a true torrent of vitriol.[60] Finding out that the Pacific was no transparent idyll was a blow to a people eager for positive spins. Discovering that it was, at the same time, neither an embryonic society justifying British incursion was similarly hard. Realizing that to expect both an idyll and an embryo was something of a contradiction turned out to be the last straw. All the anxieties bubbling up about Britain's position in India and America and now the Pacific rained down on the unfortunate Hawkesworth. He died within six months of publication, the result, his friend Frances Burney always claimed, "[of] the abuse he has of late met with."[61]

To Reynolds, these years of rising imperial anxiety were a mixed bag of experiences. On the one hand, he mostly navigated them with his usual lucky aplomb. He exhibited his Banks portrait, for instance, in the Royal Academy's 1773 annual spring show two months before the Hawkesworth scandal erupted. Many viewers then still hoped the Pacific dream might redeem imperial problems elsewhere. Certainly none seemed to take out their angst about British activities on Reynolds's representation. As well, that year he received the double tribute of an honorary doctorate at Oxford (two years before his friend Johnson received his) and the honorary mayorship of his home village of Plympton.

On the other hand, Reynolds now experienced the first real expressions of hostility from his professional male peers. No doubt the formal entrenchment of his high reputation with the actual, tangible power of a knighted presidency fueled these challenges. But they were perhaps also driven by the general malaise then amassing in Reynolds's society.

The painter who first felt confident to question Reynolds's standing was his longtime competitor Gainsborough. Almost exact opposites in temperament, the louche, engraver-trained Gainsborough had heard plenty of Reynolds's neoclassical pronouncements by the early 1770s. He'd attended the first Royal Academy lectures and seen the results in Reynolds's heightened portraits of British aristocrats dressed as Roman goddesses and senators. "Nothing can be more absurd," Gainsborough declared to a client, "than the foolish custom of Painters dressing people like scaramouches, and expecting the like-

ness to appear." He also thought Reynolds's advice to favor the "general air" over "meretricious ornaments" was stupid. "The Ornamental Style (as he calls it)," Gainsborough countered to another client, seemed on the contrary "form'd for Portraits." Altogether, he hated Reynolds's philosophizing attitude to art, preferring canvasses to speak for themselves. "I believe I shall remain an Ignorant fellow to the end of my days," he sneered, "because I never could have patience to read Poetical impossibilities." Just such a habit, however, seemed the only way in his day "to be *Knighted*. . . . So well do serious people love froth."[62]

Though constitutionally disinclined to match Gainsborough's sarcasm, Reynolds let it be known that the antipathy was mutual. He avoided Gainsborough's company whenever possible and may have taken some pleasure in denying him the best hanging spots in the Royal Academy's annual shows.[63] Everyone noticed it. Northcote admitted that the two "could not stable their horses together, for there was jealousy between them." Some people were less circumspect and revealed in their comments a sense of schadenfreude. In one 1770s review of a Royal Academy exhibition the critic Henry Bate-Dudley took delight in provoking Reynolds by stating that Gainsborough's work had "impartially placed him at the head of the artists." Later, the landscapist Richard Wilson savored Reynolds's humiliation with his proclamation in a pub that Gainsborough was "the greatest portrait painter at this time in Europe."[64]

Evidently Gainsborough's disgruntlement opened the door for others to mount direct challenges. One of the harshest was by the pseudonymous critic Fabius Pector, who wrote an open letter to Sir Joshua in the *Morning Chronicle* on 20 April 1773. At the other end of the critical spectrum to Gainsborough, Fabius Pector attacked Reynolds for not being neoclassical *enough*. "Your figures are shockingly out of drawing," he fumed, "and finished in a slobbering, herum-skerum, unartist-like way." They are, in short, "totally wide of all true historical character." Pector went on to link Reynolds's poor art with his infamously affable and successful character. "You are a very cool man," he charged, "with your passions always in proper subordination of your interests."[65]

Most contemporaries seemed to recognize that Fabius Pector was actually the fellow Royal Academician James Barry, a young Irish protégé of Burke's who had come to begrudge both of his elders' patronage. Another letter writer in the *Morning Chronicle* two weeks later offered a story that Barry had declaimed in public: "Sir Joshua Reynolds! Why he knows no more of art than my a[rse]." Reynolds did not respond in print but privately told Northcote

that "he thought it a very bad state of mind to hate any man; but that he feared he did hate Barry."[66]

At the end of summer 1773 Reynolds tried to redirect his thoughts back to art. He came up with a plan for six Royal Academicians to offer six monumental paintings of biblical scenes to London's largest church, St. Paul's Cathedral. His case to the king referred to the original plans of the architect, Sir Christopher Wren, who had indeed expressed a wish a hundred years earlier for its walls to be decorated with artworks. In the 1770s this kind of plan suggested a subtle, Toryish support of old British values—not a bad move for someone needing to balance out some recent, more abrasive Whiggish remarks. Reynolds's real motive, though, was to try a new angle in his tireless promotion of neoclassical art in the public sphere. Even the establishment of a Royal Academy had not solved permanently the problem of getting clients to commission grand and lofty art.

Reynolds numbered himself as one of the six to donate to St. Paul's. Of course. He also invited Angelika Kauffmann; his old friend the Italian-born Giovanni Battista Cipriani; his new friend the American-born Benjamin West; his apparent rival of the heart Nathaniel Dance; and, intriguingly, Barry. The latter two choices speak either of an impressive case of domesticating one's foes or of Reynolds never letting their threats get under his skin in the first place. Or, indeed, that Reynolds was truly dedicated to the neoclassicist cause, since these six probably were its best practitioners at the time.

The scheme looked to have legs, until the leading archbishop in the kingdom kyboshed it on grounds of popery (he feared it would start a fashion for altar pieces and thereby reinvigorate Catholicism).[67] Reynolds was little perturbed by the refusal and moved on. The St. Paul's plan, though, remained alive in the mind of another, lesser-known Royal Academician called Nathaniel Hone. Possibly Hone was annoyed not to have been included in the plan. Or maybe he had been spending a lot of time with Gainsborough and Barry. Whatever the origins of his complaint, Hone performed one of the decade's fiercest critiques against Reynolds out of the St. Paul's debacle. It was the culmination of this whole first wave of resentment toward the founding president.

For the 1775 show at the Royal Academy, Hone offered seven works, all of which were accepted by the exhibition committee and hung up in readiness of the show's opening. Just days before the exhibition was to admit public viewers, however, Kauffmann demanded that one be taken down. This work was entitled *The Pictorial Conjuror, Displaying the Whole Art of Optical Decep-*

Figure 24. Nathaniel Hone, sketch for the *Conjuror*, 1775. Reproduced
with permission from the Tate, London.

tion. It showed a grizzled old magician conjuring a gilt-framed painting out
of a flaming fire into which dozens of prints by Renaissance Old Masters ap-
pear to fall. A young girl stretches across the man's knee. In the background
rises St. Paul's Cathedral, before which dance six naked figures, as if in a bac-
chanalian ritual.

Kauffmann claimed that one of the naked figures was meant to be her (the
other five presumably her fellow St. Paul's schemers). Since several of her gen-
tleman friends also believed this, she said, the picture was an inadmissible slur
against her feminine reputation. Nudity was not acceptable for women in the
British eighteenth century. Led by Chambers, the Royal Academy's Council
met to deliberate, and a few of them even visited Hone to seek an explanation.
The blunt, impatient Chambers was inclined to believe Hone that the figure
in question was a man, not a woman, and he tried to persuade the Council to
keep the painting up. Public scandal was the last thing Chambers wanted for
his beloved baby. He was outvoted, however, and the work came down.

Chambers's fears had been well founded. The press jumped on the scent of controversy. In a huff, Hone moved swiftly to hang his *Conjuror* for public viewing in separate premises in St. Martin's Lane. When reporters got to see the work for themselves they saw immediately that the real issue was not a tiny, fuzzy, naked Kauffmann after all but the central, wizened, male figure. He was clearly meant to be Joshua Reynolds. Hone's slur was in fact against the supposed master of British painting, depicted here as a trickster, creating art out of other people's ideas, claiming individual genius by simply rework-ing the Old Masters. The girl over his knee indicated child's play. The six ca-vorting neoclassicists in the corner may well have been an additional jeer, insinuating that their passion for the ancients bled into a suspicious pagan-ism. But without doubt the larger share of Hone's criticism was directed against his president.

It's possible Kauffmann herself saw this and used the naked corner figure as a ruse to get Hone to retract his bigger point. In her response to Hone's apology she explained, "I was actuated, not only by my particular feelings, but by a respect for the arts and artists, and persuade myself you cannot think it too great a sacrifice to remove a picture that has even raised suspicion of disrespect to any person who never wished to offend you."[68] Was this "any person" herself or her old champion Reynolds? Further, if Kauffmann was defending the president rather than herself, was this on her own initiative or the result of Reynolds's manipulation? The latter conjecture, offered by some scholars, would confirm Elizabeth Reynolds's view of her brother as a com-plete cad. And, indeed, there is the telling point that normally Reynolds would have headed the Council's investigations himself but in this instance was absent.[69]

At the same time, Kauffmann was hardly a pliable plaything. She had earned her position as a Royal Academician and was unlikely to serve now as anyone's puppet. She may also, of course, have been genuinely vexed about her naked representation. In addition, Reynolds was not really the type to get agitated about Hone's charge of plagiarism. He had for years openly and vig-orously lectured students on the need to study the Old Masters, to learn from their superior examples, to ingest their philosophical principles—in fact, to be as close as possible to them in every way. If Hone thought this was akin to cheap conjuring, then so be it. Plainly, he just didn't understand.

As usual, the definitive answer is elusive because Reynolds goes silent in the archives at this critical juncture. The only evidence we have of him ac-knowledging the issue at all occurred a decade later, upon Hone's death.

Reynolds attended the estate sale and was seen staring "most attentively" at the *Conjuror* for a "full ten minutes."[70]

What we can say is that by 1775 Reynolds was no longer the undisputed golden boy of British art. Many still loved him and would till his own death. Some, though, seemed tired of his constantly winning ways, the firmness of his dictates about what constituted proper art, the relentlessness of his social and professional successes. The mixed nature of attitudes toward Reynolds reflected in a sense the general atmosphere of Britain's metropolitan culture in the mid-1770s. Only one week after the Hone affair armed hostilities broke out in Britain's American colonies. In Asia the British government was coming to terms with its larger share of power, having recently taken, with some reluctance, more direct control of the flailing East India Company. And now a vessel of Cook's second Pacific expedition had returned, but this time without the charming Banks, without so far even the authoritative Cook, and in the wake of Hawkesworth's partial sullying of Oceania's promising name. Just as they had been at the start and end of the Seven Years' War, British observers were extremely divided over their global exploits. Uncertain times bred an acerbic society. The bellicose jostled once more with the deeply doubtful.

This was the atmosphere in which Mai lived during his stay in Britain. It was the background to his meeting with the first artist of the kingdom that would deliver him all his dreams.

CHAPTER VII

A Pacific Celebrity and the Portrait That Worked

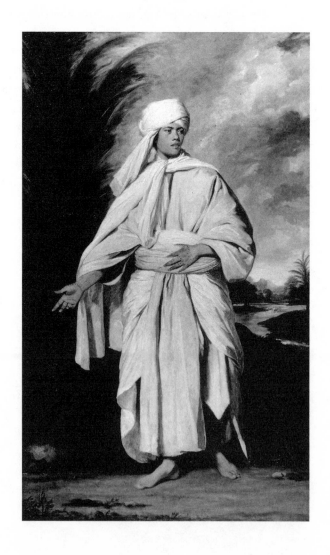

B y the time of the Hone affair Mai had been living in Britain for nearly one year. Upon docking at Portsmouth in July 1774 he had barely had time to take in the bustle of the harbor town before Tobias Furneaux, the *Adventure*'s captain, whisked him into a horse-drawn stagecoach headed for London. The pair reached Whitehall by evening. With Cook still sailing in the Pacific, Furneaux was keen to hand over his charge to the highest naval office in the land as quickly as possible. He wanted to find the first admiral before incurring too many debts or decisions on Mai's behalf.[1]

Lord Sandwich resided in Whitehall half a mile south of Covent Garden, nearer to the Thames river than Reynolds's Leicester Fields. Admiralty House at the time stood stolid and brown, the center of the British empire's practical operations. Sandwich called immediately for Banks. The famous naturalist had not journeyed on the second expedition but was still the British person most associated with Pacific matters. Banks hurried to meet the party. He brought with him Solander, from whom we have a description of the encounter.

"His name is Omai," the Swedish naturalist wrote to a friend, merging fatefully the Tahitian phrase for "it is" with Mai's name in British minds for the next two centuries. His introduction to the man was, even by Solander's admission, very "droll." Solander began conversing first with Furneaux in another room. Mai rushed in, saying, "I hear Solano's voice." Mai stopped short, though, when he saw Solander in person. He then walked fully about his body, staring at his wide girth. Questioning his memory, he then asked Furneaux to make Solano speak again. Only when he did was Mai convinced. It surely was Solano, recognizable from his distinctive Swedish accent, "but much increased in bulk" since their last meeting.[2]

Mai remembered the Swede from Cook's first visit to Tahiti, but the Swede did not remember him. Fortunately, though, Solander did recall his rudimentary Tahitian and with it gleaned for the first time the essential details of Mai's life. He had been born in Ra'iatea, "where his father was a man of considerable landed property." About twelve years ago the family had been forced to flee rampaging Bora Borans on Ra'iatea, losing both their estate and familial head in the process. As a refugee in Tahiti, Mai had been present on the "famous day" when Wallis's *Dolphin* crew had opened fire at Matavai Bay. He had suffered a wound from a musket ball to his side. Mai had also seen

Figure 25. Joshua Reynolds's portrait of Mai, 1775. Photograph courtesy of Sotheby's Picture Library.

Cook's first voyagers at Tahiti "when still a boy" and was living on Huahine when Cook's second voyage arrived.

Solander noted the strength of Mai's resolve in journeying to Britain though did not elaborate here on the reason, other than its connection somehow to Ra'iatea. He described the visitor's immediate appearance and manners. He seemed to be in his early twenties. He was "very brown." He was not, in Solander's opinion, handsome, but he was certainly "well made." He had a broad nose. His persona was instantly appealing: he was easygoing, eager, engaged. Friendly.

Banks didn't write of his first impressions, but they evidently squared with Solander's. He arranged with Sandwich straight away to take on Mai as his charge. This no doubt had been the admiral's plan all along. The canny Sandwich had to manage Banks carefully. Their friendship had been tested two years earlier when Banks had withdrawn in a huff from Cook's second voyage plans. Almost as soon as Cook and Banks had returned from the first voyage in 1771 they had started preparing for a second, this time to make British claims on Pacific regions secure against European rivals. But the vigorous, intemperate Banks had meddled too much in the building of Cook's *Resolution* vessel, demanding his scientific needs take priority over Cook's naval ones. As sympathetic as the Admiralty was to Banks's enthusiasm for Pacific exploration, it was never going to condone the promotion of a naturalist over a captain. Banks had issued an ultimatum, but Sandwich had called his bluff.

By 1774, however, all appeared forgiven. Banks probably regretted his past theatrics, given how quickly and keenly he gathered every scrap of information about the voyage from Furneaux and his unexpected guest that summer. Back on the first expedition it had been Banks who had made the case for Tupaia to join them. He had been fascinated by the idea of studying Tupaia as a specimen of Pacific Man, just as he pored over his seeds, plants, and other exemplars of biological diversity. Tupaia's death had ruined those plans. Now, here was a chance to reinstate them.[3]

Mai went home to Banks's luxurious residence near Mayfair that afternoon. He was to use it as his London base for the next five months. Solander also lived there as a kind of secretary to Banks. But it was probably the housekeeper, Mrs. Hawley, who got to know Mai most intimately. No doubt it was she who led Mai that first evening up to his room in the tall townhouse, where he could finally rest after so much intensive, and extensive, traveling.

When Mai awoke the next day he found himself alone for the first time in nearly a year. Perhaps the sun streamed in through a window onto his covers.

Both the glass pane and the kind of bed would have been unfamiliar items, though not entirely novel after their approximations on the *Adventure*. The solitude was surely rare. It may have given him the opportunity to review his actions and plans thus far. He had made this decision to journey to Britain in the early weeks of Cook's arrival in Huahine. These pale sailors, with their odd ways but impressive weaponry, promised the best means of assembling the mana required to regain his beloved Ra'iatea. He had resolved to go all the way to their homeland to see about recruiting arms and possibly more for the purpose. The journey had been longer than imagined. Colder, weirder, and more challenging. But he had made it. Time to get the next stage of his scheme under way.

After washing from the water jug provided by Mrs. Hawley and perhaps having eaten a breakfast brought by her to his room, Mai found Banks downstairs. He learned from his energetic host that he was to meet with King George III the very next day. That was quick! Far quicker than Mai's predecessor Ostenaco had had to wait to meet the head of the British empire. But then Mai had a much more illustrious escort than Ostenaco had enjoyed: the bumptious, obscure Timberlake was no match for the well-connected, charismatic Banks. As well, Mai had arrived via an official and much-anticipated vessel whereas Ostenaco had come on one of the legion of small sloops always returning from America. Still, the meeting illustrated the high degree of the British government's interest in the Pacific. Despite Hawkesworth's controversial publication the year before—or perhaps because of it—British leaders were determined to turn their explorations of Oceania to the best possible account. They needed to change the mixed story on empire that was now intensifying, especially with ongoing troubles in the Indian and Atlantic Ocean regions.

Mai was excited. He already knew that Britons ordered their society along a fairly rigid hierarchy and that George III was at the top of it. If anyone could procure him arms, it would be this king. Sadly, the accounts of Mai at St. James's Palace are more than usually unreliable. Banks's sister Sarah heard thirdhand that Mai was "much struck at first" by the sight of His Majesty. Both tall men, George III had half a generation on Mai. Sarah Banks reported that the young guest, when standing in the king's presence, blurted out how George III ruled over England, Tahiti, Ra'iatea, and Bora Bora. Even given Mai's instilled deference to elders, such a speech seems unlikely. The question of British aid, however, probably did emerge. "I am come here for Gunpowder," Sarah Banks had Mai saying. I need it "to destroy the Inhabitants of Bola Bola, who are our Enemies."[4] Whatever his actual words, translated to the king by a rusty Banks, it is intriguing to note how Mai's mission was

floated to the sovereign so early in his visit. The king did not reply conclu-
sively on this occasion, but he noted the request for later consideration.

Both a popular print of the time and a journalist for the *London Chronicle*
concurred that during the meeting Mai knelt before George III and offered
out his hand. The journalist added that Mai then forgot the protocol dictated
to him about how to greet a British king and repeated instead the phrase he
had heard his friends say so often, "*How do ye do?*" This last may easily have
been invented, though, since the same periodical took much delight a week
later in holding up the greeting as the most apt question for all European
monarchs, "after all the oppression and bloodshed [they] have been guilty of."[5]

This early newspaper commentary exemplified the edgier discussions Mai
generated in the British press. Like those on Ostenaco, they represented var-
ied political standpoints—some used Mai as a way to celebrate British impe-
rialism, some used him to voice their concerns about it. But in both instances
they were more pointed, more intense, than they had been in the 1760s. The
uncertainty around imperial destiny by the mid-1770s infected the responses
to Mai at every level.

For example, one popular pamphlet satire at the time pretended to record
Mai's views on London: "Where'er I turn, confusion meets my eyes / New
scenes of pomp, new luxuries surprise." Pretend-Mai goes on to observe
grimly that Britons

> in cool blood premeditately go
> To murder wretches whom they cannot know.
> Urg'd by no injury, prompted by no ill,
> In form they butcher, and by systems kill;
> Cross o'er the seas, to ravage distant realms,
> And ruin thousands worthier than themselves.[6]

Other squibs took other tacks. One sneered about the "wanton tribes" of
Oceania; another declaimed that for such people "every art was vain."[7] What-
ever the perspective on Britain's rights in the Pacific, each shared a notably
strident tone, heightened by the temper of the times.

Mai probably did not cotton on to this public discussion about him till
much later, if at all. Certainly in that first week he barely had time to catch
his breath, let alone discover his topicality in the press. After only a few fur-
ther days resting at Banks's house, he set off on a journey to the home of a
Dr. Dimsdale in Hertford, some thirty miles away. By carriage, this trip would
take around six hours. Mai traveled with Banks and Solander and also a

Thomas Andrews, who had been the surgeon on the *Adventure* with him and who acted haphazardly for the next year or so as Mai's main interpreter.

In Hertford Mai was to undergo inoculation for smallpox. Dimsdale was one of the best-known inoculators of the era, the author of the most up-to-date manual on how to extract matter from a pustule of an infected person and insert it under the skin of another so as to build up immunity against the disease. At the time, smallpox was one of the deadliest killers of children in Britain. Banks understood enough about immunity to see that in the context of contact with this widespread malady Mai's body was more like a child's than his own. He believed it imperative to have Mai inoculated to avoid risking the kinds of odds that children faced daily in his country. This was wise, even though Mai would have had some immunity already from his successive prior encounters with Europeans in his home islands as well as nearly a year of exposure to the *Adventure*'s crew.

How well Mai understood the procedure he was to endure is unclear. Banks wrote confidently to Sandwich that he comprehended the method thoroughly—how he was going to be deliberately infected with matter from a young girl who had "several large pustules on her face"; how he was then going to suffer a hopefully mild form of the disease, which would make him also break out into pustules and lay him low for weeks; and how the whole thing courted some chance that the dosage would go awry and he'd contract full-blown smallpox. Weeks later, however, after Mai had indeed suffered but then thankfully recovered, Mrs. Hawley thought that the patient had not been briefed well at all. He had believed his patrons were guaranteeing the complete barring of the disease, not some minor version of it. He had, he confided to the housekeeper, at one point reckoned he would die.[8]

The horrible exercise saw Mai confined to Hertford for nearly a month. Banks did not stay with him the whole time, but Andrews was always nearby. Meanwhile, Banks received the welcome news that, come the new year, the Admiralty would pay for Mai's lodgings, near but separate to Banks, as well as for the permanent chaperonage of Andrews. The Admiralty had also started discussing the necessity of one day returning Mai to the Pacific, hence confirming another major, state-paid South Seas expedition in the future.[9] The government's investment in securing Oceania as a kind of guarantor against decay in older parts of the empire was becoming ever more obvious.

Mai came back to London briefly around the end of August 1774. He was to stay only a few nights, though, before embarking with Banks on a two-month

tour of the British midlands. This was designed partly to further Banks's personal observation of his new specimen in new environments and partly to show him off to some of the most powerful and knowledgeable people in the land.[10]

The first stop was Sandwich's old, misshapen country house in Huntingdon, around one hundred miles north of London. The journey would take at least two full days of carriage-traveling, something Mai was getting used to as Banks's companion. Mai, Banks, and Solander stayed for several weeks, enjoying the entertainment laid on by the sporty first admiral. Sailing, foxhunting, concert going—one local reporter at least was confident that the Pacific visitor could not but form a "favourable idea" of British hospitality.[11] The outdoors life probably did suit Mai, and he was happy enough with his hosts to offer them a full umu feast one day in the grounds. A passing neighbor recorded the process. Mai dug a deep hole in the gardens and laid hot rocks at the base. After covering the oven up, he waited for its temperature to rise. He then wrapped a mutton in foliage, the nearest thing he could find to banana leaves, and laid it on the rocks. Covering the oven again, he then paced about the umu for hours, checking the heat at all times.[12] The resultant meal was a huge success. All the guests enjoyed it, comparing it to food fit for a palace. They pressed him to cook again, no longer out of simple curiosity, Banks reported, "but for the real desire of eating meat so dress'd."[13]

After Huntingdon, Solander went home, but Banks and Mai continued on to the town of Leicester, where they took in the taverns, horse racing, dancing, and musical nights on offer. A rendition of Handel's *Jephtha* oratorio performance was put on in Mai's honor. Performed by a full orchestra, choir, and soloists, the show perhaps reminded Mai of the dramatic Arioi set pieces back on Ra'iatea. He apparently stood up enraptured throughout the production, "a tall black man in a singular dress."[14]

The last stop was Cambridge, the beautiful university town that employed many of Banks's scientific correspondents. Mai met several of the doctors and professors. It turned out to be a mutual admiration society. Mai indicated respect toward the residents and their lovely quarters; the dons lapped up every detail of Mai's "naïve wit" and "wonderful propriety." One professor picked up, too, a detail about Mai's personal objective. The Islander was particularly interested in British firearms. His plan was to return to the Pacific well-armed in order to "shoot the King of Bola Bola, who murdered his father."[15]

After another spell at Sandwich's Huntingdon house, Mai was back in London by November. There, he embarked on activities similar to those he'd

enjoyed in the provinces: theaters, dinners, and so on. But now there were also some specific to the capital, such as the opening of Parliament in White-hall. A general election had just ushered in the fourteenth British parliament of the eighteenth century. Mai's new acquaintance King George III was there in person to oversee the proceedings. The chaos of Britain's American colonies occupied most of the royal address. "It gives me much concern," George III began, "[to note] a most daring spirit of resistance and disobedience to the law" in the Massachusetts colony. This dreadful spirit looked like it was spreading unchecked to others, too. The king implored his members of par-liament to serve as exemplars to "my people, in every part of my dominions," to have a "due reverence for the laws."[16]

American rebellion threw the already complicated politics of eighteenth-century Britain into further turmoil. All along it had been the king's critics, the Whigs in government, who most supported empire. The king had never been averse to it, but he drew succor mostly from the Toryish traditionalists who remained wary of British overextension. He had to steer a fine line, then, be-tween imperial maintenance and imperial growth. Now that those who most strenuously embodied the spirit of settler-colonial adventuring across the At-lantic were turning on both king and government, the lines of allegiance grew ever more complex. In essence what happened was the fracturing of both camps into even smaller and angrier factions. The Whigs were split by 1774 into a majority who were furious with the Americans' presumption and a minority who conceded reluctantly that the settlers' demands made sense according to their own libertarian, expansionist views. Traditional, Tory-inclined thinkers mostly preferred to side with their king when push came to shove—their rage about the settlers' hubris tended to outbid their original worries over the costs of overseas settlement. Only a tiny percentage of politicians supported the Americans out of a position of radical opposition to imperialism altogether (even if such a view burbled away unmeasured among the greater public).[17]

How much Mai ascertained of the main theme discussed in parliament that day is impossible to gauge. Few of his circle were politically committed enough to explain it to him with any coherence. Banks, rather like Reynolds, styled himself steadfastly apolitical.[18] Had Mai known that many British lead-ers then looked to his own home region as a potential site of imperial renewal, should they one day lose territories elsewhere, he may not have been too pleased. Alternatively, he may have just chuckled at the thought. These British were game, ferocious warriors to be sure, but they also lived a good ten months' hard sailing away. How could they ever hope to subdue scores of different

Pacific peoples, themselves bolstered with powerful varieties of mana, scattered over hundreds of diverse isles? They couldn't budge the hateful Bora Borans even from one isle.

The afternoon after his parliamentary visit, Mai found himself invited to share dinner with his old mate from the *Adventure*, James Burney. The meal was hosted in James's father's house, located less than a block south of Reynolds's Leicester Fields residence. Mai had probably seen James off and on over the weeks, but this was to be his first meeting with James's eagle-eyed sister Frances. Mai and Frances Burney were almost exactly the same age. Mai snapped to attention upon her entering the room and made elaborate gestures of concern once he learned she'd recently been unwell. They sat next to each other at the table, where Frances admired Mai's smart clothing and refined manners. She discovered he had enough English to speak basically, and James was on hand to translate more complicated phrases. What did he make of "the King and his Speech," inquired a guest? "He had the politeness to try to answer in English," recorded Frances, "and said, '*very well,* King George!'"[19]

Frances Burney construed their first meeting as a mild flirtation, but Mai perhaps thought of her more as a sister figure than anything else. His initial introduction to her was as James's sister, and later events showed a special fondness for his own sisters back in Tahiti. Domestic time with a warmhearted, partly familiarized peer evoked relaxing reassurance in a man now fifteen months absent from home.

Among other things, Frances Burney's record of the dinner showed how quick a study Mai was of convention. Banks had evidently instructed him at some point in how to take leave of a British host. First, bow extravagantly. Then, do the same to the host's spouse. Afterward, say a formal farewell to each guest. At the end of her report Burney thrilled to see Mai follow this protocol flawlessly. She thought it proof of the instinctive elegance of the Noble Savage. This child of enlightenment did not realize that it was instead an easy translation of Ra'iatea's own strict behavioral codes, appropriate to carefully ranked societies everywhere.

Joshua Reynolds was not present at the Burney dinner that winter. Always in steady contact with Charles Burney, though, he likely heard of it soon afterward. By this stage he would have known about Mai's arrival in London through a number of channels. He had kept up his connection with Banks since painting his portrait two years earlier. He knew all of Lord Sandwich's aristocratic friends as clients. But most of all he read the newspapers, which

these days featured a constant babble of gossip about the Pacific envoy. Mai's coverage in the press was approaching that of a celebrity. He popped up as a subject most weeks, usually in relation to some biting remark, one way or the other, about imperial culture.[20]

One source Reynolds no longer had to inform him about exotic visitors was Oliver Goldsmith. The probable link to Ostenaco back in 1762, Goldsmith had died just a few months earlier at the age of forty-five. The writer's death rattled the painter deeply; it was his first real experience of losing an intimate. Reynolds had plenty of time and cause to mull over his grief, since Goldsmith had appointed him executor of his miserly yet messy affairs. It would take him several months to sort through them.[21]

The year 1774 had proved rather friendless altogether for Reynolds. His closest companions, Johnson and Burke, were exceptionally busy in the aftermath of Goldsmith's death, each occupied in different ways with the general election. Johnson was employed by Hester Thrale's MP husband, Henry Thrale, to write his campaign materials for him. A Tory-inclined conservative like Johnson, Thrale stood for a hard line against the American rebels. When Johnson discovered that his friend was standing in the election against an American-born sheriff and a merchant for American tobacco, he threw additional energy into the task of Thrale's reelection. Among the many words Johnson penned that autumn was one particularly caustic pamphlet entitled *The Patriot*. In it Johnson drew a distinction between the false patriotism of American colonists, who were happy to break laws and provoke war in the service of so-called public interests, and the true patriotism of Britons, who saw that public interests required continuity and peace above all things.[22]

Burke, meanwhile, had been an MP himself for nearly a decade. He faced the awkward position through 1774 of no longer being able to bank on his seat in a reelection. After representing the borough around his country home in Beaconsfield all this time, he had to start looking for a new constituency. Burke's Whig colleagues found him one in Bristol, the thriving merchant town deeply reliant on American trade and impressed with Burke's renowned defense of the American colonies. It proved a fortunate transfer, but it did entail a huge amount of time that year currying favor with local Bristolians.[23]

Both Johnson and Burke got what they wanted in the election—seats for their opposing positions in the new parliament. Henry Thrale got back in as a Johnsonian supporter of the king against the American rebels. Edmund Burke got reelected as part of the minority Whigs who urged settler conciliation. But

the results hardly made things easier for their mutual friend Reynolds. As ever, he was caught between their conflicting politics. And for much of 1774 he had not even had the compensating pleasure of their vibrant company.

Whom did Reynolds see that winter? Where did he go? Unfortunately, his daily pocketbooks are missing for the years 1774 to 1776. This makes for an unexpected situation whereby we know more about the movements of a non-writing, non-English-speaking Ra'iatean in London during this time than we do about a famous, later-canonical British artist. We can only speculate about whether Reynolds was ever near enough to witness Mai's own adventures in the city that season. He was always certainly well within reach of the incidents we know about.

Perhaps Reynolds was present at the British Museum, less than a mile north of Leicester Fields, when Mai attended a reception for London's most respectable intellectuals? If so, he may also have heard Mai's reply then to a curious guest about how he found the English winter: "*cold, cold.*"[24]

Maybe Reynolds had been invited to the Admiralty's launch of a new naval ship in Woolwich, which, granted, was ten miles from his home but yet included many fashionable people of the town? At this event, Mai was bored and stole away from the crowd to a local tavern, where he was seen helping the chef cut cucumbers for salad.[25] If one attendant witnessed this diversion, then a keenly observant artist like Reynolds might have, too.

Reynolds would no doubt have enjoyed especially the sight of Mai riding down Oxford Street come the early spring. This time the Ra'iatean was with the notorious French spy and sometime ambassador the Chevalier D'Éon. A known associate of Reynolds, D'Éon mingled with a cosmopolitan London set who somehow considered his transvestite behavior only intriguing rather than scandalous. The chevalier had probably sought Mai out rather than the other way around. He himself would have delighted in the spectacle of the pair of them trotting down a shopping boulevard on horses fit for dressage. A large crowd assembled to stare at them and burst into laughter when Mai's horse stopped abruptly and could not be persuaded to move on. D'Éon started yelling at the horse in French, which only provoked the crowd further. Eventually Reynolds would have seen, if there, Mai switch horses in order to proceed onward to his destination.[26]

By the early spring Reynolds comes back into archival view. In April the Hone affair unfolded. Coincidentally, it was around this time that Mai, too, became the subject of some lascivious gossip. Until then, Mai's observers had noted that he enjoyed the company of women. He had danced with several

while visiting the town of Leicester. He had entertained more when calling on aristocrats with Banks.[27] But most celebrity-watchers also agreed that Mai did not seem committed to any one particular woman while in Britain. Banks's sister Sarah in fact specifically remarked that Mai "did not wish for a wife of this country." An anonymous writer concurred that Mai took no "extraordinary notice of the ladies" (which this writer, for one, understood since their outlandish outfits "disgusted . . . *every* admirer of simple nature").[28]

As the weather warmed again, however, so too did the imaginations of the social commentators. The *London Chronicle* reported that Mai had become engaged to a "young Lady of about 22 years of age, who will go with him to his own country."[29] Soon afterward a more scurrilous pamphlet reimagined Mai's meeting with the king. It had Mai spotting a "nymph" at the court, "just ripe for amorous sport," and inviting her to consummate their passions on the floor in front of the monarch—to the titters and shame of everyone else.[30] Then followed two more salacious publications. One was entitled *Omiah's Farewell; inscribed to the Ladies of London,* which focused on Mai's attraction to the "depravity of female inclinations." The other was *Omiah: An Ode,* which implicated Mai in a network of well-known prostitutes, including Lord Sandwich's own long-standing concubine Martha Ray.[31]

In many ways these squibs meant little in a famously bawdy culture. Just as Reynolds could easily survive the sexual innuendo of Hone's *Conjuror* painting (not so, perhaps, Kauffmann), Mai had little to fear from the insinuations of lowbrow street literature. But just as the jibe at Reynolds cloaked a more pointed attack on his professional persona, so the racier stories about Mai involved some veiled commentary, too. In Mai's case these focused on his true purpose in Britain. What was Mai doing here, exactly? Or, more to the point, what were his hosts doing for *him*? Was his entire experience of the imperial homeland to be merely rounds of frivolity with the beautiful set? Even darker, were rounds of frivolity with beautiful people the total upshot of imperial cultural achievement? Behind the inane gossip about Mai's sexual exploits lay more serious charges of decadence and political waste.

If explained like this to Mai, he may have partially agreed. Not that he appeared dissatisfied with his social life in Britain. But after nearly a year he was no closer to assembling his desired arms or men or any other sign of support for his cause. Almost everyone who got to know Mai for longer than one hour gathered what his mission was in the country. He was not shy in conveying it. Even Mrs. Hawley had the story down pat: "Omai says he wants to return with men & guns in a Ship," she once recited, "to drive the Bola Bola

Usurpers from his property."[32] Sooner or later the social rituals had to stop and the real business of Mai's journey had to start.

By the summer of 1775 the business end of American rebellion had certainly swung into action. King George's fourteenth parliament had noted its monarch's words and, overruling the minority of conciliatory MPs like Burke, maintained punishing sanctions against Massachusetts settlers for their defiant behavior. It did not work. Instead of capitulation, Massachusetts militia picked up arms against British soldiers. Violent skirmishes continued in the colony until a congress of all the American colonies sent one last overture for negotiation. George III did not even read it. The coordination of all the different outposts acting together was enough of a sign of treachery to him. He was soon to declare every one of them to be in seditious disobedience to his government. Rebellion had tipped over into revolutionary war.

Unsurprisingly, the news put the leaders of Britain's armed forces on high alert. As head of the navy, Lord Sandwich saw it was timely to conduct a thorough inspection of all the major naval quarters in the country. He invited Mai, Banks, and Solander to join him on his tour. Aboard Sandwich's Admiralty yacht, the party set off from its London base and sailed to Chatham, Sheerness, Portsmouth, the Isle of Wight, and eventually to Reynolds's boyhood town of Plymouth.

Neither Banks nor Mai seemed visibly perturbed by the seriousness of the military background to their trip. Banks indicated in his journal that they enjoyed scampering off into the countryside at each layover, hunting, fishing, and picnicking.[33] One piece of news that did give them pause came to them via a letter to Sandwich, which he received while the party was at Plymouth. The letter was from Captain Cook, the first communication about the fate of the *Resolution* since it had lost contact with Furneaux's *Adventure* in New Zealand. Sent from the African Cape, it relayed that Cook and his crew would finally reach home in about one month's time.

Mai learned that after giving up on the *Adventure* Cook had carried on with his Pacific explorations. He had felt the *Resolution* to be in good enough condition to remain another year. Consequently, he had sailed north again, up to Rapa Nui, the Marquesas, and then back to Tahiti. Perhaps Mai warmed to hear how at his native Tōtaiete mā Cook's crew received exceptional hospitality. "These good people," Cook wrote of the inhabitants, "supplyed all our wants with a liberal and full hand, and I found it necessary to spend six weeks with them." Afterward, the *Resolution* pretty much repeated the *Adventure's*

journey home, down again to New Zealand, across the Antarctic Ocean, and over to Cape Town.[34]

The thing Mai most wanted to know was whether the Bora Boran passenger, Hitihiti, was still with them and coming soon to Britain. He recalled how he had been horrified to discover Cook's adoption of this enemy representative when the two ships had convened in Tonga. He assumed that Hitihiti had continued on with Cook, just as he, Mai, had continued on with Furneaux. This meant that he'd soon have to face Bora Boran malevolence here on foreign soil. At least Mai had the advantage of a year's extra experience of the foreigners' ways.

"Omai wishes [Hitihiti] would live in the same house with him," reported Solander to Banks, also assuming Hitihiti's imminent arrival.[35] The invitation suggested not only that Mai had been pondering the problem of Hitihiti for some time but also that he had decided on the shrewd strategy of keeping one's enemies close.

Cook failed to mention Hitihiti one way or the other in his letter. Another note in the same package, however, written by the curt German naturalist George Forster, included the cryptic snippet, "the Bola Bola savage incorrigible blockhead."[36] It would be another month before Mai heard the joyful news that Hitihiti had decided to get off the *Resolution* when it circled back to Ra'iatea more than a year earlier. He had never made it out of the Pacific region.[37]

The wait for Cook at Plymouth would take too long, so Sandwich's party carried on back to base. Before leaving, however, Banks and Mai managed to take in one successful excursion to Eddystone Lighthouse in Plymouth Sound. Banks enjoyed it immensely, scrambling onto its rocky base where Reynolds and Johnson had failed to make land thirteen years earlier.[38] We don't know what Mai made of it. Standing by the lighthouse's walls, perhaps he looked south, imagining Cook's familiar three-masted ship materializing on the horizon. Perhaps also he envisaged his own voyage home in a similar vessel in the near future.

As it happened, Mai and Banks had to wait almost two months to reconnect with Cook in person. Cook's *Resolution* made tidy time back into London, but meanwhile Banks had determined to extend their summer traveling and arranged a jaunt north to Yorkshire. For Mai, though this trip was an interruption to his overall campaign, it was at least an injection of fun. In Yorkshire the pair was joined by two friends of Banks as well as two of the friends' teenaged relations. One of these youths, George Colman, became particularly

attached to Mai. Years later Colman, now a playwright, recounted his won-drous summer surfing on Scarborough beach with his "tawny" mate. He re-membered Mai's shining body "like a specimen of pale moving mahogany," tattooed, broad, and breathtakingly strong. Colman couldn't swim, but he spent nearly an hour enjoying the waves aboard Mai's back. Though the tem-perature could have blasted the memory of Pacific waters completely clear of Mai's brain, the Islander evidently recalled with blissful precision his passion and ability for swimming. He appeared "as much at home upon the waves as a rope-dancer upon a cord," Colman thought. Mai offered constant reassur-ances to his nervous passenger: "*Tosh not fraid,*" he murmured, as he pulled his long black hair away from both their faces.[39]

It was a sustaining tonic for the Ra'iatean. After so long cooped up in stuffy houses and cramped carriages Mai felt rejuvenated by his immersion in the sea. It may have confirmed, too, his resolve to push forward plans for his return home to Oceania.

Back in London, Mai and Banks at length caught up with Cook, newly installed in naval apartments at Greenwich. No records of their meeting sur-vive, but doubtless they talked of both the past and the future. By now it was common knowledge that a determined Sandwich was preparing in earnest another Pacific expedition. Locals speculated whether Cook would be chosen its leader.[40] Mai speculated about what he might be able to bring on board with him.

This next voyage would not only repatriate Mai. It was also charged with making a British attempt on the long-mythologized "northwest" passage. For centuries Europeans had wondered about the existence of a sea route over the top of North America. Such a passage would transform trade with Asia, cut-ting out the laborious journey south around the African Cape and across the Indian Ocean and replacing it with a quicker, if chillier, voyage north over just one continent. Nothing speaks more eloquently of the British govern-ment's take on the current American crisis than its commitment at this point to maximize opportunities elsewhere. The Whigs in power may have dis-agreed about how best to handle rebellious colonists, but all remained dedi-cated to the idea of empire. If they were to lose their Atlantic base, they still had Indian holdings, and who knew what else beyond. Now was the time to invest in the new, even while they struggled to hold onto the old.

Critics of expansion also saw the link between new Pacific ventures and the incendiary problem of the American colonies. Those conservatives who bristled to see American colonists throw their weight around still harbored

reservations about the notion of greedy empire in principle. Johnson, for instance, grew querulous immediately these days at any sign of the "Pacific Craze" among his British contemporaries. He snapped more than once at Boswell to stop his raving about the next voyage, "Let me have no more on't."[41] Outside of the political elite, more radical types also disparaged the effort to forge further imperial ties while those already existing were causing so much havoc. Mai was often at the center of their commentary, one way or another.

"I am shockt," wrote one letter writer to the *Gentleman's Magazine,* "when I read that [Cook's] boasted discoveries cost the lives of many Indians." The proposal to perform additional "wanton acts of cruelty" seemed downright "painful," especially in combination with what the writer felt was the ongoing madness of "transporting a simple barbarian to a christian and civilized country, to debase him into a spectacle and a macaroni, and to invigorate the seeds of corrupted nature by a course of improved debauchery."[42]

"I blush for the honour of my countrymen," joined in another writer for the *London Magazine.* At Tahiti, he went on, "I am sorry to assure you we have established a disease which will ever prove fatal to these unhappy innocents." Britons, styled here "a refined race of monsters," had "contaminated all their bliss by an introduction of our vices." Only further destruction appeared on the way for Tahitians, with a new Pacific voyage slated to return "Omiah, the senseless stupid native of Otaheite."[43]

Revolution in America had not streamlined views on empire at home. Intermixed with rumors of a fresh campaign for the Pacific, it had, on the contrary, only splintered them further. The figure of Mai was often a lightning rod for ever-sharpening opinions.

Reynolds probably met Mai around the end of 1775, at another dinner at Burney's house. Frances Burney's diary erupts with joy on 14 December, when, "to our great surprise, who should enter late in the evening, but Omiah." Frances admitted she'd not seen the Islander for nearly a year, but throughout the rest of that winter he seemed to call on the Burneys frequently. One reason Mai had not visited earlier was the absence of James, who'd been off serving the British navy around Boston during the early stages of the revolution. James returned just before Christmas, though, presumably because he'd got wind of another Pacific voyage in the offing. A second reason for the lag in visits had been Mai's own packed schedule, mostly arranged by Banks. Now, however, Mai was living by himself, as Frances reported—meaning without

Banks because he did still share a house with Andrews the interpreter. Frances was impressed with the growth of Mai's independence and language skills since she'd last talked with him. He walks everywhere "quite alone," she breathed, and "has learnt a great deal of English." Once again she praised his wonderful company: "He is lively and intelligent, and seems so open and frank-hearted."[44] Frances noted, too, her father's particular delight in Mai's visit. Doubtless it was Charles who ensured that Mai felt welcome to call again, and likely it was he also who caused Reynolds to drop by when next he came around.

Their first meeting has to be imagined. Did Reynolds identify Mai immediately as another Indigenous exemplar of the New World, following in the footsteps of Ostenaco? If so, did his eyes sparkle alight at the thought of being able to address the failure of *Scyacust Ukah*? Or did the association between Mai and Ostenaco come later, slowly, after some discussion with the young traveler and once he saw that his fellow Britons viewed the Islander as both perfectly exotic *and* an entrée into future imperial connections?

However it came about, Mai agreed to let Reynolds paint his portrait that winter. Unlike Ostenaco, Mai had grown up familiar with at least a partial tradition of portraiture. Some eastern Pacific tattoo designs and rock engravings included facial representations. But, as the scholar Nicholas Thomas has pointed out, these depictions usually evoked deities or expressed the extreme mana of eminent leaders. They were about "presence and power."[45] There was no tradition of depicting ordinary people, and especially not for the sake of investigating or questioning a society's political situation. Nonetheless, Mai had by now learned, as Ostenaco had before him, that his European hosts loved their phiz paintings. They hung them up everywhere; likenesses of their leaders and cultural mentors but also of their wives, children, and even servants. Above all, they loved portraits of themselves. Mai understood that sitting for a portraitist was a respectable, if fairly widespread, thing to do. It could result in a lasting testament to the respect others felt for you or that which you felt for yourself. Perhaps he could take the finished picture back with him to Ra'iatea—at least a copy, to show everyone and to boost his mood when needed.

Mai's dress in Reynolds's depiction has exercised many scholars (see fig. 25). Those steeped in Reynolds's neoclassical pronouncements believe the artist clothed the sitter in something approximating an ancient Roman toga. Finally, he'd found someone who'd allow at least a classical-seeming garment, if not full nudity! Pacific historians, though, say that the flowing white robe

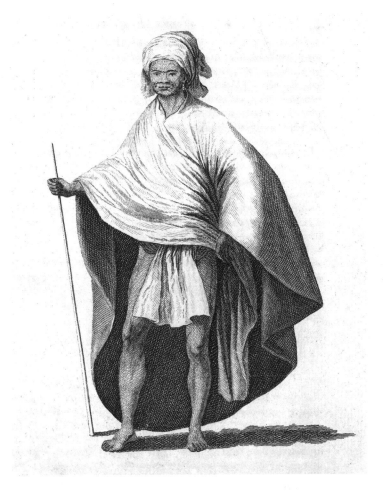

Figure 26. "A Native of Otaheite in the Dress of his Country," from an engraving after Sydney Parkinson, in his *A journal of a voyage to the South Seas, in His Majesty's ship, the Endeavour* (London: Stanfield Parkinson, 1773), plate III, between 14 and 15. Retrieved from TROVE via the National Library of Australia.

was fashioned from Tahitian *tapa,* or bark cloth. A draughtsman from Cook's first expedition showed something very similar on "a Native of Otaheite." As well, there is the turban-like headdress, which hardly fits the classical theme but which finds echoes in several pictures of Islanders by other European voyage artists.[46]

Mai, then, was probably the one who decided on what he'd wear. Assuredly, though, Reynolds made his sitter's choices advance his own aims, too.

This portrait was important to the artist. It was a second attempt at portraying a "New World" Indigenous visitor. Through it, he might be able to capture something of his ideas about human sameness as well as something fresh but acceptable about Britain's ever-trickier imperial status. These issues had tripped him up in his Ostenaco portrait thirteen years earlier. Here was a chance for redemption. Reynolds could not accept any interference that might undermine the overall intended effect.

Reynolds's special attention to this portrayal is best evinced in the two sketches he made for it. Unlike other artists, Reynolds rarely worked up preliminary versions of his pictures, and especially not in pencil. But for Mai's portrait he completed at least one pencil sketch and one oil sketch. The progression through the surviving images suggests much about his ultimate objective. Reynolds's pencil sketch (see fig. 27) compares reasonably with that made by the draughtsman on Cook's second expedition, William Hodges (see fig. 19). Designed to satisfy naturalists like Banks more than artists like Reynolds, Hodges's sketch showed a young man with a broad face, wide nose, wavy hair, and large dark eyes. So, too, Reynolds's pencil rendition has the same full face and nose, similar eyes, and hair only slightly more relaxed.

Reynolds's oil sketch, however, reveals some important adjustments (see fig. 28). The cheekbones are pulled higher, and the nose is sharper. At the same time, the hair is made less distinct while the eyes are elongated. What is going on here? Mai seems to be becoming both more European and more Oriental.

The answer is found by moving to the final, eight-foot painting. The finished piece amplified every adjustment of the oil sketch: the cheekbones go up even further, the nose narrows once again. The hair vanishes completely into an ambiguous turban—possibly Oceanic, possibly Middle Eastern—and the eyes are now perfect almonds. It is as if Reynolds wanted to evoke not only the European and the Oriental but also the Arabic and the Pacific. What's more, the full-length portrayal showed the same darkly lustrous skin tone he used in his pictures of Africans. And to a British audience of the 1770s the tattooed hands and mountainous background summoned the wilds of Native America most of all.[47] Mai emerges as an everyman from everywhere.

On top of this jumble, the obvious references to the ancient Roman world, evident in the pose and the drapery (whatever else they also meant), suggest multiple periods as well as multiple cultures. Mai is thus an everyman from *everywhen* as well as everywhere. Reynolds was piling on as many typical associations as he could think of. When compared to *Scyacust Ukah,* with its problematic flirtation with realism, the Mai portrait looks like an exceptional

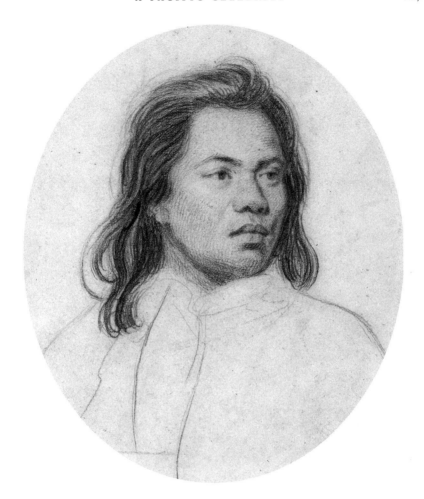

Figure 27. Joshua Reynolds, pencil sketch of Mai, 1775. Reproduced with
permission from the National Library of Australia, nla.pic-an5600097.

exercise in correction. It concludes not as a stereotype of a New World Savage
but as a conglomeration of a wide range of stereotypes. The effect is so un-
usual that it avoids, mostly, all sense of cliché or parody.

Was it a success? It is hard to say definitively. For sure, Reynolds thought it
more successful than his depiction of Ostenaco. He selected it to be one of the
thirteen works he sent into the annual Royal Academy exhibition the follow-
ing spring. He also hung it up for client viewing in his studio until his death.

But some questions lingered. On the issue of human sameness the portrait
is not transparent. In an effort to get around the problem created in *Scyacust*

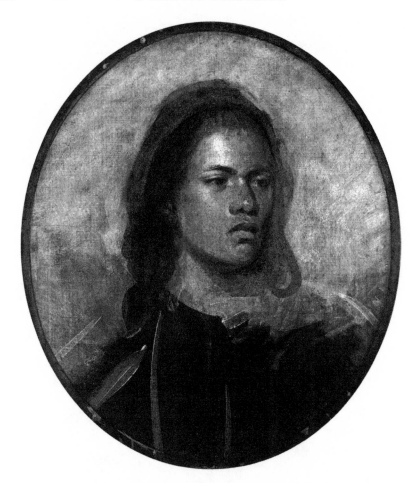

Figure 28. Joshua Reynolds, oil sketch of Mai, 1775. Reproduced with permission
from the Yale University Art Gallery. Gift of the Associates in Fine Arts.

Ukah by Ostenaco's unnerving stare, Reynolds ensures Mai's gaze assumes the
same look as those of all his other nonwhite subjects: out and away from the
viewer. The effect seems to compound rather than clarify the sense of confu-
sion. Does Mai's self-effacement tip the sense of a conglomeration of types
over into, in fact, chaos?[48]

On the issue of Britain's imperial status, Reynolds perhaps did better. He
didn't simply rectify the whiff of Johnsonian skepticism in the Ostenaco por-
trait with a bit more Burkean defense. Instead, the Mai portrait, with its ex-
cess of idealization, distracts the viewer from thinking about the conflicting

details of imperial support one way or the other. But is distraction in the end an evasion rather than a solution to any problem?

Overall, the Mai portrait worked well, though few at the time measured it a masterpiece. Despite its noisy celebration in the twenty-first century, no one in the eighteenth century beheld the work as a Reynolds exemplar. The painting attracted little comment in the 1776 Royal Academy exhibition. Horace Walpole pronounced it very good, but no similar sentiments survive. When Reynolds died, no eulogist singled it out. When it was finally sold in Reynolds's estate sale, it fetched 100 guineas, which was certainly respectable but not comparable to the 250-guinea-plus prices that some of his other paintings attracted in the same auction.[49] That Reynolds kept it in his studio instead of selling it on may well be a sign, too, of mixed appraisal rather than outright satisfaction. Reynolds rarely let private feelings get in the way of building his fortune.

Representatives from other worlds, especially the so-called New World, tested Reynolds far further than he expected. Whereas most subjects conformed in the end to pleasing displays of his neoclassical principles and mercurial politics, these sitters resisted any final pinning down. Men like Ostenaco and Mai simply did not work as models of how all humans were the same *and* also of how Britons could have power over some of them. Reynolds's two efforts at portraying New World people produced images that were either too sharp or too messy. He never attempted the task again.

By the new year Mai knew he'd be going home soon on another two-ship expedition and that it would be captained by James Cook. He was sorry that Tobias Furneaux would not be rejoining them—Furneaux had been away pretty much the whole time fighting American rebels in the Atlantic. But Mai knew and respected Cook well enough. The Islander had heard that Sandwich was consulting with Banks on what the king should send along to the Pacific for him. He felt he'd done all he could to make his case for the gift to be guns.

Until the weather improved, however, no one would be going anywhere. Mai kept himself busy through the rest of the cold season with various activities. His favorite pastime was skating, which he taught himself to do on the many waterways now frozen around London. Walpole learned through someone that Mai named the expansive ice "stone water," a fitting complement to his description of snow as "white rain."[50]

Less enthusiastically Mai agreed to some English and religious lessons with the worthy philanthropist Granville Sharp. To be fair, Sharp himself was

somewhat reluctant to undertake the task, doubting both his own and the student's abilities. But his milieu of evangelical, abolitionist, and reformist peers had also heard that Mai was departing soon and realized, late in the day, that their chance to spread the gospel to heathens would disappear with him. So they pressured Sharp into accepting the job. He in turn pitched the idea to Banks. Mai's old patron was a man firmly of the earlier eighteenth century, which preferred to scrutinize than to convert, but for some reason Banks helped make the introduction. Perhaps Mai consented to Sharp's lessons from a desire to learn more deeply the ways of his hosts. Perhaps he was just running out of things to do.

The classes proved an indifferent experience. Sharp's notes indicated some productive moments and some clear failures. "Omai came for three hours," one entry read; "called on Omai for about two hours." At other times, though, he wrote, "Omai called, but had no time for lessons . . . Omai for a very short time . . . Omai was so taken up with engagements that I could have no more opportunity of giving him lessons."[51] Mai's English was credible by the time he left Britain, but he never showed much interest in Christianity. Still, the lessons through February and March chipped away at the time.

A final activity as the days turned more spring-like was to sit for some other artists. Mai was by now something of an expert model. He sat for the obscure Welsh painter William Parry in a group picture with Banks and Solander. A former student of Reynolds, Parry was seeking election that year into the Royal Academy. Whether he undertook the painting of the trio as a favor to the president or as some form of flattering imitation is unclear. Either way, the result didn't cut the mustard. Parry chose not to include it among the five works he sent into the Royal Academy show in April.

Mai also sat for Reynolds's old personal bête noire, Nathaniel Dance. Two different drawings in fact survive from their meetings. Unlike Parry and Reynolds, though, Dance never worked these up into a formal oil painting. It seems Reynolds was not the only artist to find the distillation of what Pacific visitors meant to Britons to be a challenge.

The Royal Academy exhibition for 1776 opened in the first week of May. Reynolds, Parry, and Dance all attended. Did their Islander sitter see it, too? There is no evidence. There are, however, good reasons to think Mai might have gone along. Not only was his own portrait displayed prominently, but any number of the fashionista he'd met during his stay could have taken him with them—the Burneys, Walpole, D'Éon, several Royal Academicians, and of course the king himself.[52]

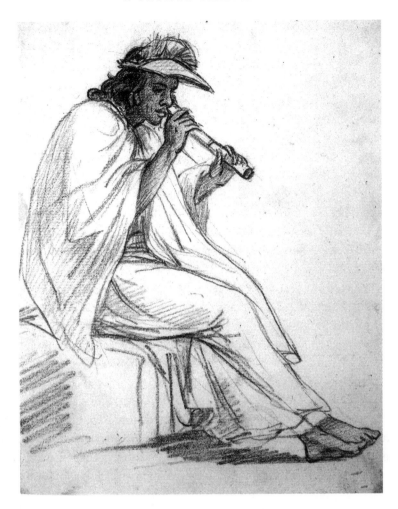

Figure 29. Nathaniel Dance, drawing from an album of Mai playing a nose flute, black and red chalk, c. 1775. Reproduced by permission of the British Museum; never before published. Thanks to Harriet Guest for alerting me to it.

If no one reported Mai's actual reactions to this exhibition, one anonymous hack did take the time to imagine what the Pacific voyager would make of a grand-scale Reynolds painting. The popular pamphlet *Historic Epistle from Omiah* included a verse in which Mai comes upon Reynolds's *Ugolino* (exhibited three years earlier). This picture was a dramatic representation of a famous medieval Italian starving to death with his children in a dungeon. Ugolino's story had been made familiar to literary London through translations of

Dante's *Divine Comedy.* Mai is said to reel from the power of Reynolds's ver-
sion, feeling that the artist had captured in it the very essence of human misery.
Mai is "with wonder struck," seeing how Reynolds's brush has nimbly
"caught / [both] the feature and the thought."[53]

Would Mai have been struck by Reynolds's portrayal of him? No doubt he
would have seen right away that it was not "like" him. But, then, he would
have recognized that Reynolds's work was never about faithful replication.
Hanging beside his own portrait was Reynolds's exquisite rendition of the
Duchess of Devonshire, looking fresh-faced and well-coiffed. Mai had met
the duchess only a few weeks earlier in a state of some disarray and had even
remarked on her disheveled appearance.[54] He saw that Reynolds tidied up
whatever reality presented. What had Reynolds tidied up about him? All those
things that made him different from the white-skinned people around him,
apparently. All things that made him different, also, to the few black-skinned
souls he'd seen on the streets outside. And even his differences from the Māori,
the Tongans, and the Bora Borans. There was little about a Ra'iatean person
in the picture.

Mai may have discerned a big "thought" in it anyway. If this thought was
not exactly human universality or indeed a meditation on Britain's role in
delivering him to British shores, it may yet have involved the great, shared
human endeavor of migration that repeated through all ages and places. Here
he was arriving from Ra'iatea, setting out once more back home. What had
been "caught" was the voyager, like one of his own ancestors journeying out
from the center of the world to explore the Pacific Ocean. Indeed, this was
also like his British counterparts, Banks or Cook, journeying in from the edge
of the world, finding him, communing with him, and then sailing off again
into oblivion. The work was certainly interesting.

Reynolds was probably too busy at the exhibition to watch any of his sit-
ters view his portraits of them. He had so much to take in that year. Alongside
his own 13 pictures hung over 350 other works, all crammed close together,
floor to ceiling. Hundreds of patrons were present. Dozens of students. Hand-
fuls of fellow painters. Some rivals and critics, to be sure. But also friends—
scores of them, mostly male, perhaps Johnson and Burke standing out as their
two great foci.

The exhibition room in 1776 presented as good a summation of Reyn-
olds's adult achievements as any. It had been a wonderful journey from phiz
monger's apprentice to president of a Royal Academy. He had made for him-
self an entire social world to replace an otherwise provincial destiny. He had

helped carve out a public space for art where there had been truly nothing before. And he had founded a national institution that enjoyed both patronage and independence. It was not quite the elevation of British culture to a state of ancient virtue. But it was a lot.

Soon after the Royal Academy exhibition the Admiralty wrapped up its final preparations for Cook's third voyage to the Pacific. Like the second voyage, this would include two ships. The *Resolution* was set to sail again; this time it was the vessel to carry Mai, now as a special guest with roomier quarters rather than as an able seaman. The other ship was called the *Discovery,* to be captained by Charles Clerke, a veteran Pacific voyager who had sailed with Wallis and both prior Cook expeditions.

With imperial goals never far from his mind, Sandwich loaded both ships to the brim with livestock. Alongside the usual hogs and goats would travel sheep, rabbits, turkeys, geese, ducks, peacocks, two cows, and a bull. Some officers later thought these animals were sent to diversify the diet in New Zealand to stop the Māori from eating each other.[55] Cook, however, had never been interested in fanning cannibalism speculations. They were more likely sent as potential bartering items. Sandwich also sent along swords, crystal, ladies' gowns, chess sets, earrings, perfume, fans, watches, and pictures of the king and queen.[56] These were the kinds of things the British valued most, so they reckoned that others might prize them above all else, too.

Certainly Sandwich intended Cook to be in the best possible position to consolidate British imperial goals however that might arise. His instructions to the captain were notably open ended. After resettling Mai, Cook was to have a solid crack at finding a "Water Passage" starting anywhere along the northwest coast of America, braving the Arctic if necessary. If a passage was found, he was to record precisely what size of vessel would get through it. If nothing, he might consider fresh ways around the old chestnut of the Asian landmass. Some new angle for Britain's overseas interests must be discovered. The once-assured Atlantic-based standbys were becoming less reliable by the week.

Sandwich's instructions do not mention breadfruit—a Tahitian staple food noted by earlier British explorers—but it's rumored that Cook was told also to undertake further study into this plant.[57] Again, this was primarily for imperial purposes. Banks and others had been lobbying Sandwich for years to consider the mass transfer of Pacific breadfruit to British colonies in the Caribbean as a cheap form of feeding their slave labor force. If Britain was to

lose its North American settler colonies, it was even more imperative to bolster their plantation holdings elsewhere. Cook's third voyage was set not only to change Britain's global reach but also to entrench that which survived.

If privy to Sandwich's final orders, Mai might have been pleased to read the particular words regarding him. "Upon your arrival at Otaheite, or the Society Isles, you are to land Omiah at such of them as he may chuse."[58] He'd be able to get Cook to sail right up to the sacred marae of Taputapuātea on Ra'iatea. Two huge, triple-masted vessels, preferably with guns blazing, would set just the right tone for his return.

Mai knew that Banks was in charge of gathering all his official gifts from George III. He still wasn't sure what they included, but he had seen several large crates loaded onto the *Resolution* for him. He was quietly confident.

As the day approached to leave London Mai's emotions veered between extremes. One diarist recorded that sometimes he appeared eager at the prospect of departure (which managed to insult this writer). At other times, though, Mai looked sad at the thought of a permanent goodbye. Cook himself saw that Mai was "low spirited" when speaking of leaving his friends in Britain. "But turn the conversation to his Native Country and his eyes would sparkle with joy."[59]

Like Cook, Mai had a formal farewell with the king in mid-June. Two weeks later both men sailed on the *Resolution* to Plymouth. At Reynolds's former town the ship took in last-minute supplies while docked in the port's ever-expanding naval precinct. Two weeks after that and nearly two years to the day since Mai had arrived he left British shores forever. The third act of his grand plan was beginning.

CHAPTER VIII

Return of the Traveler

MAI'S LAST VOYAGE

M ai had forgotten how much he enjoyed open-water sailing. His
jaunt from London to Plymouth on Sandwich's yacht had not
quite captured the sensation of becoming one with the waves. As
the *Resolution* headed southwest into the Atlantic he remembered how to
keep his legs strong and yet bendy at the same time; to predict and roll with
the pitch rather than against it.

The extra load of livestock on this voyage, however, was something new.
Coping with the waste, noise, and feed of nearly fifty animals made for a chal-
lenging atmosphere. The livestock could not help but intrude on the personal
living space of the 114 sailors on board, all contained within a 110-foot vessel.
Still, Mai believed that many of these animals were destined for his own use
once back home. He could put up with a bit of mess till then.

The livestock situation forced Cook to include more stopovers than usual.
His first was at Tenerife, off the west coast of Spain. He docked there for two
weeks in August, gathering enough feed for the long journey south. It made
for an easy and uneventful passage to Cape Town.[1]

At this famous international victualing port the *Resolution* and the *Discov-
ery* stayed for nearly six weeks. Mai recalled it from his voyage to Britain with
Furneaux. This time the extraordinary mix of people and styles did not seem
so stark. At Cape Town Cook added further to his animal haul by purchasing
four horses. He told Mai they were intended for him, which made the
Raʻiatean "compleatly happy." The idea of possessing beasts that stood for
speed, prestige, and even a possible cavalry inspired Mai to offer his own
cabin for their accommodation.[2]

Little other evidence attests to Mai's time at the Cape, other than the story
of one piece of evidence now vanished. Apparently at some point Mai visited
a house owned by the acting governor of the Cape, Gysbert Hemmy. He and
Captain Clerke of the *Discovery* together scratched their names onto a win-
dowpane. Cape dignitaries cherished this memento of their rare, globetrotting
visitor for decades, installing the glass in a local museum (before it disappeared
sometime in the twentieth century). If the African Cape did not register par-
ticularly with Mai, he certainly registered with many of its residents.[3]

Cook and Clerke steered their two vessels out of Cape Town harbor in late
November 1776. There followed two months of fairly plain, if cold, sailing.
The ships' crossing of the Indian Ocean did not dip as far south as Furneaux's

Figure 30. Map of Mai's Return Voyage, 1776–77. © Mark Gunning.

Adventure had back in 1774. But it was a chilly ordeal all the same. Mai knew he just had to keep his head down and endure. At the end of this leg they'd reenter familiar waters.

The plan had been to push on until New Zealand. But again the additional livestock needs compelled Cook to adapt. The two ships broke their long sail instead at the point where the oceans changed. This was Van Diemen's Land, the island just south of the east-Australian landmass. Cook had never visited Van Diemen's Land but knew of its existence through testimonies left by the Dutch navigator Abel Tasman more than a century before and by Tobias Furneaux, who had landed there briefly in early 1773 before encountering Mai.[4]

The expedition stayed only two days. On the first day Cook and Mai met with some local Palawa men. Cook indicated to one of them that he wanted to learn what their tools could do to a target. The Palawa obliged, seemingly, with a throwing club but missed the mark. Mai then demonstrated how a European musket could hit the same target more accurately. Mai's shot made the Palawa flee in terror. Some historians have read this incident as an example of Mai's contempt for Indigenous Australians.[5] It seems likelier, though, that Cook had asked Mai to perform the demonstration. It was the captain who wanted "to shew them how much superior our weapons were to theirs."[6] Mai probably had no investment one way or the other in showing the Palawa people anything. They were not the enemy colonizing Ra'iatea.

On the last day of January 1777 the vessels set off from Van Diemen's Land for New Zealand, or Aotearoa as Mai knew it. It was a stormy crossing, and Clerke's *Discovery* lost one crew member overboard. This death and the generally foreboding weather were a fitting prelude to the British return to Totara-nui. Everyone on board had heard the story of Furneaux's horrifying loss of ten men to the Māori at what they called Grass Cove. Most of the sailors were gripped with fascinated dread at the prospect of reuniting with presumed cannibals.

Mai especially remembered the gruesome episode. He'd been among the small party to discover the roasted remains of the ten men. He knew at the time it had been the result of some major failure in communication, almost certainly caused by his blundering British friends, whom he'd seen misread signs often enough throughout the Pacific. All the same Mai remained shaken by the memory of such violence. He did not look forward to the Aotearoa stopover.

As the *Resolution* approached Totara-nui scores of Māori gathered about in their canoes. Cook sensed that they, too, were remembering the Grass Cove incident. He thought they looked "apprehensive we were come to revenge." Mai removed all doubt on the question when it arose as the first topic in his conversation with them. Cook tried to indicate to the Māori, via Mai, that revenge was, nonetheless, not his aim "and that I should not disturb them on that account."[7]

Mai's ability to communicate with the locals at Aotearoa had not been apparent before. But throughout the two-week visit the Ra'iatean and the Māori managed to talk extensively through a *lingua franca*. Perhaps during his first trip to the country Mai had simply not thought to discover this medium. Now he knew the price of miscommunication.[8]

Mai gleaned from the Māori that the ill-fated Grass Cove party from 1773 had probably met with two separate but simultaneous attacks led by a powerful local man called Kahura.[9] He also saw that one of the most frequent visitors to the *Resolution* now was Kahura himself. Exceptionally large and muscly, Kahura swaggered confidently among the British once he realized that Cook was not seeking punishment. Mai understood Cook's rationale for wanting to avoid a cycle of retribution, but something about Kahura's demeanor irked him. His dislike of the man deepened when, day after day, other Māori came up to him to request that the British indeed enact some vengeance—so long as it focused solely on Kahura. The leader was detested in his community.[10]

As the expedition's departure date drew near and as more and more Māori put their case to him, Mai lost patience with Cook's guise of neutrality. He hauled Kahura onto the *Resolution* and said plainly to the captain, "There is Kahourah kill him." When Cook demurred again, Mai called out his strange logic. "Why won't you kill him? You tell me that if a man kills another in England he is hanged for it. This man has killed ten and yet you will not kill him, *tho a great many of his countrymen desire it.*" Cook had to admit that Mai's grasp of British law was reasonable.[11] Mai was probably more motivated by a respect for Islander majority justice. Either way, Cook refused to engage. Mai had to let it go.

The last few days in Aotearoa were taken up with negotiations of a different kind. Mai presented Cook with the enlistment of two local youths to the expedition; they were to serve as his personal attendants. The youths were called Te Weherua, aged around seventeen, and Koa, aged only about nine. Cook was not surprised by Mai's announcement: the Ra'iatean had spoken of his intention to recruit some Māori long before reaching Aotearoa.[12] It was

thus probably Mai who had broached the idea to the locals—or at least to Te Weherua—rather than the other way round. Still, the teenager seemed just as eager for the plan as Mai. Maritime exploration was, after all, deeply embedded in his culture. As well, he might have been excited to see the legendary land of Taputapuātea, the well-known birthplace of his island world. Or perhaps Te Weherua had a personal reason to undertake the voyage, just like Mai so many years ago. Koa's recruitment seemed to be more Te Weherua's doing than Mai's. The boy was already bound to the older youth in some way. Joining the expedition would be simply a continuation of his role.

Cook was worried that the youths' family and friends did not understand the absolute nature of their departure. He tried repeatedly to convey to them the impossibility of the youths ever returning—he had no plans to voyage back here. But none seemed overly perturbed. Maybe they supported the youths' ambitions. Maybe they believed that the youths, like their ancestors, might one day find their own way home.[13]

Cook turned out to know Te Weherua quite well. He had met him on both his earlier layovers in Aotearoa and declared him an "exceedingly well disposed young man with strong natural parts."[14] The crew also liked the teen. He "behav'd in a manner that gain'd him the love and esteem of every one," reported one officer. "A good natured honest young fellow," said another. Little Koa won admirers, too. "A witty smart boy," reflected Cook some time later. "Always full of mirth and good humour and for his mimicry and other sportive tricks, was the delight of the whole ships company."[15] Certainly Mai never seemed to have cross words with either of his Islander attendants.

Despite their firm resolve to join the expedition, the two Māori were not unmoved to leave Totara-nui. The amateur linguist on board, the surgeon David Samwell, recorded the dirge they sang together as the *Resolution* pulled out of harbor for the last time:

Nau mai ra a hika haramai ra koe, tiu ki Tahiti.
Kei hear a koe? Tu ki Heiao, ki Heretu, he kawau
E ngeri rai a ki'hiwahiwa atu koe. Kei te taha au
O te umu. Aue!

[Welcome, O Sir, come hither, soar to Tahiti.
Where are you? Standing at Heiao, at Heretu, is a
Cormorant who is chanting to you to be wary.
I am at the edge of the umu. Alas!][16]

They knew they were bound for Mai's famous island group. They knew the voyage ahead might be dangerous. They were perched on the edge of the abyss, but they launched themselves into it anyway.

Now the Islanders were three, reminiscent—if it occurred to any of the Britons on board—of the three Cherokees who had set out on a similarly audacious journey half a generation earlier. The ships' first stop was the island group known today as the southern Cook Islands. At Atiu, a middle island, Mai chanced upon a discovery he never expected to make. Four of his own countrymen were living on the island, more than seven hundred miles from Ra'iatea. The men engaged in animated conversation for some time. Mai learned that the Ra'iateans had set off in a party of around twenty from Tahiti about a dozen years before. Like Mai, they had evidently been refugees sheltering in Tahiti from Bora Boran aggression. They had intended to voyage to Ra'iatea but their vessel had blown off course. Many had died from thirst, but five had managed to float to Atiu by hanging onto their now-capsized boat. Four yet remained, content enough with their new home to refuse the offer Mai made then of transporting them back to Tahiti.[17]

For the British, the existence of the Ra'iatean voyagers helped consolidate their emerging ideas about Pacific migration. Cook thought it a classic instance of how the Pacific Islands had been peopled—by a mixture of nautical design and freak accident. For the Māori, it may have provided reassurance that traversing the Pacific was not as inconceivable for local folks as their new hosts were making out. For Mai, the Ra'iateans probably just brought the taste of home closer. He had not too much longer to wait.

On a tiny atoll off what the British called Palmerston Island the ships found an uninhabited oasis of good feed for the livestock. They stopped for a few days. There, the sailors were reminded of how good a hunter, fisherman, and chef Mai was. The three traveling Islanders together prepared a load of fish, fowls, and vegetables in a customary umu (or what the Māori would have called a *hāngi*). Even the plain-speaking Cook admitted that here they "fared sumptuously." Mai's old friend James Burney—who associated with Mai rarely since he was on the other ship—chipped in that "we had the good luck . . . to have Omiah on shore, who was a most usefull companion for a party of this kind. [He was] a keen sportsman, an excellent cook and never idle."[18]

By May 1777 the *Resolution* and *Discovery* arrived in the tropical Tongan Island group. This was not exactly on the way to Tahiti, but Cook knew he'd find friendly, generous help there. He would need it to fit out his ships for the

anticipated long stretches through the northern Pacific. At a central isle, No-
muka, they settled in for a couple of weeks. The Māori realized that they
could understand Tongans. And Mai remembered that Tongan culture had
more similar features to Ra'iatean than anywhere else he'd visited in the
Pacific—the dances, the gestures, the words, even the ways men and women
related to each other, all resembled what he'd known as a child.

At the Tongan Islands Mai continued to help Cook communicate with
the locals. Just as he had in Aotearoa and the Cook Islands Mai translated,
enquired, explained, defused, and generally helped produce a peaceful atmo-
sphere. How well Cook understood his debt to Mai is unclear. Some other
officers, though, were beginning to notice. "Omai is of great use to us," re-
corded Lt. James King, "not only as interpreter, but in keeping up a good
understanding between us & the Natives, for they pay him great attention &
listen to the stories he tells them about Britannee." King thought this work
crucial in balancing out the more negative views that Islanders formed of the
British when they discovered the terrible legacies of venereal disease.[19]

All the same, Mai's language skills were not perfect. One misunderstand-
ing caused him much embarrassment. At this central isle of Nomuka Mai
befriended a visiting chief called Finau, who told Mai he was the ruler of the
whole Tongan group. Mai and Finau became taio mates, exchanging names
and small gifts. Cook treated Finau with due respect, until a couple of weeks
later another Tongan turned up also claiming to be the "King of all the Isles."
It became evident that this later claimant, called Paulaho, attracted more
reverence from the Tongans. Cook was bemused, but Mai burned over the
incident.[20]

Mai was still smarting when Cook arranged to present a portion of the
expedition's livestock to several Tongan leaders. To Paulaho he gave two
cattle, to Finau he gave two horses, and to yet another man he gave three
sheep. Mai was further rattled. He thought most of those animals had been
earmarked for him.[21] It suddenly occurred to Mai that Cook might not
hand over all that he imagined he would when the time came to resettle on
Ra'iatea.

Mai's shaken mood spilled over one night when arguing with some able
seamen on shore. Mai took offense at something and hit one of the sailors. An
overseeing corporal in retaliation knocked Mai down. Mai exploded and
stomped off with the Māori youths, Te Weherua and Koa, declaring the
three would leave the British ships forever.[22] Cook sent words of placation—
with Mai's departure one of his prime missions, not to mention his grip on a

critical diplomatic asset, would be under threat.[23] Mai relented within a day and came back to the *Resolution*. But a vapor of mistrust had entered the ship's personal relations.

Just before the ship left the Tongan Islands the new tension between Mai and Cook reared once more. Some locals were accused of stealing from the British, and they approached Mai for intercession. Mai alerted both Paulaho and Finau, who promptly disappeared, leaving Cook with no formal mechanism for resolving the issue. "I was very displeased at this,' commented Cook, "and gave Omai a reprimand for meddling in it." It was Cook's first word against Mai that trip. The Ra'iatean had the last, though, since he brought Finau back eventually, but only after Cook had declared there would be no consequences for the thefts.

The expedition set off from Tonga for the Tahitian archipelago, Tōtaiete mā, on a squally mid-July evening. Mai's heart lifted at the prospect, despite the currents of doubt also snaking through his mind.

Mai understood that Cook was not going to sail straight to Ra'iatea. This would be the captain's third visit to Tōtaiete mā. If he was going to build up Britain's reputation in the area, Cook would need to re-greet several important dignitaries throughout the island group. It was not a shock therefore to find that the *Resolution* aimed first for the island of Tahiti itself.

Visiting the island that had been Mai's home for many years through his youth was certainly no hardship. A few relatives and friends still lived there, and the language, food, and manners would all, finally, be familiar. In fact, Mai could hardly contain his emotions when he first glimpsed the soaring green peaks of Vaitepiha Bay on the southeast of Tahiti. True, they looked a little similar to many he'd seen in Aotearoa. But these felt more like home. Mai's Māori companions were also deeply moved by the sight, whether from empathy with their friend or from Tahiti's similarities to their own island.[24]

One of the first local canoes to come up to the *Resolution* carried Mai's brother-in-law. Evidently Mai was not close with this man, but the sight of someone intimate stirred his feelings. He reached to embrace the relative "with great tenderness."[25] Observant Britons, though, saw that the warmth was not reciprocated. This was probably due to the man's obvious association with a Bora Boran chief who also traveled in the canoe. Both local men received Mai "rather coldly" thought a miffed Lieutenant King. The British were doubly nonplussed when the pair changed their tune once Mai presented them with some of the red feathers he'd collected in Tonga. Now that they had some

powerful emblems of their premier god 'Oro the two men were "most cor-
dial." The British were displeased to see such naked greed and cunning among
supposed noble savages.[26] Mai probably expected nothing less from a Bora
Boran and his consort.

Mai's reunion with his sister was more satisfying. It occurred the next day,
after the *Resolution* had anchored. The long-missed woman came on board,
where the siblings hugged and cried so joyfully that even old Cook's eyes
misted over. Once they went ashore the heartfelt celebrations continued. Mai
spied an elderly woman among the crowd of locals. She was already upon him
by the time he fully recognized her as his aunt. Mai had not shed so many
tears in all the time he'd been away.[27]

Gradually the embraces gave way to talking. Just as his relatives began to
hear about all the strange habits and sights of Britain, Mai started to gather
news about Tahiti. Most significantly, he heard that Purea, the leading Arioi
woman of the southern district of Papara, was dead. He learned that the main
Arioi of this southeastern district was now a young boy, recently installed,
called Vehiatua. And, least expected, he saw evidence of a visit by some other
Europeans.[28]

The most solid evidence of this visit was a European-styled house. Mai
gleaned that the visitors had been Spaniards from Peru and moreover that
they had come to Vaitepiha Bay not once but three times. The first visit had
been in late 1772. On this occasion they had taken four Tahitians with them
to Peru. Two Tahitians returned sometime in 1774, when the Spaniards built
the house and then deposited four of their own men. The third visit had
occurred about a year after that, when the Spaniards came to collect their
missionaries.[29]

Cook was not thrilled to hear about the Spanish voyagers from Mai. Al-
though none of the locals appeared to have converted to Catholicism—the
cult of 'Oro still reigned—the captain knew what had been intended. The
Spanish stops had been clear attempts to stake a claim to the Pacific region.
Agents for imperial expansion always recognize one another. When Cook
found a cross planted near the house with the inscription "Christus Vincit
Carolus III imperat 1774," he took grim delight in having its post inscribed
counterwise, "Georgius tertius Rex Annis 1767, 69, 73, 74 & 77."[30]

In an increasingly rare moment of empathy, Mai shared something of
Cook's chagrin. He was not pleased to have to encounter at Vaitepiha Bay one
of the returned Tahitian travelers. Although his objective in journeying to
Britain had always been primarily the restitution of his birthright, Mai turned

out to feel some pride, too, in being the first world traveler among his peers. He cut short his conversation with the returned Tahitian and made it clear he was not welcome around the *Resolution* in future.[31]

After two weeks' layover the expedition packed up and headed north toward Tahiti's Matavai Bay. Mai was happy to take on board with him his beloved sister as well as, perhaps less happily, the fickle brother-in-law. He intended to set up his home with them at Ra'iatea.[32]

Although Mai and his sister had spent many of their early years in Matavai Bay they seemed to have fewer connections there than down south. Most of their relatives presently resided on the island of Huahine. Oddly enough, Cook looked to have more connections than Mai. The captain was especially eager to meet up with the main leader of that district, Tu, with whom he had in his last voyage established a taio bond. Tu was expecting him; he'd heard of Cook's arrival on Tahiti much earlier. The expedition's first night at Matavai Bay, therefore, saw a gigantic feast laid out, one "sufficient to have served the companies of both ships for a week."[33]

Cook knew Pacific protocol well enough to realize that the feast demanded, in turn, plenty of gifts. He spent hours presenting wares in exchange for the lavish food. Mai expected Cook to bestow the various trinkets that the British always gave on these occasions and particularly some of the 'Oro-pleasing red feathers they'd picked up in Tonga. The red feathers were plainly the most prized offering in Tahiti. One headdress of them delighted Tu so much that he offered Cook ten hogs for it. But why, Mai wondered, did Cook also insist on handing over to the chief a full linen suit, several iron tools, thirteen fowls, many sheep, two horses, three cows, and the long-suffering bull?[34] Mai churned with anxiety. What exactly was going on? The livestock gifts to the Tongans had been bad enough. This haul pretty much cleaned the *Resolution* out.

Mai must have confronted Cook at this moment because it was here that he learned, in response, of Cook's quietly forming hope to resettle him at Matavai Bay in Tahiti rather than on Ra'iatea. Cook admitted that he wanted to unload the animals with Tu for he thought Mai's unique skills in managing them would ingratiate Mai with the leader of the area and thus preserve his safety. Cook understood Tahiti far better than he did Ra'iatea and so felt more confident in acquitting his task of resettling Mai here. Also, he was sick of traveling with so many wretched animals.[35]

Mai realized then that, despite Lord Sandwich's clear instructions otherwise, Cook was planning to place British judgments and needs over his own.

Whether this made the Ra'iatean panic or boil or slump inward, he kept it together before all observers. No officer recorded any calamitous confrontation between the pair. Instead, Mai heard Cook out on the finer details of his scheme: if Mai would consent to marry Tu's youngest sister as well as manage the chief's exotic animals his future would be assured. He also listened to Cook explain how it was more prudent to work at raising one's personal "consequence" than to indulge in liberation fantasies that could never come true.[36] Afterward, however, Mai firmly if politely set Cook right. He had devoted four years of his life to this mission. He would not now be diverted from his destiny by anyone or anything. Cook conceded defeat but noted only that Mai "rejected my advice."[37]

From that point on—though few on board registered it, and no historians have seen it—Mai existed apart from the expedition. He never again slept on the ships and rarely took food from the British. Instead, he communed mostly with his sister, her husband, and a few of their acquaintances. Some of the British officers did notice that these hangers-on took gross advantage of Mai, whenever they saw the relatives use or take Mai's "most valuable things."[38] But no observer stopped to wonder if the Islanders perhaps understood possession in a different way to them.

Mai knew that Cook's next stop was the small island of Mo'orea and after that Huahine, and he certainly planned to be present at both when the British ships arrived. He still expected to receive his due from the captain. But by the time the expedition departed Matavai Bay Mai had acquired for himself his own means of transport. He had obtained, by exchanging some of his so-called valuable things, "a very fine double sailing canoe, completely manned and fit for sea." Unfortunately, this meant he could not now take his relatives with him. All space had to be given to his crew of around five Tahitians as well as to the two Māori, Te Weherua and Koa. Mai asked Cook if the *Resolution* would carry his family members for him, but the captain took this opportunity to offer his own point-blank refusal. Mai decided he'd send for his relatives later.[39]

Before the expedition left Matavai Bay two events occurred that encapsulated the increasing strain evident among the party—at least from Mai's perspective. The first involved none other than Mai's old nemesis, the Bora Boran Arioi called Hitihiti. The man he'd worried had followed him to Britain in 1775, only to discover he'd remained all along in the Pacific, was back to blight his life once more. Mai knew that Cook had, during his last voyage, deposited

Hitihiti at Ra'iatea. Somehow the Bora Boran had made his own way over to Tahiti in the meantime. But Tahiti was as yet free of Bora Boran imperialism—there was no official role for Hitihiti to play here. It was almost as if he lived simply to menace Mai.

Though Cook had earlier declared a fondness for Hitihiti, he seemed neither surprised nor excited to reconnect with the man at Tahiti. He offered Hitihiti some clothing and tools in greeting but made no further mention of him in his journals.[40] Some other officers, however, were intrigued by the Bora Boran's curious reappearance. They learned he'd married a Tahitian woman, which is why he lived on the island. All agreed he was an unpleasant character. He was "one of the most stupid Fellows on the Island," thought David Samwell. He was clumsy, awkward, heavy, and "almost constantly drunk with Kava." Yes, a "foolish Youth," chimed in Lieutenant King.[41]

The officer William Bayly went further and offered a sinister anecdote involving Mai. Bayly thought Hitihiti had pimped his own wife to Mai in order to have her steal Mai's well-noted possessions for him in the dead of night, leaving him with a dose of VD to boot. It's hard to know what to make of this tale. Certainly many noticed that Mai had fewer things upon leaving Tahiti than when he'd arrived. And something turned those officers against Hitihiti. If the story was true, Mai may have felt the sting of being set up more than that of losing trinkets. Nothing good ever seemed to come from knowing Hitihiti, as far as Mai was concerned. The sooner he put ocean between him and that "raskel" the better.[42]

The second fraught event happened out in the harbor of Matavai Bay. Cook asked Tu for a demonstration of Tahitian maritime fighting technique. Tu accordingly arranged for two war canoes to perform an engagement. The chief made himself skipper of one of them and put Mai in charge of the other. Each had several paddlers digging furiously in the water to maneuver the craft about and a cast of warriors standing on deck and brandishing weapons to intimidate the other.

Cook traveled in Tu's canoe, from which he could clearly see Mai direct the multiple advances and retreats of his craft. He would have seen Mai calculate, deliberate, and then signal his final charge, aiming straight for his and Tu's canoe. The crafts clashed head to head, and the warriors of both pretended to fight. Mai won the advantage, and he and his associates boarded Tu's canoe to declare their victory. Instead of playing along, however, Tu and all his paddlers jumped overboard and swam to shore. Cook was left alone in the bested canoe with the defeated warriors.[43]

No British observer seemed to read this "mock fight" as anything other than an amusing or informative show. Cook himself went on only to mention that what he'd experienced turned out to be one among a number of ways the Tahitian conducted warfare. Mai, though, probably found the episode more freighted with unspoken feelings than others saw. His relationship with the older man was fraying, and the staged event had provided a chance to act out some new emotions. It also underscored the proficiency of his skills for Pacific-focused combat. Cook may be the master of British naval procedure, but Mai had all he needed to meet the challenges before him in his own region. That Cook gleaned any of this subtext is identifiable perhaps in a single comment he made after the event. When Mai performed a victory lap of the bay after the event, the captain sniffed "it did not draw . . . attention so much as might be expected."[44]

The *Resolution* and *Discovery* departed Tahiti at the end of September 1777. Mai, however, had set off one day before and in glamorous fashion. He'd fastened a collection of European flags and naval pendants to his double-hulled canoe, making sure they fluttered out like streamers behind him as he left Matavai Bay. British observers commented merely that it made for a diverting sight.[45] The resemblance of his vessel to that of an Arioi's, though, as it headed toward a fresh mission of conquest, was not accidental.

Mai's canoe and crew were well established at Mo'orea by the time Cook drew in. Mai continued to help out as an interpreter. The captain behaved as if this was business as usual, but Mai was assisting now from a subtly changed position. He was no longer as beholden to the British as he'd been through the more southern islands. He was choosing to provide aid in an even more strategic manner.

Mai's precise strategy became apparent in an unfortunate episode that unfolded one week into their stay at Mo'orea. Cook discovered two of his goats had been stolen and suspected the chief of the island to be the culprit. Through Mai, the captain asked for the goats back. When his request was rebuffed, Cook showed his displeasure—and some sign of his own tightening mood—by setting on fire "six to eight houses" as well as three local war canoes. Mai saw an opportunity. He kept relaying messages between the British captain and the Mo'orean chief but also realized that in the material destruction Cook was determined to wreak he might obtain some benefit. The goats remained lost. Cook ordered the burning of "six more war canoes." Mai begged to have two for himself instead of torching them. Cook allowed it.

Figure 31. Cook's ships approaching Mo'orea, "A. Omai's Boat." From [John Rickman],
Journal of Captain Cook's last voyage to the Pacific Ocean (London: Newbery, 1781), 165.
Retrieved from TROVE via the National Library of Australia.

Mai also asked if a few could be broken up rather than burned so he might
salvage some useful planks of wood. Again, Cook agreed.[46]

By the time the goats were returned Cook was suffering remorse for his
extreme reaction. The affair, he admitted, "could not be more regretted on
the part of the Natives than it was on mine."[47] Mai, all the same, had emerged
significantly richer. He'd had to witness wanton imperial vandalism—maybe
he cared, maybe he didn't—but at least he'd retrieved some resources from the
mayhem. He could no longer be sure Cook would hand over all that the Brit-
ish had promised him.

Mai and his growing entourage arrived on Huahine Island in the morning
of 12 October 1777. It had been almost exactly four years since he'd left it as a

game twenty-year-old aboard Furneaux's *Adventure*. Against everyone's odds he'd traveled to the ends of the earth and made it back in one piece. A brother and his other sister greeted him, though no Briton was there yet to witness it. Doubtless the tears flowed again.[48]

A couple of hours later, at noon, Cook's ships drew in. Cook recorded that more locals came out in their canoes to meet him than to meet Mai, though how he could have known this is unclear.[49] That afternoon the captain broached the conversation that Mai had been half dreading and half craving for weeks. Why was he so dead set on Ra'iatea, really? If Tahiti was no good, what about Huahine? Mai must have drawn a very large breath. The captain knew the man's reasons but somehow found them hard to keep in his head. Mai explained one more time. It had to be Ra'iatea and no other island. Yes, he did have relatives on other islands, including Huahine, but this was because all had been cast out by Bora Boran invaders nearly fifteen years ago. Mai's father had owned land on Ra'iatea. His family was the victim of dispossession. He was determined to regain what was rightfully theirs.

Cook seemed only now to absorb fully these founding facts of Mai's life. Happily, he found them striking, and Mai's plan a worthy one. At last, the captain spoke the words Mai had been waiting so long to hear: not only could he convey Mai home, but he might also be able to help get the land "restored to the Son."[50]

Immediately, however, the pair quarreled "upon the conditions." Cook's method would be to negotiate with the colonizing Bora Borans to seek a special dispensation for Mai, probably by offering some unique European goods. Mai, however, wanted nothing less than the total ousting of his enemy. He didn't want to be an isolated case in a sea of hostility. Regaining his land was equivalent in Mai's mind to regaining Ra'iatea's entire culture, status, and sovereignty. Absolutely not, said Cook. No way, countered Mai.

How long the quarrel lasted is unknown. In his journal Cook compressed it into two lines: "I wanted to reconcile him to the BolaBola men, and he was too great a Patriot to listen to any such thing. Huahine was therefore the island to leave him at and no other."[51] Perhaps Mai consented early, knowing how immovable Cook could be on some things. He'd just witnessed the captain ransack an entire line of houses on Mo'orea, after all. However it came about, Mai's concession to being left on Huahine rather than Ra'iatea was not the end of all his hopes to use the British in some way. He must have felt pummeled by the death of his preferred plan. But he still had a Plan B and— if worst came to worst—a Plan C up his sleeve.

Mai's Plan B got under way the next morning, when Cook and Mai together paid their respects to the reigning chief of the area. Cook's old Huahine counterpart and taio, Ori, was still alive, but the captain discovered that Ori had only ever been a regent-ruler for a toddler. The rightful heir was today a boy "not above eight or ten years" but old enough to assume his position as leader.[52] He was surrounded by older ari'i men, who as a court heard Cook out on his request for a parcel of land for Mai's resettlement. Using Mai as his interpreter, as ever, Cook explained he'd be prepared to offer attractive compensation in European goods for the favor. The chiefs hesitated. At this, Cook thought he'd be clever by snatching away the very temptation he'd just dangled. If the Huahine chiefs did not provide a home for Mai, the captain said, then he would be forced to land Mai instead over at Ra'iatea. That island, not Huahine, would gain all the rare European treasures.

Cook was surprised to find this ruse backfire. The Huahine chiefs seemed thrilled at the idea of Mai going to Ra'iatea instead! What exactly did you translate to them? demanded Cook. Mai confessed that he'd implied that if the captain deposited him on Ra'iatea, then the British would also apply their substantial muscle to help oust the Bora Borans from the sacred island. Apparently the Huahine Islanders' hatred of Bora Borans outweighed their attraction to European goods. Huahine was still clinging to its political independence, but the threat from across the channel was real and constant.

Cook stepped in to clarify that he would not be taking part in any Bora Boran engagement and in fact would actively stop all Huahine-initiated attacks on the invaders.[53] The chiefs decided to take the next best deal and said Mai could choose any part of the island he liked.

Plan B, then, had failed. The only thing left for Mai was to try to get the best possible situation for himself on Huahine: a sturdy house, on prosperous land, with as much British weaponry as he could store. He already had three canoes and a small crew of Tahitians as well as his two loyal Māori attendants. The dream of using British naval power for his own ends was over, but there was no reason he couldn't build a decent base for a purely Indigenous attack on Ra'iatea in the near, if unfortunately now delayed, future.

Cook and the local chiefs hammered out a deal for Mai's plot. It would stretch around two hundred yards along the shore of the main harbor and more than this back from it, including some hillside ground. In exchange Cook gave fifteen axes and "some beads & other triffles."[54] Cook's carpenters started building a house, mainly from the wood Mai had salvaged from

Mo'orea. Other sailors began planting a small garden around it with seedlings of shaddock, grapevine, pineapple, and melon.

During the fortnight the British worked on his plot Mai tried to acclimatize himself to his new reality. He caught up with his siblings, perhaps telling them how he would bring over their other sister from Tahiti soon enough. He reconnected to the religious and cultural life of the Tahitian archipelago, worshiping 'Oro in the local marae, preparing foods for umus and storage. He fished. He swam. He gossiped. There was also a lot of organizing to do. Perhaps he started already to recruit other refugee Ra'iateans and sympathetic Huahine Islanders to his grand cause.

With his old British friends Mai spared some time to go horse riding and to share a feast or two, which he prepared. But the distance between him and them was stretching ever wider. To Mai, they were fading into the role of mere transporters: past acquaintances, now almost as good as gone. To the British, Mai was hardening daily into a caricature of the impulsive, grating native.

One night about ten days into their stay at Huahine a group of Cook's men joined a crowd of Islanders for a special Arioi dance, performed, as it happened, by Ra'iateans. Mai was there, too, enjoying the show. Suddenly, midperformance, Cook strode in to stop it.[55] He'd just discovered that someone had stolen a sextant from his ship—one of the most valuable navigational instruments he owned. He ordered the presiding chiefs to locate the thief immediately. While waiting, he took several local canoes as surety.

The chiefs soon found a suspect. Mai brought the man to the *Resolution*—unsurprised to find him a Bora Boran. He interrogated the suspect on behalf of Cook, eventually extracting from him the whereabouts of the missing object. By morning the sextant was found. Cook, though, was still on his unmerciful streak. Even he confessed to punishing the Bora Boran thief "with greater severity than I had ever done any one before." The captain had the man's head shaved completely, including eyebrows, and then sawed off both his ears. Cook sent the thief back to shore, ruined and bloodied. It was meant to be a lesson to the rest at Huahine never to mess with the British.[56]

Cook's desire to send out a message cost Mai dearly. The Bora Boran lost no time in wreaking revenge on this special native newcomer who seemed to work so assiduously for the visiting white men. A day or so later Mai discovered most of his new garden shredded and now a bounty placed on his head. The Bora Boran swore to kill him the minute Cook's ships departed.

Cook responded to this threat by hunting the thief down and placing him in iron cuffs back on the *Resolution*. Mai knew, though, that Cook would not

take him with him. Instead, when the British finally left, the captain would release him back into the community, issuing vague threats to return if he ever caught wind of trouble for his onetime charge. Mai's Plan C was looking more precarious by the minute.

No, no, no! This was not what he'd imagined at all. When the carpenters finally revealed their handiwork to Mai the disappointment was visceral. Mai had expected two stories at least. Solidity, such as he'd seen characterize some houses in Britain. A sanctuary. Or at least something big enough to be a mess hall for a growing army. This structure reminded Mai of those he'd seen in Britain to pen up pigs. It was really just one room, five to six yards square, with a mezzanine loft.[57]

Only the lowly German-born able seaman on board the *Discovery,* Heinrich Zimmermann, bothered to notice Mai's horrified reaction. The British officers were losing interest in Mai as quickly as he was growing disenchanted with them. The single thing these officers recorded was how the new resident dragged a camp bed into his house and attached a lock to its door. Mai also moved in his brother's family, his whole Tahitian crew, and the Māori youths, Te Weherua and Koa. Cook was surprised to note no girlfriend had yet appeared to share the place with him, but there would hardly have been room.[58]

On top of the disappointment of the house, Mai soon received another, far harsher blow. Cook now brought off the ships all those crates that Joseph Banks had packed up for him in Britain. Mai had been looking forward to opening them for over a year. He was expecting muskets, loads of gunpowder, perhaps a canon. Instead, what he found was a bad joke. Women's dresses, a set of cutlery, porcelain dishes, glassware, a wheelbarrow, two drums and a hand organ, some toy horses and tin soldiers, a jack-in-the-box, a model globe, an umbrella.

The officer William Bayly saw that the crates' revelation sent Mai into a tailspin: "When it came to examine the contents of his Boxes & Casks, he was very near going out of his Senses." Although Bayly blamed Mai for the crates' deficiency—"Omi being a man of pleasure neglected to inspect into his own affairs but left it entirely to other people"—he did wonder at the choices of these so-called patrons: "I cannot help remarking that those who had the care of fitting out Omi, used him exceeding ill, by giving him a collection of the worst things that could be procured."[59]

Among the refuse Mai did find some more useful implements, though these were all the shabbiest versions possible. The hatchets were of the least

Figure 32. Mai's house on Huahine, from aquatint *View of Huaheine, one of the Society Islands in the South Seas*, from a drawing by James Cleveley (1777). Reproduced courtesy of the National Library of Australia.

quality, and the eight spike nails seemed to have been thrown in by accident. The roughly "20ˢ worth of glass beads" were so poor that Bayly knew no one in Huahine would give a coconut for the lot. "Tho Mr Banks was considered as Omi's friend," the officer muttered, he did not provide the young man with anything more serviceable "than a Lectrifying Machine," which would be utterly useless in the tropics even if Mai had known how to work it.[60]

Cook, as usual, was more sanguine. He thought the playful ephemera did intrigue the observing locals. But he acknowledged that the dishes, plates, and glassware were a load of garbage. When Mai began bartering these with his officers for more practicable tools, the captain looked on approvingly at his entrepreneurial spirit.[61]

Mai's mood never really lifted for the rest of the time the British were in Huahine. A lieutenant called John Rickman became his closest observer. "One would have imagined," this officer wrote, "that seeing himself apparently the greatest man in the island, and possessed of much the finest house, [Mai] would have been elated with his situation." But against Rickman's expectation the man appeared "quite the reverse." He was "apprehensive," "dejected," and "melancholy." At first Rickman thought the cause of the problem was the British ships' imminent departure. The traveler would miss his worldly companions, his precious conduits to European culture. Then Rickman decided it was probably more related to the practical threat of the Bora Boran thief still on board the *Resolution*. As soon as the man was released back onto shore he would terrorize Mai and raze his prized new dwelling.[62]

Rickman saw Cook go through the predicted routine of assuring Mai he would come back to punish anyone who molested or hurt him. But Mai knew as well as anyone that Cook was never returning. The ships were headed north after their rounds of this archipelago, off to colder waters in search of that trade route for the British empire and then home, as always, in another ocean altogether. Cook's protection was good for no more than a week at best.

Probably Rickman also sensed the futility of Cook's promises. Now he turned to a more philosophical approach to explain Mai's continuing despondency. It was a universal problem, he concluded, to be found the world over. No matter what the British did for him, Mai could not escape becoming the victim of other people's envy. His fellow Islanders "beheld him in the same light as the gentlemen in every country see low-born citizens suddenly rising from indigence to wealth, giving themselves airs, and affecting state." Mai was destined to be laughed at for owning special things even while others enjoyed these objects. He would always be mortified, despite the entertainment he provided. "Such is the disposition of mankind throughout the world," waxed Rickman. "Men sprung from the dregs of the people must have something more than accidental riches to recommend them to the favour of their fellow citizens."[63]

Not a single officer wondered if Mai's mood might be connected to a grand disillusionment in the British themselves; that the man they had traveled with for sixteen months had all along harbored richer plans than the mere exploration of the unknown; that he had committed to the near impossible— the global pursuit of arms—in order to rectify an immense wrong. The British surely knew a thing or two about fighting for the restitution of what they felt was theirs. The nation was still deeply immersed in its war to reclaim so-

called sovereignty in North America from a bunch of independence-declaring rebels.

Over the centuries few historians either have wondered about Mai's temperament. Most have taken on the officers' assumptions, especially to explain Mai's behavior in the last few weeks of the expedition. Reading Cook's growing frustration with Mai's refusals and fuss have made them decide the young man was "annoying" and "callow."[64] Reading Rickman's ponderous rationalizations have made them say Mai was in fact actively "alienating" his own people. He irritated the British because he had the "airs" and "graces" of a "born sycophant." He irritated his fellow Islanders because he was a "one-trick pony," only special as the protégé of Captain Cook, which in the end made them "dislike" him anyway.[65]

Even scholars sympathetic to Mai's perspective have allowed Cook's sense of tested toleration and Rickman's sorrowful world-weariness to have the last word. At best they excuse Cook's views as those of a typically aging, and possibly sickening, eighteenth-century British leader. And they have run with Rickman's philosophizing about class differences to suggest, further, that Mai exemplified the global problem of straddling separate cultures. Mai was destined to fall tragically between two stools: the Indigenous world he'd half abandoned and the European world he could never quite attain.[66]

Cook and Rickman, however, did not see all that could have been seen of Mai's position in late October 1777. Neither of them could keep in their heads the long game Mai had been playing. They analyzed his behavior only ever in the short term, a failing, ironically, that they accused Mai of all the time.[67] Thus Mai appeared either a victim of an erratic personality or else a victim of European interference. But the colonial Bora Boran backstory to Mai's presence in Huahine—a backstory now some fifteen years running—indicated Mai's personality was more focused than that of most. It also showed that Europeans had only ever been supporting actors in his personal drama.

As minor as it was, all the same, the Europeans' bit part at this point was going badly off script. The British were not delivering on the means that their extensive empire had always suggested in Mai's mind. Every glimmer of potential aid they had represented to Mai was now at an end.

Two days before departing Huahine Cook decided to improve Mai's inventory a little. Whether he had always planned on doing this or felt moved to after thinking further on Mai's life is unclear. He handed over two horses, three pigs, and a goat. He also bestowed two muskets, two pistols, five blades,

a few cartridges, some bullets, and twenty pounds of gunpowder.[68] It would not arm a regiment. But it would supply Mai himself for a while. Perhaps Mai cheered up a little at the final dinner he prepared for the British. He shared with them the last of his allocated wine. Cook lit some fireworks in his honor.

But on 2 November Mai saw the British ships run up their sails for the last time. At this sight he was overcome with grief for all that had been lost. He started crying tears that flowed for hours. The Bora Boran thief was released again onto the island, under the supposed guarantee of the boy-chief's mother. Cook repeated his promises of protection, but Mai was no longer listening. Te Weherua and Koa suddenly started crying, too, adding to the stress of the day. The youths broke into racking sobs, asking too late to be carried back to Aotearoa. Or on to Britain. Or anywhere. Perhaps they sensed the deteriorating state of their situation. Little Koa in particular was inconsolable. Three times he tried to swim after the ships as they pulled slowly out of harbor. Three times he had to be grabbed and hauled back into a canoe.[69]

Mai was on the deck of the *Resolution* as it edged out of harbor. James King would row him to shore after a shipboard farewell with the captain. It turned out to be a desperate affair. Though he managed to keep it together when saying goodbye to the other men, Mai collapsed when he came to Cook. He clasped him. He hung arms around his neck. Rickman reported tears in Cook's own eyes. How far apart, though, were the reasons for each man's distress the lieutenant would never guess.[70]

After King deposited Mai on shore, did the Ra'iatean turn around to watch the ships fade to the horizon? Or did he keep his back to them, determined not to brood on what might have been? The quality of evidence for Mai's life changes markedly at this point, from the eyewitness account to the record of other people's later memories.

From these sources, though, we can say at least three things about Mai's post-voyage life. First, he did see Ra'iatea again. He went there often, in fact, sailing in his various vessels.[71] He saw once more the glimmering reefs and precious villages of his home island. Presumably, too, he reencountered the sacred center of Taputapuātea facing out toward all the islands his ancestors had peopled in the past.

Second, Mai did participate in a war to oust the Bora Borans from Ra'iatea, probably within a year of Cook's departure. He used his foreign armaments in the battle and at some level was successful. Many "Bora Boran

men were killed." The victory was not total, however, and the island of Ra'iatea remained in Bora Boran hands for the rest of Mai's life.[72]

Third, he soon lost most of his animals. One horse, however, lived on. Mai rode the creature frequently. When the ill-fated Capt. William Bligh visited Huahine in 1789 he reported not only several tales of Mai's riding days but also a number of pictures of a horseman tattooed onto the legs of local men and women.[73] Mai never realized his main ambition. But his adventures had made an indelible impression on the people he lived among.

Epilogue

ON DYING IN THE EIGHTEENTH CENTURY

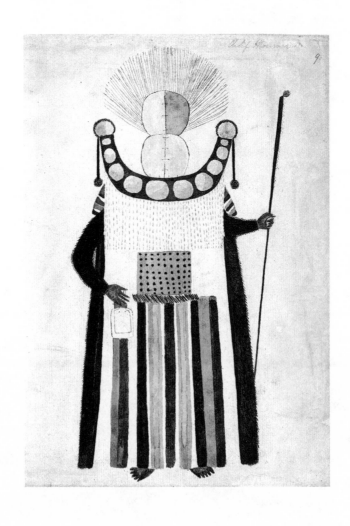

B y the time Captain Bligh made his enquiries at Huahine in 1789 Mai had been dead at least eight years. Probably nine. He had not reached his thirtieth birthday. Against everyone's expectations, however, Mai did not perish through war. Most posthumous accounts agree that he died a natural death about three years after he said goodbye to Cook. Following multiple trips to his native Ra'iatea and a credible attempt at its liberation, he succumbed in the end to a fever, or "ague."[1]

Contrary, too, to Lieutenant Rickman's melancholy prediction about Mai's prospects, later European accounts suggest that the voyager had made a decent home for himself on Huahine. With Ra'iatea unbreachable, he had done the next best thing and found a community. When George Vancouver stopped by the island group in 1791 he heard that Mai was "universally regret-ted and lamented." Even the censorious William Ellis, the British missionary who set up in Huahine in 1818, admitted that Mai's name was still honored by locals forty years after his death. (Ellis had not forgiven Mai for failing to convert to Christianity while in Britain and frowned upon rumors of Mai's enduring obsession with firearms.)[2]

Having earned this broad respect, Mai was probably given the burial rites appropriate to a well-loved man. These were elaborately remarkable, or so Joseph Banks at least had thought when he observed them ten years earlier. Subsequent testimonies of east Pacific deathways confirm that upon his death Mai's relatives and friends would have assembled in his house, wailing loudly their grief and sorrow.[3]

Perhaps Te Weherua and Koa lead the lamentations. Perhaps his Tahitian crewmen do. Or maybe there is a woman in the end, to direct the other local women in the cries that last all night. At daybreak Mai's mourners place his body on a bier. The Chief Mourner, a leading man dressed entirely in tapa, heads a procession down to the beach. There, he sprinkles the body with seawater and coconut oil. When the body is brought back up from shore it is placed in a makeshift hut. In Mai's case this is probably his house. Mai's body is then partially embalmed with cloths, aromatic wood, and oils.[4] Women relatives strike their heads with shark's teeth till the blood min-gles with their tears. Young relatives cut off some of their hair and place it in the *fare tupapau* (house of the corpse). Finally, the men lead the dances

Figure 33. Tupaia's drawing of the Chief Mourner, Tōtaiete mā, 1769. © The British Library Board Add. 15508, no. 9.

and chants that herald Mai's transition out of this world and into that of the ancestors.

Depending on the status of the deceased and the mood of the Chief Mourner a body can be left in state for several months. Certainly burial takes place when there are only bones to wash and place in the grave. Before the gravelly mud is piled on top of the body, however, the mourners destroy the fare tupapau completely, pulling it apart "as if done by a quick and sudden hurricane."[5] When Bligh met one of Mai's Tahitian crewmen in 1789 he discovered that Mai's house had been "torn to pieces."[6] Bligh wondered if this was a sign of disrespect. It may instead have been one of the last tributes his friends gave to the most adventurous man they had ever known.

Later Europeans also gleaned information about the other major Indigenous characters in Mai's story. The fates of Te Weherua and Koa, who had joined Mai in April 1777, were grim. They perished soon after the death of their Ra'iatean friend, also from natural causes. This suggests a contagion may have collected all three. Te Weherua and Koa held Aotearoa in their hearts till the very end, visibly grieving "their native country" in the eyes of those who survived to tell their tale.[7]

Of Mai's immediate relatives there are no written testimonies, although one source said he never fathered children.[8] Likewise, we do not know when or how Huahine's various leading chiefs of the late eighteenth century died or even precisely the fate of Bora Bora's old despot Puni.[9] In terms of the formal political narrative of the Tahitian archipelago, though, these deaths turned out not to matter. For it was around Tu, Cook's old taio at Matavai Bay in Tahiti, that the currents of history soon unexpectedly swirled.

A few years after Cook departed the region Tu led a successful mission of colonization to nearby Mo'orea. In a conquering frame of mind, he changed his name to Pōmare, a dynastic title chosen to honor his sickly daughter. In 1797 he gave cautious welcome to the first British missionaries to land at Matavai Bay, though it was really his son and successor, Pōmare II, who capitalized on the introduction of the Christian religion. Pōmare II used his connections to Christians (and through them to pork traders from the new British colony at Sydney) to consolidate power against other Tahitian contenders. By 1815 he had managed to extend his influence across the whole island—a new experience of centralization for the archipelago. By the 1820s Pōmare II's rule had extended to Huahine, Ra'iatea, and even Bora Bora. It brought Christ in its wake, toppling the dominance of 'Oro after more than a century. In the end Mai's beloved island did find freedom

from its local oppressor but only in the form of another kind of Indigenous takeover.[10]

The other outstanding Indigenous character in the written records of Mai's story is the ubiquitous Hitihiti. Last seen in Matavai Bay scheming against Mai, he was among the first to greet Captain Bligh when he landed in Tahiti in 1788 (before Bligh went on to Huahine). Hitihiti tried to preempt Bligh's discoveries about Mai by telling him that the Ra'iatean had died in a lowly state and his house had burned down accidentally.[11] The troublemaker also appeared when Bligh's *Bounty* ship returned to Tahiti six months later, minus Captain Bligh who had been deboarded in a mutiny near the Tongan Islands. Perhaps attracted to the mutineers' methods of power grabbing, Hitihiti joined the rogue *Bounty*, reenacting his ship-hopping experience with Cook sixteen years earlier. His voyage with the *Bounty* mutineers didn't last long, though. Hitihiti returned to Tahiti a few months later when the mutineers themselves split among each other and several elected to stay permanently. Perhaps only Mai would have been unsurprised to learn that Hitihiti then made immediate contact with the crew of the British navy's *Pandora* in 1791 when it came hunting for the mutineers. He caught a ride with the *Pandora* to Huahine but jumped off and traveled back to Tahiti in time to meet Captain Bligh once more when he arrived in the *Providence* in 1792 to complete his original imperial mission.

Thirty-two years later still, in 1824, a Russian vessel captained by Otto von Kotzebue visited Tahiti in its own quest for a northwest passage and global advantage. Kotzebue reported meeting a wizened old man who said he'd traveled with Captain Cook all around the Pacific. He could name all the officers from the *Resolution*'s first visit, he demonstrated use of a sextant, and he knew that Russia was much bigger than Britain.[12] Mai's old nemesis had survived him by over four decades.

Of the Europeans in Mai's world, Cook had by far the most famous death. Just over one year after leaving Mai on Huahine, he was killed in Hawai'i by locals at Kealakekua Bay. His old hostage-taking methods for getting what he wanted—increasingly relied upon in his third expedition—finally backfired. He was clubbed to death on 14 February 1779. For a British man who had spent so much time in the Pacific, his remains attained a somewhat appropriate fate. Hawaiians took charge of Cook's body, treating it to the same partial embalming that Tahitian Islanders gave to their dead. They hastened the usual process of decomposition with dismemberment, washed the bones clean for their own use, and gifted a portion back to the aggrieved officers. Cook's crew gave this portion a typical British naval burial at sea.[13]

Mai's official host in Britain, Lord Sandwich, died in 1792. His spirit, though, had broken years earlier when his long-standing lover, Martha Ray, was murdered within weeks of Cook meeting a similar end. As head of the British navy Sandwich then presided over the ignominious defeat of 1781, when American revolutionaries finally gained the upper hand in their war against the British state. Descendants still debate whether or not he lent his name to his favorite handy meal of cold meat between two bread slices.[14]

Both James Burney and Joseph Banks, like Tu and Hitihiti, survived the eighteenth century. Burney, after arriving home from Cook's third voyage, returned to the fighting in America. He became a writer like his sister and died in 1821 at the age of seventy-one. Banks never saw the Pacific again but remained forever fascinated by its natural world and its potential benefit to Britain. In 1778 he became head of the prestigious Royal Society, a post he held till his death forty-two years later in 1820. Burney and Banks were buried in local London churchyards respectively, consecrated to a God neither had spent much time pondering.

Half a world away the aging Cherokee warrior-diplomat utsidihi Ostenaco died about the same year as his unbeknownst counterpart Mai of Ra'iatea. As in Mai's case, there are no precise records, but it seems Ostenaco did not survive the settlers' revolution. Most likely he succumbed to the smallpox epidemic that tore through the Chickamauga region in 1780. He had staved off the terrible outbreak of 1738, which had laid low the entire Overhills population for a while, as well as the terrible eruption in 1760, which had disturbed Attakullakulla's desperate negotiation for the Fort Prince George hostages. But this time, well into his sixties after an eventful life, Ostenaco's body might not have been able to fight back.[15]

If he survived till 1780 Ostenaco would have seen his young Chickamauga compatriots fight American settlers continuously through the previous three years. He would have heard of many victories as well as many losses in lands now designated Virginia, North Carolina, South Carolina, and Georgia. He would have seen the young fighters return triumphant after playing their roles in the captures, briefly, of Savannah, Augusta, and Charleston. More surprising perhaps, he would have glimpsed solid connections forming between the Chickamaugas and several surrounding Indigenous peoples, many of them erstwhile foes. Most heartening of all, he would have gathered that numerous Cherokees still living in the Overhills sent surreptitious aid to the breakaway group. It whispered of a reunion one day of all Cherokees.[16]

Between ongoing war and a new disease epidemic, whichever way Ostenaco died there may not have been time to award him due burial rites. Like Mai, Ostenaco died in atypical circumstances, to which customs always have to adapt. But the respect Ostenaco commanded was never in doubt.

His mourners, then, do their best to follow the rituals of sitting with his body for one day and one night, of then smoking out his house, and finally of allowing the local undertaker to wash both him and themselves. Many chop off some of their hair—strangely reminiscent of Pacific custom. All help ensure that Ostenaco's few possessions are destroyed or set alongside him for burial. No important movable goods should transfer to survivors if matrilineal control of a redistributive economy is to continue.[17]

Contrary to later beliefs, Ostenaco's mourners are unlikely to build a mound over his grave. Ancient mounds in Appalachia indicate that Cherokee ancestors probably formed these structures for supremely eminent leaders. But by the eighteenth century most men are buried in cemeteries close by the townhouses they served in life. In keeping with the general gender differentiation of Cherokee society most women are buried in lots near to their own site of power, the domestic home. After burial, as in so many cultures, there is dancing.[18]

The deaths of Ostenaco's wife and daughter are not recorded. Notices of the life of his grandson Richard Timberlake, however, dot the archives into the nineteenth century. They show that he tended a farm in the Chickamauga region purportedly owned by his grandfather Ostenaco until 1819. Whether or not this land had truly been Ostenaco's in the settlers' sense or the home of Richard's mother, Sokinney, is vague. Certainly some of the patriarchal ways of whites had started to infiltrate Cherokee life by the 1770s and perhaps with them new ideas about individual male landownership.[19] But Ostenaco had almost certainly joined the Chickamaugas in the first place to preserve, not to transform, old customs. It is possible that the warrior-diplomat had in his last years laid a formal claim to some ground in the Ani-Yunwiya region as a way of signaling boundaries to his settler foes in the only way they understood. With the rise of the United States after 1783, landownership—in the whites' sense— became the most eloquent currency left remaining to Native Americans.

Whichever way Richard came about his land, by the 1810s white locals identified him as a grandson "improving" his grandfather's property. These same locals in 1819 negotiated with him and five other Indigenous landowners to exchange this property for a new farm about twenty miles northwest of the old Chickamauga site. Two years later Richard Timberlake sold that lot for

three thousand dollars, roughly the price of two hundred guns, thirty horses, or five slaves.[20] Thereafter his name slips from public archives.

Ostenaco was, hopefully, spared news of the death of Attakullakulla. Again, the records are vague, but his old Overhills peer seems to have died around the same time as Ostenaco.[21] The two elders had had their differences, even though Europeans always exaggerated them in their inability to imagine both Indigenous agency and communal cooperation existing together. Ostenaco had disagreed with Attakullakulla over the Fort Prince George hostage situation and had defied him most painfully over the 1777 truce with the settler revolutionaries. But at the same time he had never tried to unseat his peer as a leader. He had followed the man's command during the peace negotiations of 1762. And he had worked alongside him over countless, heart-wrenching land cessions through the interwar period. It must have rattled Ostenaco deeply to leave Attakullakulla alone in the Overhills when he joined the man's own son, Dragging Canoe, on the Chickamauga. No one knew better than Ostenaco how dedicated Attakullakulla had always been to their shared cause. Each had simply decided on different methods along the way.

The third player in the oft-joined trio of Cherokee leaders, Oconostota, outlived both his peers. After Ostenaco's departure and after Attakullakulla's death he struggled to keep peace with the revolutionary settlers. In late 1780 Thomas Jefferson ordered an assault on the remaining Cherokee towns, for fear of the inhabitants absconding like the Chickamaugas to forge a new offensive against the revolution. Oconostota was forced to flee the Overhills. He left behind a valuable cache of documents. At the time, some revolutionaries believed these showed he had been playing a "double game" with them. Perhaps he had. Still, the Virginian agent to the Cherokees at the time took sufficient pity on the old man to house him during the last stages of the American Revolution. Oconostota asked this agent to take him home to die. He was buried in a canoe in the charred town of Chota in the spring of 1783.[22]

As for Ostenaco's other pair of Cherokee comrades, Cunne Shote and Woyi, who had journeyed with him to Britain, few records survive. Woyi was apparently pressed into a revolutionary regiment and died in battle in 1777.[23] No trace of Cunne Shote exists after 1762. The story of Dragging Canoe, however, is different. He led the Chickamaugas through attack after attack until he dropped dead during a victory dance in 1792. He endured three major town razings and innumerable alliance renegotiations, but a war feast finally felled him. When Dragging Canoe died, most surviving Cherokees,

now removed to New Chota in Georgia, honored his memory. The first three principal chiefs of the freshly formed Cherokee Nation, established in 1794 in New Chota to face a surgent United States of America, had been Chickamauga warriors under Dragging Canoe.[24]

Most of the Europeans whom Ostenaco had come to know ended their lives far from the North American mainland. His shrewdest acquaintance in Britain, Lord Egremont, did not live to see the implementation (and certainly not the failure) of his hopeful royal proclamation line. He expired from a stroke in August 1763, sometime after sitting for a portrait by Joshua Reynolds. The unfinished painting, if Reynolds even kept it, is now lost.[25]

Henry Timberlake did make it back to Virginia briefly in 1763. He was penniless then, with a newly acquired wife called Helen Binel. Together, the Timberlakes may or may not have heard about the birth of Richard Timberlake over in Cherokee country. Still desperate for colonial favor, Henry decided to act once again as an escort for Indigenous travelers. In 1764 he and Helen accompanied to London four Cherokee men angry about early violations of the royal proclamation line. The trip proved disastrous. No one like Egremont now resided in Whitehall. Timberlake failed to obtain a royal audience for the Cherokees, though British officials did agree to ship them home on the next available vessel. Stranded in London himself with a dependent bride and immobilized by debt Timberlake tried to raise funds by turning his encounters with the Cherokees into a book. His *Memoirs* were published in September 1765. A few days later, though, he died, from smallpox, aged only about thirty.[26]

A literary scholar has unearthed an extraordinary postscript to Timberlake's life, contained in the pension requests made by his widow to the British government.[27] Over the following twenty years Helen Timberlake received intermittent pension payments. She may have gone to live in North America during the off years when there are no accounts. By 1786, however, Helen was in Britain requesting consideration once more for her plight. This time she appealed directly to George III, spinning an elaborate tale designed to soften the middle-aged monarch. She claimed that Henry Timberlake had been in fact Ostenaco's long-lost son and that Helen and Henry had produced an infant while in Cherokee country back in 1762—a grandson for Ostenaco, left behind to receive a Cherokee childhood. Helen was asking George III for security now partly so she might rescue her son at last from the hands of "uncivilized Indians." She signed the document, intriguingly, "Helen Maria Theresa Timberlake Ostenaco."[28]

While it is clear that Helen was living in Britain when Henry Timberlake met Ostenaco in the Overhills and thus could not have been the mother of Richard, she may yet have heard of this boy's existence. Perhaps she learned of his birth when first visiting Virginia in 1763? Or maybe it was later, during undocumented travels in America through the revolutionary era? Possibly, too, it was all a wild guess or strange coincidence; an invention to pull at the heartstrings of a king who had just lost his own son but which turned out to resonate with the story of a man whose life had come to revolve around descendants. Henry was not Ostenaco's son, and Richard was not Helen's. But all the figures in this tale were inextricably bound together even so. If not by blood, they were connected by the threads of historical narrative. By empire. And by the persistence of Indigenous life.

Joshua Reynolds outlived both Mai and Ostenaco. After exhibiting Mai's portrait in 1776, he continued as president of the Royal Academy until his death sixteen years later. In many ways those years were professionally uneventful. He had achieved all his chief ambitions. He had nothing left to prove. He had nothing left to pour his extraordinary powers of placation into. True, the rivalries and sniping against him continued after being unleashed in the early 1770s. But none ever threatened his position as the leading oracle and practitioner of art in the nation.

Reynolds's rivalry with Thomas Gainsborough especially continued in the aftermath of Mai's visit. Gainsborough consistently sent works to the Royal Academy exhibitions that drew attention away from Reynolds's examples. The president would have been better able to swallow the annual celebrations of his challenger if Gainsborough's paintings did not go so damningly against Reynolds's dictates on neoclassical fundamentals. The jostle between the two came to a head in 1784 when the official royal position of the King's Painter became available. Old Allan Ramsay, who had held the position for nearly twenty years in preference to any involvement with the Royal Academy, died midyear. Reynolds believed the post should now go to the head of the king's formal institution for the arts. Gainsborough, however, who had always maintained an easier relationship with the royal court, let it be known he wouldn't mind being considered.[29]

Reynolds mobilized every aristocratic favor he'd ever curried to get his way. His manner was so unusually grasping that his old friend Samuel Johnson felt compelled to censure his "furious purposes." Gainsborough conceded that external forces had defeated him, feeling he'd been "very near being

King's Painter only Reynolds's Friends stood in the way." In the end the competition ruined the privilege. Reynolds never stopped complaining about the position's poor salary—deliberately lowered by the king, Reynolds felt, to be less than that of the royal rat catcher.[30]

At least the new position never interfered with Reynolds's presidential duties. But it did turn Gainsborough away from exhibiting much afterward, withdrawing in the process a major force for diversity and excellence in British art. By 1788 Gainsborough knew he was dying and sent word that he'd like to speak in person to Reynolds, whom he said then he had always admired. Sir Joshua went to his house for an undisclosed talk and soon afterward served as Gainsborough's pallbearer. In his Royal Academy address that winter the president devoted its better part to Gainsborough. While it was not as flattering as it might have been, the speech concluded by referring to his deathbed rapprochement with the artist. "If any little jealousies had subsisted between us," Reynolds revealed, "they were forgotten in those moments of sincerity." And then, completely out of character, he cried. The years were catching up with him.[31]

Reynolds had started to feel old, in fact, a few years earlier when his great North Star, Johnson, died at the age of seventy-five. The last years of Johnson's life oversaw the end of what he always reckoned was the worst war in Britain's war-filled eighteenth century. Opposed always to the dispossession and slavery at the core of Britain's empire, Johnson had taken particular exception to the idea of British American settlers now preaching to him about rights and liberty. He had made his disgust for the revolutionaries clear in 1775 with an incendiary pamphlet called *Taxation No Tyranny*. This pamphlet had put him in diametric opposition to Reynolds's other great friend, Edmund Burke, who weathered a similarly tough American Revolution. Burke had pleaded for conciliation between Britain and its colonies in 1775. Johnson was aggrieved to watch the ensuing war unfold, for the insult it represented to old British values and for its increasingly probable victory against the British state. Burke was equally aggrieved. He had wanted leniency over militancy, not because he was happy to lose a chunk of the empire but solely in order to keep it, in however compromised a fashion.[32]

Reynolds would have been relieved to find—or maybe he always knew—that the personal would win out over politics between his two closest mates. In 1783, just as peace was finally negotiated, amid wild ministerial fluctuations and furious mudslinging at all those involved in British defeat, Burke came to Johnson discouraged. The MP thought he would retire. "Never think of that," said Johnson. "I should then do no ill," Burke explained. "No nor

good either," Johnson replied.[33] Burke continued to serve as a member of parliament for another thirteen years. The two never agreed on matters of war or empire. But they took care of the bonds between them. It is no stretch to wonder if this was chiefly out of love for their shared friend, Joshua Reynolds.

Reynolds was an executor for Johnson upon his death and received in Johnson's will the writer's personal folio edition of his great *Dictionary*.[34] Thereafter Reynolds turned more and more to Burke for company and guidance. He attended most of the four-day opening speech that Burke famously gave in parliament against the British governor of India, Warren Hastings.[35] Burke was the lead prosecutor for the impeachment of Hastings, trying him for misconduct as an imperial leader. Reynolds may have offered up a silent prayer of thanks that Johnson was no longer around to shout that constant aggressive expansion into other people's lands was *already* conduct unbecoming.

Reynolds was also with Burke on 14 July 1789 when the Parisian royal jail, the Bastille, fell to a different kind of revolutionary. He saw Burke recoil in horror at the idea of a revolution bent on overturning all established principles rather than on returning, like a technical revolution, to well-tested and time-honored precepts. Burke's hatred of the French Revolution was entirely in keeping with his mournful acceptance of the American Revolution. One was born out of British understandings of liberty, with a due reverence for certain parts of British history. The other sought to invent liberty from scratch and dump all historical precedents in the bin. If Reynolds had wavered between Johnson and Burke on the American crisis, he supported Burke fully on the French one. He listened to early drafts of Burke's influential *Reflections on the Revolution in France* (1790), congratulating his friend for seeing so well how this revolution would result in an ungovernable populous and perpetual dissatisfaction. If one "set at nought the accumulated wisdom of ages," Reynolds declared, then one could expect nothing less than anarchy. The wisdom of ages was, after all, the bedrock upon which he ruled the Royal Academy.[36]

In 1789 Reynolds suddenly lost sight in one eye. He scarcely painted thereafter. He gave his last address to the Royal Academy in December 1790. Burke was in attendance. Reynolds last visited Burke's country house in September 1791, after which he mostly stayed in bed with various internal complaints. He died that winter. Burke was by his side.[37]

Reynolds's funeral is an extravagant affair—astronomically more extravagant than that given most men in Britain. After a postmortem operation

identifies an enlarged liver, his body is placed in a wooden coffin draped in black velvet. The coffin spends a night at the Royal Academy in a blackened room, where ministers of state and other dignitaries come to pay their respects. The next day it is placed on a six-horse hearse, which winds slowly toward London's massive St. Paul's Cathedral. Over ninety carriages of customers, courtiers, and friends follow in its wake. All the shops and law offices along the way close their doors, and hundreds of ordinary locals stand in "awful respect." In the cathedral the bishop of London leads the service, which includes a full choir chanting psalms. Reynolds's body is buried under a paver beneath the soaring dome. Afterward Burke tries to say a eulogy back at the Royal Academy but can get no further than a few words before giving in to his grief.[38]

It is fair to say Burke's life was unhappy for the next five years until his own death. In 1794 Burke had the devastating task of burying both his favorite brother and his only son. One year later he was appalled to find that his passion to impeach Warren Hastings for imperial misconduct had come to nothing. Hastings was pronounced guilty after a seven-year trial, but the upper house overturned the verdict on the grounds of imperial expediency. Burke's cautious pro-imperialist stance was always going to leave him vulnerable to inviting and thus falling victim to far more virulent versions of the same. In this case he fell victim to the outright jingoism of a right-marching elite. Burke had been forced to witness the loss of Britain's American colonies through what he thought was a mismanagement of imperial feelings. Now he had to stand by as Britain struggled to resist an even greater threat to its future from across the Channel. He died in the summer of 1797 and was buried alongside his sibling and child in Beaconsfield's churchyard.[39]

Just two of Reynolds's close friends saw in the nineteenth century. These were Angelika Kauffmann and Frances Burney. Kauffmann was delighted when her first husband died in 1781. It had been a terrible marriage. Whatever romantic feelings she may have had for Reynolds were well gone, and she remarried a Venetian artist that same year. They retired to Rome soon after, where she died a celebrated painter in 1807, aged sixty-six. Burney outlived her father, brother, and pretty much everyone else in this book. She didn't marry until she was forty-one. She had one son at the age of forty-two. An initial sympathizer with the French Revolution, she found herself stranded in Napoleonic France for ten years before returning to Britain in 1814. Always a brilliant correspondent about her inner life, she reflected in a letter just a few months before her own demise that the ways of the afterlife "are not dark and

intricate but unknown and unimagined till the great Teacher, Death, develops them."[40] She received her ultimate lesson in 1840, aged eighty-seven.

Ostenaco, Mai, and Reynolds offer three little-considered faces of empire in the eighteenth century. Ostenaco's life shows that the colonial intrusion into Cherokee country threatened land and health but never overtook the Cherokees' sense of themselves as a people or their core ideals. His life is a rarely acknowledged example of how Indigenous people always confronted newness through their own framing rather than those of the newcomers: Ostenaco continued to see the world through Cherokee understandings of gender, wealth, leadership, and war even as he came to recognize that the British shared none of them and would seldom view their own norms as anything other than universal. He realized, too, that just as the Cherokees had made adjustments in response to the colonists during his lifetime, the colonists had also been forced to change. They had fought unwanted battles, they had compromised on trade, and they had broken their own laws. Ostenaco's move to the Ani-Yunwiya at the end of his life symbolized the way he had resisted cultural and personal colonization despite several defeats otherwise endured. It inspired his younger relatives.

Mai's life reveals less empire's incompleteness or compromises than the limits of its interest to Indigenous people. While still a teenager Mai had glimpsed the possibilities of gaining imperial resources for his already established goals, but further than this it is hard to say he ever succumbed to empire's lures. Britons assumed he wanted, through a connection with them, some leverage in prestige or at the least the bedazzlement of exotic travel. But Mai was always more driven by his own culture's trends and prizes. Seeing empire through Mai's eyes punctures the sense of imperialism reigning supreme over everything in an Indigenous world. It also challenges us to consider alternate meanings of Indigenous responses to European incursion. Into the nineteenth century, as Europeans brought more havoc to the Pacific, Indigenous people continued to assess and interact with empire through their own terms of reference. These approaches have featured too infrequently in explanations of the imperial past.

Though he lived in the heartland of empire, Reynolds is not usually associated with imperialism. His life, though, adds a third facet to our understanding of empire in the eighteenth century. It illustrates the diversity of opinion about imperialism during this era. Some Britons were proud of it. Others were critical. By midcentury, at least, none could avoid it. Reynolds exemplifies the

way empire saturated everyday life in Britain. His peculiar education, ambition, and friendships meant that his work and persona spanned much of the range of the British response to it. To comprehend empire as beginning in conflict rather than in celebration is to grasp its shaky foundations and its far-from-inevitable progression. Empire was not a natural consequence of Britain's history. Nor of Indigenous history. It was forged against criticism from within and without. This criticism went on to shape much of the reactive jingoism of later centuries.

When things lose their sense of seeming natural in the past, they also crack open enough to let in new light. Imperialism continues to have far-reaching effects around the globe, not easily erased by switching out a flag. But new light cast onto old problems shows that these effects, too, are historical. They, too, can change.

When Natalie Zemon Davis closed her book on three seventeenth-century lives she reminded readers that each had once been "flesh and blood." At length, though, what was left were "memories, portraits . . . and their art."[41] Threading together the lives of Ostenaco, Mai, and Reynolds brings out the profoundly different ways that people could inhabit flesh and blood in the eighteenth century. None fitted easily into modern ideas about selves.

Combining these three men also reveals that they left behind more than has been assumed. In the case of Ostenaco and Mai—so readily thought lost to history—it is their portraits by Reynolds that have prompted deeper investigations into their lives and their societies. They have also instigated further explorations into their particular *arts*—into Ostenaco's arts of war and diplomacy and into Mai's arts of travel and revenge. Reynolds left behind portraits in abundance as well as substantial writings. But these sources have sometimes obscured as much as they have exposed. Only when placed next to the portraits of Ostenaco and Mai do the portraits *by* Reynolds start to suggest a neglected commentary on empire. Such a commentary has never before joined considerations of Reynolds's more obvious achievements in the art of human representation.

As for the memories of each man, perhaps these are not for the historian at all but belong solely to community and kin. Some legacies are private, to be held in hearts untethered by the patterns of place or time.

Notes

1. For the weather, see website, compiled from contemporary newspaper reports: http://booty.org.uk/booty.weather/climate/1750_1799.htm (accessed March 2018). Reports of the evening in *London Chronicle,* 12 December 1776, and *St James's Chronicle,* 12 December 1776.

2. Joshua Reynolds, "Discourse VII" of his *Discourses on Art,* ed. R. R. Wark (New Haven: Yale University Press, 1997), 115–42. On Reynolds's delivery, see James Northcote, *The Life of Sir Joshua Reynolds* (London: Henry Colburn, 1819), 1:179.

3. See Nicholas Serota, quoted in Department of Culture, Media, and Sport, *The 49th Report of the Reviewing Committee on the Export of Works of Art* (London, 2003), 50; Art Fund Charity, "Noble Savage," at www.artfund.org (accessed 2009); Tate News, "Anonymous Donor Steps in to Help Acquire Omai," 26 March 2003, http://www.tate.org.uk/press/press-releases/anonymous-donor-steps-help-acquire-omai (accessed March 2018). The portrait of Ostenaco, titled *Scyacust Ukah,* hangs in the Thomas Gilcrease Institute of American History and Art, Tulsa, Oklahoma. On the contemporary history of these two portraits, see Kate Fullagar, "Reynolds' New Masterpiece: From Experiment in Savagery to Icon of the Eighteenth Century," *Journal of Cultural and Social History* 7/2 (2010): 191–212.

4. The decision to label Ostenaco primarily a "warrior-diplomat" has been difficult in light of James Merrell's powerful warning against using damaging clichés in Native American history. It has, however, been impossible to characterize Ostenaco without this term: I have tried to use the word only in the case of individuals and not en masse as a synonym for Indigenous Americans. See James Merrell, "Second Thoughts on Colonial Historians and American Indians," *William and Mary Quarterly* 69/3 (3rd series): 451–512.

5. On biography's resurgence, see Ian Donaldson, "Matters of Life and Death: The Return of Biography," *Australian Book Review* (November 2006): 23–29. See also J. B. Margadant, "The New Biography in Historical Practice," *French Historical Studies* 19/4 (1996): 1045–58; David Lambert and Alan Lester, "Imperial Spaces, Imperial Subjects," in *Colonial Lives across the British Empire: Imperial Careering in the Long Nineteenth Century,* ed. David Lambert and Alan Lester (Cambridge: Cambridge University Press, 2006), 1–31; and G. Curless, S. Hynd, T. Alanamu, and K. Roscoe, "Networks in Imperial History," *Journal of World History* 26 (2015): 705–32.

6. Kenan Malik has summarized the contemporary popular debate in his "The Great British Empire Debate," *New York Review of Books,* 26 January 2018. He cites Niall Ferguson, Bruce Gilley, and Nigel Biggar as leading the apologists' side. Alan Lester's equally public and accessible article was a noble attempt at outlining fundamental problems in the apologists' resurgence: "Britain should stop trying to pretend that its empire was benevolent," *The Conversation,* 13 May 2016. The critics over the past few decades might best be grouped under the now old label of the New Imperial History, spearheaded in eighteenth-century studies by historians such as Catherine Hall, Mrinalini Sinha, and Kathleen Wilson. Their efforts have been aided by those from scholars in subaltern studies and settler colonial studies.

7. Some innovative examples of such life-focused imperial histories for our period include Linda Colley, *Captives: Britain, Empire and the World, 1600–1850* (London: Jonathan Cape, 2002), Miles Ogborn, *Global Lives: Britain and the World, 1550–1800* (New York: Cambridge University Press, 2008), and Clare Anderson, *Subaltern Lives: Biographies of Colonialism in the Indian Ocean World, 1790–1920* (Cambridge: Cambridge University Press, 2012). These all, however, assemble fairly brief (and rarely entire) lives. Fuller lives are evident in Emma Rothschild, *The Inner Lives of Empire: An Eighteenth-Century History* (Princeton: Princeton University Press, 2012), though these are all imperial. For further discussion of the challenge to write nuanced imperial histories from Indigenous perspectives, see Kate Fullagar and Michael A. McDonnell, eds., *Facing Empire: Indigenous Experiences in a Revolutionary Age* (Baltimore: Johns Hopkins University Press, 2018).

8. For an appraisal of both older histories that assumed an "absence of mind" about empire and later histories that have assumed jingoism, see Kate Fullagar, "Popular Contests over Empire in the Eighteenth Century: The Extended Version," *History Australia* 13/1 (2016): 67–79. This article built on the foundational work of Kathleen Wilson, who showed how there was no absence of mind but argued that the sentiment was chiefly pro-imperial, and of Jack Greene, who showed it was a conflicted discourse but felt it really existed only from the 1760s: Kathleen Wilson, *The Sense of the People: Politics, Culture and Imperialism in England, 1715–1785* (Cambridge: Cambridge University Press, 1995); Jack P. Greene, *Evaluating Empire and Confronting Colonialism in Eighteenth-Century Britain* (Cambridge: Cambridge University Press, 2013).

9. For some historians of British thought, this later summary of Burke is apparently one of the more controversial claims in this book. It is elaborated further in chapters 2 and 6; suffice it here to say it has been influenced by the scholarship of Jennifer Pitts,

"Burke and the Ends of Empire," in *The Cambridge Companion to Edmund Burke,* ed. D. Dwan and C. Insole (Cambridge: Cambridge University Press, 2012), 145–55; Richard Bourke, *Empire and Revolution: The Political Life of Edmund Burke* (Princeton: Princeton University Press, 2015); and Daniel O'Neill, *Edmund Burke and the Conservative Logic of Empire* (Berkeley: University of California Press, 2016).

10. Classic encounter histories include Greg Dening, *Islands and Beaches: Discourse on a Silent Land, Marquesas, 1774–1880* (Honolulu: University of Hawai'i Press, 1980); Richard White, *The Middle Ground: Indians, Empires, and Republics in the Great Lakes Region, 1650–1815* (Cambridge: Cambridge University Press, 1991); Inga Clendinnen, *Aztecs: An Interpretation* (Cambridge: Cambridge University Press, 1991). For a succinct critique of the encounter model for Indigenous biography, see Alice Te Punga Somerville and Daniel Heath Justice, "Indigenous Conversations about Biography," *Biography* 39/3 (2016): 239–47. For a cogent example of Indigenous-centered Indigenous biography, see Michael Oberg, *Uncas: First of the Mohegans* (Ithaca: Cornell University Press, 2006). See further into relevant chapters for citations to the literature on Ostenaco and Mai.

11. James Clifford, *The Predicament of Culture: Twentieth-Century Ethnography, Literature, and Art* (Cambridge: Harvard University Press, 1988), 324. For the most lucid discussion of Clifford's ideas here for history, see Kerwin Lee Klein, *Frontiers of Historical Imagination: Narrating the European Conquest of Native America, 1890–1990* (Berkeley: University of California Press, 1997), 284.

12. The best exception—though it does not center wholly on Reynolds—is Douglas Fordham, *British Art and the Seven Years' War: Allegiance and Autonomy* (Philadelphia: University of Pennsylvania Press, 2010). Fordham's insights no doubt owe more to contextualist work on the role of empire in art institutions than to older kinds of artist-centered work. For contextualist works, see especially Tim Barringer, Geoff Quilley, and Douglas Fordham, eds., *Art and the British Empire* (Manchester: Manchester University Press, 2007), and Bernard Smith, *European Vision and the South Pacific* (Oxford: Oxford University Press, 1960).

13. Liz Cook [Elizabeth Cook-Lynn], "Some Thoughts about Biography," *Wicazo Sa Review* 10/1 (1994): 73. See also Elizabeth Cook-Lynn, "Life and Death in the Mainstream of American Indian Biography," *Wicazo Sa Review* 11/2 (1995): 90–93. In Pacific scholarship, see similar sentiments discussed in Michael Goldsmith, "Telling Lives in Tuvalu," in *Telling Pacific Lives: Prisms of Process,* ed. B. V. Lal and V. Luker (Canberra: ANU Press, 2008), 107–16, and Konai Helo Thaman, "Cultural Rights: A Personal Perspective," in *Culture, Rights, and Cultural Rights: Perspectives from the South Pacific,* ed. M. Wilson and P. Hunt (Wellington: Huia, 2000).

14. Natalie Zemon Davis, *Women on the Margins: Three Seventeenth-Century Lives* (Cambridge: Harvard University Press, 1995).

CHAPTER ONE. THE WARRIOR-DIPLOMAT

1. Jefferson to Adams, 11 June 1812, online at Founders Online, The National Archives: https://founders.archives.gov/documents/Jefferson/03-05-02-0100 (accessed August 2018).

2. The literature on Ostenaco specifically is slim. E. Raymond Evans wrote a thirteen-page biography in "Notable Persons in Cherokee History: Ostenaco," *Journal of Cherokee Studies* (1976): 41–54, and David Corkran assembled a useful encyclopedic entry out of his more general researches: NCpedia, online (1991); http://www.ncpedia.org/biography/osteneco-judds-friend (accessed August 2018). More often Ostenaco features fleetingly in sweeping histories of Cherokee or southeastern American history; for example, John Brown, *Old Frontiers: The Story of the Cherokee Indians* (Kingsport, TN: Southern Publishers, 1938); John Oliphant, *Peace and War on the Anglo–Cherokee Frontier 1756–63* (Baton Rouge: Louisiana State University Press, 2001); and Colin G. Calloway, *The Indian World of George Washington: The First President, the First Americans, and the Birth of the Nation* (New York: Oxford University Press, 2018). Greater details about Ostenaco emerged out of Duane King's wonderful research into Henry Timberlake for the Museum of the Cherokee Indian's 2006 exhibition, "Emissaries of Peace," but these did not add up to new arguments about his biography: see Henry Timberlake, *The Memoirs of Lt. Henry Timberlake,* ed. D. H. King (Cherokee, NC: Museum of the Cherokee Indian, 2007), and D. H. King, "Mysteries of the Emissaries of Peace: The Story Behind the Memoirs of Lt. Henry Timberlake" in *Culture, Crisis, and Conflict: Cherokee British Relations 1756–1765,* ed. A. Rogers and B. Duncan (Cherokee, NC: Museum of the Cherokee Indian, 2009).

3. Some scholars estimate he was born around 1705 in the town of Hiwassee. E. Raymond Evans suggested this in his influential summary "Notable Persons," 42. Evans designated the birthdate by counting back from Timberlake's estimate that Ostenaco was around sixty when he met him in 1762: Timberlake, *The Memoirs,* 27. However, he looks younger than this in his famous portrait by Joshua Reynolds. John Trusler reckons he was forty when he met him the same year: his *Memoirs,* 1809, Lewis Walpole Library, Yale University, MS 71, folio 14. As well, general Cherokee scholars suggest that warriors retired and became elders around the age of fifty-five, but Ostenaco was still an active warrior in the 1760s (see Fred Gearing, "The Structural Poses of 18th-Century Cherokee Villages," *American Anthropologist* 60/6 [1958]: 1152). Evans's estimation of Hiwassee was, I believe, a misinterpretation of a colonial record, which referred to a different utsidihi: see "Talk of Tasitte of Euphassee," 30 July 1751, in *Documents Relating to Indian Affairs,* 2 vols., ed. William M. McDowell Jr. (Columbia: South Carolina Department of Archives and History, 1992) [hereafter referred to as *DRIA*], 1:107–8. The first records on Ostenaco all place him in Tellico.

4. See Tom Hatley, *The Dividing Paths: Cherokees and South Carolinians through the Revolutionary Era* (New York: Oxford University Press, 1995), 8. Peter H. Wood is a bit more conservative at sixteen thousand: "The Changing Population of the Colonial South," in *Powhatan's Mantle Indians in the Colonial Southeast,* ed. P. H. Wood, G. A. Waselkov, and M. T. Hatley (Lincoln: University of Nebraska Press, 1989), 60. T. Gragson and P. Bolstad agree on sixty towns in "A Local Analysis of Early-Eighteenth-Century Cherokee Settlement," *Social Science History* 31/3 (2007): 443. For the country's size, see Gregory Smithers, *The Cherokee Diaspora: An Indigenous History of Migration, Resettlement, and Identity* (New Haven: Yale University Press, 2016), 29.

5. Ostenaco's birth order is suggested in Timberlake, *Memoirs,* 27. For birth rituals, see Theda Perdue, *Cherokee Women* (Lincoln: University of Nebraska Press, 1998), 32–33. Also see John Lawson, *A New Voyage to Carolina* (London, no pub., 1709), 189–90.

6. See S. D. Swearingin, "A Reassessment of Cherokee Identity Consciousness During the Colonial Era," PhD diss., Southern Illinois University, 2005, 71, and Perdue, *Cherokee Women,* 42. Where the Wolf clan was traditionally the source of most warriors, Ani-tsiskwa, or Bird, were usually hunters and keepers of birds; Ani-wodi, or Paint, created a red, plant-based application for healing and adornment; Ani-sahoni, or Blue, made a blue, plant-based application also for healing and adornment; Ani-gatogewi, or Wild Potato, were often gatherers of wild potato and seen to be the traditional land carers; and Ani-gilohi, or Long Hair (sometimes rendered Twister), were often the source of the Peace Chiefs.

7. Perdue, *Cherokee Women,* 42–43.

8. Timberlake, *Memoirs,* 27. Note also James Adair on the superannuated: "The natives live commonly to a great age," in his *The History of the American Indians* (London: Dilly, 1775), 229.

9. See Perdue, *Cherokee Women,* 33, citing William de Brahm (1771) and James Adair (1775).

10. Timberlake, *Memoirs,* 35. Perdue, *Cherokee Women,* 33.

11. See Alexander Longe, "A Small Postscript on the Ways and Manners of the Indians called Cherokees (1725)," reprinted in *Southern Indian Studies* 21 (1969): 32. For Big Head, see the Cherokee scholar William R. Reynolds, *The Cherokee Struggle to Maintain Identity in the 17th and 18th Centuries* (Jefferson, NC: McFarland, 2015), 349. Ostenaco's name is spelled in more than a dozen ways in the colonial archives. I have chosen one of the most common in the eighteenth-century sources. Today, it might be best rendered Ustanakwa.

12. Lawson, *New Voyage,* 238, and Mark Catesby, "Of the Aborigines" (n.d., c. 1730), cited in Hatley, *Dividing Paths,* 59.

13. See C. B. Rodning, "Reconstructing the Coalescence of Cherokee Communities in Southern Appalachia," in *The Transformations of the Southeastern Indians, 1540–1760,* ed. R. Ethridge and C. Hudson (Jackson: University Press of Mississippi, 2002), 172–73, and Trusler, *Memoirs,* folio 20.

14. Adair, *History,* 146. See also Alexander Long stating how "the woman rules the roost and wears the breeches," "Small Postscript (1725)," 30. On towns, see also Rodning, "Reconstructing," 158.

15. Perdue, *Cherokee Women,* 13. See also Michelle LeMaster, *Brothers Born of One Mother: British–Native American Relations in the Colonial Southeast* (Charlottesville: University of Virginia Press, 2012), 15–50.

16. For competing views on this issue, see Perdue, *Cherokee Women,* 41–49; Rodning "Reconstructing," 158; and John Reid, *A Better Kind of Hatchet: Law, Trade, and Diplomacy in the Cherokee Nation during the Early Years of European Contact* (Philadelphia: Pennsylvania State University Press, 1976), 38. Then see Ian Chambers, "The Movement of Great Tellico: The Role of Town and Clan in Cherokee Spatial Understanding," *Native South* 3 (2010): 90, who argues for the duality of town and clan as equally influencing the core of Cherokee identity. And see Tyler Boulware's

ambition not to "dismiss the significance of kinship, but to elevate town . . . to an equal footing with clan membership," *Deconstructing the Cherokee Nation: Town, Region, and Nation among Eighteenth-Century Cherokees* (Gainesville: University Press of Florida, 2011), 5.

17. George Chicken, "Journal . . . to the Cherokee" (1725), cited in Chambers, "The Movement of Great Tellico," 92.

18. Chambers, 93. Timberlake, *Memoirs,* 62.

19. Adair, *History,* 428. And see Trusler, *Memoirs,* folio 16.

20. Skiagunsta [*sic*] to Governor Glen, 5 July 1753, *DRIA,* 1:441.

21. See Hatley, *Dividing Paths,* 12–13. Note that Gearing calls all chiefs priests, which is different from his mention of "priest-specialists" in "Structural Poses," 1150.

22. "Talk of Tasitte," *DRIA,* 1:107–8. Mankillers discussed in Timberlake, *Memoirs,* 122, and Oliphant, *Peace and War,* 5.

23. Jud's Friend to Governor Glen, 31 March 1752, *DRIA,* 1:244.

24. See William Fyffe letter to his brother (1761), cited in Susan Abram, "Real Men: Masculinity, Spirituality, and Community in Late Eighteenth-Century Cherokee Warfare," in *New Men: Manliness in Early America,* ed. T. A. Foster, M. B. Norton, and T. L. Ditz (New York: New York University Press, 2011), 71. I am mindful here of James Merrell's great warning against tinting native history red by repeating the prejudices of colonists, who saw only ferocity in Indians. I hope my Ostenaco chapters, however, defend my understanding of the warrior as central to eighteenth-century Cherokee culture. I aim to refer to warriors only as specific individuals, though, rather than as synonyms for Native Americans in general. See James Merrell, "Second Thoughts on Colonial Historians and American Indians," *William and Mary Quarterly* 69/3 (3rd series): 486.

25. On weapons, see Timberlake, *Memoirs,* 27. On tactics, see Wayne Lee, "Peace Chiefs and Blood Revenge: Patterns of Restraint in Native American Warfare, 1500–1800," *Journal of Military History* 71/3 (2007): 701–41, and Wayne Lee, "Fortify, Fight, or Flee: Tuscarora and Cherokee Defensive Warfare and Military Culture Adaptation," *Journal of Military History,* 68/3 (2004): 713–70.

26. Adair, *History,* 161–62, 416–17. See also Perdue, *Cherokee Women,* 90, and Calloway, *The Indian World of George Washington,* 124–68.

27. See William Anderson, "The Cherokee World Before and After Timberlake," in *Culture, Crisis, and Conflict: Cherokee British Relations, 1756–1765,* ed. A. Rogers and B. Duncan (Cherokee, NC: Museum of the Cherokee Indian, 2009), 8. See also Ken Traisman, "Native Law: Law and Order among Eighteenth-Century Cherokee, Great Plains, Central Prairie, and Woodland Indians," *American Indian Law Review* 9/2 (1981): 273–87.

28. See Hatley, *Dividing Paths,* 22. On the Yamasee War, see also William L. Ramsey, *The Yamasee War: A Study of Culture, Economy, and Conflict in the Colonial South* (Lincoln: University of Nebraska Press, 2010).

29. See Oliphant, *Peace and War,* 4. On Muscogee peoples, see Jean Chaudhuri and Joyotpaul Chaudhuri, *A Sacred Path: The Way of the Muscogee Creeks* (Los Angeles: UCLA American Indian Studies Center, 2001).

30. Boulware, *Deconstructing,* 57.

31. Gearing, "Structural Poses," 1149.

32. Fred Gearing, *Priests and Warriors: Social Structures for Cherokee Politics in the 18th Century* (Menasha, WI: American Anthropological Association, 1962), 18, 26. And see Oliphant, *Peace and War,* 5.

33. Raymond Demere to Gov. Lyttleton, 11 December 1756, *DRIA,* 1:267–68. Demere relates that the complainant was endorsed by Judge's Friend, who "sent me Word to use him well." For factory system, see Boulware, *Deconstructing,* 37, and Joseph M. Hall, *Zamumo's Gifts: Indian–European Exchange in the Colonial Southeast* (Philadelphia: University of Pennsylvania Press, 2009), ch. 6.

34. For fascinating insight into the Cherokee-colonial trade, see Hatley, *Dividing Paths,* 44–47, and Hall, *Zamumo's Gifts,* chs. 6, 7.

35. Adair, *History,* 305.

36. Ostenaco's words in transcript, July 1753, *DRIA,* 1:452. On deerskins, see Perdue, *Cherokee Women,* 70, and Hatley, *Dividing Paths,* 70. See also Gary B. Nash, *Red, White, and Black: The Peoples of Early North America* (Englewood Cliffs: Prentice Hall, 2000), 112.

37. Attakullakulla to Raymond Demere, 13 July 1756, *DRIA,* 2:138. See also Hatley, *Dividing Paths,* 44. On Cherokee gifting relations in general, see Jessica Stern, "Native American Taste: Re-evaluating the Gift–Commodity Debate in the British Colonial Southeast," *Native South* 5 (2012): 1–37.

38. Timberlake, *Memoirs,* 37.

39. Paul Demere to William Lyttelton, 24 November 1757, *DRIA,* 2:417.

40. Timberlake, *Memoirs,* 26–7.

41. On family demographic estimates, see Gragson and Bolstad, "A Local Analysis," 455. For more on games, see Michael Zogry, *Anetso, the Cherokee Ball Game: At the Center of Ceremony and Identity* (Chapel Hill: University of North Carolina Press, 2010).

42. Timberlake, *Memoirs,* 15, 17, 27. Note also William Fyffe (1761): Cherokees "are a hardy people . . . and generally taller than whites," cited in G. S. Woodward, *The Cherokees* (Norman: University of Oklahoma Press, 1963), 36. Note that while many of these miles were covered by foot, Tyler Boulware's research suggests that Ostenaco also traveled a lot by horse: " 'Skilful Jockies' and 'Good Sadlers': Native Americans and Horses in the Southeastern Borderlands," in *Borderland Narratives: Negotiation and Accommodation in North America's Contested Spaces, 1500–1850,* ed. A. G. Frank, and A. G. Crothers (Gainesville: University of Florida Press, 2017), 68–95.

43. Memorial Book of Alexander Cuming. BL Add. Mss. 39. 855, folio 1. See also Kate Fullagar, *The Savage Visit: New World People and Popular Imperial Culture in Britain, 1710–1795* (Berkeley: University of California Press, 2012), 67.

44. See account in Ludovic Grant, *Historical Relation* (1756), reprinted in *South Carolina Historical and Genealogical Magazine* 10/1 (1909): 54–68.

45. See Cuming, Memorial Book, and the periodical, *Political State of Great Britain* (London: Baker & Warner, 1730), 384.

46. Boulware, *Deconstructing,* 48, and Calloway, *The Indian World of George Washington,* 125. Further on the treaty, see Fullagar, *Savage Visit,* ch. 3.

47. Boulware, *Deconstructing,* 49.

48. Cited in K. Mellon, "Christian Priber's Cherokee 'Kingdom of Paradise,'" *Georgia Historical Quarterly* 57/3 (1973): 327. On Priber, see also Claus Bernet, "Christian Priber," in *Bibliographisch-Bibliographisches Kirchenlexikon* (Band 23 Nordhausen, 2004), 1132–38, and V. Crane, "A Lost Utopia of the First American Frontier," *Sewanee Review* 27/1 (1919): 48–61.

49. Grant, *Historical Relation,* 59. Adair, *History,* 240–41.

50. Antoinne Bonnfoy, his MS c. 1740s, reprinted in Samuel Williams, *Early Travels in the Tennessee Country, 1540–1800* (Johnson City, TN: Watauga Press, 1928), 156–57. Adair, *History,* 240.

51. Grant, *Historical Relation,* 59–61. Adair, *History,* 240.

52. See Calloway, *The Indian World of George Washington,* 125–26, countering broad claims about how "Cherokees and the British in South Carolina . . . adhered to a treaty of alliance for more than two decades." See also Kristofer Ray, "Cherokees and Franco–British Confrontation in the Tennessee Corridor, 1730–1760," *Native South* 7 (2014): 33–67.

53. Timberlake saw they were "masterly" in policy making: "We cannot be surprized at it, when we consider that merit alone creates their ministers," *Memoirs,* 37.

54. Talk of Caneecatee of Chote and Others, 22 April 1752, *DRIA,* 1:253. See also Brown, *Old Frontiers,* 46.

55. South Carolina Council Journals, 28 May 1751, cited in D. H. Corkran, *The Cherokee Frontier: Conflict and Survival, 1740–62* (Norman: University of Oklahoma Press, 1962), 15. The best discussion of Glen's proactive politics regarding Indians is Joshua Piker's *The Four Deaths of Acorn Whistler: Telling Stories in Colonial America* (Cambridge: Harvard University Press, 2013), part 1.

56. Governor Glen to the Traders of the Cherokee Nation, 1751, *DRIA,* 1:66–67.

57. Governor Glen to Robert Bunning, 1751, *DRIA,* 1:109.

58. Talk from Jud's Friend to Governor Glen, 31 March 1752, *DRIA,* 1:44.

59. Gregory Evans Dowd has written an illuminating chapter (though not from Ostenaco's perspective) on the events of 1751: *Groundless: Rumors, Legends, and Hoaxes on the Early American Frontier* (Baltimore: Johns Hopkins University Press, 2015), ch. 4.

60. Dinwiddie to Pearis, 2 August 1754, in *The Official Records of Robert Dinwiddie, 1751–1758,* ed. R. A. Brock (Richmond: Virginia Historical Society, 1883), 1:267. And see Brown, *Old Frontiers,* 56.

61. Jud's Friend to Governor Glen, 31 March 1752, *DRIA,* 1:244, and see also talks of "Tassittee" and "headmen" of Tellico, in *DRIA,* 1:254, 255.

62. See Corkran, *Cherokee Frontier,* 39–40.

63. Corkran, 43, 72; Oliphant, *Peace and War,* 22, 37; Daniel Tortora, *Carolina in Crisis: Cherokees, Colonists, and Slaves in the American Southeast, 1756–1763* (Chapel Hill: University of North Carolina Press, 2015), 29ff.

64. Transcript of July 1753 meeting, *DRIA,* 1:433–34.

65. Transcript of July 1753 meeting, *DRIA,* 1:440, 451–52.

66. Perdue, *Cherokee Women,* 25, 44–45, 57–58, 90, 93–94, 99.

67. See William W. Baden, *Tomotley: An Eighteenth Century Cherokee Village* (1983): on-line at http://users.ipfw.edu/baden/anthro/tellico/tomotley/ (accessed August 2018).

68. In English-speaking North America it was first known as the last and greatest "French and Indian War," and it went, in its entirety, for nine years: 1754–63. For a sweeping survey of the war, see Fred Anderson, *Crucible of War: The Seven Years' War and the Fate of Empire in British North America, 1754–1766* (New York: Knopf, 2000).

69. Washington cited in Calloway, *The Indian World of George Washington*, 128. For a good summary of the larger war from an Indian perspective, see Daniel Richter, *Facing East from Indian Country: A Native History of Early America* (Cambridge: Harvard University Press, 2001), 185–86.

70. *A Treaty Held with the Catawba and Cherokee Indians* (1756), cited in Tortora, *Carolina in Crisis*, 29.

71. On forts in Cherokee country generally, see Daniel Ingram, *Indians and British Outposts in Eighteenth-Century America* (Gainesville: University of Florida Press, 2012), ch. 1.

72. Governor Dinwiddie to Richard Pearis, 15 December 1755, *The Official Records of Robert Dinwiddie*, 2:296–97. On Ostenaco's proceeding 1756–58 ventures with Virginians generally, see D. M. Wood, "'I Have Now Made a Path to Virginia': Outacite Ostenaco and the Cherokee–Virginia Alliance in the French and Indian War," *West Virginia History* 2/2 (2008): 31–60.

73. George Washington to Dinwiddie; Lewis, January 1756, *The Official Records of Robert Dinwiddie*, 2:315–16, 322.

74. *Maryland Gazette*, 6 May 1756. And see Tortora, *Carolina in Crisis*, 29.

75. Glen to Dinwiddie, 1 June 1754, *DRIA*, 1:526. See also Corkran, *Cherokee Frontier*, 77.

76. Cited in Tortora, *Carolina in Crisis*, 36.

77. See Cherokee Headmen at the Governor of Virginia, "At the House of Otacite Oustenaka," 21 December 1756, *DRIA*, 2:277. This is *pace* Corkran, who suggests that his prestige fell somewhat due to the poor Virginian fort; NCpedia, online (1991); http://www.ncpedia.org/biography/osteneco-judds-friend (accessed August 2018).

78. See William Gerard de Brahm, "Map indicating the Overhill Cherokee Village of Tomotley," c. 1756, at Frank H. McClung Museum Photographic Collection Public domain. record_0117_000050_000212_0001 Univ. of Tennessee, http://digital.lib.utk.edu/collections/volvoices (accessed August 2018). See also all documents in *DRIA*, 2:277–87. And see Ingram, *Indians and British Outposts*, 27–58.

79. On Lyttelton, see Boulware, *Deconstructing*, 104; Corkran, *Cherokee Frontier*, 142; Tortora, *Carolina in Crisis*, 45.

80. Governor Lyttelton to O Tacite, n. d. *DRIA*, 2:480.

81. Dinwiddie to Washington (June and October 1757), cited in Wood, "I Have Now Made a Path to Virginia," 47. Note that Paul Demere claimed that among Ostenaco's "supplies" for his service was a "white man to wait on him," Paul Demere to William Henry Lyttelton, 11 October 1757, Lyttelton Papers. No other traces of this legacy exist.

82. William Richardson, Diary (1758–59), online at http://www.parsonjohn.org/images/Richardson.pdf (accessed August 2018).

83. Washington (1757), cited in Tortora, *Carolina in Crisis,* 45. For Cherokees in the Duquesne effort generally, see Paul Kelton, "The British and Indian War: Cherokee Power and the Fate of Empire in North America," *William and Mary Quarterly* 69/4 (2012): 763–92.

84. William Richardson, Diary (1758–59), online at http://www.parsonjohn.org/images/Richardson.pdf.

85. Lyttelton to Demere 5 July 1758, Lyttelton Papers. And see Boulware, *Deconstructing,* 106.

86. Demere to Lyttelton, 28 August 1759, Lyttelton Papers. And see Boulware, *Deconstructing,* 109. See also *South Carolina Gazette,* 11–18 August 1759, and Tortora, *Carolina in Crisis,* 67.

87. *South Carolina Gazette,* 13–20 October 1759. See also Tortora, *Carolina in Crisis,* 72ff., and Boulware, *Deconstructing,* 112.

88. Coytmore to Lyttelton, 7 October 1759, Lyttelton Papers. *South Carolina Gazette,* 8–12 January 1760.

89. John Stuart to Lyttelton, cited in Tortora, *Carolina in Crisis,* 78.

90. See the treaty of release in *The Official Papers of Francis Fauquier 1758–1768,* ed. George Reese (Charlottesville: University Press of Virginia, 1980–83), 1:292–94.

91. Miln to Lyttelton, 24 February 1760, *DRIA,* 2:498–500.

92. Alexander Garden to John Ellis, May 26, 1760, cited in Tortora, *Carolina in Crisis,* 100. George Milligen, *A Short Description of the Province of South-Carolina* (London: John Hinton, 1763), 86. Adair, *History,* 250.

93. *South Carolina Gazette,* 21 June 1760.

94. Amherst Papers, 24 February 1760, WO 34/48, ff. 1–5. And see Oliphant, *Peace and War,* 113.

95. *Maryland Gazette,* 5 June 1760. See also Corkran, *Cherokee Frontier,* 198.

96. Amherst papers, 4 June 1760, WO 34/47. And see Oliphant, *Peace and War,* 125.

97. *South Carolina Gazette,* 25 October 1760. The final stages of the campaign are discussed well in Corkran, *Cherokee Frontier,* 211–14.

98. *South Carolina Gazette,* 9–23 August 1760. And see Brown, *Old Frontiers,* 99.

99. See Boulware, *Deconstructing,* 123.

100. See Tortora, *Carolina in Crisis,* 133. See also Alexander Hewatt, *Historical Account of South Carolina and Georgia* (London: Alexander Donaldson, 1779), 56–59.

101. On the numbers, see Oliphant, *Peace and War,* 135; Boulware, *Deconstructing,* 123.

102. Cited in Brown, *Old Frontiers,* 105.

103. Brown, 105. Like Dinwiddie, Bull was actually a lieutenant governor.

104. South Carolina Council Journals for 9 September 1760, cited in Corkran, *Cherokee Frontier,* 230.

105. Amherst to Grant, 15 December 1760, WO 34/48, ff. 38–44.

106. Marion cited in Brown, *Old Frontiers,* 111; Moultrie cited in Tortora, *Carolina in Crisis,* 152.

107. Amherst papers, 13 February 1761, WO 34/48, f. 61. And see Oliphant, *Peace and War,* 143. Grant's journal, cited in Hatley, *Dividing Paths,* 156.

108. See Brown, *Old Frontiers,* 114.

109. Fauquier to Board of Trade, January 1757, *The Official Papers of Francis Fauquier,* 1:146. Fauquier was actually always acting governor.

110. Timberlake, *Memoirs,* 8. Scholars owe Duane King and his team at the Museum of the Cherokee Indian a huge debt for their archival scouring of all things related to Timberlake, evident in the 2007 edition of Timberlake's *Memoirs;* King, though, takes a kinder or more neutral view of the character that emerges from Timberlake's writings.

111. Timberlake, 9.

112. Timberlake, 10–15.

113. Timberlake, 17–18.

114. Timberlake, 42, 45.

115. Timberlake, 55.

116. Timberlake, 55.

117. Fauquier to Board of Trade, 1 May 1762, *The Official Papers of Francis Fauquier,* 2:727–28.

CHAPTER TWO. THE ARTIST-PHILOSOPHER

1. For general discussions, see Roy Porter, ed., *Rewriting the Self: Histories from the Middle Ages to the Present* (London: Taylor and Francis, 2002). See also Mechal Sobel, "The Revolution in Selves," in *Through a Glass Darkly: Reflections on Personal Identity in Early America,* ed. R. Hoffman, M. Sobel, and F. J. Teute (Chapel Hill: University of North Carolina Press, 1997), 163–205; Kathleen Wilson, "Introduction," K. Wilson, ed., *A New Imperial History: Culture, Identity and Modernity in Britain and the Empire, 1660–1840* (Cambridge: Cambridge University Press, 2004), 6–21; and David Sabean and Malina Stefanovska, eds., *Space and Self in Early Modern European Cultures* (Toronto: University of Toronto Press, 2012).

2. C. R. Leslie, with Tom Taylor, *Life and Times of Sir Joshua Reynolds* (London: John Murray, 1865), 1:2–3.

3. See E. A. Wrigley, "The Growth of Population in Eighteenth-Century England: A Conundrum Resolved," *Past and Present* 98 (1983): 122.

4. Daniel Defoe, *The Life and Strange Surprising Adventures of Robinson Crusoe* (London: Buckland, 1772 [1719]), 163. On early eighteenth-century notions of empire, see Kate Fullagar, "Popular Contests over Empire in the Eighteenth Century: The Extended Version," *History Australia* 13/1 (2016): 67–79.

5. For Samuel Reynolds, see Ian McIntyre, *Joshua Reynolds: The Life and Times of the First President of the Royal Academy* (London: Penguin, 2003), 5–9, and Leslie, *Life and Times,* 1:5–7. Plympton was a rotten borough in the eighteenth century, sending its own member to parliament despite being so tiny. The village lost its MP in the great electoral shake-up of the 1832 Reform Act.

6. James Northcote, *The Life of Sir Joshua Reynolds* (London: Henry Colburn, 1819), 1:25.

7. On middling provincial women's activities, see Mary Abbott, *Life Cycles in England 1560–1720: Cradle to Grave* (London: Taylor and Francis, 1996), 62–66.

8. R. M. S. McConaghey, "Sir George Baker and the Devonshire Colic," *Medical History* 11 (1967): 345–60. N. C. Oswald, "Epidemics in Devon, 1538–1837," *Devon Assoc. Adv. of Science* (1977): 469.

9. Cited, McIntyre, *Joshua Reynolds,* 6.

10. Linda Pollock, *Forgotten Children: Parent–Child Relations from 1500 to 1900* (Cambridge: Cambridge University Press, 1983), 130–38. Samuel Reynolds cited in Leslie, *Life and Times,* 1:22. The other child to die young was Humphrey, who drowned at sea.

11. Charles Hoole, *Vocabularium Parvum,* 1666, cited in Abbott, *Life Cycles in England,* 61.

12. See Derek Hudson, *Sir Joshua Reynolds, A Personal Study* (London: Bles, 1958), 11.

13. Citations in Postle in Oxford Dictionary of National Biography Online; Hudson, *Sir Joshua Reynolds,* 12; Leslie, *Life and Times,* 1:8–9.

14. Troy Bickham, "Eating the Empire: Intersections of Food, Cookery and Imperialism in Eighteenth-Century Britain," *Past and Present* 198 (February 2008): 73, 76. See also Woodruff D. Smith, "Complications of the Commonplace: Tea, Sugar, and Imperialism," *Journal of Interdisciplinary History* 23/2 (1992): 259–78. For the general early infiltration of imperial culture, see Kathleen Wilson, *The Sense of the People: Politics, Culture and Imperialism in England, 1715–1785* (Cambridge: Cambridge University Press, 1995), ch. 2.

15. See Maggie Lane, *Jane Austen and Food* (London: Hambledon Press, 1995), 55; Bickham, "Eating the Empire," 99; S. D. Smith, "Accounting for Taste: British Coffee Consumption in Historical Perspective," *Journal of Interdisciplinary History* 27 (1996): 183–214; K. E. Braund, *Deerskins and Duffels: The Creek Indian Trade with Anglo-America, 1685–1815* (Lincoln: University of Nebraska Press, 1993), 87–88.

16. An excellent summary of all this is John Brewer, *The Sinews of Power: War, Money, and the English State, 1688–1783* (Cambridge: Harvard University Press, 1988). For the Glorious Revolution especially, see Steven Pincus, *1688: The First Modern Revolution* (New Haven: Yale University Press, 2009).

17. Cited in N. A. M. Rodger, *The Command of the Ocean: A Naval History of Britain 1649–1815* (London: Penguin, 2006), 234. Note that between 1689 and 1815 Britain was at war for sixty-eight years (or 53 percent of the time).

18. On Plymouth, see Peter Borsay, *The English Urban Renaissance: Culture and Society in the Provincial Town 1660–1770* (Oxford: Oxford University Press, 1989), 47, 142.

19. Reynolds cited in Leslie, *Life and Times,* 1:16.

20. Mary Palmer helped to pay for the apprenticeship: see McIntyre, *Joshua Reynolds,* 13. On apprentices, see Abbott, *Life Cycles in England,* 76–80.

21. See Edmond Malone, who said Reynolds had been "delighted and inflamed" by Richardson in his *The Works of Sir Joshua Reynolds* (London: Cadell & Davies, 1809), 1:viii.

22. Samuel Reynolds cited in Leslie, *Life and Times,* 1:19.

23. First letter cited in Leslie, *Life and Times,* 1:24. Letter of 3 August 1742, in Joshua Reynolds, *The Letters of Sir Joshua Reynolds,* ed. J. Ingamells and J. Edgcumbe (New Haven: Yale University Press, 2000), 4.

24. See Joseph Farington, *Memoirs of Sir Joshua Reynolds* (1819), ed. M. Postle (London: Pallas Athene, 2005), 39. And McIntyre, *Joshua Reynolds*, 28, and Richard Stephens, "City and Country," in *Sir Joshua Reynolds: The Acquisition of Genius,* ed. Sam Smiles (Plymouth: Redcliffe, 2009), 17–27.

25. Jonathan Richardson, *An Essay on the Theory of Painting* (London: A. C., 1725), 13. An excellent introduction to Richardsonian ideas is John Barrell, *The Political Theory of Painting from Reynolds to Hazlitt* (New Haven: Yale University Press, 1986), 1–68. I note a cogent critique of Barrell's book in Andrew Hemingway, "The Political Theory of Painting without the Politics," *Art History* 10/3 (1987): 381–95, but argue that Barrell's insistence on seeing Richardsonian art theory as indirectly political was not "unaware."

26. Malone, *The Works,* 1:x. See also John Brewer, *The Pleasures of the Imagination: English Culture in the Eighteenth Century* (London: HarperCollins, 1997), 300. Reynolds's student Joseph Farington indeed stated that Malone misunderstood the event: *Memoirs,* 41. See also here Stephens, "City and Country," 20–21.

27. On Anson, see Glyndwr Williams, *The Prize of All the Oceans: The Triumph and Tragedy of Anson's Voyage Round the World* (London: HarperCollins, 2008). On the navy and the War of Jenkins' Ear, see Sarah Kinkel, "Disorder, Discipline, and Naval Reform in Mid-Eighteenth-Century Britain," *English Historical Review* 128/535 (2013): 1451–82.

28. On Keppel, see Thomas Keppel, *The Life of Augustus, Viscount Keppel* (London: Colburn, 1842).

29. Reynolds, *Letters,* 7–9.

30. Reynolds, 9.

31. Reynolds, *Discourses,* 171. See also Discourses IV and IX in entirety, and Barrell, *Political Theory of Painting,* 69–162.

32. See Reynolds's Roman notebook cited in Leslie, *Life and Times,* 1:41–42. The best exegesis on eighteenth-century neoclassical thought in general political theory is J. G. A. Pocock, *Virtue, Commerce, History: Essays in Political Thought and History, Chiefly in the Eighteenth Century* (Cambridge: Cambridge University Press, 1985), 1–50. John Barrell ingeniously elaborated how such thought operated—in, of course, more oblique ways—in art theory of the era: see Barrell, *Political Theory of Painting,* 86. See also Reynolds's later Discourse IV in *Discourses,* 60.

33. Reynolds's own reflections in a letter to his friend Edmond Malone, n.d. cited in Leslie, *Life and Times,* 1:43–44.

34. Reynolds cited in Leslie, *Life and Times,* 1:87. On pervasive anti-gallicism, see Gerard Newman, *The Rise of English Nationalism* (New York: St Martin's Press, 1987), 68–84.

35. *The Idler,* 20 October 1757, reprinted in H. W. Beechey, *The Literary Works of Joshua Reynolds* (London: Henry Bohn, 1852), 2:127–30.

36. Vic Gatrell, *The First Bohemians: Life and Art in London's Golden Age* (London: Penguin, 2013), 206–7.

37. See Gatrell, xiv, 142. See also Brewer, *Pleasures of the Imagination,* 28, 211, and Roy Porter, *London: A Social History* (London: Penguin, 2000), 121–224.

38. See Gatrell, *The First Bohemians.*

39. For a theoretical overview of the meaning of new forms of wealth, see Pocock, *Virtue, Commerce, and History,* 103–23. For the physical creation of the new economy's culture, or public sphere, see Lawrence Klein, "Politeness for Plebes: Some Social Identities in Early Eighteenth-Century England," in *The Consumption of Culture: Word, Image, and Object in the Seventeenth and Eighteenth Centuries,* ed. A. Bermingham and J. Brewer (London: Routledge, 1995), 362–82; Brewer, *Pleasures of the Imagination,* 39–50; Lawrence Klein, "Sociability, Solitude and Enthusiasm," in *Enthusiasm and Enlightenment in Europe, 1650–1850,* ed. L. E. Klein and A. J. LaVopa (Los Angeles: Huntington Library Press, 1998), 153–77; and Roy Porter, *The Creation of the Modern World: The Untold Story of the British Enlightenment* (New York: Norton, 2001), 36–38.

40. For an excellent, accessible reading of this portrait, see Mark Hallett, *Reynolds: Portraiture in Action* (New Haven: Yale University Press, 2014), 100–102.

41. David Solkin, "Great Pictures or Great Men? Reynolds, Male Portraiture, and the Power of Art," *Oxford Art Journal* 9/2 (1996): 46.

42. Edgcumbe, cited in Leslie, *Life and Times,* 1:104–5. The student was Joseph Farington, *Memoirs,* 61. Malone, *The Works,* 1:xxiii. Popular print by Fisher, reported by Samuel Felton, *Testimonies to the Genius and Memory of Joshua Reynolds* (London: Walker, 1792), 9.

43. See pocketbooks toted up in Leslie, *Life and Times,* 1:101–2.

44. Reynolds, *Letters,* 14–15.

45. See Randolph Trumbach "London's Sodomites: Homosexual Behavior and Western Culture in the 18th Century," *Journal of Social History* 11/1 (1977): 1–33. On Reynolds's *Cupid,* see Martin Postle, *Sir Joshua Reynolds: The Subject Pictures* (Cambridge: Cambridge University Press, 1995), 94–95.

46. See Alexandra Shepard on the seventeenth-century bachelor in her *Meanings of Manhood in Early Modern England* (Oxford: Oxford University Press, 2003), 168, 206–7, 213. She shows that single men after a certain age were often considered "fugitives"; were "more vulnerable to accusations of sexual dishonor"; and were frequently excluded from several "trading privileges." See also Klein, "Politeness for Plebes," and Klein, "Sociability, Solitude and Enthusiasm." For increasing homosociality, see Tim Hitchcock, "Redefining Sex in Eighteenth-Century England," *History Workshop Journal* 41 (1996): 77.

47. Edmund Burke, cited in Richard Wendorf, *Sir Joshua Reynolds: The Painter in Society* (Cambridge: Harvard University Press, 1996), 61.

48. Malone and Boswell both cited in Wendorf, 15, 27.

49. Farington, *Memoirs,* 27; James Northcote in William Hazlitt, *Conversation with James Northcote* (London: Colburn & Bentley, 1830), 325.

50. Goldsmith cited in McIntyre, *Joshua Reynolds,* 274.

51. Charles Burney cited in Wendorf, *Sir Joshua Reynolds,* 28.

52. See James Northcote, who declared that "politics never amused him nor ever employed his thoughts for a moment": *The Life,* 2:250.

53. For Reynolds as latently Tory, see Gatrell, *The First Bohemians,* 204, and McIntyre, *Joshua Reynolds,* 141. For Reynolds as circumstantially Whig, see Wendorf, *Sir Joshua*

Reynolds, 196–99, and Douglas Fordham, *British Art and the Seven Years' War: Allegiance and Autonomy* (Philadelphia: University of Pennsylvania Press, 2010), 171.

54. Northcote, *The Life,* 2:282.

55. On Toryism, see Linda Colley, *In Defiance of Oligarchy: The Tory Party 1714–60* (Cambridge: Cambridge University Press, 1982), and Eliga H. Gould, *The Persistence of Empire: British Political Culture in the Age of the American Revolution* (Chapel Hill: University of North Carolina, 2000), 35–71. A good summary of eighteenth-century political labels can be found in Iain Hampsher-Monk's "British Radicalism" in *The Cambridge History of Eighteenth-Century Political Thought,* ed. M. Goldie and R. Wokler (Cambridge: Cambridge University Press, 2006), 660–87. However, there is also a case to be made for the benefits of taking a wider view of the period's politics, sidestepping its intricately differentiated labels, and seeing its forest as rather tending toward two great ideological positions, which for simplicity's sake I have labeled Toryish, including most Patriot, Country, and Blue Water positions, and Whiggish, referring chiefly to liberty heralding expansionists: see Pocock, *Virtue, Commerce, and History,* 32.

56. Cited in Frederick Hiles, ed., *Portraits* (New York: McGraw Hill, 1952), 76.

57. Charles Burney cited in Wendorf, *Sir Joshua Reynolds,* 28.

58. James Boswell, *The Life of Samuel Johnson,* ed. William Wallace (Edinburgh: Nimmo, Hay & Mitchell, 1887), 138.

59. See McIntyre, *Joshua Reynolds,* 487.

60. Malone, *Works,* 1:cii.

61. James Northcote, *Memoirs of Sir Joshua Reynolds, Knt* (London: Colburn, 1813), 254. See above, note 55, on political labels. For more on Whiggism, though, see Gould, *The Persistence of Empire,* 1–34. Gould contends that Whiggism was by far the dominant leaning through the age, though his own book provides loads of evidence to suggest that, through the prism of expansion, it was rather deeply contested.

62. Edmund Burke, *The Correspondence of Edmund Burke,* ed. T. W. Copeland et al. (Cambridge: Cambridge University Press, 1958–78), vii, 75. Burke's letter to Malone, reprinted in H. C. Mansfield, *Selected Letters of Edmund Burke* (Chicago: University of Chicago Press, 1984), 123.

63. See Samuel Johnson, *Taxation No Tyranny* (London: Cadell, 1775), 89. See also Samuel Johnson, "Observations of the State of Affairs in 1756," *Literary Magazine* 4 (15 July–15 August 1756): 161–65: https://andromeda.rutgers.edu/~jlynch/Texts/observations.html, and Samuel Johnson, *The Idler* 81 (3 November 1759). On Johnson and empire, see John Cannon, *Samuel Johnson and the Politics of Hanoverian England* (Oxford: Oxford University Press, 1994), chs. 3, 7; Carol Watts, *The Cultural Work of Empire: The Seven Years' War and the Imagining of the Shandean State* (Toronto: University of Toronto Press, 2007), 40; and Thomas Keymer, "To Enjoy or Endure: Samuel Johnson's Message to America," *Times Literary Supplement,* 27 March 2009.

64. On Burke and empire, see Jennifer Pitts, "Burke and the Ends of Empire," in *The Cambridge Companion to Edmund Burke,* ed. D. Dwan and C. Insole (Cambridge: Cambridge University Press, 2012), 145–55, and Daniel O'Neill, *Edmund Burke and the Conservative Logic of Empire* (Berkeley: University of California Press, 2016).

65. See Brewer, *The Sinews of Power,* 29–30.

66. Johnson, "Observations of the State of Affairs in 1756," 161–65. On Johnson's imperial politics, see note 63, and Jack Lynch, ed., *Samuel Johnson in Context* (Cambridge: Cambridge University Press, 2012): chapters by Sharon Harrow on "Empire," 182–90, Nicholas Hudson on "Social hierarchy," 360–66, and John Richardson on "War," 393–99.

67. Edmund Burke, *Account of the European Settlements in America* (1757), 298, 328: https://catalog.hathitrust.org/Record/009008422. See also Richard Bourke, "Edmund Burke and the Politics of Conquest," *Modern Intellectual History* 4/3 (2007): 403–32.

68. *Public Advertiser,* 27 August 1755. For the battle, see David L. Preston, *Braddock's Defeat: The Battle of the Monongahela and the Road to Revolution* (New York: Oxford University Press, 2015).

69. See Hallett, *Reynolds,* 165–70, and Fordham, *British Art and the Seven Years' War,* 68–70.

70. *Lloyd's Evening Post,* 29 May 1761, and Northcote in his *The Life* (1819). See Hallett, *Reynolds,* 170–74.

71. Both Walpole and Talbot cited in Shaun Regan and Frans de Brun, "Introduction" to their edited collection *The Culture of the Seven Years' War: Empire, Identity, and the Arts in the Eighteenth-Century Atlantic World* (Toronto: University of Toronto Press, 2014), 10. See also Richard Middleton, *The Bells of Victory: The Pitt–Newcastle Ministry and the Conduct of the Seven Years' War, 1757–1762* (Cambridge: Cambridge University Press, 1985).

72. Cited Regan and de Brun, "Introduction," 12.

73. Samuel Johnson, *The Prince of Abissinia: A Tale* [later known as *The History of Rasselas*] (London: Dodsley and Johnston, 1759); Samuel Johnson, *The Idler* 81 (3 November 1759). See also here Keymer, "To Enjoy or Endure."

74. Edmund Burke in *Annual Register* (1760): 43.

75. The proposer was Francis Hayman, an old friend and peer of Thomas Hudson. The poet was Samuel Boyce, a contemporary of Reynolds. Both in the *Royal Magazine* (November 1759): 265.

76. See Matthew Hargraves, *Candidates for Fame: The Society of Artists for Great Britain, 1760–1791* (New Haven: Yale University Press, 2005), 15, and Brandon Taylor, *Art for the Nation: Exhibitions and the London Public* (Manchester: Manchester University Press, 1999), 7.

77. Note this civic organization was called the Society for the Encouragement of Arts, Manufacture and Commerce. See Hargraves, *Candidates,* 17–23. See also Brian Allen, "The Society of Arts and the First Exhibition of Contemporary Art in 1760," *RSA Journal* 139/5416 (1991): 265–69.

78. John Gwynne, *London and Westminster Improved* (London: The Author, 1766). See also Hallett, *Reynolds,* 156.

79. "An Account of the late Exhibition of Pictures," *Imperial Magazine, or Complete Monthly Intelligencer* 2 (1760): 244–48.

80. "The Papers of the Society of Artists of Great Britain," cited in David Solkin, *Painting for Money: The Visual Arts and the Public Sphere in Eighteenth-Century England* (New Haven: Yale University Press, 1993), 178. For the second exhibition, see also Hargraves, *Candidates*, 30–35, and Taylor, *Art for the Nation*, 8–14. Note the Society of Artists was not officially incorporated till 1765. Note also that in 1761 the society ended up charging a shilling for a catalogue, which turned into the price of a season's admission. Only in 1762 was there a flat, actual entrance fee—with now an additional cost for the catalogue.

81. On the dissenters, see Algernon Graves, *The Society of Artists of Great Britain, 1760–1791, the Free Society of Artists, 1761–1783* (London: Bell, 1907).

82. A great discussion is in Solkin, *Painting for Money*, 157–213. See also Taylor, *Art for the Nation*, 11, and Hargraves, *Candidates*, 27. For Reynolds's part in it all, see Allen, "Society of Arts," 268, and McIntyre, *Joshua Reynolds*, 132.

83. See Brewer, *Pleasures of the Imagination*, 232.

84. Cited in McIntyre, *Joshua Reynolds*, 136.

85. Catalogue cited in Graves, *The Society of Artists*, 317–18.

86. Taylor, *Art for the Nation*, 13. See also Hargraves, *Candidates*, 35.

87. Reynolds, *Discourses*, 233.

88. Edward Edwards, cited in Taylor, *Art for the Nation*, 14.

89. See Paul Langford, *A Polite and Commercial People* (Oxford: Oxford University Press, 1989), 331–88; Linda Colley, *Britons: Forging a Nation 1707–1837* (London: Pimlico, [1992] 1994), 101–3; and Gould, *The Persistence of Empire*, 106–47.

90. On the predominant subjects, see some descriptions listed in Graves, *The Society of Artists*, 1–292.

91. On Vernon and Kingsley, see Hallett, *Reynolds*, 148–50.

92. Nelly O'Brien was the mistress of the 2nd Viscount Bolingbroke, who perhaps carved out few political views of his own amidst his notorious extramarital affairs but who nonetheless carried his staunchly Tory uncle's title. On the 1762 portraits, see Graves, *The Society of Artists*, 211.

93. Northcote, *The Life*, 1:111.

94. See W. J. Bate, *Samuel Johnson* (New York: Harcourt, 1977), 391, describing how Johnson was ribbed that spring for writerly dilatoriness. Johnson's later trip to Plymouth that year, Boswell attests, gave him "a great accession of new ideas," Boswell, *Life of Samuel Johnson*, 107.

CHAPTER THREE. A CHEROKEE ENVOY AND
THE PORTRAIT THAT FAILED

1. *The Official Papers of Francis Fauquier 1758–1768*, ed. George Reese (Charlottesville: University Press of Virginia, 1980–83), 2:727–8.

2. *Official Papers of Francis Fauquier*, 2:730.

3. Duane King claims Woyi died in 1777; see his editorial comment in Henry Timberlake, *The Memoirs of Lt. Henry Timberlake*, ed. D. H. King (Cherokee: Museum of the Cherokee Indian, 2007), 132. Aside from King, short accounts of the

visit include John Oliphant, "The Cherokee Embassy to London, 1762," *Journal of Imperial and Commonwealth History* 27/1 (1999): 1–26; Alden Vaughan, *Transatlantic Encounters: American Indians in Britain, 1500–1776* (New York: Cambridge University Press, 2006), 165–89; Kate Fullagar, *The Savage Visit: New World People and Popular Imperial Culture in Britain, 1710–1795* (Berkeley: University of California Press, 2012), 88–109; and Coll Thrush, *Indigenous London: Native Travelers at the Heart of Empire* (New Haven: Yale University Press, 2016), 68–73, 88–92. All the foregoing have figured the visit more in imperial contexts than in Cherokee ones.

4. *Official Papers of Francis Fauquier,* 2:731.

5. Timberlake, *Memoirs,* 56. See also Tom Hatley, "An Epitaph for Henry Timberlake," in *Culture, Crisis, and Conflict: Cherokee British Relations 1756–1765,* ed. A. Rogers and B. Duncan (Cherokee: Museum of the Cherokee Indian, 2009), 19–33.

6. Timberlake, *Memoirs,* 81, 128.

7. See Timberlake, 58. I calculate maritime odds from the roughly 5 percent naval death rate given in N. A. M. Rodger, *The Wooden World: An Anatomy of the Georgian Navy* (London: Collin, 1986), 99–102, and the roughly 3 percent crude midcentury English death rate tabled in J. Schellekens, "Irish Famines and English Mortality in the Eighteenth Century," *Journal of Interdisciplinary History* 27/1 (1996): 35.

8. Timberlake, *Memoirs,* 58.

9. Timberlake, 58. *Lloyd's Evening Post,* 21–23 June 1762. Also *St James's Chronicle,* 19 June 1762.

10. See Oliphant, "The Cherokee Embassy," 11. See also Timberlake, *Memoirs,* 59.

11. H. M. Scott, "Charles Wyndham," Oxford Dictionary of National Biography Online. And see Edward J. Cashin, *Governor Henry Ellis and the Transformation of British North America* (Athens: University of Georgia Press, 1994).

12. Timberlake, *Memoirs,* 59.

13. See Duane King, "Mysteries of the Emissaries of Peace," in *Culture, Crisis, and Conflict,* ed. Rogers and Duncan, 156.

14. Timberlake, *Memoirs,* 59.

15. Timberlake, 59. Egremont to Fauquier, 10 July 1762, CO 5/1345, ff. 9–10.

16. Synthetic accounts of these visits as a "Native American" tradition exist in C. T. Foreman, *Indians Abroad 1493–1938* (Norman: University of Oklahoma Press, 1943) and Vaughan, *Transatlantic Encounters.* Later scholars have seen this tradition is better figured as one involving "New World" Indigenous people: Fullagar, *Savage Visit,* and Thrush, *Indigenous London.* (Strangely, this picks up on an earlier vision, exemplified in literary works such as H. N. Fairchild, *The Noble Savage: A Study in Romantic Naturalism* [New York: Columbia University Press, 1928].) Excellent work also exists on single episodes within the tradition, such as Eric Hinderaker's "The 'Four Indian Kings' and the Imaginative Construction of the First British Empire," *William and Mary Quarterly* 53 (1996): 487–526.

17. *St James's Chronicle,* 24–26 June 1762. *British Magazine* (July 1762): 378.

18. Timberlake, *Memoirs,* 72.

19. Timberlake, 59. *Public Register,* 20 July 1762.

20. *Public Register,* 20 July 1762.

21. *The Annual Register for 1762* (London: Dodsley, 1763), 3.

22. *The Royal Magazine,* 16 July 1762. Henry Howard, *A New Humorous Song of the Cherokee Chiefs* (London: The Author, 1762). *St James's Chronicle,* 21 August 1762.

23. *London Chronicle,* 24 August 1762. Indigenous visits as a lightning rod for both pro- and anti-imperial sentiment is the central thesis of my earlier book, *Savage Visit.*

24. Timberlake, *Memoirs,* 62, 67. See also *Lloyd's Evening Post,* 28 July 1762; cf. *St James's Chronicle,* 3 July 1762.

25. Timberlake, *Memoirs,* 66.

26. Timberlake, 64–65.

27. See Fullagar, *Savage Visit,* 94, and John Forster, *The Life and Times of Oliver Goldsmith* (Leipzig: Bernard Tauchnitz, [1848] 1873), 1:217. See also Jack Plumb on Goldsmith's hatred of being laughed at and his approval-seeking: http://www.ourcivilisation.com/smartboard/shop/goldsmth/about.htm (accessed March 2018).

28. Goldsmith dedicated *The Deserted Village* (1770) to Reynolds since his brother was dead and Reynolds seemed like the next closest kin. After Goldsmith's death in 1774, Reynolds attempted a short biography, which acknowledged Goldsmith's great feeling and "real genius" but also recognized that many thought him "an idiot inspired." See Ian McIntyre, *Joshua Reynolds: The Life and Times of the First President of the Royal Academy* (London: Penguin, 2003), 159, 211, 272–74.

29. Goldsmith's Altangi did not spare much sympathy for American "savages," but he did acknowledge that they had been "in possession" of the land in question "for time immemorial." Later, these fake letters were collated into a book, *A Citizen of the World,* which became one of Goldsmith's best-known works.

30. See McIntyre, *Joshua Reynolds,* 140, and *St James's Chronicle,* 6 July 1762.

31. See *Paul Henry Ourrey,* 1748, in David Mannings, *Sir Joshua Reynolds: The Complete Catalogue* (New Haven: Yale University Press, 2000), plates vol., 3, and text vol., 359, and *Lady Elizabeth Keppel,* 1761, in Mannings, *Sir Joshua Reynolds,* plates vol., 45, and text vol., 291. For a survey of eighteenth-century portrayals of black people, including Reynolds's, see David Bindman, "Subjectivity and Slavery in Portraiture: From Courtly to Commercial Societies," *Slave Portraiture in the Atlantic World,* ed. in Agnes Lugo-Ortiz and Angela Rosenthal (Cambridge: Cambridge University Press, 2013), 71–88.

32. For disentangling this title, thanks to Stephanie Pratt, "Reynolds's King of the Cherokees," *Oxford Art Journal* 21/2 (1998): 147. Reynolds had advancing deafness. Note that Ostenaco was sometimes known as Ostenaca. Also, as Pratt points out, one of the seven Cherokees to visit Britain in 1730 was named Oukah. The Indigenous scholar Pratt provides the only extended analysis of *Scyacust Ukah* in print.

33. For lack of portraiture painting, see Susan Power, *Art of Cherokee: Prehistory to the Present* (Athens: University of Georgia Press, 2007). An old tradition of mask making in Cherokee culture was more about adorning a face than representing it. On the critical transition process to warrior mode, see Ian Chambers, "The Movement of Great Tellico: The Role of Town and Clan in Cherokee Spatial Understanding," *Native South* 3 (2010): 89–102. See also for clay balls (http://childrenofthesunnativeculture.com/cosnc/?q=node/49)

34. See Pratt, "Reynolds' King of the Cherokees," and also Oxford Dictionary of National Biography Online for Francis Parsons.

35. *British Chronicle*, 2 July 1762.

36. Timberlake, *Memoirs*, 59.

37. See John Oliphant, "Lord Egremont and the Indians" in *Culture, Crisis, and Conflict*, ed. Rogers and Duncan, 124.

38. Timberlake, *Memoirs*, 69–72.

39. See Timberlake, 71, 146, and *Gazetteer and London Daily Advertiser*, 9 July 1762.

40. *St James's Chronicle*, 1 July 1762.

41. Official transcript reproduced by Duane King in Timberlake, *Memoirs*, 147. See also *Gazetteer and London Daily Advertiser*, 9 July 1762.

42. See George III Certificate, 16 August 1762, reproduced: https://arts-sciences. und.edu/native-media-center/_files/docs/1400-1763/certificationofroyalvisit1762. pdf (accessed March 2018). And see Egremont to Boone, 7 August 1762, CO 5/214 Part 2.

43. Timberlake, *Memoirs*, 71–72.

44. *Lloyd's Evening Post*, 13 August 62. See also *London Evening Post*, 6 July 1762, and *Public Advertiser*, 24 July and 30 July 1762. See Warwick Wroth, *The London Pleasure Gardens of the Eighteenth Century* (London: Macmillan, [1896] 1979), 48–53, and Foreman, *Indians Abroad*, 75.

45. See Wroth, *London Pleasure Gardens;* David Solkin, *Painting for Money: The Visual Arts and the Public Sphere in Eighteenth-Century England* (New Haven: Yale University Press, 1993), 106–56; and John Brewer, *The Pleasures of the Imagination: English Culture in the Eighteenth Century* (London: HarperCollins, 1997), 59–74.

46. Timberlake, *Memoirs*, 20–21, 40–41, 43, 62. And see *South Carolina Gazette*, 2 October 1762.

47. *Lloyd's Evening Post*, 2 August 1762.

48. *St James's Chronicle*, 31 July 1762; *Public Advertiser*, 7 August 1762; *London Chronicle*, 27 July 1762; "You Know Who" in *St James's Chronicle*, 7 August 1762.

49. Again, this contention derives from and is more fully explicated in my earlier work, *Savage Visit.*

50. Timberlake, *Memoirs*, 72–3.

51. *St James's Chronicle*, 7 August 1762.

52. *Lloyd's Evening Post*, 12 August 1762.

53. *Public Advertiser*, 20 August 1762. See also *Gentleman's Magazine*, 20 August 1762.

54. K. N. Cameron, *Samuel Johnson: A Biography* (Cambridge: Harvard University Press, 1974), 287, 354.

55. James Northcote, *The Life of Sir Joshua Reynolds* (London: Henry Colburn, 1819), 1:111. On Johnson's rationale for the Plymouth trip and his *Dictionary* quotation, see David Nokes, *Samuel Johnson: A Life* (London: Faber, 2009), 201.

56. See G. B. N. Hill, ed., *Johnsonian Miscellanies* (London: Clarendon Press, 1897), 2:455, 299, and Joseph Farington, *The Farington Diary* (London: Hutchinson, 1924), 4:208.

57. Northcote, *The Life*, 2:161.

58. For these anecdotes, see James Boswell, *The Life of Samuel Johnson,* ed. William Wallace (Edinburgh: Nimmo, Hay & Mitchell, 1887), 107, and Hill, *Johnsonian Miscellanies,* 2:278.

59. Boswell, *Life of Johnson,* 107.

60. See both Boswell, *Life of Johnson,* 107, and H. W. Beechey, *The Literary Works of Sir Joshua Reynolds* (London: Cadell, 1835), 1:158.

61. Egremont to Boone, 7 August 1762, CO 5/214 Part 2.

CHAPTER FOUR. HOME TO A NEW WORLD

1. Blake to Egremont, 17 November 1762, CO 5/390.

2. Boone to Egremont, 11 November 1762, CO 5/390.

3. *Papers of Henry Laurens,* ed. P. M. Hamer and G. C. Rogers (Colombia: University of South Carolina Press, 1972), 3:286.

4. See Tom Hatley, *The Dividing Paths: Cherokees and South Carolinians through the Revolutionary Era* (New York: Oxford University Press, 1995), 155–56, and Tyler Boulware, *Deconstructing the Cherokee Nation: Town, Region, and Nation among Eighteenth-Century Cherokees* (Gainesville: University Press of Florida, 2011), 130.

5. The most eloquent articulation of this interpretation is in Hatley, *Dividing Paths,* 161. See also Boulware, *Deconstructing,* 131. For traders who saw the implications of hog farming, see James Adair, *The History of the American Indians* (London: Dilly, 1775), 230.

6. Hatley, *Dividing Paths,* 163.

7. *Papers of Henry Laurens,* iii, 286.

8. See Hatley, *Dividing Paths,* 159.

9. Boulware, *Deconstructing,* 111.

10. John Lawson, *A New Voyage to Carolina* (London, no pub., 1709), 190.

11. Francis Parkman, *Montcalm and Wolfe: France and England in North America* (Boston: Little, Brown, [1884] 1901), 2:391. See this cited and analyzed especially in Colin G. Calloway, *The Scratch of a Pen: 1763 and the Transformation of North America* (Oxford: Oxford University Press, 2006).

12. See Calloway, *Scratch of a Pen,* 18ff.

13. See Michael A. McDonnell, *Masters of Empire: Great Lakes Indians and the Making of America* (New York: Hill and Wang, 2015), and Colin G. Calloway, *The American Revolution in Indian Country: Crisis and Diversity in Native American Communities* (New York: Cambridge University Press, 1995). On tone and focus, see also Daniel Richter, *Facing East from Indian Country: A Native History of Early America* (Cambridge: Harvard University Press, 2001), 187.

14. McDonnell, *Masters of Empire,* 216.

15. See Richter, *Facing East,* 192, and Calloway, *Scratch of a Pen,* 69.

16. Cited in Gregory Evans Dowd, *War under Heaven: Pontiac, the Indian Nations, and the British Empire* (Baltimore: Johns Hopkins University Press, 2004), 77.

17. On Cherokee reluctance to join Pontiac War, see Boulware, *Deconstructing,* 137, and Hatley, *Dividing Paths,* 159.

18. Reprinted in *London Gazette,* 4 October 1763.

19. See Edward J. Cashin, *Governor Henry Ellis and the Transformation of British North America* (Athens: University of Georgia Press, 1994), 153. See also John Oliphant, *Peace and War on the Anglo–Cherokee Frontier 1756–63* (Baton Rouge: Louisiana State University Press, 2001), 200–201.

20. Only Oliphant has raised the same question, but he did not pursue it: *Peace and War,* 201.

21. Ellis, "Hints Relative to the Division and Government of the Conquered and Newly Acquired Countries in America," 5 May 1763, PRO CO 323/16, also transcribed at http://academic.brooklyn.cuny.edu/history/dfg/amrv/ellisplan.htm. Note that the contrast of a porous border with a dividing border is from Hatley, *Dividing Paths,* 204.

22. Royal proclamation in *London Gazette,* 4 October 1763.

23. See Cashin, "The Crucial Year," 16: http://archives.columbusstate.edu/gah/1990/16-23.pdf (accessed 22 June 2017).

24. See Calloway, *Scratch of a Pen,* 102. Most historians mention there were seven hundred men, but Cashin reminds that there were also two hundred women present: "The Crucial Year," 19–20.

25. Minutes of the Southern Congress at Augusta, Georgia, copied from PRO South Carolina B. T. xx, m. 92 at http://docsouth.unc.edu/csr/index.html/document/csr11-0084. This document states only that the "Prince of Chota" was the second speaker; Corkran claims that this is Kittagusta: D. H. Corkran, *The Cherokee Frontier: Conflict and Survival, 1740–62* (Norman: University of Oklahoma Press, 1962), 267.

26. See Cashin, "The Crucial Year," 19–20. See also Steven Hahn, *The Invention of the Creek Nation, 1670–1763* (Lincoln: University of Nebraska Press, 2004), 266.

27. Cashin, "The Crucial Year," 21.

28. Cited in Boulware, *Deconstructing,* 134, 136.

29. For a discussion, see Daniel Tortora, *Carolina in Crisis: Cherokees, Colonists, and Slaves in the American Southeast, 1756–1763* (Chapel Hill: University of North Carolina Press, 2015), 138.

30. Minutes of the Southern Congress at Augusta, Georgia (1763) [PRO South Carolina B. T. xx, m. 92], 199.

31. A. Cameron to J. Stuart, 3 February 1765, CO 323/23/234–38. See also Dowd, *War under Heaven,* 227.

32. A. Cameron to J. Stuart, 3 February 1765, CO 323/23/234–38. See also Dowd, *War under Heaven,* 227, and Boulware, *Deconstructing,* 138.

33. A. Cameron to J. Stuart, 3 February 1765, CO 323/23/234–38.

34. See Dowd, *War under Heaven,* 213.

35. Copy of "Talk from the Headman and Warriors of the Cherokee Nation dated Fort Prince George 20th October 1765," *Colonial Records of North Carolina,* 7:115–17. At http://docsouth.unc.edu/csr/index.html/document/csr07-0036 (accessed 16 June 2014). See also D. E. Davis, *Where There Are Mountains: An Environmental History of the Southern Appalachians* (Athens: University of Georgia Press, 2003), 59–66, and K. E. H. Braund, *Deerskins and Duffels: The Creek Indian Trade with Anglo-America, 1685–1815* (Lincoln: University of Nebraska Press, 1993), 164–88.

36. "Jud's Friend's Talk to Governor Tryon in Answer to his Excellency's Talk delivered yesterday at Tyger River Camp," *Colonial Records of North Carolina,* 7:464–66. At http://docsouth.unc.edu/csr/index.html/document/csr07-0194 (accessed 16 June 2014).

37. See Treaty of Hard Labor transcribed: http://jeffersonswest.unl.edu/archive/view_doc.php?id=jef.00089 (accessed 22 June 2017) (Colonial Records of North Carolina, 1886–90, 7:851–55).

38. Speeches Made by Judd's Friend at Chota, 17 March 1771, CO 5/661.

39. A Talk from the headmen and warriors of the Cherokee Nation [to John Stuart], 29 July 1769, CO 5 /70.

40. Treaty of Lochaber: http://jeffersonswest.unl.edu/archive/view_doc.php?id=jef.00091 (accessed 1 June 2017). A General Meeting of the Principal Chiefs and Warriors of the Cherokee Nation, Lochaber, 18 October 1770, CO 5/72.

41. A General Meeting of the Principal Chiefs and Warriors of the Cherokee Nation, Lochaber, 18 October 1770, CO 5/72.

42. Virginian cession: John Stuart to the Earl of Hillsborough, 12 June 1772, CO 5/73, 162–66. Georgia cession: Dartmouth letter to Governor Wright, 10 June 1773, CO 5/662, and Letters from John Stuart, 16 June–24 August 1773, CO 5/74.

43. For the Henderson incident, see Claudio Saunt, *West of the Revolution: An Uncommon History of 1776* (New York: W. W. Norton, 2014), 17–23.

44. Depositions of John Lowry (1777) and John Reid (1777), in *Calendar of Virginia State Papers and other Manuscripts 1652–1781,* ed. W. M. P. Palmer (Richmond: Walker, 1875), 1:283, 284–85.

45. Speeches Made by Judd's Friend at Chota, 17 March 1771, CO 5/661.

46. Deposition of Charles Robertson (1777), *Calendar of Virginia State Papers,* 1:291.

47. For the nickname, see Oconostota in July 1777, cited in John Brown, *Old Frontiers: The Story of the Cherokee Indians* (Kingsport, TN: Southern Publishers, 1938), 165 (see also 5): "You Carolina Dick . . . Why are you always telling lies?" For Dragging Canoe's part, see Depositions of Samuel Wilson (1777), John Reid (1777), and Charles Roberston (1777): *Calendar of Virginia State Papers,* 1:283, 284, 291.

48. Dragging Canoe's words in Letter from Henry Stuart to John Stuart, 25 August 1776, CO 5/77.

49. On the habits of Native American elders at this time, see Hahn, *Invention of the Creek Nation,* 272–77. For controversy over payment amounts, see Saunt, *West of the Revolution,* 22–23, 217.

50. See N. Inman, "'A Dark and Bloody Ground': American Indian Responses to Expansion during the American Revolution," *Tennessee Historical Society* 70/4 (2011): 263, Hatley, *Dividing Paths,* 213, Boulware, *Deconstructing,* 157, and Deposition of Charles Robertson, 3 October 1777, in *Calendar of Virginia State Papers,* 1:291.

51. A General Meeting of the Principal Chiefs and Warriors of the Cherokee Nation, Lochaber, 18 October 1770, CO 5/72.

52. Dragging Canoe's words in Letter from Henry Stuart to John Stuart, 25 August 1776, CO 5/77.

53. *Papers of Henry Laurens,* 9:229. See also Jim Piecuch, *Three Peoples, One King: Loyalists, Indians, and Slaves in the Revolutionary South, 1775–1782* (Columbia: University of

South Carolina Press, 2008), 69; and James O'Donnell, *Southern Indians in the American Revolution* (Knoxville: University of Tennessee Press, 1973), 46–64.

54. Cited in Piecuch, *Three Peoples, One King,* 70.

55. See Calloway, *American Revolution in Indian Country,* 198.

56. Both revolutionary quotes in Calloway, 197, and Tortora, *Carolina in Crisis,* 193. For final tallies, see Piecuch, *Three Peoples, One King,* 71–72.

57. See Calloway, *American Revolution in Indian Country,* 198, 201.

58. On the misnomer of secessionism, see Boulware, *Deconstructing,* 152–53.

59. See Calloway, *American Revolution in Indian Country,* 201, and Hatley, *Dividing Paths,* 222.

60. Dewitts Corner is now known as Due West, South Carolina. For a facsimile of the treaty, see http://teachingushistory.org/lessons/treatyofdewittscorner.htm (accessed 22 June 2017).

61. See full transcription in A. Henderson, "The Treaty of Long Island of Holston, July 1777," *North Carolina Historical Review* 8/1 (1931): 74.

62. See transcription in Henderson, 112.

63. Details of Chickamauga history are slim, but see especially Hatley, *Dividing Paths,* 225.

INTERLUDE. ON ORNAMENTS

1. Reynolds, *Discourses,* 123, 59, 44, 133.

2. Reynolds, 171.

3. Reynolds, 129.

4. Reynolds, 128.

5. Reynolds, 137.

6. Reynolds, 137. My interpretation of Reynolds on tattoos owes to Harriet Guest, *Empire, Barbarism, and Civilization: Captain Cook, William Hodges, and the Return to the Pacific* (Cambridge: Cambridge University Press, 2007), 73–74.

7. On his fondness for wine, see James Boswell, *The Life of Samuel Johnson,* ed. William Wallace (Edinburgh: Nimmo, Hay & Mitchell, 1887), 138. On his snuffboxes, see Frances Burney, *Diary and Letters of Madame d'Arblay,* ed. C. Barrett and A. Dobson (London: Macmillan, 1904), 2:163.

8. For the significance of white cloth, see Fred Gearing, *Priests and Warriors: Social Structures for Cherokee Politics in the 18th Century* (Wisconsin: American Anthropological Association, 1962), 4. Gourds and skins discussed in Theda Perdue, *Cherokee Women: Gender and Culture Change, 1700–1835* (Lincoln: University of Nebraska Press, 1998), 22.

9. James Cook in *The Journals of Captain James Cook on His Voyages of Discovery,* ed. J. C. Beaglehole (Cambridge: Cambridge University Press, 1955–74), 3:24.

CHAPTER FIVE. MAN ON A MISSION

1. On 9 July 2017 Taputapuātea gained recognition as a UNESCO World Heritage site: "As the ancestral homeland of Polynesian culture, Taputapuātea is of outstanding

significance for people throughout the whole of Polynesia, for the way it symbolises their origins, connects them with ancestors and as an expression of their spirituality." https://whc.unesco.org/en/list/1529 (accessed August 2018).

2. Many scholars have written on Mai, though all focus chiefly on his two-year sojourn in Britain. Without question the most thorough of the early works is Eric McCormick, *Omai: Pacific Envoy* (Auckland: Auckland University Press, 1977).

3. On Ra'iatea in the eighteenth century, see Anne Salmond, *Aphrodite's Island: The European Discovery of Tahiti* (Berkeley: University of California Press, 2010), 22–26. On Ra'iatea's role in the *longue durée* of Pacific history, see Patrick Vinton Kirch, *On the Road of the Winds: An Archaeological History of the Pacific Islands before European Contact* (Berkeley: University of California Press, 2000), 245–301. Kirch had earlier been a leading exponent of the theory that Ra'iatea was the initial center of east Pacific migrations; he now suggests it might have involved three separate migrations from the west. The debates are ongoing. See also Kirch and R. C. Green, *Hawaiki, Ancestral Polynesia: An Essay in Historical Anthropology* (Cambridge: Cambridge University Press, 2001). See also Kirch on the earliest confirmed date of human activity in the Society Islands (AD 1000). Kirch now speculates that it may have begun earlier. He notes that domesticated coconuts have now been dated to AD 600; he also notes that many scholars are convinced that Hawai'i, Aotearoa, and Rapa Nui were settled after the Society Islands, and evidence of humans there dates from around AD 800–1000. See Kirch, *On the Road of the Winds*, 230–45. See also Deryck Scarr, *The History of the Pacific Islands: Kingdoms of the Reefs* (Melbourne: Macmillan, 1990), 26–30.

4. See Niel Gunson, "Sacred Women Chiefs and Female 'Headmen' in Polynesian History," *Journal of Pacific History* 22/3 (1987), 139–72.

5. See P. V. Kirch, *On the Evolution of the Polynesian Chiefdoms* (Cambridge: Cambridge University Press, 1984), 37.

6. See James Burney, *With Captain James Cook in the Antarctic and Pacific*, ed. B. Hooper (Canberra: NLA, 1975), 70. And see Kirch, *On the Road of the Winds*, 283; Marshall Sahlins, *Social Stratification in Polynesia* (Seattle: American Ethnological Society, 1958); K. R. Howe, *Where the Waves Fall: A New South Seas Island History from First Settlement to Colonial Rule* (Honolulu: University of Hawai'i Press, 1984), 125; Scarr, *History of the Pacific Islands*, 36, and P. Wallin and R. Solsvik, "Marae Reflections: On the Evolution of Stratified Chiefdoms in the Leeward Society Islands," *Archaeology in Oceania* 45/2 (2010): 92.

7. On east Pacific districts, see Kirch, *On the Evolution of the Polynesian Chiefdoms*, 33, 37. Most earlier scholars (including Kirch) thought the population figures were lower than stated here (see, for example, Scarr, *History of the Pacific Islands*, 114), but Kirch has revised it upward: *On the Road of the Winds*, 284.

8. Howe, *Where the Waves Fall*, 126. Salmond, *Aphrodite's Island*, 26.

9. On 'Oro, see Howe, *Where the Waves Fall*, 127–28; Salmond, *Aphrodite's Island*, 23–35; Edward Dodd, *Polynesia's Sacred Isle* (New York: Dodd, Mead, 1976), 103–34.

10. See Kirch, *On the Evolution of the Polynesian Chiefdoms*, 205–6, and Salmond, *Aphrodite's Island*, 35. See also Meredith Filihia, "Oro-Dedicated 'Maro 'Ura' in Tahiti: Their Rise and Decline in the Early Post-European Contact Period," *Journal of Pacific*

History 31/2 (1996): 128, and Richard Connaughton, *Omai: The Prince Who Never Was* (London: Timewell, 2005), 24. Also see Wallin and Solsvik, "Marae Reflections," 91, and Salmond, *Aphrodite's Island,* 28.

11. Kirch, *On the Evolution of the Polynesian Chiefdoms,* 132–35. See Johann R. Forster, *Observations Made during a Voyage round the World,* ed. N. Thomas, H. Guest, and M. Dettelbach (Honolulu: University of Hawai'i Press, 1996), 149.

12. J. H. Forster cited in H. J. M. Claessen, "Learning and Training: Education in Eighteenth-Century Traditional Polynesia," *Bijdragen tot de Taal-, Land-en Volkenkunde (BKI)* 165–2/3 (2009): 328.

13. William Ellis, *Polynesian Researches: Hawai'i* (1824) (Rutland, VT: Charles E. Tuttle, 1969), 345–46. See also Helen Leach, "Did East Polynesians Have a Concept of Luxury Foods?" *World Archaeology* 34/3 (2010): 443.

14. See Daniel Solander to Joseph Banks, in *The Journals of Captain James Cook on His Voyages of Discovery,* ed. J. C. Beaglehole (Cambridge: Cambridge University Press, 1955–74) 2:953. See also James Magra, *A Journal of a Voyage Round the World in HMS Endeavour* (London: Becket & De Hondt, 1771), 62.

15. Magra, *Journal of a Voyage,* 61. Burney, *With Captain James Cook,* 79.

16. George Forster cited in Salmond, *Aphrodite's Isle,* 36; Joseph Banks cited in Salmond, *Aphrodite's Isle,* 201, and William Monkhouse cited in Glyn Williams, "Tupaia: Polynesian Warrior, Navigator, High Priest—and Artist," in *The Global Eighteenth Century,* ed. F. Nussbaum (Baltimore: Johns Hopkins University Press, 2003), 39. For Cook, see *The Journals,* 1:442. On Tupaia, see Joan Druett, *Tupaia: The Remarkable Story of Captain Cook's Polynesian Navigator* (Auckland: Random House, 2011).

17. Salmond, *Aphrodite's Island,* 36.

18. See Kirch and Green, *Hawaiki,* 149. For a contemporary description of an *umu,* see Joseph Cradock, *Literary and Miscellaneous Memoirs* (London: J. B. Nichols, 1826), 1:127–28.

19. Burney cited in McCormick, *Omai,* 210; Banks in Sarah S. Banks, [unpublished] Memorandums, August–November 1774, Papers of Sir Joseph Banks, NLA MS9. Cook in *The Journals,* 3:206. See also George Colman, *Random Records* (London: Colburn, 1830), 1:187–97.

20. See Burney cited in McCormick, *Omai,* 210. Hunting methods discussed in Kirch and Green, *Hawaiki,* 136. For the begrudging European, see William Anderson cited in *The Journals,* 3:854.

21. Joseph Banks, *Journal of the Right Hon. Sir Joseph Banks,* ed. J. D. Hooker (Cambridge: Cambridge University Press, 2011), 129. See also Kirch and Green, *Hawaiki,* 187–88; Nicholas Thomas, *Cook: The Extraordinary Voyages of Captain James Cook* (New York: Walker, 2003), 69; and Rachel Robinson, "The Commodification of Tattooing," MA thesis, University of Kansas, 2010.

22. J. Ritchie and J. Ritchie, *Growing Up in Polynesia* (Sydney: Allen and Unwin, 1979), 90.

23. The Frenchman cited in Salmond, *Aphrodite's Island,* 100, 102, 70. For ethnographers, see Irving Goldman, *Ancient Polynesian Society* (Chicago: University of Chicago Press, 1970), 564; McCormick, *Omai,* 4. See also Claessen, "Learning and Training," 334.

24. See Douglas Oliver, *Ancient Tahitian Society* (Honolulu: University Hawai'i Press, 1974), 352. The key revisionist scholar is Serge Tcherkezoff: see his "A Reconsideration of the Role of Polynesian Women in Early Encounters with Europeans," in *Oceanic Encounters: Exchange, Desire, Violence,* ed. M. Jolly, S. Tcherkezoff, and D. Tryon (Canberra: ANU Press, 2009), ch. 4.

25. Salmond, *Aphrodite's Island,* 284, 36–37.

26. Mrs. Hawley cited in Sarah S. Banks, [unpublished] Memorandums, August–November 1774, Papers of Sir Joseph Banks, NLA MS9. James King in *The Journals,* 3:1368–69.

27. On Wallis in Tahiti, see Greg Dening, "The Hegemony of Laughter: Purea's Theatre," in *Pacific Empires,* ed. A. Frost and J. Samson (Melbourne: Melbourne University Press, 1999), 127–46, and, especially, Salmond, *Aphrodite's Island,* 38–85. Dening and Salmond together offer brilliant exposés of British and Tahitian views, but neither assume Mai's perspective.

28. The battle recounted in Salmond, *Aphrodite's Island,* 54–55, from the manuscript of Francis Wilkinson and the 1928 compilation history of Teuira Henry. For the possible Tahitian missiles, see Kirch and Green, *Hawaiki,* 190.

29. See George Robertson, *The Discovery of Tahiti,* ed. H. Carrington (London: Hakluyt Society, 1948), 150. For later historians, see Dening, "Hegemony of Laughter," and Salmond, *Aphrodite's Island.* On Mai here, see Daniel Solander excerpted in *The Journals,* 2:949.

30. Solander in *The Journals,* 2:949.

31. Salmond, *Aphrodite's Island,* 61–62. Cook found the red flag repurposed in an Indigenous ceremony at Matavai Bay when he visited during his third Pacific voyage: see Cook in *The Journals,* 3:203. And see Filihia, "Oro-Dedicated 'Maro 'Ura' in Tahiti."

32. Salmond, *Aphrodite's Island,* 64.

33. Matt Matsuda, *Pacific Worlds: A History of Seas, Peoples, and Cultures* (Cambridge: Cambridge University Press, 2012), 135.

34. John Dunmore, ed., *The Pacific Journal of Louis-Antoine de Bougainville 1767–1768* (Cambridge: Hakluyt Society, 2002), 265. On the Bougainville stay, see Salmond, *Aphrodite's Island,* 95–109.

35. Dunmore, *Pacific Journal of Bougainville,* 74.

36. Cook in *The Journals,* 1:76–77. For the *Endeavour* in Tahiti, see also Thomas, *Cook,* 62–83.

37. Salmond, *Aphrodite's Island,* 154.

38. See both Burney, *With Captain James Cook,* 70, and Solander in *The Journals,* 2:949.

39. Cook in *The Journals,* 1:84–85.

40. Banks, *Journal of Sir Joseph Banks,* 84.

41. Solander in *The Journals,* 2:949.

42. Thomas, *Cook,* 76.

43. Joseph Banks, Letter to Dawson Turner, 1812, Fitzwilliam Museum, Cambridge, Banks Collection, MS 82. For the story of the 1997 recovery of Tupaia's artistry, see Thomas, *Cook,* 435. See also Harriet Parsons, "British–Tahitian Collaborative Drawing

Strategies on Cook's *Endeavour* Voyage," in *Indigenous Intermediaries,* ed. Shino Konishi et al. (Canberra: ANU Press, 2015), 147–68.

44. Cook in *The Journals,* 1:117.

45. See Anne Salmond, *The Trial of the Cannibal Dog: Captain Cook in the South Seas* (London: Penguin, 2003), 96.

46. See one historian, though, who has wondered: Thomas, *Cook,* 199.

47. See Salmond, *Trial of the Cannibal Dog,* 162, and Druett, *Tupaia,* 358–76.

48. Burney, *With Captain James Cook,* 70ff.

49. See Burney, 80.

50. Burney, 72.

51. For this expedition, see Thomas, *Cook,* 187–201, and Salmond, *Trial of the Cannibal Dog,* 192–219.

52. Cook in *The Journals,* 2:221.

53. Cook 2:216.

54. Cook 2:221.

55. Cook 2:217.

56. Salmond, *Trial of the Cannibal Dog,* 205.

57. Cook in *The Journals,* 2:218–19.

58. Sarah Banks records that Mai was advised against the trip by his fellow Islanders because Tupaia and "the man that went with Mr Bougainville never had returned to Otaheite." Sarah S. Banks, [unpublished] Memorandums, August–November 1774, Papers of Sir Joseph Banks, NLA MS9. That his mother was dead by the time he left was noted by a contemporary conversant, a German scientist visiting Britain in 1775, Georg Lichtenberg: cited in McCormick, *Omai,* 139.

59. See Cook in *The Journals,* 2:221 and Burney, *With Captain James Cook,* 70.

60. Burney, *With Captain James Cook,* 76.

61. Burney, 77.

62. Cook in *The Journals,* 2:399–400.

63. Cook in *The Journals,* 2:251; Salmond, *Trial of the Cannibal Dog,* 217.

64. Cook discusses these social customs in *The Journals,* 2:247, 262–68.

65. Salmond, *Trial of the Cannibal Dog,* 127–28.

66. See Cook in *The Journals,* 3:571.

67. See Bayly on *Adventure* in *The Journals,* 2:242n and 281n. Note this quote refers to a different time but a similar kind of storm.

68. Cook in *The Journals,* 2:573. Captain Furneaux's Narrative in James Cook, *A Voyage towards the South Pole, and Round the World,* 4th ed. (London: Strahan & Cadell, 1784), 2:251.

69. Burney, *With Captain James Cook,* 88. Furneaux's Narrative in Cook, *A Voyage towards the South Pole,* 2:251–54.

70. Burney, *With Captain James Cook,* 89.

71. On the earlier incident with Cook's *Resolution* crew, see Thomas, *Cook,* 209–13, and Salmond, *Trial of the Cannibal Dog,* 222–25. On the *Adventure's* time in Totara-nui, see Furneaux's Narrative in Cook, *A Voyage towards the South Pole,* 2:254–61.

72. Furneaux's Narrative in Cook, *A Voyage towards the South Pole,* 2:254.

73. Burney, *With Captain James Cook,* 95–99.

74. See Banks in *The Journals,* 1:420, and Cook in *The Journals,* 2:294. Note also William Wales's observations of Mai on Māori cannibalism elsewhere, *The Journals,* 2:819.

75. See Gananath Obeyesekere, "British Cannibals: Contemplation of an Event in the Death and Resurrection of James Cook, Explorer," *Critical Inquiry* 18 (1992): 630–54. Then see Peter Hulme, "Introduction: The Cannibal Scene," in *Cannibalism and the Colonial World,* ed. F. Barker, P. Hulme, and M. Iversen (Cambridge: Cambridge University Press, 1998), 1–38, and Harriet Guest, *Empire, Barbarism, and Civilization: Captain Cook, William Hodges, and the Return to the Pacific* (Cambridge: Cambridge University Press, 2007), 133–36. Also see more sanguine accounts in Thomas's *Cook* and Salmond's *Trial of the Cannibal Dog.*

76. Furneaux's Narrative in Cook, *A Voyage towards the South Pole,* 2:261–63. Mai's recollection of white rain reported by the naturalist Sir John Cullum, cited in McCormick, *Omai,* 130.

77. Cook in *The Journals,* 2:654–55.

CHAPTER SIX. THE MASTER ASCENDANT

1. On Bute, see John Brewer, *Party Ideology and Popular Politics at the Ascension of George III* (Cambridge: Cambridge University Press, 1776), especially chs. 1, 7, 12; and Karl W. Schweizer, "Lord Bute and the Press: The Origins of the Press War of 1762 Reconsidered," in *Lord Bute: Essays in Re-Interpretation,* ed. K. W. Schweizer (Leicester: Leicester University Press, 1988).

2. From *A Select Collection of the Most Interesting Letters on the Government, Liberty, and Constitution of England* (London: Almon, 1763), 1:15. See also P. K. Monod, *Imperial Isle: A History of Britain and Its Empire, 1660–1837* (Chichester: Wiley, 2009), 212.

3. *The Briton,* 3 July 1762; *Scots Magazine* 34 (1772): 558; *Correspondence of William Pitt, Earl of Chatham,* ed. W. S. Taylor and J. H. Pringle (London: John Murray, 1838), 3:405. Further on this popular debate, see Jack P. Greene, *Evaluating Empire and Confronting Colonialism in Eighteenth-Century Britain* (Cambridge: Cambridge University Press, 2013), 84–91; and Kate Fullagar, "Popular Contests over Empire in the Eighteenth Century: The Extended Version," *History Australia* 13/1 (2016): 67–79.

4. Further on this commission, see Douglas Fordham, *British Art and the Seven Years' War: Allegiance and Autonomy* (Philadelphia: University of Pennsylvania Press, 2010), 171–79.

5. *North Briton* 45 (23 April 1763). See also Brewer, *Party Ideology,* ch. 9.

6. See Fordham, *British Art,* 176. For some comparison of prices, see Martin Postle, *Sir Joshua Reynolds: The Subject Pictures* (Cambridge: Cambridge University Press, 1995), 278.

7. My understanding of the Bute portrait owes significantly to Fordham, *British Art,* 171–79, which itself built on John Brewer, "The Faces of Lord Bute," *Perspectives in American History* 6 (1972): 95–116. The pro-Wilkes periodical was the *Contrast* 14 (28 September 1763), cited in Fordham, *British Art,* 175.

8. See Hester Thrale, *Thraliana,* ed. K. C. Balderston (Oxford: Oxford University Press, 1951), 1:80.

9. Thrale, 1:80. See also Richard Wendorf, *Sir Joshua Reynolds: The Painter in Society* (Cambridge: Harvard University Press, 1996), 68.

10. See Wendorf, *Sir Joshua Reynolds,* 82–84, and Lyle Larsen, *The Johnson Circle* (Lanham, MD: Rowman and Littlefield, 2017), 190.

11. On deafness, see Martin Postle, "Sir Joshua Reynolds," in *The Tyranny of Treatment: Samuel Johnson, His Friends, and Georgian Medicine,* ed. N. McEnroe and R. Simon (London: British Art Journal, 2003), 32, discussing Lord Edgcumbe, "Concerning the Parentage of Joshua Reynolds," in A. Graves and W. V. Cronin, *A History of the Works of Sir Joshua Reynolds* (London: Graves, 1899–1901).

12. For Burney citations, see Ian McIntyre, *Joshua Reynolds: The Life and Times of the First President of the Royal Academy* (London: Penguin, 2003), 346, 410.

13. Kauffmann's letter (now lost) and Reynolds's pocketbook cited in Angela Rosenthal, *Angelica Kauffman: Art and Sensibility* (New Haven: Yale University Press, 2006), 97–99.

14. See W. T. Whitley, *Artists and Their Friends in England 1700–1799* (London: Medici, 1928), 1:372, and see Rosenthal, *Angelica Kauffman,* 118.

15. Boswell cited in Wendorf, *Sir Joshua Reynolds,* 65. The only other strong evidence of a heterosexual romance in Reynolds's life came earlier in three letters to a Miss Weston, sent during the Italian sojourn: see Joshua Reynolds, *The Letters of Sir Joshua Reynolds,* ed. J. Ingamells and J. Edgcumbe (New Haven: Yale University Press, 2000), 7, 8, 11.

16. See Matthew Hargraves, *"Candidates for Fame": The Society of Artists of Great Britain, 1760–1791* (New Haven: Yale University Press, 2005), 40.

17. The first statement is Horace Walpole, the second *Lloyd's Evening Post:* both cited in Hargraves, *Candidates,* 58.

18. For example, Hargraves, *Candidates,* 54.

19. See John Steegman, *Sir Joshua Reynolds* (New York: Macmillan, 1933), 40–43, and Martin Postle, "Sir Joshua Reynolds, Edmund Burke, and the Grand Whiggery," in *Art and Culture in the Eighteenth Century: New Dimensions and Multiple Perspectives,* ed. E. Goodman (Newark: University of Delaware Press, 2001), 108.

20. See McIntyre, *Joshua Reynolds,* 173–74, and Wendorf, *Sir Joshua Reynolds,* 53.

21. Anonymous pamphlet entitled "A Candid Display of the Genius and Merits of the Several Masters . . ." cited in McIntyre, *Joshua Reynolds,* 170–71.

22. Gainsborough letter to David Garrick, 1766, cited in Thomas Gainsborough, *The Letters of Thomas Gainsborough,* ed. John Hayes (London: Yale University Press, 2001), 38; for Reynolds, see his *Discourses* (Discourse V), 90.

23. Hargraves, *Candidates,* 90.

24. See Postle, "Sir Joshua Reynolds, Edmund Burke, and the Grand Whiggery," 115. See also Fordham, *British Art,* 182, 188, and James Hamilton, *Gainsborough: A Portrait* (London: Weidenfeld and Nicolson, 2017), 208.

25. James Barry paraphrasing his mentor, Edmund Burke, in *The Works of James Barry* (London: Cadell, 1809), 1:48. See also Fordham, *British Art,* 188–89.

26. Richardson cited in R. Lonsdale, "Jonathan Richardson's *Morning Thoughts,*" in *Augustan Studies: Essays in Honor of Irvin Ehrenpreis,* ed. D. L. Patey and T. Keegan (Newark: University of Delaware Press, 1985), 179.

27. See Fordham, *British Art,* 188.

28. See rationale offered in McIntyre, *Joshua Reynolds,* 189.

29. Transcript of the Instrument of Foundation of the Royal Academy of Arts in London RAA/IF Instrument of Foundation, 10 December 1768.

30. The attendee went on to report that Reynolds added, nevertheless, "that if he did— he should exhibit with the original incorporated Body." The tagalong comment rings less securely, however, than the declaration of opting out from both parties: cited in Hargraves, *Candidates,* 90.

31. James Northcote, *The Life of Sir Joshua Reynolds* (London: Henry Colburn, 1819), 1:166. The Society of Artists did survive till the 1790s, but it was never as powerful as the Royal Academy.

32. Royal Academy Council Minutes, cited in McIntyre, *Joshua Reynolds,* 190.

33. Transcript of the Instrument of Foundation.

34. See the historian Amanda Vickery for the RA blog (who, as a historian of Britain, thinks that even to include two was remarkable): https://www.royalacademy.org. uk/article/ra-magazine-summer-2016-hidden-from-history, 3 June 2016 (accessed November 2017).

35. Northcote, *The Life,* 1:170. See also Holger Hoock, *The King's Artists: The Royal Academy of Arts and the Politics of British Culture, 1760–1840* (Oxford: Oxford University Press, 2003), 34.

36. Northcote, *The Life,* 1:171.

37. Northcote cited in *The Annual Biography and Obituary: 1832 Volume XVI* (London: Longman, 1832), 358.

38. Peter Pindar, *Lyric Odes for the Year 1785* (London: Jarvis, 1785), 26.

39. See Reynolds's pocketbooks on visiting Wilkes in McIntyre, *Joshua Reynolds,* 149. On Burke's attitude to Wilkes, see David Bromwich, *The Intellectual Life of Edmund Burke* (Cambridge: Harvard University Press, 2014), 136–37.

40. David Garrick, *The Private Correspondence of David Garrick* (London: Colburn & Bentley, 1835), 1:333.

41. Reynolds, *Discourses,* 13.

42. That Reynolds took a deliberately independent attitude to the Royal Academy is a central thesis of Fordham, *British Art,* 1, 3. As noted in my prologue, Fordham's insights into the imperial dimensions of Reynolds's thought built on contextualist work about imperialism and art institutions: see especially Tim Barringer, Geoff Quilley, and Douglas Fordham, eds., *Art and the British Empire* (Manchester: Manchester University Press, 2007).

43. The residence was called Wick House, not be confused with The Wick, built next door a few years later by Robert Mylne and owned subsequently and consecutively by Keith Richards and Pete Townshend.

44. Joseph Farington, *The Farington Diary* (London: Hutchinson, 1924), 4:208. Letter in Reynolds, *Letters,* 69.

45. See James Boswell, *The Life of Samuel Johnson,* ed. William Wallace (Edinburgh: Nimmo, Hay & Mitchell, 1887), 349–52, and see for an excellent wider discussion Michael Bundock, *The Fortunes of Francis Barber* (New Haven: Yale University Press, 2015), 112.

46. Northcote, *The Life,* 1:186.

47. Northcote, 1:205–6, and see Bundock, *Fortunes,* 101–4.

48. Northcote, *The Life,* 1:204.

49. By my count these thirteen include the portraits of Ourrey and Keppel discussed in chapter 3 here; Ostenaco (1762); an Indian woman depicted in a portrait of Clive (1763: David Mannings, *Sir Joshua Reynolds: The Complete Catalogue* [New Haven: Yale University Press, 2000], plates vol., 322); Granby (1765: Mannings, plates vol., 56); Schaumburg-Lippe (1767: Mannings, plates vol., 57); three more black attendants from the 1780s (Mannings, plates vol., 91, 529, 557); two sole portraits of a young black man, both from 1770 (Mannings, plates vol., 415); Reynolds's 1775 portrait of Mai (Mannings, plates vol., 101); and a portrayal of a Chinese visitor in 1776 (Mannings, plates vol., 468).

50. Charles Leslie, *Life and Times of Sir Joshua Reynolds* (London: Murray, 1865), 1:428–29. On Burney's involvement, see Eric McCormick, *Omai: Pacific Envoy* (Auckland: Auckland University Press, 1977), 28.

51. On the "Pacific Craze," see Kate Fullagar, *The Savage Visit: New World People and Popular Imperial Culture in Britain, 1710–1795* (Berkeley: University of California Press, 2012), 119–25. For a discussion of the portrait of Banks, see Mark Hallett, *Reynolds: Portraiture in Action* (New Haven: Yale University Press, 2014), 247.

52. Cited in Leslie, *Life and Times,* 1:428.

53. Boswell, *Life of Samuel Johnson,* 288.

54. Burke in a letter to William Robertson, 1777, cited in Daniel O'Neill, *Edmund Burke and the Conservative Logic of Empire* (Berkeley: University of California Press, 2016), 64.

55. See Steve Pincus, *The Heart of the Declaration* (New Haven: Yale University Press, 2016), 90.

56. See Samuel Johnson, *Taxation No Tyranny* (London: Cadell, 1775). Edmund Burke, *On American Taxation* (London: Dodsley, 1774).

57. Britain's rediscovery of the Pacific began with John Byron's voyage, but this hit few islands and missed Tahiti altogether.

58. See Horace Walpole, *Letters,* ed. P. Toynbee (Oxford: Oxford University Press, 1903–5), 7:277.

59. Boswell cited in Philip Edwards, *The Story of the Voyage: Sea-Narratives in Eighteenth-Century England* (Cambridge: Cambridge University Press, 2004), 8. "Vicious indulgences" in *Public Advertiser,* 3 July 1773. Attacks on Hawkesworth cited in Jonathan Lamb, "Minute Particulars and the Representation of South Pacific Discovery," *Eighteenth-Century Studies* 28/3 (1995): 292.

60. Edwards, *The Story of the Voyage,* 86.

61. *Public Advertiser,* 2 July 1773. For a discussion of Burney and others, see Edwards, *The Story of the Voyage,* 86, and Gillian Russell, "An 'Entertainment of Oddities':

Fashionable Sociability and the Pacific in the 1770s," in *A New Imperial History: Culture, Identity and Modernity in Britain and the Empire, 1660–1840,* ed. K. Wilson (Cambridge: Cambridge University Press, 2004), 48–70. The Hawkesworth book still sold extremely well in the eighteenth century, despite—or perhaps due to—the attacks on its author.

62. See Gainsborough, *Letters,* 112–13; see also McIntyre, *Joshua Reynolds,* 242–43.

63. See Martin Postle, *Thomas Gainsborough* (Princeton: Princeton University Press, 2002), 55. On the hanging style of the RA, see Mark Hallett, "Reading the Walls: Pictorial Dialogue at the British Royal Academy," *Eighteenth-Century Studies* 37/4 (2004): 581–604.

64. James Northcote, *Conversations of James Northcote* (London: Methuen, 1901), 159. Bate-Dudley cited in Postle, *Thomas Gainsborough,* 55; Wilson cited in Wendorf, *Sir Joshua Reynolds,* 98.

65. Cited and discussed in Postle, *Sir Joshua Reynolds,* 153–55.

66. Northcote, *The Life,* 2:196.

67. Northcote, 1:309.

68. Cited in Angelica Goodden, *Miss Angel: The Art and World of Angelica Kauffman, Eighteenth-Century Icon* (Pimlico: Random House, 2011), 100.

69. See McIntyre, *Joshua Reynolds,* 294. See also Martin Butlin, "An Eighteenth-Century Art Scandal," *Connoisseur* 174 (1970): 1–9.

70. Cited in John Newman, "Reynolds and Hone: 'The Conjuror' Unmasked," in *Reynolds,* ed. N. Penny (New York: Abrams, 1986), 354.

CHAPTER SEVEN. A PACIFIC CELEBRITY AND THE PORTRAIT THAT WORKED

1. *General Evening Post,* 14 July 1774.

2. Solander to Lind, 19 August 1774, reprinted in *The Journals,* 2:949–51.

3. On Banks and the second voyage, see Nicholas Thomas, *Cook: The Extraordinary Voyages of Captain James Cook* (New York: Walker, 2003), 147–50; on Banks and Tupaia, see Thomas, *Cook,* 80–81.

4. Sarah S. Banks, [unpublished] Memorandums, August–November 1774, Papers of Sir Joseph Banks, NLA MS9. Eric McCormick traces Sarah Banks's information chiefly from a Dr. Mills in Exeter, who got it from a Mr. Desalis, who got it from Mr. Bates, the secretary to Lord Sandwich: Eric McCormick, *Omai: Pacific Envoy* (Auckland: Auckland University Press, 1977), 95.

5. *London Chronicle,* 28 July 1774.

6. Anon., *An Historic Epistle from Omiah to the Queen of Otaheite* (London: T. Evans, 1775).

7. Anon., *Omiah's Farewell; Inscribed to the Ladies of London* (London: G. Kearsley, 1776); Anon., *Transmigration; A Poem* (London: J. Bew, 1778).

8. For the whole inoculation process and Banks's letter to Sandwich, see McCormick, *Omai,* 101–6. For Mrs. Hawley, see Sarah S. Banks, [unpublished] Memorandums, August–November 1774, Papers of Sir Joseph Banks, NLA MS9.

9. Sandwich to Banks, 14 August 1774, Banks Papers MS9, Dixson Library, SLNSW. See also S. S. Banks, Memorandums.

10. *General Evening Post,* 25 August 1774.

11. *General Evening Post,* 3 September 1774.

12. Joseph Cradock, *Literary and Miscellaneous Memoirs* (London: J. B. Nichols, 1826), 1:127–28.

13. Banks recorded in Sarah S. Banks, [unpublished] Memorandums, August–November 1774, Papers of Sir Joseph Banks, NLA MS9.

14. William Gardiner, *Music and Friends; Or Pleasant Recollections of a Dilettante* (London: Longman, 1838), 1:5.

15. *General Evening Post,* 5 November 1774.

16. *The Parliamentary Register* (London: Almon, 1775), 1:3–4.

17. See in notes earlier, chapter 2, on political cleavages in the era. For their increased complexity during the American Revolution, see John Brewer, "English Radicalism in the Age of George III," in *Three British Revolutions,* ed. J. G. A. Pocock (Princeton: Princeton University Press, 1980), ch. 10; Eliga Gould, *The Persistence of Empire: British Political Culture in the Age of the American Revolution* (Chapel Hill: University of North Carolina Press, 2000), 106–80; Iain Hampshire-Monk, "British Radicalism and the Anti-Jacobins," in *The Cambridge History of Eighteenth-Century Political Thought,* ed. M. Goldie and R. Wokler (Cambridge: Cambridge University Press, 2006), 660–87.

18. John Gascoigne, *Science in the Service of Empire: Joseph Banks, the British State and the Uses of Science in the Age of Revolution* (Cambridge: Cambridge University Press, 1998).

19. Frances Burney, *The Early Diary of Frances Burney,* ed. A. R. Ellis (London: Bell, 1889), 1:324–25. For an analysis of the event from the perspective of the Burneys, see Ruth Scobie, "'Bunny! O! Bunny!': The Burney Family in Oceania," *Eighteenth-Century Life* 42/2 (2018): 56–72.

20. On Mai's press coverage and celebrity status, see Kate Fullagar, *The Savage Visit: New World People and Popular Imperial Culture in Britain, 1710–1795* (Berkeley: University of California Press, 2012), 130–44.

21. Ian McIntyre, *Joshua Reynolds: The Life and Times of the First President of the Royal Academy* (London: Penguin, 2003), 272–73.

22. John Cannon, *Samuel Johnson and the Politics of Hanoverian England* (Oxford: Oxford University Press, 1994), 68–117.

23. Richard Bourke, *Empire and Revolution: The Political Life of Edmund Burke* (Princeton: Princeton University Press, 2015), ch. 8.

24. Georg Lichtenberg, cited in McCormick, *Omai,* 138.

25. Cradock, *Literary and Miscellaneous Memoirs,* 1:127.

26. Henry Angelo, *Reminiscences of Henry Angelo* (London: Colburn, 1830), 2:55–56. On D'Éon, see Gary Kates, *Monsieur D'Éon Is a Woman* (New York: Basic Books, 1995).

27. See Cradock, *Literary and Miscellaneous Memoirs,* 1:125; Burney, *Early Diary,* 1:325.

28. Sarah S. Banks, [unpublished] Memorandums, August–November 1774, Papers of Sir Joseph Banks, NLA MS9; Anon., *A Second Letter from Oberea* (London: Carnegy, 1774).

29. *London Chronicle,* 20 April 1775.

30. Anon., *An Historic Epistle.*

31. Anon., *Omiah's Farewell;* Anon., *Omiah: An Ode,* written c.1776, pub. in *The New Foundling Hospital for Wit* (London: Debret, 1784), 2:132–37.

32. Mrs. Hawley discussed in S. S. Banks, Memorandums.

33. Joseph Banks, "Journal of a Voyage Made in the Augusta Yatch [*sic*]," MS, cited by McCormick, *Omai,* 146.

34. Cook to The Admiralty Secretary, 22 March 1775, reprinted in *The Journals,* 2:691–93.

35. Solander to Banks, 28 June 1775, reprinted in *The Journals,* 2:952–53.

36. As reported in Solander to Banks, 28 June 1775, in *The Journals,* 2:953.

37. *The Journals,* 2:399–400.

38. Banks's "Journal of a Voyage," MS, cited in McCormick, *Omai,* 147.

39. George Colman, *Random Records* (London: Colburn, 1830), 1:163–67.

40. Thomas, *Cook,* 263–65.

41. James Boswell, *The Life of Samuel Johnson,* ed. William Wallace (Edinburgh: Nimmo, Hay & Mitchell, 1887), 162, 288.

42. *Gentleman's Magazine* 45 (1775): 132.

43. *London Magazine* 44 (1775): 497, 441.

44. Burney, *Early Diary,* 2:131.

45. Thomas, *Cook,* 76.

46. On Reynolds's preference for his sitters to appear in classical mode, see *Discourses,* 128. For scholars seeing classical references, see B. Smith, *European Vision and the South Pacific* (Oxford: Oxford University Press, 1960), 80–81; G. Williams in his and P. J. Marshall's *The Great Map of Mankind* (London, 1982), 283; and Marcia Pointon, *Hanging the Head: Portraiture and Social Formation in Eighteenth-Century England* (New Haven: Yale University Press, 1998), 154. For a summary of the Pacific historians' counterview, see Caroline Turner, "Images of Mai," in *Cook and Omai: The Cult of the South Seas,* ed. Michelle Hetherington (Canberra: NLA, 2001), 27. Note also that Dance and Parry (discussed further in this chapter) depicted Mai largely as he appeared in Reynolds's work, too.

47. On Mai as Oriental, see William Cummings, "Orientalism's Corporeal Dimension," *Journal of Colonialism and Colonial History* 4/2 (2003): para 30. On Mai as African, see McCormick, *Omai,* 174. On Mai as Rajastani, see McIntyre, *Joshua Reynolds,* 303. For my more extensive analysis of this work, see Kate Fullagar, "Reynolds' New Masterpiece: From Experiment in Savagery to Icon of the Eighteenth Century," *Journal of Cultural and Social History* 7/2 (2010): 191–212.

48. The idea that Mai's gaze seems to consolidate the general "blank" effect of Mai's portrait is discussed in Harriet Guest, *Empire, Barbarism, and Civilization* (Cambridge: Cambridge University Press, 2007), ch. 3.

49. Walpole cited in David Mannings, *Sir Joshua Reynolds: Complete Catalogue of His Paintings* (New Haven: Yale University Press, 2000), 1:357. On his estate sale, see Martin Postle, *Sir Joshua Reynolds: The Subject Pictures* (Cambridge: Cambridge University Press, 1995), 278.

50. Horace Walpole, *Letters,* ed. P. Toynbee (Oxford: Oxford University Press, 1903–5), 9:322. Mai's recollection of white rain reported by the naturalist Sir John Cullum, cited in McCormick, *Omai,* 130.

51. P. Hoard, *Memoirs of Granville Sharp* (London: Colburn, 1820), 146.

52. On the 1776 exhibition, see *The exhibition of the Royal Academy, M.DCC.LXXVI. The eighth* (London: Davies, printer to the Royal Academy, 1776). It notes that William Hodges, who had been the artist onboard the *Adventure,* showed three landscapes of Tahiti in this show.

53. *An Historic Epistle,* 30–31. For a discussion of the thirteenth-century Ugolino, his incarnation in Dante's *Inferno,* and British culture's peculiar fascination with him, especially from Jonathan Richardson's revival of the story in the eighteenth century, see F. A. Yates, "Transformations of Dante's Ugolino," *Journal of the Warburg and Courtauld Institutes* 14/1 (1951): 92–117.

54. As reported by a deliciously amused Frances Burney: *Early Diary,* 2:139–40.

55. Officer John Williamson, cited in Anne Salmond, *The Trial of the Cannibal Dog: Captain Cook in the South Seas* (London: Penguin, 2003), 477.

56. See Salmond, 306.

57. See Thomas, *Cook,* 275; David Mackay, "Banks, Bligh, and Breadfruit," *New Zealand Journal of History* 8/1 (1974): 61–77; and Jennifer Newell, *Trading Nature: Tahitians, Europeans and Ecological Exchange* (Honolulu: University of Hawai'i Press, 2010), 150.

58. "The Instructions," in *The Journals,* 3:ccxxi.

59. Cook in *The Journals,* 3:5.

CHAPTER EIGHT. RETURN OF THE TRAVELER

1. Cook in *The Journals,* 3:3–15.

2. Cook to Sandwich, 26 November 1777, in *The Journals,* 3:1520.

3. Eric McCormick, *Omai: Pacific Envoy* (Auckland: Auckland University Press, 1977), 194, drawn from: "A Cape Link with Omai," *Africana Notes and News* 40 (1954): 169–70.

4. Cook, *The Journals,* 3:48. Furneaux's *Adventure* had landed in Van Diemen's Land in early 1773, when first separated from Cook's *Resolution* but before meeting up with Mai in later 1773.

5. Anne Salmond, *The Trial of the Cannibal Dog: Captain Cook in the South Seas* (London: Penguin, 2003), 311; Frank McLynn, *Captain Cook: Master of the Seas* (New Haven: Yale University Press, 2011), 290; McCormick, *Omai,* 197.

6. Cook in *The Journals,* 3:53.

7. Cook 3:59.

8. Alternatively, Mai may not have been thought of a high enough station to warrant communication during the earlier encounter.

9. Cook 3:59–64.

10. Cook 3:62.

11. Cook 3:68 (my italics). This incident, as per Van Diemen's Land, is another good example of when historians have taken Cook's view in seeing Mai as simply annoying.

12. Cook 3:69.

13. Cook 3:70.

14. Cook in 3:241. See also Anderson in *The Journals*, 3:801, and Samwell in *The Journals*, 3:995.

15. Cook in *The Journals*, 3:242; Samwell in *The Journals*, 3:995; Cook in *The Journals*, 3:242; Gilbert in *The Journals*, 3:242.

16. The Māori here is a modern iteration of Samwell's recording, by J. M. McEwen in *The Journals*, 3:1299–1300. The English translation provided also by McEwen. The boys did plunge into deep unhappiness and possibly regret during the first few days at sea, but this "at length went off," Cook in *The Journals*, 3:76.

17. Cook in *The Journals*, 3:86–87; Anderson in *The Journals*, 3:836.

18. Cook in *The Journals*, 3:93; Burney in *The Journals*, 3:93; Anderson in *The Journals*, 3:854.

19. Cook in *The Journals*, 3:99.

20. Cook 3:112–16.

21. Cook 3:133.

22. Burney in *The Journals*, 3:1341.

23. Samwell in *The Journals*, 3:1032.

24. Samwell 3:1052.

25. King in *The Journals*, 3:1369.

26. Cook in *The Journals*, 3:186, and see King in *The Journals*, 3:1369. It is possible, too, that the cold reception was due to the initial perception of a lack of appropriate gifts.

27. See Cook in *The Journals*, 3:187–88. On sibling reunion, see also King in *The Journals*, 3:1370.

28. Cook in *The Journals*, 3:186.

29. Cook 3:222–23 provides a garbled version. The record is set straighter by McCormick, *Omai*, 226–27.

30. Cook in *The Journals*, 3:188. Cook later wrote disparagingly of his would-be rivals. These trumped-up colonials "even went so far as to tell them that we [Britain] no longer existed as a nation; that [Britain] was only a small island like Otaheite, which they, the Spaniards, had wholly distroyed." And "as to me," Cook spluttered, they had told the Tahitians "they had met me at sea and with a few shot sent the Ship and every soul in her to the bottom," Cook 3:223.

31. Cook 3:224.

32. See Samwell in *The Journals*, 3:1059.

33. Cook in *The Journals*, 3:192.

34. Cook 3:192–94.

35. Cook 3:193. And see Gilbert in *The Journals*, 3:193.

36. Cook in *The Journals*, 3:193; King in *The Journals*, 3:1368.

37. Cook in *The Journals*, 3:193, and see also 221.

38. King in *The Journals*, 3:1387; see also Cook in *The Journals*, 3:220.

39. Cook in *The Journals*, 3:219–20, 239.

40. Cook 3:195.

41. Samwell in *The Journals*, 3:1059; King in *The Journals*, 3:1375; Bayly in *The Journals*, 3:193, 195.
42. Bayly in *The Journals*, 3:193.
43. Cook in *The Journals*, 3:212–13.
44. Cook 3:213. Cook learned about the other ways, of course, from Mai.
45. Cook 3:219–20. On the subject of English flags, during the Matavai Bay layover Cook spied what he thought was the old red pennant that Tupaia had retrieved from Wallis's possessive attempts, nearly a full decade earlier, woven into Tu's *maro 'ura,* or royal girdle. It was a fitting show of Indigenous appropriation—the kind that Tupaia might have loved. See Cook 3:203. See also Guillaume Alevêque, "Remnants of the 'Wallis Maro 'Ura' (Tahitian Feathered Girdle): History and Historiography," *Journal of Pacific History* 53/1 (2018): 1–24, and Meredith Filihia, "Oro-Dedicated 'Maro 'Ura' in Tahiti: Their Rise and Decline in the Early Post-European Contact Period," *Journal of Pacific History* 31/2 (1996): 127–43.
46. Cook, in *The Journals*, 3:230. See also Samwell in *The Journals*, 3:1069.
47. Cook in *The Journals*, 3:232.
48. Cook 3:235.
49. Cook 3:233.
50. Cook 3:233.
51. Cook 3:233; see also Samwell in *The Journals*, 3:1070, and Bayly in *The Journals*, 3:233.
52. Cook in *The Journals*, 3:234.
53. Cook 3:234.
54. Home in *The Journals*, 3:235. Cook in *The Journals*, 3:235; see also King in *The Journals*, 3:1384.
55. Samwell in *The Journals*, 3:1070.
56. Cook, *The Journals*, 3:236. See also Samwell, *The Journals*, 3:1071, and King in *The Journals*, 3:1385. And [John Rickman], *The Journals of Captain Cook's Last Voyage to the Pacific Ocean* (London: Newbery, 1781), 168.
57. Heinrich Zimmermann, *Zimmerman's Account of the Third Voyage of Captain Cook,* ed. U. Tewsley (Wellington: Alexander Turnbull Library, 1926), 59.
58. Samwell in *The Journals*, 3:1070. Cook in *The Journals*, 3:239.
59. Bayly in *The Journals*, 3:193.
60. Bayly 3:193. The "Lectrifying Machine" was probably a portable plate-glass machine built by Jesse Ramsden to generate shocks; it worked poorly in humid climates. Banks adored such gadgets. See Anita McConnell, *Jesse Ramsden: London's Leading Scientific Instrument Maker* (Farnham: Ashgate, 2007).
61. Cook in *The Journals*, 3:237.
62. [Rickman], *Journals of Captain Cook's Last Voyage*, 170–71.
63. [Rickman], 174.
64. Salmond, *Trial of the Cannibal Dog,* 357, and Glyn Williams, "Tupaia: Polynesian Warrior," in *The Global Eighteenth Century,* ed. F. Nussbaum (Baltimore: Johns Hopkins University Press, 2003), 41.
65. Mostly see McLynn, *Captain Cook,* 330–31. He is solidly backed by Dan O'Sullivan, *In Search of Captain Cook* (London: I. B. Tauris, 2008), 154–57. Salmond agrees on the airs: *Trial of the Cannibal Dog,* 372.

66. Salmond, Thomas, and McCormick all allow Cook and Rickman to wrap up the Mai part of their histories.

67. Cook in *The Journals*, 3:235; Rickman, *Journals of Captain Cook's Last Voyage*, 41, 171, 174.

68. Cook in *The Journals*, 3:238–39.

69. Samwell, in *The Journals*, 3:1072. And Bayly in *The Journals*, 3:242.

70. Cook in *The Journals*, 3:240; Bayly in *The Journals*, 3:240; Rickman, *Journals of Captain Cook's Last Voyage*, 177. See also Burney (2 November 1777) cited in McCormick, *Omai*, 260.

71. John Watts in *The Voyage of Governor Phillip to Botany Bay* (London: Stockdale, 1790), 339, 349.

72. William Bligh, *Log of the Bounty*, ed. O. Rutter (London: Golden Cockerel Press, 1937), 1:385–94.

73. On the animals, see Watts in *The Voyage of Governor Phillip*, 344. On the tattooed mementos, see Bligh, *Log*, 2:83.

EPILOGUE

1. For "natural death," see *The Journal of Arthur Bowes Smith: Surgeon*, Lady Penrhyn *1787–1789*, ed. P. G. Fidlon and R. J. Ryan (Sydney: Australian Documents Library, 1979), 108; William Bligh, *Log of the Bounty*, ed. O. Rutter (London: Golden Cockerel Press, 1937), 2:83; George Mortimer, *Observations and Remarks during a Voyage to the Islands* (London: Cadell, Robson, & Sewell, 1791), 24–25. For "ague," see James Morrison, *Journal of James Morrison*, ed. O. Rutter (London: Golden Cockerel Press, 1935), 112.

2. George Vancouver, *A Voyage of Discovery* (London: Robinson & Edwards, 1798), 1:141. William Ellis, *Polynesian Researches*, new ed. (London: Bohn, 1853), 2:369.

3. Joseph Banks, *The Endeavour Journal of Joseph Banks 1768–1771*, ed. J. C. Beaglehole (Sydney: Angus and Robertson, 1962), 1:376–78. See also Cook in *The Journals*, 3:208–9; E. H. Lamont, *Wild Life among the Pacific Islanders* (London: Hurst and Blackett, 1867), 124–25, 208–10; Nihi Vini, "Tongareva Death and Mourning Rituals," *Journal of the Polynesian Society* 85/3 (1976): 367–74; Vanessa Smith, "Performance Anxieties: Grief and Theatre in European Writing on Tahiti," *Eighteenth-Century Studies* 41/2 (2008): 149–64.

4. Samwell, *The Journals*, 3:1020, and Cook, *The Journals*, 3:209.

5. Vini, "Tongareva Death," 371.

6. Bligh, *Log*, 2:83.

7. Morrison, *Journal*, 112.

8. Vancouver, *Voyage of Discovery*, 1:141.

9. Bligh, *Log*, 1:394, reported that Puni died around 1786. See also Vancouver, *Voyage of Discovery*, 1:113.

10. For a good summary of the Pōmares, see K. R. Howe, *Where the Waves Fall* (Honolulu: University of Hawai'i Press, 1984), 127–51.

11. Bligh, *Log*, 1:394.

12. David Chappell, *Double Ghosts: Oceanian Voyager on Euroamerican Ships* (Armonk, NY: Sharpe, 1997), 142–43.

13. This death has generated a minor industry of its own in controversial scholarship. For a good narrative of the event, see Nicholas Thomas, *Cook: The Extraordinary Voyages of Captain James Cook* (New York: Walker, 2003), 390–401. For the best overview of the controversy, see Robert Borofsky, "Cook, Lono, Obeyesekere, and Sahlins," Forum on Theory in Anthropology in *Current Anthropology* 38/4 (April 1997): 255–82.

14. N. A. M. Rogers, *The Insatiable Earl: A Life of John Montagu, Fourth Earl of Sandwich* (London: HarperCollins, 1994).

15. Paul Kelton, "Avoiding the Smallpox Spirits: Colonial Epidemics and Southeastern Indian Survival," *Ethnohistory* 51/1 (Winter 2004): 45–71.

16. See J. M. Mize, "Sons of Selu: Masculinity and Gendered Power in Cherokee Society, 1775–1846," PhD diss., University of North Carolina, 2017, 36, 44, 50–51. See also Natalie Inman, "'A Dark and Bloody Ground:' American Indian Responses to Expansion during the American Revolution," *Tennessee Historical Quarterly* 70/4 (2011): 258–75, and Colin G. Calloway, *The American Revolution in Indian Country: Crisis and Diversity in Native American Communities* (New York: Cambridge University Press, 1995), 200–204.

17. Michan Chowritmootoo, "So Their Remains May Rest: Cherokee Death Rituals and Repatriation," MA thesis, Texas Woman's University, 2009, ch. 5. See also C. Rodning, "Mortuary Practices, Gender Ideology, and the Cherokee Town at the Coweeta Creek Site," *Journal of Anthropological Archaeology* 30 (2011): 145–73, and Alexander Longe, "A Small Postscript on the Ways and Manners of the Indians called Cherokees (1725)," reprinted in *Southern Indian Studies* 21 (1969): 26.

18. C. Rodning "Mounds, Myths, and Cherokee Townhouses in Southwestern North Carolina," *American Antiquity* 74/4 (2009): 627–63.

19. See Theda Perdue, *Cherokee Women* (Lincoln: University of Nebraska Press, 1998), 103–4.

20. J. W. Livingood, *Hamilton County* (Memphis: Memphis State University Press, 1981), 20–21; T. R. Williams, "The Long Pond Place," *Dry Valley Messenger* 7/2 (2014), 3; Treaty of Colhoun, 1819, transcribed: http://cdn.lib.unc.edu/ncmaps/files/cherokee_k12.pdf (accessed March 2018). US Dept. of Interior National Parks Service, *National Register of Historical Places* (July 1969)—thanks to Mills McArthur for this document. For prices, see http://anotherandrosphereblog.blogspot.com.au/2013/03/how-much-did-things-cost-in-1850s-usa.html (accessed 2018). Note that if this land had been in the hands of Ostenaco, it was not part of the original eleven-town settlement forged in 1776–77 but instead part of the five-town settlement that the Ani-Yunwiya formed twenty miles southwest of there, after their original plots were razed by revolutionary forces in 1779.

21. See D. C. Corkran, "Attakullakulla," in https://www.ncpedia.org/biography/attakullakulla (accessed April 2018).

22. Calloway, *American Revolution in Indian Country*, 200–211. For the cache, see John Alden, "Eighteenth-Century Cherokee Archives," *American Archivist* 5/4 (1942): 240–44. On Oconostota's burial, see D. King and D. Olinger, "Oconostota," *American Antiquity* 37/2 (1972): 222–28, which details the identification of the body

in a 1960s exhumation by its canoe coffin and by a pair of spectacles. The authors postulate that the spectacles were brought home from Britain by Ostenaco and given to his notoriously poor-sighted friend. Oconostota's remains were reconsecrated near the Tellico Reservoir in Tennessee (site of old Chota).

23. Duane King, "Mysteries of the Emissaries of Peace," in *Culture, Crisis, and Conflict: Cherokee British Relations 1756–1765,* ed. A. Rogers and B. Duncan (Cherokee: Museum of the Cherokee Indian, 2009), 159.

24. See G. E. Dowd, *A Spirited Resistance: The North American Indian Struggle for Unity, 1745–1815* (Baltimore: Johns Hopkins University Press, 1992), 55, 160; and see Mize, "Sons of Selu," ch. 1. Note that New Chota is now better known as New Echota.

25. David Mannings, *Sir Joshua Reynolds: The Complete Catalogue* (New Haven: Yale University Press, 2000), plates vol., 484.

26. Susan Nash, "Signature Stories: Helen Timberlake's Petition to George III," *Bulletin of the John Rylands Library* 90/2 (2014): 192.

27. Nash.

28. The National Archives at Kew, T. 1/633, fo. 336, 21 July 1786, photographically reproduced in Nash, "Signature Stories," 206–9. It seems that Helen had been pregnant when Henry died, delivering a daughter, Elizabeth, in March 1766 only to bury the baby within eight months.

29. See Ian McIntyre, *Joshua Reynolds: The Life and Times of the First President of the Royal Academy* (London: Penguin, 2003), 426–27.

30. Samuel Johnson, *The Letters of Samuel Johnson,* ed. B. Redford (Oxford: Oxford University Press, 1992–94), 4:387–88. Thomas Gainsborough, *The Letters of Thomas Gainsborough,* ed. J. Hayes (London: Yale University Press, 2001), 161. For Reynolds grumbling about the post and its pay: Joshua Reynolds, *The Letters of Joshua Reynolds,* ed. J. Ingamells and J. Edgcumbe (New Haven: Yale University Press, 2000), 128–30.

31. Gainsborough, *Letters,* 176. Reynolds, *Discourses,* 252. *European Magazine* 32 (1797): 58. See also McIntyre, *Joshua Reynolds,* 475–76.

32. Samuel Johnson, *Taxation No Tyranny* (London: Cadell, 1775). Edmund Burke, speech "On Conciliation with America" (1775) at http://www.let.rug.nl/usa/documents/1751-1775/edmund-burke-speech-on-conciliation-with-america-march-22-1775.php (accessed March 2018).

33. See Elizabeth R. Lambert, *Edmund Burke of Beaconsfield* (Newark: University of Delaware Press, 2003), 138, who quotes from Boswell's unpublished journal. Burke goes unnamed in the "official" anecdote in James Boswell, *The Life of Samuel Johnson,* ed. William Wallace (Edinburgh: Nimmo, Hay & Mitchell, 1887), 490.

34. McIntyre, *Joshua Reynolds,* 428.

35. Reynolds, *Letters,* 189. See also McIntyre, *Joshua Reynolds,* 469.

36. See Edmond Malone, *The Works of Sir Joshua Reynolds* (London: Cadell & Davies, 1809), 1:civ. For a fascinating meditation on Reynolds and the French Revolution, see Richard Wendorf, *Sir Joshua Reynolds: The Painter in Society* (Cambridge: Harvard University Press, 1996), 191–205.

37. Joshua Reynolds died on 23 February 1792. McIntyre, *Joshua Reynolds,* 526–27.

38. Joseph Farington, *Memoirs of Sir Joshua Reynolds* (1819), ed. M. Postle (London: Pallas Athene, 2005), 152–64.

39. Richard Bourke, *Empire and Revolution: The Political Life of Edmund Burke* (Princeton: Princeton University Press, 2015), 840–50, 867, 918–19.

40. Frances Burney, *Diary & Letters of Madame d'Arblay, 1778–1840,* ed. C Barrett and A. Dobson (London: Macmillan, 1904), 6:416. For Kauffmann, see Angelica Goodden, *Miss Angel: The Art and World of Angelica Kauffman, Eighteenth-Century Icon* (London: Random House, 2006).

41. Natalie Zemon Davis, *Women on the Margins: Three Seventeenth-Century Lives* (Cambridge: Harvard University Press, 1995), 212.

Acknowledgments

Readers will have surmised by now that my ambitions for this book were somewhat lunatic, covering as they did so many different historical and critical fields of scholarship. My defense rests, first, on how invigorating it was to put one's head above the parapet of a single academic niche and learn about the hugely varied developments going on in research about the same era. And, second, I was encouraged all the way by the extraordinary generosity of so many scholars in my chief fields. Discipline policing may be alive and well in academia but so is an eagerness to welcome newcomers to knowledge areas and to share ideas.

Perhaps the most welcoming field of all has been that of Native American history. Ever since an initial spontaneous lunch invitation from Theda Perdue back in 2010 I have been buoyed by the support of specialists such as Tyler Boulware, Kris Ray, Colin Calloway, Greg Smithers, Bruce Duthu, Josh Piker, Phil Deloria, Michael Oberg, Josh Reid, and the staff of the Museum of the Cherokee Indian. Tyler and Kris generously read portions of this book. My understanding of Cherokee history would be impossible without the work of these scholars, just as it clearly builds on the research of those I did not have the fortune to meet, such as David Corkran, Tom Hatley, John Oliphant, Duane King, Daniel Tortora, and Daniel Heath Justice.

My association with Pacific historians has been longer and no less warm. Over many years I have been sustained by conversations with Nick Thomas,

John Gascoigne, Brij Lal, Miranda Johnson, Leah Lui-Chivizhe, Jenny Newell, Jude Philp, Vanessa Smith, Warwick Anderson, Harriet Parsons, Margaret Jolly, and the late Greg Dening. Jenny, Jude, and Vanessa all went above and beyond with their close readings of the Pacific-focused chapters. Alice Te Punga Somerville has deepened my thinking about Indigenous identity and scholarship—and about friendship—in more ways than I can say here. As is the case with my writings on Ostenaco, my work on Mai is indebted to certain unmet leaders of the field—here, Teuira Henry, John Beaglehole, Eric McCormick, and Anne Salmond.

My teachers and advisors in British history stay with me always. I am grateful to count among my friends the professors at UC Berkeley from years ago, Thomas Laqueur, James Vernon, and David Lieberman. Early encouragement from John Brewer, Jon Mee, James Chandler, John Barrell, and Harriet Guest helped get this book off the ground. In the middle of writing it I was delighted to meet and share work with the great Reynolds scholar Mark Hallett. Every historian of Reynolds owes immeasurably to the research of Martin Postle, Douglas Fordham, Richard Wendorf, Ian McIntyre, and especially David Mannings.

Many colleagues and friends from other fields have helped by reading, questioning, and listening to me. I am thankful to Michelle Arrow, Nic Baker, Alison Bashford, Bernadette Brennan, Bruce Buchan, David Christian, Anna Clark, Deirdre Coleman, Peter Denney, Tanya Evans, Emma Gleadhill, Tom Griffiths, Mark Hearn, Jarrod Hore, Shino Konishi, Alan Lester, Mark McKenna, Jennifer McLaren, Drusilla Modjeska, Tamson Pietsch, Sarah Pinto, Keith Rathbone, Robert Reynolds, Killian Quigley, and, in particular, Clare Corbould. My women's scholarly/drinking group, the wonderfully self-named scrags, reviewed and improved several chapters—special thanks to Zora Simic, Amanda Kearney, Frances Flanagan, Jess Whyte, Baylee Brits, and our inestimable founder, Clare Monagle.

Research for this book was significantly funded by my own Faculty of Arts, Macquarie University, as well as by fellowships from the British Academy and the Lewis Walpole Library at Yale University. I wish to acknowledge here as well the early research assistance I received from Michaela Cameron and the generous illustration subsidy granted by the Australian Academy of the Humanities. The board and staff at Yale University Press have been models of publishing excellence. I'm deeply grateful to series editor Steven Pincus for his time and trust in this project, and to my copyeditor Lawrence Kenney for his care and engagement.

My debt to three particular historian friends can never be repaid. Michael McDonnell has certainly lived up to his promise always to be my "hardest audience." He is also my most loyal and inspirational. Marina Bollinger and Leigh Boucher are my poststructuralist besties who would never dream of writing the life of anyone but who nonetheless cheer me on in all my endeavors. Thank you for such faith.

My dear and expanding family provide succor of every kind, especially my husband, Iain McCalman, who read everything with a writer's eye, and my siblings-in-law, who read one thing with a hawk's eye. This book is dedicated to my dad, who celebrates curiosity in all forms. And to the memory of my mum, who urged me to find a way to do the same.

Index